MULTIPLE VIEWS

MULTIPLE VIEWS

LOGAN GRANT ESSAYS
ON PHOTOGRAPHY
1983–89

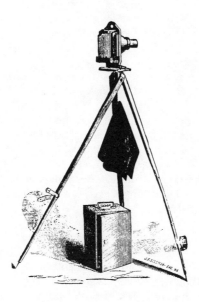

Edited by
Daniel P. Younger
Photographic Resource Center

Introduction by
Alan Trachtenberg

UNIVERSITY OF NEW MEXICO PRESS
Albuquerque

Library of Congress Cataloging-in-Publication Data

Multiple views : Logan grant essays on photography, 1983–89 / edited
by Daniel P. Younger : introduction by Alan Trachtenberg.—1st ed.
p. cm.
Includes bibliographical references.
ISBN 0–8263–1244–6
1. Photography. I. Younger, Dan.
TR185.M85 1991
770—dc20
90-46889
CIP

Design: Milenda Nan Ok Lee

"The Crisis of the Real," by Andy Grundberg, the title essay of *The Crisis of the Real* (New York: Aperture, Inc., 1990), is reprinted with the permission of Aperture Foundation, Inc.

"The Eyes of the Poor," from Charles Baudelaire, *Paris Spleen*
(New York: New Directions Publishing Corp., 1970), translated by Louise Varèse, is excerpted in "Parisian Views," by Shelley Rice, with the permission of New Directions.

The Aleph and Other Stories, 1933–1969, by Jorge Luis Borges, edited and translated by Norman Thomas di Giovanni in collaboration with the author, is excerpted in the essay "Borges, Stryker, Evans: The Sorrows of Representation," by Judy Fiskin, with the permission of E. P. Dutton, a division of Penguin U.S.A.

CONTENTS

Preface
vii

Introduction
Alan Trachtenberg *1*

THE NINETEENTH CENTURY

Toward a New Prehistory of Photography
Mary Warner Marien *17*

François Arago and the Politics of the
French Invention of Photography
Anne McCauley *43*

Parisian Views
Shelley Rice *71*

Electrical Expressions:
The Photographs of Duchenne de Boulogne
Nancy Ann Roth *105*

Almost Nature:
The Typology of Late Nineteenth-Century American Photography
Miles Orvell *139*

Emplacement, Displacement, and
the Fate of Photographs
Roger Hull *169*

THE TWENTIETH CENTURY

Documentary Photography in Americal Social Reform Movements:
The FSA Project and Its Predecessors
Maren Stange *195*

The Worker Photography Movement:
Camera as Weapon
Leah Ollman *225*

Borges, Stryker, Evans:
The Sorrows of Representation
Judy Fiskin *247*

American Graphic:
The Photography and Fiction of Wright Morris
Colin L. Westerbeck, Jr. *271*

CRITICAL THEORY AND ANALYSIS

Meditations on an Ukranian Easter Egg
James Hugunin *305*

The Privileged Eye
Max Kozloff *315*

Victory Gardens:
The Public Landscape of Postwar America
Deborah Bright *329*

The Crisis of the Real:
Photography and Postmodernism
Andy Grundberg *363*

The Viewless Womb:
A Hidden Agenda
Suzanne Seed *387*

Appendix A:
Logan Grant Recipients and Jurors, 1983–89 *407*

Appendix B:
About the Contributors *411*

PREFACE

 MULTIPLE VIEWS: Logan Grant Essays on Photography 1983–89 is a selected anthology of essays that have been awarded on the basis of merit through the Reva and David Logan Grants in Support of New Writing on Photography, a program funded by the Reva and David Logan Foundation in Chicago, and administered by the Photographic Resource Center in Boston. Currently in its eighth year, this is an annual, juried program, open to U.S. residents (students are not eligible), intended to encourage and support outstanding writing on photography, encompassing criticism, history, esthetics, theory, and other issues of relevance to the field.

Witnessing a burgeoning field of writing on photography, and sensing the urgency of increasingly new, pluralistic challenges to accepted canons of response to the medium, the staff and board of directors of the Photographic Resource Center embarked upon a program in 1983 that would provide direct monetary support to writers contributing to the history and criticism of photography. With the generous support of the Reva and David Logan Foundation, the Logan Grants were established. Since this time, monies have been awarded to forty-five writers. An additional seventeen writers have been recognized as finalists or honorable mentions during this period (1983–89). The Photographic Resource Center is committed to providing continued support and recognition for those contributing to the formative literature of photography. At present, the Logan Grant program is the only one of its kind in the U.S. that provides such support. We are indebted to Reva and David Logan for their continued belief in the efficacy of this program.

While one volume alone cannot encompass the many fine essays that have been awarded and recognized in the course of this program, a complete list of recipients and awards to date is presented in the appendix. The fifteen essays that make up this volume have been previously published in the Photographic Resource Center's *VIEWS: The Journal of Photography in New England*. Those essays chosen for publication in *VIEWS* reflect the rankings of independent jurors selected each year. Essays included in this book coincide with these rankings.

Alan Trachtenberg (who served as a co-juror in the first year of the grants) has contributed the introduction to this volume, reflecting on directions and prospects for the histories, theories, and criticism of photography, and categorizing the heterogeneous approaches of the essays brought together here. In so doing, he proposes an open-ended framework for understanding the complexity of issues we face in evolving a literature of photography. We extend our gratitude and sincere thanks to Mr. Trachtenberg for his astute addition to this anthology.

We most emphatically thank all of the writers spanning many disciplines who have participated in this program. It is their direct engagement with and contribution to the discourse on photography that has given value and substance to the Logan Grants. In particular, we thank the writers represented in this volume for their permissions and cooperation in bringing these essays together to a larger audience. We also commend and heartily thank the jurors who have contributed their valuable time and expertise to this program each year. To date they include: Andy Grundberg and Alan Trachtenberg (1983), Ben Lifson and Beaumont Newhall (1984), A. D. Coleman and Naomi Rosenblum (1985), Nathan Lyons and Anne Tucker (1986), Vicki Goldberg and Colin Westerbeck (1987), and Thomas Barrow (1988).

Those who have participated in the genesis, administration, and publication of the Reva and David Logan Grants in Support of New Writing on Photography are numerous. The program is the brainchild of Stan Trecker, director of the Photographic Resource Center, and David Logan. Reva and David Logan have been active and important partners throughout. They have demonstrated intelligence, flexibility, and patience in shaping and revising the grants to fit the needs of the field. Their willingness to seek input from jurors, award-winners, and others, and to take risks, has been essential in formulating the best program possible. Their ongoing role should serve as a model for sponsor collaboration. The Logan Grants have been administered by Stan Trecker, Jean Caslin, Brenda Sullivan, Tammy Ricker, and Daniel P. Younger. Editors of *VIEWS* responsible for the presentation of the essays as they appeared initially in the journal include (listed chronologically): Martin Jukovsky, Susan E. Cohen and William S.

Johnson, and Daniel P. Younger. Assistance in the reading and editing of manuscripts over the years has been performed by Cheryl Andonian, Jean Caslin, Timothy Druckrey, Kristen Engberg, Carol Payne, Nancy Rich, Melissa K. Rombout, and Daniel P. Younger. Robin Lee Clark and Robert Seydel served as editorial assistants for *Multiple Views,* and Carol Payne also served in this capacity in the early months. We thank them both for their important organizational contributions. Jean Caslin participated in preliminary conversations and planning for the book. Floyd Yearout and Henry Horenstein gave valuable advice along the way. We appreciate Thomas Barrow's support for the idea of this volume, and we thank him for suggesting the University of New Mexico Press for publication. Dana Asbury, editor at UNM Press, has been a pleasure to work with and has provided important advice in shepherding this publication through its various stages. She was generous in accommodating our needs and was insistent when she needed to be in keeping us on schedule.

The publication of *Multiple Views* has been made possible, in part, by support from the Reva and David Logan Foundation and the National Endowment for the Arts. The Photographic Resource Center expresses its gratitude to them for making this project possible.

D. Y.

INTRODUCTION
ALAN TRACHTENBERG

 WRITING ABOUT PHOTOGRAPHY IS AS OLD AS THE MEDIUM itself, but so far, there is no history of such writings, no study of photography as a subject of discursive writing.[1] Nor has much attention been paid to how photography *becomes* a subject of discourse and study—a different but related question from how the medium developed its sundry picture-making practices. What is missing is a comprehensive account of ways people have thought about and imagined the medium in the corollary medium of written language. We feel the lack all the more because in the past decade writings on photography have proliferated at an extraordinary rate; new approaches to past and present photographies abound, and definitions of the subject itself have undergone radical change. The present collection offers fresh examples of these developments—a ferment which can be taken as the sign of something new coming into being: a new practice of photographic studies in which culture, politics, history, and ideology have replaced obsessions with esthetic evaluation and essentialist speculation about the "nature" of the medium.[2]

A perspective is wanted. How might we situate writings on photography within what is commonly taken as "the history" of the medium? By and large that "history" is understood by a wide public as an "objective" account of invention, technological change, and accompanying stylistic variations. But is not this "history," or any other, itself a function of writing, a verbal artifact whose authority rests less on irrefutable objectivity than on factors such as rhetorical and institutional power? In all written histories the reader encounters the subject of photography as a construction made more of words than of images. Words prevail over things among the resources

available to any historian; the most basic materials of written histories are writings themselves.[3] But rarely do writings alluded to and drawn upon designate a subject—the subject or discourse of writing on photography—in its own right. Typically "photography" appears as a chronology of changes, a record of differences within a fixed set of variables—technical elements such as apparatus and chemicophysical processes; esthetic elements such as genres, styles, pictorial programs; economic and cultural elements such as modes of production and distribution tied to marketplace structures, proliferating social uses, political purposes, and ideological appropriations of camera-made imagery, and competing representations of the medium in the public realm (art or science; intentional artifact or value-free document; personal expression or objective information). Writings provide the basis of such histories, their sources of information and authorities of fact. Yet on the whole photographic writings have not been identified as interesting in their own right, not taken as anything other than supplementary to the "real" history of tangible objects and visible images—not, in short, as a discursive practice in its own right, tied to other discourses of knowledge and interpretation.

The same can be said, to be sure, about histories of any material objects or processes, railroads or furniture, lithography or printing: that the verbal foundation of their status as historical subjects is taken for granted. Material culture is often thought to be only material—the culture of objects of use, the dense environment of physical things (including images) by which people orient themselves to their external worlds. Written documents undergird the historian's confidence in describing such objects, their provenance, their uses—and their meanings. The thing, object, image, enjoys priority over the accompanying words. Or so an older school of material-culture studies implicitly declared by its positivist scholarship and its connoisseurship of objects. But it is coming now to be recognized that objects cannot be understood apart from meanings, that understanding entails interpretation, that even the most seemingly objective or neutral acts of classification and curatorial description—saying what the object is—are verbal acts so enmeshed in the definition of the object itself that thing and word can hardly be rent apart. There are no objects, either for the people who use them or the historian who studies them, that are not at once meanings, meanings articulated as much in language as in praxis. Language itself is a material praxis, a way of *acting* the object or image, of enacting it as meaning. Material culture has no existence apart from immaterial meanings, no being separate from the words, the stories, the accounts people construct for the objects which fill their world, which *are* their world. Objects are inextricably interwoven with language; like images, they are embedded in verbalizations through which they perform as a cultural language in themselves.[4]

Writings on photography have a more than supplemental relation to the history of the medium; they are inseparable from it, as integral to what we mean when we speak of photography as having a history, as are images, cameras, formats, processes, markets, and exhibition spaces. If the history of the medium "began," in the conventional way of recording sequences of events, with the announcements by Daguerre and Fox Talbot in 1839, those words themselves, the language by which each writer couched his account of invention and discovery and projected uses and functions—the system of explanation employed by each author—are as basic to the historical beginnings of the medium as the actual equipment employed by each, and the first pictures they displayed. These announcements placed the new medium within old discourses having to do with science and art; they represent initial acculturations by which the medium achieved identity.

From the earliest accounts to the most recent essays and books, writings on photography have represented a continuing effort, a more or less conscious struggle, to endow the medium with identity, to give it a graspable meaning within existing mental universes. From the beginning the challenge proved difficult and hazardous. While the medium seemed to accord comfortably with the familiar categories of visual craft and art, the mechanical and apparently automatic character of its procedures defied categorization as either craft or art. Thus, most writing about photography until quite recently has taken as its question: what *is* this medium? Is it a medium of fine art, or is it doomed to be a "handmaiden" of the arts, to the lowly status of the practical arts, a thing of utility only, a source of information rather than esthetic pleasure and refreshment? Is a photograph inherently different from other kinds of pictures? What kind of difference do its different means make—the vastly diminished role of the trained hand and of prior conception (the artist's "genius" or "spirit")? From the earliest statements by Daguerre and Talbot, to comments by scientists like Sir John Herschel, David Brewster, and Samuel F. B. Morse (also a well-known painter), to countless articles in newly established photographic journals beginning in the 1850s, to the "pictorialist" writings of the last decades of the nineteenth century and the "modernist" writings early in the twentieth century, the chief thread was an often metaphysical theorizing of the medium couched in the terms of available esthetic doctrine. And even well into the twentieth century such writings adopted a defensive-aggressive tone—a distinguishing sign of the combative situation in which photographers and their advocates perceived themselves.

Like the making of photographic images, writing on photography occurs within specific settings. Within a decade after the birth of the medium, photographic communities began to take shape—amateur and professional groups sharing in a growing body of writings on subjects ranging from the scientific and technical to the historical and esthetic. Self-definitions

in writing served these communities as an adjunct to self-expression in picture-making. The first journals appeared in the 1850s, serving broadening interests of amateur and professional groups. National societies, professional associations, trade organizations, local amateur clubs, exhibition and competition arrangements, all contributed to the making of increasingly specific communities of interest and shared values. The structure of these communities, how they perceived their status and role within their larger societies, how they conducted their internal politics—there is much to be learned from these questions about the relation of writing to context in the history of photographic literature. For example, why did so many photographers themselves take up the pen to address their fellows? We can think of American daguerreotypists like Gabriel Harrison and Marcus Aurelius Root and Albert Sands Southworth as precursors of early twentieth-century modernists like Alfred Stieglitz and Paul Strand and Edward Weston, and even recent photographer-writers of an anti- or postmodernist slant like Victor Burgin, Martha Rosler, and Allan Sekula.[5]

Tracking down such a question leads one directly to a major contextual change in the early twentieth century. With Stieglitz's *Camera Work* and "291" the notion of an exclusively photographic community begins to dissolve in favor of a more cosmopolitan community of like-minded, rebellious artists in all media, including writers and intellectuals.[6] This development, and a corresponding broadening of the audience for critical writings about the medium, can be understood in part as an effect of further fragmentation and stratification in twentieth-century practices of the medium: the emergence of "serious" photography as a separate sphere characterized by pursuit of the "pure" elements of the medium, against other groupings defined by practices such as amateur salon pictorialism, photo-journalism, social documentary, commercial or advertising photography, and various branches of scientific photography. (Demarcations do not, of course, prohibit individuals from crossing boundaries in different facets of their work.) *Camera Work* did not confine itself to writings on photography; Paul Strand published important early modernist defenses of photography in avant-garde literary journals like *Seven Arts* and *Broom;* Walker Evans wrote for *Hound & Horn*. This tendency continues. Periodicals serving specifically photographic communities, such as *Aperture, Afterimage, exposure,* and *VIEWS,* regularly open their pages to writers from other fields, and increasingly, to academic historians and critics of literature, art, politics, and culture. The blurring and crossing of boundaries has indeed increased sufficiently to remap the field of photographic writing as a distinctly postmodern terrain. Today's writings display a pluralism of critical languages, a freedom of allusion and reference beyond the boundaries of the strictly photo-

graphic, and a resolutely skeptical attitude toward received pieties—enough so to represent a fracture with the past, a radical departure in *kind* of writing.

This has come about perhaps principally by a fusion of internal and external influences. If the writings fostered and nurtured within the photographic communities of the nineteenth and early twentieth centuries constitute more of a distinct tradition than has been recognized, and deserve attention for the light they cast on the social processes by which photography achieved institutional identity, writings from outside those communities have a quite different status. They tend to be better known, and have had a greater influence in forming a general audience for ideas about the medium. It was through the interpretive writings of outsiders, so to speak, that photography slowly emerged from the parochialism of its early intellectual situation to its status today, as one of the cardinal topics in cultural criticism and theory. As the contents of this volume show so amply, critical and historical writing on photography now proceeds from many sources, out of a variety of intellectual interests and motives.

From the earliest years of the medium, writers and intellectuals have been notably inquisitive about photography, drawn to the many conundrums and metaphors implied by its procedures, its lens and shutter and inner dark chamber—the endlessly beguiling mystery of nature writing itself through the medium of light. They were also alert to implications, for better and worse, of this new, cheap mechanism for reproducing likenesses. Baudelaire in France scorned camera imitations of high art, berated the bourgeoisie for mistaking photographic description for serious art. In America Poe, Emerson, Thoreau, and Whitman all wrote with fascination, sometimes mixed with distrust, in brief articles, journal entries, letters, and, in the case of Hawthorne, in a novel, *The House of the Seven Gables* (1852). Such writings, often appearing in popular journals, generally shared the project of the photographic communities in seeking an identity true to the medium, a way of putting into words what photography's inherent properties are. Precisely this motive appears in the two most substantial and acute investigations, after Talbot's *Pencil of Nature*, in the mid-nineteenth century, by Lady Elizabeth Eastlake in England and Oliver Wendell Holmes in the United States.[7] Eastlake took up the question of photography's relation to fine art, and concluded that, rather than a new art, photography was a new mode of communication. Holmes focused on stereographic photography and dealt with the medium as a new form of acquisition, of possession and experience of the world. Both figures enjoyed tangential relations to photographic communities; Lady Eastlake's husband, a noted painter, was the first chairman of the London Photo-

graphic Society, and Holmes was an ardent amateur photographer. Both also published their essays on photography in prestigious journals of cultivated opinion.

From Eastlake and Holmes to Walter Benjamin, Roland Barthes, Susan Sontag, John Berger, and Rosalind Krauss in the twentieth century, the most challenging and productive writings have come from locations beyond the boundaries of photography itself. In the recent past those boundaries had seemed fairly well sealed. The post–World War II era witnessed in America a remarkable consolidation of a nationwide community of photographers and teachers who shared a number of strong assumptions: that the "straight photography" of Stieglitz, Strand, and Weston represented the fulfillment of photographic purity, Beaumont Newhall's *History of Photography* the accepted authority, and Minor White's *Aperture* the highest standard of photographic criticism. Beginning in the 1970s, new writers broke sharply with the immediate past. Arising in the wake of 1960s social and political activism, and drawing inspiration from such extra-photographic sources as Michel Foucault's analyses of discourses of knowledge as structures of power, Walter Benjamin's cultural Marxism, Roland Barthes's adaption of structural linguistics to cultural interpretation, and from psychoanalysis, the new critics of photography have virtually abandoned the old quest for an intrinsic identity for photography. Indeed, they have called into question all previous efforts to say what the medium *is* on behalf of concrete studies of what the medium does—the cultural and ideological work it performs within specific conditions and circumstances.

New critical and historical writings of the past decade have appeared, not coincidentally, at a time of intensifying visibility and prestige for photography—a new status within the networks which make up the American art world: museums, galleries, auction houses, art journals, academic art history departments. In an important sense the very success of the medium in winning institutional acceptance provoked and instigated much of the new writing and helps account for its predominant oppositional thrust. For many of the new breed of writers, institutional prestige and legitimacy represent a kind of power play, a capturing of a still problematic medium within structures and vocabularies which drain the image of its historical life, the actual conditions of its making and functions. The very success of what some call "museumization" has provoked a deconstructive response.

A similar process has been under way in most fields of the academic "humanities" for at least two decades, and new writers on photography clearly associate themselves with winds of opposition and change upsetting convention and tradition throughout the American intellectual landscape. Writings on photography are no longer isolated from the mainstream of critical and historical writings. Drawing on the same theories of language,

discourse, and power which have altered the face of literary and art criticism, on the methods and findings of social history, psychoanalysis, and ideological criticism, and on activist concerns with injustice, war, the environment, and social constructions of identity and gender, the new historians, critics, and theorists of photography are producing a body of work no longer recognizable as "photographic" in any narrrow sense. New writings on photography seek to identify social forms, political and economic interests, ideological constraints, and cultural patterns. What is at stake in many instances is not the interpretation of photographs as such, but social and cultural processes illuminated and empowered by photography. Discussions of photographs can now be expected to lead in previously unthinkable directions. No longer a hermetic subject, photography is attracting writers with broad interests in contemporary culture and cultural history. Photographs appear increasingly as subject matter in university courses in communications, cultural studies, and American studies, as well as history, literature, and social science. No longer the exclusive property of photography and art history departments, the subject of photography is rapidly undergoing redefinition, becoming a subject of far greater internal complexity and external linkages than had been assumed.

The present collection offers an excellent and opportune cross-section. The authors themselves represent a typical mix among recent writers on photography: academic scholars in art history and American studies, photographers and teachers of photography, art critics, and professional (unaffiliated) writers. Their presence together in a single volume testifies to a convergence of diverse interests upon an emerging field which might be called photographic cultural studies. Diversity and pluralism in professional identity, in academic discipline, in intellectual method, and in definition of the subject of photography, represent a new community of interest in the making. It is also notable that a number of these essays represent sections of larger scholarly projects.

The essays are arranged conveniently, if arbitrarily, under three headings: The Nineteenth Century, The Twentieth Century, and Critical Theory and Analysis. The chronological headings call attention to the predominantly historical interests of the authors included here—an interest both in reconceiving the history of the medium, how it is told, and in expanding the boundaries of what the history of photography properly includes. Overlappings or blurring of boundaries, of strict divisions between the history of the medium and the history of society and culture, occur prominently in many of the historical essays. There are overlappings as well between the historical and theoretical/analytical essays. The third category is no less historical for its emphasis upon new hermeneutical practices,

new approaches to the reading or interpretation of specific images or gen-
res, or reflections upon the problem of reading/interpretation. Indeed,
reflecting in their methods, if not their subject matter, active currents in
theory and practical criticism, the third heading might also be labeled
chronologically, as "contemporary."

The majority of the essays concern aspects of the history of the medium—
its internal history, and its place within a broader history of modern culture.
As a group these essays reflect the set of problems presently refocusing
photographic history away from older models of monographic art history,
connoisseurship, or the history of invention, toward a history of institu-
tional contexts and ideological mediations. They reflect, too, the absorption
by historians of structuralist, poststructuralist, Marxist, Freudian, and Fou-
cauldian theories—although theoretical baggage is generally kept discretely
out of sight in many of these essays. Theory is explicit in some of the
essays, however, and among these pieces we can detect points of difference,
divergence, and implied debate. *Multiple Views* is far from homogenous;
the collection judiciously represents a field of writing still in a high state
of growth and experiment. Taken as whole, the essays propound no or-
thodoxy and give privilege to no dogma.

One of the cardinal historical problems here and in the field at large
concerns the narrative of the early history of the medium. Mary Warner
Marien's "Toward a New Prehistory of Photography" offers a refreshing
challenge to single-factor explanations of photography's "prehistory," such
as an accumulation (inexplicable in its own terms) of discoveries by chem-
ists about the properties of light, the role of the *camera obscura* in promoting
a quest for a process of fixing the camera image, or experiments in image-
making within the practice of perspectival painting since the Renaissance.
Basing her argument on the perplexities of the very notion of "prehistory"
encountered by archeologists, Marien shows the inadequacy of typical
accounts of what came "before photography." She argues for multiple caus-
ality, "the preconcertation of various material, social, and intellectual forces"—
a broad approach which "emphasizes functional and conceptual forebears,
rather than technical ones."

One feature of the "common conceptual terrain" Marien evokes is "the
politics of knowledge" at stake in the initial publication of Daguerre's in-
vention. Anne McCauley's "François Arago and the Politics of the French
Invention of Photography," explores precisely this issue: how the initial
presentation of Daguerre's work was shaped by Arago to promote a specific
social program, the Republican policy of state support for science and
technology. By detailed examination of Arago's social beliefs and commit-
ments, and of the political situation in the 1830s, McCauley shows that
the picture of Daguerre and his invention which persists in the standard

narrative is a construction of the times, an ideological artifact manipulated by Arago in response to perceived political needs. Taken together the Marien and McCauley essays open new vistas not just on the early history of the medium but on how narratives of that history are constructed—seemingly disinterested stories discovered to be grounded in and slanted by politics and ideology.

The essays by Nancy Ann Roth and Roger Hull also bear on the internal history of the medium; they have to do implicitly (neither refers directly to the term) with canonization. Each casts new light on a figure peripheral to the main lines of the standard narrative, one whose place has been defined in terms each author finds too simple and reductive. Their purposes are not to reevaluate or rescue but to reexamine the character of the work of these marginal figures. Roth's "Electrical Expressions: The Photographs of Duchenne de Boulogne" finds new interest in Duchenne's photographic illustrations of his theory that facial expression of emotion is controlled by a single physiological mechanism. Rather than "science" pure and simple, his pictures, as Roth shows, drew significantly from art, from sculptured portraits, and from the *tableau vivant*. What presented itself as science proves to be the product of artifice. As early experiments in manipulated persuasion, Roth argues, Duchenne's images anticipate advertising photography: employing the camera to claim "reality" for manipulated scenes.

Hull's "Emplacement, Displacement, and the Fate of Photographs" concerns a different sort of anticipation: how Rudolph Eickemeyer, Jr., wrote himself out of the history of fine-art photography simply by making the wrong choices in presenting or "emplacing" his pictures. Once considered the equal of Stieglitz (in the 1890s) in fine printing and salon exhibitions, Eickemeyer turned toward halftone reproductions for mass-circulation journals and suffered retribution: deletion from the history of photography as art, and oblivion. Hull's essay poses again the essential question of structures of prestige—in this case, represented by modes of emplacement—and their role in qualifying places in the narrative of photographic art.

Like Roth, Miles Orvell also focuses on the role of artifice in nineteenth-century practices of the medium widely believed to be the epitome of truth-to-nature. But "Almost Nature: The Typology of Late Nineteenth-Century American Photography" takes a different tack by defining as its subject a continuum of beliefs regarding the naturalness or artificiality of the medium's pictures. These beliefs, Orvell argues, participate in more general cultural patterns: "the photograph was part and parcel of a middle-class culture in which replications of all sorts were becoming a common feature of popular entertainment and the household environment." Orvell's essay—part of his book *The Real Thing: Imitation and Authenticity in American*

Culture, 1880–1940 (1989)—places photography within an original inter-
pretation of American cultural responses to technology and modernity in
general. His essay proposes a significant enhancement of the narrative of
photographic history, adding the dimension of culture, of patterns, habits,
and beliefs structuring the everyday lives of the public to whom photog-
raphy appealed.

Indeed the largest concentration of essays here shares Orvell's project
of a cultural history of photography, a placement of photography within
a broader history of social practices, forms, and discourses—a redefinition,
in short, of photography as a cultural subject. Shelley Rice undertakes in
"Parisian Views" an ambitious reinterpretation of Parisian photography in
the age of Baudelaire and Haussmann as symptomatic of changes in per-
ception fostered by changes in the city's spaces. Through detailed and
insightful accounts of Haussmann's new boulevards, and of the photo-
graphic industry in Second Empire Paris, Rice recreates a rich, complex,
and subtly unstable context for Parisian photographers "struggling to come
to terms, not only with a new urban environment, but also with a new
medium of expression." She finds in the variety of urban perspectives
attempted by photographers an analogue to the modernizing changes within
the city itself, and concludes provocatively that photography "codified
perception, and transformed the individual eye into a material part of a
communications network as systemic, and as suprapersonal, as the pre-
fect's own."

The essays by Maren Stange and Leah Ollman concern important move-
ments in twentieth-century photography driven by social purposes. In
Stange's "Documentary Photography in American Social Reform Move-
ments: The FSA Project and Its Predecessors," the purpose is liberal and
reformist, and the dominant style is realist. Here, and in extended form
in her book *Symbols of Ideal Life: Social Documentary Photography in America,
1930–1950* (1989), Stange reinterprets the documentary tradition, particu-
larly work produced for the FSA in the 1930s, in light of the political goals
and visual rhetoric of earlier reform movements. Including close analysis
of specific pictures along with social and institutional history, the essay
explains how the rhetoric of documentary photography achieved its au-
thority as "realism." The essay cogently pinpoints the social and political
biases of institutional uses of documentary "realism" in the representation
of social facts and problems.

The social purpose Ollman addresses in "The Worker Photography
Movement: Camera As Weapon" is not reformist but revolutionary. The
essay brings to light a little-known photographic project in Weimar Ger-
many: the "worker photographers" movement, which sets its eye on com-

bating "bourgeois picture-lies." Against the surface charm and studied neutrality of the *Neue Sachlichkeit* work by Albert Renger-Patzsch and Karl Blossfeldt, the workers' movement experimented in counter-visions. Ollman reconstructs a cultural moment of controversy and debate over social uses of the medium—debates about the place of art and beauty in a photography devoted to revolution, about photo-montage and the combination of images and texts. As in the Stange essay, the issue is not to isolate for discussion a certain style of purposeful imagery, but to show how certain uses of photographic imagery arose within particular political contexts. Both essays explore connections between style or mode of image and ideological purpose.

Ideological analysis of imagery is also Deborah Bright's undertaking in "Victory Gardens: The Public Landscape of Postwar America." Venturing into popular imagery in the 1940s and 1950s, Bright examines photographs linked to "landscape tourism"—mass-circulation magazines, travel picture books, and tourist guidebooks. The context is the Cold War and the push toward further "development" or privatization of the landscape. Bright argues that photographs helped market a conventional landscape image "useful for creating public consensus around abstract values" of patriotism and anticommunism—an insidious palliative for "a mass public looking for simple reassurance in a complicated world." The subject here, once more, is not "photography" but the political exploitation of cultural values embodied in commercialized photographic imagery.

The remaining essays address matters less historical and political than formal, esthetic, and philosophical. And here we find significant differences regarding photography as a subject of writing. James Hugunin's "Meditations on an Ukrainian Easter Egg" and Max Kozloff's "The Privileged Eye" represent decidedly contrasting perspectives. Both essays offer self-conscious records of personal encounters with a single image; both take the occasion to meditate on photographic meaning in general. But there the similarities end. Hugunin chooses a conventional studio portrait, a "found object," the product of a dense set of pictorial conventions and cultural (especially gender) determinations; Kozloff aims his eye at a well-known picture by Henri Cartier-Bresson. For Hugunin meaning is a semiosis, a communication grounded in certain discernible rules and patterns. His approach is structuralist and psychoanalytic; he takes the photograph as an "analogical plenitude," in Barthes's words, a surplus of meaning contained within given polarities. The photograph, in Hugunin's view, is never innocent, never privileged, but determined by structures governing the communicative process. For Kozloff the encounter with Cartier-Bresson's inexplicable image leads to insights regarding the "pseudo-

intimacy" which photographs often seem to provide—the enigmatic and paradoxical privilege photographs allow us—of seeing from the outside what the subjects of the image themselves do not, and cannot, see. While Hugunin stresses the fictive aspect of photographs, Kozloff eschews structuralist theory and tries to site the photograph in an indeterminate realm between the fictive and the real.

The Westerbeck and Fiskin essays might also be seen as lying along an axis of difference, although not as sharply delineated as in the previous pair. Colin L. Westerbeck, Jr.'s "The Photography and Fiction of Wright Morris" is an elegant personal essay on a writer-photographer for whom elegance itself is a prime theme—the elegance of vernacular style. The essay argues for the esthetic importance of Morris's experiments in integrating sequences of pictures within narrative structures, and for the significance of "anonymity" to Morris's work as a whole. Also a literary essay, Judy Fiskin's "Borges, Stryker, Evans: The Sorrows of Representation" explores another kind of relation between photographs and words. From Borges's "The Aleph" she derives a lesson in the "sorrows of representation"—that while the imagination has a voracious appetite for reality, including images of the real, representations themselves always disappoint profoundly because in the end they only reveal that the "real" is absent. The Borges story is uncannily reenacted by Stryker, head of the FSA, and Walker Evans. Stryker stands for the guileless appetite for more and more images, and Evans for the tragic sensibility of the artist who knows the limits of his art.

Radically different perspectives appear, finally, in the essays by Grundberg and Seed. The issue concerns mediations, and the theorizing tendencies in postmodernism. Arguing that postmodernism is not a passing fashion but a logical development out of modernism itself, Andy Grundberg's "The Crisis of the Real: Photography and Postmodernism" examines new currents in art photography as reflexes of new theoretical interests among artists and critics. Postmodernism, he explains, is based on the theory that "our image of reality is made up of images," that photography itself "makes explicit the dominion of mediation." As soon as the concept of mediation appears, old modernist notions of authenticity, originality, and artistic genius dissolve. Suzanne Seed takes just this outlook as her antagonist in "The Viewless Womb: A Hidden Agenda." The state of mind which finds mediation everywhere, she argues, reflects a foolish nostalgia for a mythic lost state of immediacy. Calling the polarized opposition between the immediate and mediated a "viewless-womb ideology," Seed describes anti-mediation theorizing as a "self-serving academic shell game" and a dangerous course for criticism. Media, she reminds us, often restore "lost immediacies," as her complex experience of the sky after watching the televised

moon landing had revealed to her. Through sharp-edged critiques of Barthes, Lacan, Marx, and Sontag, and the uses to which they are put by recent critics, Seed reaches for a more nuanced and balanced view of the actual role of mediations in human experience.

More than a random collection, even if less (as it must be) than a monolithic statement, *Multiple Views* surveys a field in the grip of change. The progress report registered here encourages the conviction that the subject of photography steadily gains in sophistication and maturity, that as a subject photography has as much to teach us about the culture of modernity as do photographic images themselves. The reading of photographs, the act of experiencing and understanding them—whether historical pictures, recent snapshots, or exhibited or published prints—has in the past received too little attention. If we take to heart Walter Benjamin's remark that the "illiterate of the future" (in Moholy-Nagy's words) may be the "photographer who can't read his own pictures," then the education in reading proposed by the authors assembled here is not ancillary but integral to the medium. Might it not portend a new historical and cultural literacy in photography itself?

Notes

1. Two useful anthologies of nineteenth- and twentieth-century writings are Beaumont Newhall (ed.), *Photography: Essays and Images* (New York: Museum of Modern Art, 1980), and Alan Trachtenberg (ed.), *Classic Essays on Photography* (New Haven: Leete's Island Books, 1980).

2. The present volume joins two other recent anthologies in presenting examples of new directions in criticism and history: Richard Bolton (ed.), *The Contest of Meaning: Critical Histories of Photography* (Cambridge, Mass.: MIT Press, 1989), and Carol Squiers (ed.), *The Critical Image: Essays on Contemporary Photography* (Seattle: Bay Press, 1990). An earlier collection of essays concerned with photographs as cultural communications is Victor Burgin (ed.), *Thinking Photography* (London: Macmillan Press, 1982). Other examples of contemporary writing can be found in Van Deren Coke (ed.), *One Hundred Years of Photographic History: Essays in Honor of Beaumont Newhall* (Albuquerque: University of New Mexico Press, 1975), and Peter Walch and Thomas Barrow (eds.), *Perspectives on Photography: Essays in Honor of Beaumont Newhall* (Albuquerque: University of New Mexico Press, 1986).

3. The most widely available and influential of the standard histories is Beaumont Newhall, *The History of Photography from 1839 to the Present*, revised and enlarged edition (New York: Museum of Modern Art, 1982). Helmut and Alison Gernsheim, *The History of Photography* (New York: McGraw Hill, 1969), includes a useful appendix listing early photographic periodicals.

4. I am indebted to Jules David Prown's lucid and insightful discussion of these

issues in "Mind in Matter: An Introduction to Material Culture Theory and Method," *Winterthur Portfolio* 17, no. 1 (Spring 1982): 1–19.

5. See Victor Burgin, *Between* (Oxford: Basil Blackwell, 1986), and essays in Burgin (ed.), *Thinking Photography;* Martha Rosler, *Martha Rosler: 3 Works* (Halifax: The Press of the Nova Scotia College of Art and Design, 1981); Allan Sekula, *Photography Against the Grain: Essays and Photo Works, 1973–1983* (Halifax: The Press of the Nova Scotia College of Art and Design, 1984). See also Nathan Lyons (ed.), *Photographers on Photography* (Englewood Cliffs, N.J.: Prentice-Hall, 1966).

6. See William Innes Homer, *Alfred Stieglitz and the American Avant-Garde* (Boston: New York Graphic Society, 1977).

7. Lady Elizabeth Eastlake, "Photography," *London Quarterly Review* (1857): 442–68; Oliver Wendell Holmes's three articles on photography and stereography appeared in *Atlantic Monthly* in June 1859, July 1861, July 1863.

THE NINETEENTH CENTURY

TOWARD A NEW PREHISTORY
OF PHOTOGRAPHY

MARY WARNER MARIEN

 MOST WORK IN PREHISTORY IS SPADE WORK. THE RESEARCHER must sift through quantities of material that yield modest results. The view is necessarily contracted. One searches for the encrusted flint, or the revealing sentence lost among diary entries. Prehistory, photographic or human, is the stuff of monographs, seldom self-conscious and rarely transcendent.

Although the subjects of human prehistory and the prehistory of photography are about as distant from each other in time as any two fields can be, they are characterized by a compelling parallel. In each, the material record is incomplete—ever incomplete. Conjecture and prejudice, politics and naiveté, leaps of imagination and dogged credulity work to knit the meager facts into form. To be sure, the plethora of data available in other fields has its inherent problems; but great numbers of agreed upon facts and testable theories serve to control and direct conclusions.

Also, both areas of knowledge share the increasingly blemished illusion that they rest on the quiet accumulation of fact. As a consequence, both have been easily encumbered by unexamined received ideas, which, over time, have become canonical.

The perception of deep trouble in the field, with more to follow, has come first to human prehistory. However incomplete, the twentieth-century material record and fund of theory have grown faster than that of photographic prehistory. In the second quarter of this century older theories, like uniformitarianism—the notion that all societies develop in and through the same stages—gave way to more permissive ones, like diffusionism—the idea that thoughts and techniques spread and mix from lenticularly shaped points of origin, like so many paint stains. Diffusionism

has caused more than one archeology or art history student to think that history is little more than the tracing of endless skeins of influence.

The pattern of disillusionment in human prehistory, not the particular ideas and theories that have brought it about, but the stages of awareness through which it has passed in the last fifty years, foreshadow what is happening today in the history of photography. A useful example—there are many—is found in the gentle complaint of J. D. S. Pendlebury in the late 1930s as he surveyed *The Archeology of Crete:*

> I have tried hard in the following pages to keep fact and theory apart. A theory, honestly stated as such by its original propounder, is too apt to be used as a fact by his successors until it passes into a basis for fresh theories. Petrie's (in those days) justifiable theory that certain vases found by him at Abydos were of Aegean origin has passed, in archeological quotation, through the 'Petrie's suggestion that . . .' stage to "the Early Minoan pottery found by Petrie." Even now the fallacy lingers on in spite of Frankfort's authoritative denial.[1]

Pendlebury's words are more than a warning about careless reading and the calcification of hypotheses. They offer a caution about too uncritical an acceptance of the work of founding scholars.

Twenty years later, Pendlebury's caution had become a commonplace. Reviewing the state of his field in the Mason Lectures at the University of Birmingham for the academic year 1956–57, Glyn Daniel, the Cambridge prehistorian wrote:

> We were brought up at school to believe that there were immutable historical facts, and find when we grow up that they are as mutable as the interpretations of those who write about them, and as varying as the models which those writers assume.[2]

Today, prehistory is bewildering, contentious, and complex. Out of the turmoil has come an awareness, an archeology of prehistory, which seeks to examine the underlying values of the field. Glyn Daniel again:

> The prehistory of man has varied so much with the prehistorian and with the state of development of our knowledge, and with the preconceptions brought to bear on the archeological record as it is being translated into historical contexts. It is fair, therefore, to speak of Worsaae's prehistory of Gabriel de Mortillet's prehistory, of Gordon Childe's prehistory, of Nazi and Marxist prehistory.[3]

Since World War II the study of the history of photography has burgeoned. There are more students, more journals, much more research,

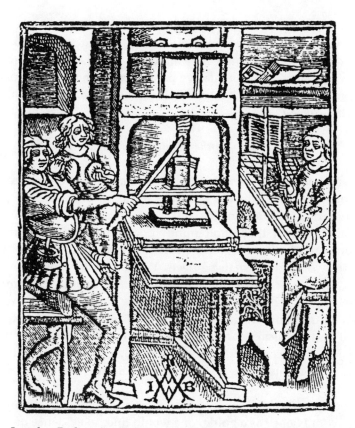

Figure 1. Jocodus Badius Ascensius, 1507. Printing presses may be considered photography's ancestors because they allowed exact multiple reproduction.

many more theories. Fact and theory are interactive. More facts strain the framework of accepted generalizations; new theories engender new perceptions and new finds. By the numbers alone, one should have anticipated the current turbulence in the history of photography. A quick review of journals like *October* and *Afterimage* leads one to conclude, using Glyn Daniel's structure, that it is fair to speak of Newhall's photographic history, of Coke's photographic history, of the Gernsheims' photographic history, even of Nazi, and certainly of Marxist photographic history.[4]

"It is a perennial temptation—and trap—to suggest that the developments of one's own age indicate the most profound intellectual revolutions," Donald Preziosi reflected in a recent issue of the *Arts Journal*. Nevertheless, he concludes that the growth of fact and theory in the last two decades is reshaping the study of Paleolithic art and wrenching that field away from textbook truisms.[5] A similar sort of change is occurring in

the history of photography. It is the argument of this paper that the scrutiny given the values and procedures underlying the history of photography will soon reach into the comfortably antiquarian pursuit of its prehistory. The following pages offer a tentative prediction of those soft spots in the prehistory of photography that will first feel the pinch of reevaluation. We begin with a review.

A Brief History of the Prehistory of Photography

Before the book, the codex; before the automobile, the carriage. Before photography? Painting? In the broadest sense, of course. Both painting and photography produce images. But painting involves the manipulation of materials in a way that photography does not. Painting lacks the apparent automatism of photography. It is deliberate and gestural. Photography, in the words of one of its pioneers, William Henry Fox Talbot, depicts its images "by optical and chemical means alone." The image is "impressed by Nature's hand."[6] Daguerre put it this way: "the DAGUERREOTYPE is not merely an instrument which serves to draw Nature; on the contrary it is a chemical and physical process which gives her the power to reproduce herself."[7] Joseph Nicéphore Niépce, the nearly unknown inventor of heliography, defined his work as "automatic reproduction, by the action of light."[8]

If one were to search all the histories of art and technology using Talbot, or Daguerre, or Niépce as a guide, one would find no evidence of a specific apparatus that, however humbly, recorded and maintained nature's image through optical *and* chemical means—at least before the end of the eighteenth century. There is the *camera obscura*, literally the dark room, which had been used since the Renaissance in the West and the Han Dynasty in the East. In the dark room an observer could view an image of nature projected on a far wall by means of a tiny hole that was sometimes equipped with a lens. The observer studied the view, or manually recorded the image by tracing the outlines of its projected shapes. The recording had to be done by hand. There was no chemistry involved. Nothing was automatic.

In fact, *camera obscura* results are often unsatisfactory. Projected colors and tonal changes are seldom true. Subtle declensions of shade and shadow are difficult to copy. In addition, *camera obscura* tracings can be stiff and mechanical. They have neither the technical pizazz of close renderings nor the fluidity of line characteristic of an artist's spontaneous reaction to light and movement in nature.

And, the *camera obscura* lacks imagination. It cannot create a religious, historical, or mythological scene. It cannot be used for portrait-making, and it cannot be used in dim light. Its primary employ in the past was as

Figure 2. A portable camera obscura, ca. 1800. From *The Photographic News*, September 1858.

an aid to the artist in taking views from nature, which, until the seventeenth century, were merely backdrops to the action of a painting, and not primary subject matter.

Over time, the *camera obscura* became the *camera portabilis*, smaller and more convenient for outings. Its greatest vogue came in the middle years of the eighteenth century. But to locate the formative history of photography in the development of the *camera obscura* is, as one wag put it, like tracing the history of painting through the brush. In Western art, the *camera obscura* has been no more than an auxillary tool for the artist and the amateur draughtsman. It changed size, but it did not greatly improve its function or fidelity, from the Renaissance to the invention of photography. No *camera obscura* automatically, or chemically, recorded anything. Like the pantograph, the *camera lucida*, the *velo*, the *vetro*, and a host of *machines á dessiner*, the *camera obscura* was intended to assist manual recording.[9]

Because the *camera obscura* was modified to house the photochemical process known as photography, its importance in the development of photography has been exaggerated. From the first accounts of photography

and its formation, penned in 1839, to those written in the modern period, one reads that "men . . . strove . . . : to capture the images in the camera obscura,"[10] yet a thoughtful reading of the works of Niépce, Daguerre, and Talbot reveals that none of them had this precisely in mind when they began their work.[11] Niépce may have constructed his own cameras, but his aim in heliography was to create cheap multiple images. Talbot, though he idly mused along the shores of Lake Como that the "fairy pictures" of the *camera obscura* would "imprint themselves durably and remain fixed upon the paper," began his experiments with chemistry.[12] Like the other pioneers, he later used the *camera obscura*, but his emphasis and theirs was on the photochemistry of photography.

If one is searching only for technical antecedents, it makes sense to begin the search among those artists and scientists who experimented with light-sensitive and light-producing chemicals. Unfortunately, there are few such forebears. Johan Heinrich Schulze's early eighteenth-century experiments demonstrated the light sensitivity of silver compounds, but he, along with other chemists, sought only to reveal the properties of various substances, not to find a practical application for their results. Most experiments along Schulze's line produced, at best, contact prints of simple objects, like leaves. These prints soon faded since the photochemical process which engendered them could not be stopped.

Ironically, these geneological considerations ignore the major feature of photography. Even Talbot's notion of the photochemical production of images neglects the strength of his own photography, which he called the calotype. The calotype is a negative-positive process, capable of producing multiple copies. Imagine the place of photography if it produced, as the daguerreotype did, only single, nonreproducible pictures. It might have remained a charming toy, something to amuse the ladies, as Daguerre forecast, rather than an integral modern art and technology.[13] Walter Benjamin was correct when he noted that it is not mere image making, but plural image making that has made photography both revolutionary and transformational.[14] If we append reproducibility to Talbot's definition of photography, can we then find the art, craft, or technology which preceded it?

What is the prehistory of photography?

William Ivins, curator of prints at the Metropolitan Museum of Art in New York for thirty years, believed that he had found a fresh view in the casting of photography's lineage. In *Prints and Visual Communication* (1953), Ivins derided the arid connoisseurship that saw all prints as high art. He observed that "the principal function of the printed picture in western Europe and America has been obscured by the persistent habit of regarding prints as of interest and value only in so far as they can be regarded as

works of art."[15] He concluded that "the importance of being able exactly to repeat visual statements is undoubtedly greater for science, technology and general information than it is for art."[16] Exact repeatability and attendant credibility, more than any printmaking process in history, were the accomplishments Ivins assigned to photography. Emphasizing reproduction and deemphasizing both photochemical technology and high art values, Ivins attempted to shift the parentage of photography.

He was too late (or too early). With the important exceptions noted below, few historians mention Ivins or attempt to broaden the discussion of photography's beginnings beyond the barriers of technical antecedents. It is not so much a matter of the correctness of Ivins's ideas, but that this ideas opposed the lore of photohistory in one pivotal area: its originality.

Many of the first accounts of the discovery of photography minimized or omitted the mention of forebears. Daguerre's operating manual and *Historique* contains a short history borrowed from the French Academy records, but Niépce's writings are largely technical. In *The Pencil of Nature* Talbot remarks that photography is a "process entirely new, and having no analogy to anything in use before."[17] Classical scholar that he was, Talbot embellished the title page with a quotation from Virgil: *"Juvat ire jugis qua nulla priorum castaliam molli deritur orbia clivo."*[18] (Joyous it is to cross the mountain ridges where there are no wheel ruts of earlier comers, and to follow then the gentle slope to Castalia.)

The notion that photography was "a new art in the middle of an old civilization,"[19] continued even when photohistory absorbed the evolutionary model of development bequeathed by science and social science. Late Victorians began to look for the idea of photography before the eighteenth century, even before the Renaissance. But they did not look into the wide realm of visual communications. Instead, they predicted the past in terms of possible technical preconceptions of photography. J. M. Eder began his book of 1900 with an account of the concepts of light held by Plato and Aristotle. A decade before, John Werge titled his book *The Evolution of Photography,* and his opening remarks recalled the "dark ages" when men became acquainted with photochemical reactions.[20] The prehistory of photography proved to be as pliant and expansive as the Victorian concept of time. By 1930 photohistorians wrote in requisite generalities about ancient observations of the bleaching effects of sunlight.

Nevertheless the unexamined assumption that photography is unique and unprecedented descended pretty much intact. As photohistory reaches for greater historiographic and methodological sophistication, it must examine the persistence and coexistence of contradictory ideas like these. A place to start, of course, is with an exploration of whose interests are served

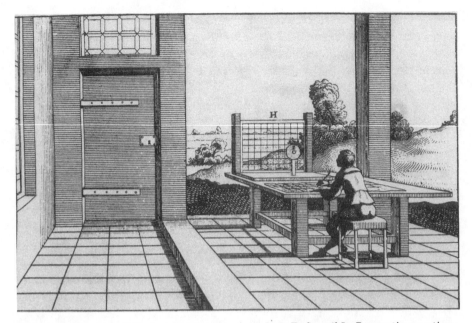

Figure 3. *"Machine á Dessiner,"* engraving from Jean Dubreuil *La Perspective practique,* Paris, 1663.

by each theory, indeed by the coexistence of each. It may turn out that their contradiction is illusory.

The contemporary reader has a choice between those historians who elaborate some prehistory and those who ignore it. The Gernsheims, Newhall, and Daval give the reader prehistorical accounts. Ian Jeffrey's *Photography* starts with Talbot and never looks back.[21] One wonders if there is a prehistory worth knowing, or whether the problems in presenting it are beyond the lay readership.

If one accepts that photography is the product of a felicitous marriage between the miniaturized *camera obscura* shell and a controlled photochemical process, then its prehistory is untroubling. No such device or process occurred before 1839. Still, some contemporary historians, in the mode of William Ivins, are distressed by the narrowed scope of technical genesis and urge a contextual or societal analysis of the beginnings of photography.

Photography in Context: The Ripeness of Time

Progressive Victorians proposed that the inventor or creative individual is merely the right person in the right place, in nineteenth-century phrase,

"the proximate initiator of change." A progressive Victorian would grant that Watt was the inventor of the steam engine while insisting that his invention was made possible by thousands of years of observation of the power of steam conflated by the right historical moment. Watt could only invent the steam engine because the physical materials, technological knowledge, economic need, and social capacity for use came into conjunction in the late eighteenth century. In short, the time was ripe.

This understanding of causation was not only favored by such diverse intellectuals as Buckle, Marx, and Spencer, it also informed everyday opinion. When writing his book on the influence of the daguerreotype in America, Richard Rudisill encountered it in the words of an anonymous author in the *North American Review*. "All is life and growth in the universe,—forces seeking form," wrote the author, "by some inscrutable means all needed books, pictures, and inventions find authors for themselves."[22]

The near-simultaneous appearance of several related, yet independently developed photographies during the first half of the nineteenth century could have impressed the Victorians as one more datum to support this argument. Strangely, it seldom did. One suspects that the understanding of photography's prehistory was somehow insulated from being so appraised, perhaps because photography quickly claimed high art status. In any case, the application of the time-is-ripe theory is largely modern.

One can locate it in the writings of Walter Benjamin, who viewed cultural changes in terms of changes in the modes of production, and who posited, somewhat ironically, that photographic reproduction might lift the work of art from its immediate contextual significance and so alter the concept of art in the modern period.[23] In her writing on photography, Susan Sontag harkens back to Feuerbach in suggesting that the essence of the modern period is the demand to produce and the ability to devour vast numbers of images. In her view, "the new age of unbelief strengthened the allegiance to images."[24]

The issue of causality was revived and reinterpreted in a controversial show at the Museum of Modern Art in 1981. The show's curator, Peter Galassi, theorized that the scientific and technological bases for photography had been well known to scientists since the early eighteenth century. For him, the actual invention of photography waited not only on the formation of a middle class with the self-interest and money to buy plural images, but also on the accumulation of image-making experiments since the Renaissance. In sum, "an embryonic spirit of realism," itself the product of the increasingly material culture of industrialism, created the need for photography as surely as did the social upheavals and scientific achievements of the past.[25] Ivins might have said it more simply by suggesting that the times demanded a new pictorial syntax.

Social historians generally agree that the years surrounding the French Revolution were pivotal in photographic prehistory, although these same scholars differ in their understandings of the direct effects of the revolution on the future consumers of photography.[26] It is clear that the revolution created a fundamental change in art patronage and promoted the increased demand for images that had begun several decades earlier. History painting, which includes religious and mythological subject matter as well as depictions of historical scenes, had been to the taste of the major prerevolutionary patrons: the rich, the royals, and the religious institutions. The new bourgeoisie preferred portraiture, landscape, and still life. Not coincidentally, these latter genres were soon to be within the technical range of photography. The pastel palette and confident, sensuous brushstroke of the prerevolutionary period gave way to somber grey tones and a smooth canvas—for critics like Galassi, photography before photography.

At the same time, multitudes of upwardly mobile art appreciators, who did not buy art objects but required art reproductions, gathered at the salons. It is they who increased the work of portraitists before and after the development of photography. In addition, the spread of trade throughout the world created a significant core of individuals who had visited foreign lands and who wanted more, and more exact, views than a gentleman's watercolorist could produce. Science and industry became reliant on visual documentation. No wonder that it was the draughtsman, not the painter, who quaked upon the announcement of photography.[27]

In these years preceding the invention of photography and in the short interval during which photographic portraits were technically impossible, the increased middle-class taste for portraits was supplied by what Gisèle Freund distinguished as the "ideological predecessor" of photography.[28] The physionotrace, a device combining silhouette-making with engraving, could produce multiple images. Although its procedures were mechanical and chemical, not photochemical, it is a true forebear to photography in that it served the need of the middle class in a way that photography would soon do. Like the photograph it challenged the unique art object. It was mechanized, and it could be produced by persons of lesser talent and experience than miniature painters. In a sense, the portrait became an industrial commodity with the invention and proliferation of the physionotrace. It is easy to overlook the importance of the physionotrace because it is prior to the common, rather than art photograph, and because it is functionally rather than technically similar.

The notion that invention takes place because of the preconcertation of various material, social, and intellectual forces emphasizes functional and conceptual forebears, rather than technical ones. The panoramic dimensions of this stance can blur important details. All images merge, and the

Figure 4. Physionotrace of Gilles-Louis Chrétien, inventor of the process, 1792. GEH.

practical distinction between art history and photohistory disappears. With Roland Barthes, we may wonder about the ontological nature of photography: "by what essential feature . . . [is it] to be distinguished from the community of images?"[29] Some of these problems can be focused in a brief discussion of photography and magic.

The Prehistory of Photography and Illusionism

The wish to make images real and to make realistic images is as old as the human imagination, a fact that confounds those who would discuss photography as a special category of images. In particular, the intense realism of the photographic image has impressed critics as magical, and as having conceptual forebears in images that fool the eye, or images created for or during divination: Zeuxis's grapes or Apelles's portraits: One prevision of photography is especially celebrated in the literature. *Giphantie,* a French utopian journey published in 1760 by Tiphaigne de la Roche, takes the voyager to an island where elemental spirits dwell. In their art a viscous material is smeared on a canvas and the canvas retains a mirror-image of the scene to which it has been exposed.[30]

The uncanny resemblance to photographic processes has been inculcated in the lore of photohistory. By inference, the *Giphantie* canvases are taken to mean that imagination can outrun the material means of production. At least, the notion is debatable. The greater problem is with the genesis of the works and their bearing on photography. *Giphantie's* paintings are the products of elemental spirits, the secret conspirators of witches and alchemists throughout the ages. It is they who create the viscous materials. Magic ties this mid-eighteenth century vision to the stories of Zeuxis and Apelles, as well as to Faust's vision of the enchantress in the mirror, or the image of the beloved that permanently stains a mirror in one of the tales of Hoffmann.

It is one thing to look to magic to establish the cult value of early photography, as Walter Benjamin did.[31] It is quite another to assume that photography has antecedents in magic, which, after all, gets its effects from the audience not knowing the means of the illusion. The wonder of photography is just the opposite: one knows the processes and still the result seems magical. Nevertheless, it is right to start looking for expectations of photography in the last years of the Enlightenment and the beginnings of the Industrial Revolution, when knowing how things worked was all important.

Thomas Wedgwood and the Constraints of Technological History

Thomas Wedgwood grew up in regular contact with "a kind of scientific general staff for the Industrial Revolution."[32] His father, Josiah, was a man for the age, believing with so many others in those brief years before the French Revolution, in the perfectability of human society. Like many early industrialists, the elder Wedgwood saw himself as a man living through a wide-sweeping renaissance. Although Josiah was not a formal member, he participated in the meetings of the Lunar Society, a group which included Dr. Erasmus Darwin, James Watt, and Joseph Priestley. Through correspondence, the society kept abreast of scientific discoveries in Europe and America, and, importantly, sought out practical applications to new scientific findings. Thomas inherited his father's scientific interests, and he attended meetings of the society. Photohistorians know Thomas Wedgwood to be the individual who first attempted to fix an image by photochemical means, and that he failed.

The treatment of Wedgwood in photographic prehistory underscores one of the problems of technical histories. First, the facts of technical histories obscure the wider societal and intellectual matrix that makes invention possible. Second, and corollary, inventions do not necessarily beget inventions, like so many caged rabbits.[33] With Wedgwood's brief life and

studies—he died at the age of thirty-four—we move beyond the realm of magic, beyond alchemy, into science.

Wedgwood's particular interest was chemistry, what the young of his day called the new chemistry, the French chemistry, the chemistry of Lavoisier, which required empirical demonstration through seemingly endless experiments. The drudgery of the lab was relieved by the knowledge that one was working at the forefront. Every element in the wide world was a potential subject for analysis. The new chemists were making the world afresh through analysis. They not only knew what happened, but posited why. For every generation of scientists there is a vogue science. In 1820 it would be geology, whose finds stretched the world's time and led to evolutionary theory. At the end of the eighteenth century the vogue science was chemistry.

Together with Humphry Davy, then an apothecary's apprentice, Wedgwood talked chemistry, especially his work with photochemical responses. Davy was a man of polymathic talent, the sort who was more common before the age of scientific specialization. His energy must have seemed boundless to the ailing Wedgwood. Davy wrote poems, did his chemical experiments, and even took fishing very seriously. Much of what we know of Wedgwood's work in photography we know through Davy. The unassuming, measured paper that Davy wrote recounting their experiments is fresh and modern: "Nothing but a method of preventing the unshaded part of the delineation from being coloured by exposure to the day is wanting, to render the process as useful as it is elegant."[34] Useful and elegant: science wedded to technology. Wedgwood and Davy's is not so much a technological accomplishment—it was an acknowledged failure. Instead, it marks a moment when the discovery of photography was potentiated and hastened by the introduction of utility to the study of science, at least in the area of photochemistry. Photometry was similarly boosted by a utilitarian emphasis.

Omitting this background, the Gernsheims and Eder have wondered why Davy had not read the work of Carl Wilhelm Scheele, the Swiss chemist, more carefully. Scheele's work, available in English and known to Davy, who quoted it in a footnote of his article, recorded that ammonia dissolved chloride of silver. Chloride of silver, still actively sensitive to light in the unexposed areas of the Wedgwood-Davy print, would have been washed out by ammonia. The Gernsheims write: "One cannot absolve so eminent a chemist as Davy from blame for his failure to find a fixing agent."[35] Harsh words for the poet-chemist, and, sadly, they might prove true. We know that Davy was given to grand schemes and that many imagined experiments were never conducted.

But there is a more likely possibility, one which underlies the position

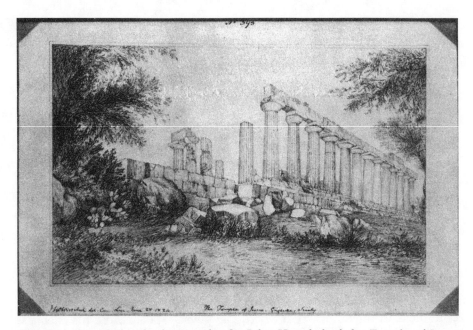

Figure 5. Camera lucida drawing by Sir John Herschel of the Temple of Juno, Girgenti, Sicily, 1824. The Science Museum, London.

of Wedgwood and Davy in scientific and cultural history. Davy was a new chemist, a chemist in the mode of Lavoisier. Scheele upheld the old chemistry and in particular the theory of phlogiston, thought to be a material lost in burning. Some historians generously assume that phlogiston is just another word for oxygen. In fact, phlogiston represents a body of chemical theory refuted by the new chemistry.

The old chemistry was more scholastic than the new. It stressed deductive reasoning over laboratory observation. Relying on Priestley's newly discovered gas, oxygen, Lavoisier formulated a theory of combustion that effectively ignited the phlogiston model. By 1800 the theoretical model for physical behavior based on phlogiston had crumbled. Consequently, it is not difficult to understand why Davy did not return to Scheele's volumes for a close reading. To Davy, Scheele must have seemed like a vastly out-of-date roadmap.

The Problem of Originality in a New Prehistory of Photography

The notion that invention takes place because of the preconcertation of material, social, and intellectual forces was born in the nineteenth century, but not applied to photohistory until the twentieth. The most durable

theory of creativity, one which amplifies the uniqueness of invention, is that of the originator or original genius. The originator creates where nothing before existed. The invention is unprecedented and unexpected. From now on the old ways seem reactionary.

A new prehistory of photography must confront the issue of originality both as it threaded its way through the years prior to the announcement of photography and as it colors contemporary thought. In the future, more scholars may come to agree with the contentions of Joseph Nicéphore Niépce's son that Louis-Jacques Mandé Daguerre, the putative original genius of photography, merely perfected the elder Niépce's photographic process.[36]

On the surface, there are many reasons why Daguerre overshadowed Niépce, not the least of which is that Daguerre's process produced superior results. The clarity and detail of the daguerreotype were far greater than that of Niépce's work. Moreover, the daguerreotype took less exposure time than Niépce's invention (Daguerre, twenty minutes; Niépce, about eight hours).

In addition, Niépce died six years before Daguerre's process was announced to the world. His heir initially participated in Daguerre's attempt to have himself singled out as the principal inventor of photography. Still, there are at least two aspects crucial to the ascendancy of Daguerre that have not been widely aired: social class and politics.

French society in the 1830s was like an ice-clogged river in March. Winter and spring were visible in the same view. Winter, the hold of the class-based, agrarian interests, was still strong but beginning to give way to the forces of commerce, industrialization, and bourgeois egalitarianism. Although liberty most often meant that one was free to make a fortune, it also could and did mean that an elite based on intelligence and ability, and no small measure of cunning, could rise to power. Persons of humble birth held some important positions in government. Spring favored the intellectual consideration of the decency of the common man, and mixed that idea with another: romantic individualism. Napoleon, dead for almost a decade, entered French legend as the self-made man, fulfiller of his own destiny. It was the age of the entrepreneur, the virtuoso, the *arriviste*.

The facts of Daguerre's life, together with the public image he carefully manufactured, argued for Daguerre as the hero of his own life. Born to a petit-bourgeois family, he had little formal education. Daguerre worked his way up from an apprenticeship at the age of thirteen to be a Paris set designer, painter, and, finally to create his convincing stage illusions, the diorama. What strikes one today as Daguerre's attitude of unembarrassed advantage-seeking was not just a quirk of personality best ignored, but a requisite part of getting ahead in the Paris of the 1830s.

Indeed, Daguerre's skill at self-promotion rivaled the brilliance of his

invention. For example, Daguerre published a pamphlet as a requirement of his French government stipend. The cover of the booklet shows not an illustration of the invention itself, but an engraving of the Pantheon, the temple to French luminaries like Voltaire, Rousseau, and Mirabeau. Over the main portal of the building, and clearly visible on the pamphlet cover, is the inscription, *"Aux grands hommes la patrie reconnaisante."* This bid for fame was greeted with grudging admiration by many of the public.

Joseph Nicéphore Niépce, on the other hand, was somewhat disabled by his prerevolutionary background. His family's wealth provided a fine education and fostered a set of expectations out of tune with the tenor of the times. Born in 1765 to a family of Royalists, Niépce had plenty of inventor's drive, but he was an awkward entrepreneur, unable and unwilling to push his inventions with much success. The meekness—or was it aristocratic hauteur—of Niépce contrasts with the aspiration—or was it opportunism—of Daguerre.

As the records of the French Academy were being inscribed with the first accounts of photohistory, the accounts used by scholars today, Daguerre and his partisans utilized the model of the heroic original genius to promote Daguerre. A Royalist sympathizer, six years dead, need not be accorded many courtesies. In the annals of the French Academy, Daguerre is credited with having made discoveries parallel in time, but not in procedure, with those of Niépce.

Daguerre's process was asserted to be *"entièrement neuf."*[37] And it may have been. The issue here is not to argue for Niépce or Daguerre, but to demonstrate the extent to which matters external to the facts may have influenced the writings of the prehistory of photography right down to the present day.

The Politics of Knowledge: Photographies at Their Inception

Early photography's material record is slim at the point where it excites much interest, in the immediate years of its development. This is often the case with beginnings, and it has been exacerbated in the study of photographic prehistory. Over time, the year 1839, the year the French government gave photography to the world, has become an intellectual barrier and line of demarcation. What happened before 1839 is prehistory; what happened after is early history. Having 1839 as a fixed point fosters a historiographic model of incremental, linear development: a before b, before c; or Niépce before Daguerre, before Talbot.

The fact remains that no one has been able to construct a prehistory of photography in which each careful and deliberate concept or experiment

leads to another, which, in turn, yields a plateau of shared understanding upon which the next generation of researchers begins again to build. Indeed, many of the difficulties that historians of science have perceived with "the concept of development-by-accumulation"[38] can be found at the moment of photography's inception. Linear development, even when augmented by concern for the generative potential of societal and intellectual culture, even when tempered by an awareness of the tendency toward hero-worship, blunts an understanding of the politics of choice (and the choice of politics) that made Daguerre the Columbus of photography.

At least two photographies were invented by Joseph Nicéphore Niépce.[39] The history of their invention is sketchy and, because of the caution exercised by Niépce in his correspondence, likely to remain so. Ironically, Niépce abandoned his first photography, which employed the photosensitivity of silver, the basis of the modern technique. Instead, he turned to a second process, using bitumen of Judea, which was much closer to engraving and etching. For a number of reasons, Niépce agreed to divulge the particulars of his second photography to Daguerre.

We have only unsubstantiated anecdotes to support the contention that Daguerre developed his own sort of photography by 1829, the year of the agreement with Niépce. Daguerre's success with photography may have taken at least five years from the agreement. In fact, the first daguerreotype can be dated to May of 1837.

Unlike Niépce's photography, the daguerreotype was based on a latent image. Photographic plates were made more sensitive by the application of a surface of silver iodide, and were then exposed in a *camera obscura*. The image, which was not visible at the time of the exposure, was developed out using mercury fumes. Daguerre's technique was faster and produced a highly detailed image. His attempts to promote and sell his new photography are well documented. What prehistorians of photography lack is some notion of the state of French science and French politics that made it possible for Daguerre to be singled out as the sole inventor of photography.

Government support of science and invention is a feature of nineteenth-century French intellectual life that differs greatly from English and American practice in the same period.[40] Where an Englishman or American would likely persist in attempting to raise private capital to fund a venture, a Frenchman would approach the government. The system was as old as the French Academy, incorporated in 1666. Although the Academy of Science had been briefly disbanded during the revolution, its postrevolutionary form continued to mirror the centralized and hierarchical character of the ancien régime. To obtain a government pension—there was no shame in asking—one would solicit the sponsorship of an academician, who would

then instigate a committee of academicians to judge the worthiness of the invention and recommend it, possibly, to an appropriate department of government. Although postrevolutionary practice and politics had changed the system somewhat, the academy generally followed the procedure begun with its incorporation.

The revolution and its aftermath helped to dispel some of the preciosity of science. Condorcet ranked scientific studies above *belle-lettres*. Scientists were still well-to-do gentlemen, but science had new emphases. Under Napoleon, science became the buttress of national greatness, evidence of French intellectual superiority. Science, not literature, was the fulcrum of a new public education effort. Moreover, practical applications of scientific theory were prized.

No wonder, then, that Daguerre took advantage of the government's policy when his attempts to raise private capital failed. He succeeded in gaining the attention of Dominique-François Arago, academician and secretary of the French Academy of Science, director of the Paris Observatory, and, since 1830, a decidedly liberal deputy in the French lower house.

Arago was aligned with those forces who saw in the early tenure of Louis-Philippe possibilities for social progress. He advocated public education, new invention, and carried forward the revolutionary notion that technical achievement would increase national well-being. During his government service, Arago sponsored bills for the development of railroads and the telegraph, and he urged the government to support a museum at Cluny, the monastery nearly wrecked during the revolution. Arago was on the scientific forefront. His studies included analyses of the properties of light. In 1838, the year he was approached by Daguerre, he sponsored government support of a photometric device. Daguerre showed Arago his photographic process, and Arago even made some photographs himself.

Arago immediately began a campaign to pension both Daguerre and Niépce's heir, Isidore, and to give photography to the world as a gift from the French nation. In his first public statement to the French Academy of Science, Arago so minimized the contributions of Niépce—he is called a collaborator in one sentence of the presentation—that the newspapers did not pick up Niépce's name in their reports. Arago does not appear to have wanted to rob Niépce's heir, but to have realized the wisdom of having a single inventor of photography.

Undoubtedly Arago was familiar with the continual challenges of prior formulation within the scientific community, Priestley and Lavoisier for oxygen, for example. Fortunately for the memory of Niépce, an English acquaintance, learning of the newspaper's error, reintroduced Niépce's contribution to the debate. Unfortunately for Arago, the specter of multiple claimants to the origination of photography arose.

Arago put pressure on the Minister of the Interior by recommending

Figure 6. Joint Meeting of the Academies of Sciences and Fine Arts in the Institute of France, Paris, August 19, 1939. Engraving. Gernsheim Collection, Humanities Research Center, University of Texas, Austin.

expeditious action. He made his plea as an academician but reminded the minister that he was also a deputy, able to speak on behalf of Daguerre's invention from the floor of the Chamber of Deputies. Still, during 1839 several individuals came forward to assert the simultaneous or prior invention of photography. At home Hippolyte Bayard, a minor official in the Ministry of Finance, claimed to have been experimenting with a direct positive process since 1837. Arago effectively nullified his claim. Abroad, William Henry Fox Talbot announced himself to be the first inventor. To Talbot the issue was not (or at least not immediately) one of financial advantage, but of recognition in the scientific community.

Arago could use his persuasions to still the claims of Bayard, a timid clerk, but he could take little direct action against the statements of Talbot. Instead he politicized the matter of photography's introduction by enlisting French Anglophobia.

In Arago's report to the Chamber of Deputies (July 3, 1839), one reads the thoughts of a generous and prescient scientist, and an accomplished Machiavellian. A report to the Chamber of Peers (July 30, 1839), was prepared by Arago's old friend and scientific colleague, Joseph Louis Gay-Lussac. Likely enough, Arago and Gay-Lussac foresaw the importance of photography to photometry, and especially its applications to astronomy. Both assured their audiences that photography would assist the natural sciences in the organization and transmission of knowledge, and in making various sorts of scientific calculations. Topography, meteorology, physiology, and even medicine would be aided by the new invention.

Arago and Gay-Lussac went beyond scientific arguments for the acceptance of the daguerreotype to an emotional appeal. Years after the French occupation of Egypt, the French recollection of that brief and militarily unsuccessful experience became as rhapsodic as did the memory of Napoleon. To scientists, the Egyptian campaign was a model of government collaboration with science. More than one hundred and fifty scientists and men of letters had worked in Egypt. Subsequent decades were filled with publication of their work, which, in turn, served as a sort of intellectual and cultural victory over the English.

The monumental *Description de l'Egypte* (1809–28) was the sturdy backdrop against which the sensation of decoding the Rosetta Stone was played. The stone, found by a Frenchman, but passing into English hands with the defeat in Egypt, was given an initial, spare, and faulty interpretation by an Englishman. However controversial, Champollion's extensive translation of the stone was a source of French national pride and a vindication of the French occupation. When Arago enlisted the French adventure in Egypt as an argument for the acceptance of the daguerreotype he was issuing a covert warning about another threatened English scientific coup, Talbot's photography, which the French must forestall.

Nationalism and Anglophobia also warmed Arago's subsequent arguments. In the period since the revolution, medieval architecture in France had become a source and symbol of national pride. In fact, the French created their own Gothic Revival, extending to all the architecture of the middle ages. The revolution's suppression of religious orders hastened the decay of churches and abbeys. Learned societies early in the century attempted to secure monies for restoration, but it was not until the late 1820s that public sympathy and government funding supported their pleas. It was well into the reign of Louis-Philippe that a new generation demanded and received significant subvention for medieval architecture. In 1837 a Historic Monuments Commission was created, composed primarily of archeologists. Their task was to assess the state of medieval architecture in France and to focus restoration funds.

The vast project, rivaling the English and German concern for the past, called for a seemingly objective method to document the state of the monuments. The "great national enterprise,"[41] as Arago called it, must have the new medium of photography. To deprive France of the benefits of the invention would be a loss of great magnitude, as great, Arago argued, as the alleged loss of visual records in Egypt. This was no ordinary invention to serve the base interests of French capitalism. It would serve high ideals, love of country, and one's duty to history. In Arago's speech to the Chamber of Deputies one finds the urgency and rationale of American statesmen in the months following the successful launching of Sputnik.

Gay-Lussac, too, invoked Anglophobia. The English are the "other people" he refers to in his reflection "that a people excels in achievement in over *other peoples* only in proportion to their respective progress in civilization."[42] Arago took a similar tack. If the Chamber of Deputies did not vote to pension Daguerre, if it "misjudg[ed] the importance of the daguerreotype and the place which it will occupy in the world's estimation, every doubt would have vanished at the sight of the eagerness with which foreign nations pointed to an erroneous date, to a doubtful fact, and sought the most flimsy pretext in order to raise questions of priority and try to take credit for the brilliant ornament which photography will always be in the crown of discoveries."[43] The erroneous date? 1835. The doubtful fact? The invention of the first photography by William Henry Fox Talbot. The foreign nation? England.

Summary and Conclusion

In April 1979 a group of papers was presented at the University of Chicago conference called "Towards the New Histories of Photography." Three years later Victor Burgin introduced the essays in *Thinking Photography* by writing: "The essays in this book are contributions toward photography

Figure 7. Cover of Daguerre's Manual, August 1837.

theory. I say 'towards' rather than 'to' as the theory does not yet exist. . . ."[44] In this paper, *toward* has been employed similarly. Its use indicates that the old prehistory of photography cannot stand, but that the new prehistory is, at best, germinal.

Christopher Phillips has suggested that "photography's rapid revaluation is undoubtedly one of the most astonishing episodes in what has been called, skeptically, *le champ de l'esthétisable*."[45] Even those who burrow among the millions of extant photographs, annotating and restoring, have begun to question the processes of history and scholarship that have valorized some photographers and some photographies to the neglect of others.[46]

What is happening in photohistory? We can take a clue from human prehistory. An archeology of the field is getting under way, and with it the search for "a common conceptual terrain"[47] arising out of fresh analysis. The work of founding scholars, and, because of their strategic importance, founding collections, are being examined both for their factual accuracy

and for their underlying historiographic models. Petrie's Minoan pots are being disclosed and discredited everywhere.

Glyn Daniel's words apply equally well to the history of photography:

> We were brought up at school to believe that there are immutable historical facts, and find when we grow up that they are as mutable as the interpretations of those who write about them, and as varying as the models which those writers assume.[48]

To a certain extent, art history has become a target for the new criticism.[49] Art historical models are said to appropriate photographs from their societal contexts, and to lionize photographers who imitate painting styles. Interesting, too, is the fact that the push to make new histories of photography has found its impetus outside the field itself, largely from semiotics.[50] A similar circumstance occurred when psychoanalytic theory scorched the impulses of archeologists.

Many of the conflicts abroad in the history of photography will not be assuaged. Instead, the field will change. As it changes the prehistory of photography will necessarily change. Perhaps our perspective has already shifted sufficiently that we can now explore some of its values and dimensions. Certainly, technical histories of the formative years of photography, which lean on the notion of individual invention, while ignoring material culture, ideology, and societal directions, in an attempt to create the illusion of linear development are no longer convincing. The question of origination is altering from a consideration of who came first to why it matters, and why photography came into being in 1839. The danger is that societal questions will seem to substitute for political ones, and the once narrow view become so wide that it flattens the unique political history of photography.

Many questions are shared with the larger field of photohistory, especially this pivotal one: What is photography? Those who conjure the prehistory of photography are charged to find the antecedents of an item differently construed by different audiences. Should we search the roots of the common photograph, or a unique art object? Is photography another form of writing, or sign-making, or has it a genius so special that it must be pursued on its own terms? All of these questions reverberate in prehistory.

For the history of photography it is a time of hope and caution. The hope—a long-standing one—is that photohistory will spring from its second-class status, finding its Wolfflins, acknowledging its Marshacks, and rediscovering its Le Grays. The caution is that the field will tolerate such a plurality of approaches that it merely trades old problems for new ones.

Notes

1. J. D. S. Pendlebury, *The Archeology of Crete: An Introduction* (New York: Biblio and Tannen, 1963), xxv–xxvii.
2. Glyn Daniel, *The Idea of Prehistory* (Baltimore: Penguin Books, 1962), 12.
3. Ibid., 12.
4. There is no short-cut to an understanding of the turbulence in photohistory, but for recent examples that bring together many of the issues and ideas, see Christopher Phillips, "A Mnemonic Art? Calotype Aesthetics at Princeton," in *October* 26 (Fall 1983): 35–62, and *Thinking Photography*, ed. Victor Burgin (London: Macmillan Press, 1982).
5. Donald Preziosi, "Constru(ct)ing the Origins of Art," *Art Journal* 42 (1982): 325.
6. W. H. F. Talbot, *The Pencil of Nature* (1844; facsimile rpt. New York: DaCapo Press, 1969), unpaginated. See "Introductory Remarks."
7. From Daguerre's Broadsheet. See Helmut and Alison Gernsheim, *L. J. M. Daguerre: The History of the Diorama and the Daguerreotype*, 2nd ed. (New York: Dover Publications, 1968), 81.
8. Joseph Nicéphore Niépce, "Notice sur l'heliographie," trans. in J. M. Eder, *History of Photography* (New York: Columbia University Press, 1945), 218. In Victor Fouque, *The Truth Concerning the Invention of Photography: Nicéphore Niépce, His Life, Letters and Works* (1935; rpt. New York: Arno Press, 1973), 90, Edward Epstean translates the passage as "the *spontaneous* reproduction . . ." (emphasis Niépce).
9. For an introduction to these devices in photohistory see Heinrich Schwarz, "Art and Photography: Forerunners and Influences," *Magazine of Art* 42 (November 1949): 252–57.
10. Walter Benjamin, "A Small History of Photography," in *One-Way Street and Other Writings*, trans. Edmund Jephcott and Kingsley Shorter (London: New Left Books, 1979), 240. For one of the earliest examples, see Arago's speech to the French Chamber of Deputies, *Comptes-rendus*, IX, 252. Partial trans. J. M. Eder, *A History of Photography*, 232–41.
11. The lack of original sources in most cases is frustrating to the scholar. One has to put the picture together from Fouque, the Gernsheims' *Daguerre*, and Talbot's *Pencil*. A handy guide to the pioneers' stated objectives appeared in Carl Chiarenza's "Notes Toward an Integrated History of Picture-making," *Afterimage* 7 (Summer 1979): 39.
12. Talbot, *Pencil*, Part I and H. J. P. Arnold, *William Henry Fox Talbot: Pioneer of Photography and Man of Science* (London: Hutchison Benham, 1977), 106–7.
13. Gernsheims, *Daguerre*, 81.
14. Walter Benjamin, "The Work of Art in the Age of Mechanical Reproduction," in *Illuminations* (New York: Schocken Books, 1968), 218–19.
15. William Ivins, *Prints and Visual Communication* (Cambridge, Mass.: Harvard University Press, 1953), 1.
16. Ibid., 2.
17. Talbot, *Pencil*, "Introductory Remarks," unpaginated.

18. Talbot, *Pencil*, title page.

19. Joseph Louis Gay-Lussac in his presentation to the Chamber of Peers. Translated in J. M. Eder, *History of Photography*, 241.

20. The full title of Werge's text is *The Evolution of Photography with a Chronological Record of Discoveries, Inventions, Etc., Contributions to Photographic Literature, and Personal Reminiscences extending over Forty Years* (1890; rpt. New York: Arno Press, 1973).

21. See Helmut and Alison Gernsheim, *The History of Photography from the Camera Obscura to the Beginning of the Modern Era* (New York: McGraw-Hill Book Co., 1969); Beaumont Newhall, *The History of Photography from 1839 to the Present* (New York: Museum of Modern Art, 1982); Jean-Luc Daval, *Photography: History of an Art* (New York: Rizzoli, 1982); Ian Jeffrey, *Photography: A Concise History* (New York: Oxford University Press, 1981).

22. *North American Review*, July 1854, 20–21, in Richard Rudisill, *Mirror Image: The Influence of the Daguerreotype in America* (Albuquerque: University of New Mexico Press, 1971), 30–31.

23. Benjamin, "The Work of Art in the Age of Mechanical Reproduction," 220–23.

24. Susan Sontag, *On Photography* (New York: Delta Books, 1977), 153.

25. Peter Galassi, *Before Photography: Painting and the Invention of Photography* (New York: Museum of Modern Art, 1981), 18. For an important related argument see Carl Chiarenza, "Notes Toward an Integrated History."

26. One of the most durable social histories of photography is Gisèle Freund, now available in translation: *Photography and Society* (Boston: David R. Godine, 1980). Also see Jean-Luc Daval, 10–11, and Alan Thomas, *Time in a Frame: Photography and the Nineteenth Century Mind* (New York: Schocken Books, 1977). For general social history of art, Arnold Hauser, *The Social History of Art*, vol. 3 (New York: Vintage Books, n.d.), and Charles Morazé, *The Triumph of the Middle Classes* (Garden City, N.Y.: Anchor Books, 1966) are helpful.

27. For miniature painters and their reaction to photography see John Murdoch, Jim Murrell, Patrick Noon, and Roy Strong, *The English Miniature* (New Haven: Yale University Press, 1981), 207–9. Paul Delaroche's tongue-in-cheek remark that painting was dead after the invention of photography is one of the most overblown tales in photo-folklore. In fact, Delaroche supported the daguerreotype as an aid to preliminary drawing. See *Comptes-rendus*, IX, 260.

28. Freund, *Photography and Society*, 18.

29. Roland Barthes, *Camera Lucida: Reflections on Photography* (New York: Hill and Wang, 1981), 3.

30. The important passage from *Giphantie* is reproduced in Gernsheims' *History*, 35.

31. See Benjamin, "The Work of Art in the Age of Mechanical Reproduction," 225.

32. F. D. Klingender, *Art and the Industrial Revolution*, ed. Arthur Elton (New York: Schocken Books, 1970), 35. For science in the period see Charles Coulston Gillispie, *The Edge of Objectivity: An Essay in the History of Scientific Ideas* (Princeton: Princeton University Press, 1970), J. D. Bernal, *Science and Industry in the Nineteenth*

Century (Bloomington: Indiana University Press, 1970), and J. T. Merz, *History of European Thought in the Nineteenth Century* (Edinburgh: William Blackwood and Sons, 1907).

33. Bernal writes: "What is most apparent . . . are the contradictions—the easy and rapid realization in practice of some ideas at some times, the many false starts and halting progress of others." Bernal, *Science and Industry*, 135.

34. Quoted in J. M. Eder, *History of Photography*, 138.

35. Gernsheims, *History*, 40–41.

36. See Fouque, Part III, 102–41.

37. *Comptes-rendus*, XIII, 172.

38. Thomas S. Kuhn, *The Structure of Scientific Revolutions*, 2nd ed. (Chicago: University of Chicago Press, 1970), 2.

39. See Fouque, *The Truth Concerning the Invention of Photography*, Part II, especially 56–101.

40. For science sources, see note 32, above.

41. *Comptes-rendus*, IX, 259. Translated in J. M. Eder, *History of Photography*, 235.

42. Translated in J. M. Eder, *History of Photography*, 244 (emphases mine).

43. *Comptes-rendus*, IX, 226–67. Translated in J. M. Eder, 240. The point was not lost on the English who noted that Arago was being "even more French than usual." (See *Literary Gazette* (July 20, 1839): 459).

44. Burgin, 1.

45. Phillips, 35.

46. See, for example, Colin L. Westerbeck, Jr., "A Random Walk: Some Reflections on Photographic Research," *Aperture* 84: 2–7.

47. Erik Olin Wright, "The Value Controversy and Social Research," in Ian Steedman, Paul Sweezy, et al., *The Value Controversy* (London: Verso and NLB, 1981), 37.

48. Daniel, *The Idea of Prehistory*, 12. See footnotes 3 and 4.

49. See, for example, John Szarkowski's introduction to *Mirrors and Windows: American Photography since 1960* (New York: Museum of Modern Art, 1978), Carl Chiarenza's critique of E. H. Gombrich in "Notes Toward an Integrated History of Picture-Making," 36 and passim, and John McCole, "Walter Benjamin, Susan Sontag, and the Radical Critique of Photography," *Afterimage* 7 (Summer 1979): 14

50. Archeologists and anthropologists might note the resemblance between Alexander Marshack's work with signs and their contexts and contemporary work, like Burgin's, on photography and semiotics.

FRANÇOIS ARAGO AND THE POLITICS OF THE FRENCH INVENTION OF PHOTOGRAPHY

ANNE McCAULEY

"The advantage of machinery is not limited to the bare substitution of it for human labor, but that, in fact, it gives a positive new product, inasmuch as it gives a degree of perfection before unknown."
J.B. Say, *A Treatise on Political Economy*, v. 2
(Boston, 1821, orig. 1803), 43.

"In general, it is a serious mistake to think that the theories of scholars are independent from the common principles that govern human societies."[1]
L.C., "Variétés—Revue de J. B. Buchez,
Introduction à l'étude des sciences,"
Le National (April 18, 1839): 3.

ON JANUARY 6, 1839, THE FRONT PAGE OF THE LEGITIMIST Parisian daily, *La Gazette de France*, carried a long notice of a "new discovery": "We are announcing an important discovery by our celebrated diorama painter, M. Daguerre. This discovery is marvelous. It baffles all scientific theories of light and optics and will cause a revolution in the arts of drawing."[2] Using a camera obscura, Daguerre placed a "nude piece of copper" in his apparatus and in three minutes in sunny weather withdrew the metal "covered with a ravishing design." According to the author, Henri Gaucheraud, "It was only a question of a short material operation of washing, I believe, and then the viewpoint that had been conquered in only a few minutes stayed invariably fixed."

Gaucheraud was working from a press release issued by François Arago prior to his official announcement on January 7 to the Académie des Sciences. As a consequence, he somewhat garbled Daguerre's process.[3] But he does appear to have seen some of Daguerre's products and provides the first published assessment of photographic imagery. "Moving nature," he observed, could not be captured: in one view of a boulevard, a horse's body was visible, but its head had moved during the length of exposure and was reduced to a blur. Still-life and architecture promised to be the strengths of the new medium, and "a dead spider could even be studied." On the whole, Gaucheraud concluded, the images resembled mezzotints more than engravings, but surpassed them in truthfulness.

With this announcement began a series of events, largely orchestrated by François Arago, aimed at establishing Daguerre as the primary inventor of this amazing new process. The chronology recited in most histories of

photography—from Arago's first speech in the Académie on January 7 and W. H. Fox Talbot's challenge at the end of that month to the proposal on June 15 in the Chambre des Députés to award a pension to Daguerre and the son of his deceased partner, Nicéphore Niépce—is normally mustered to confirm the overwhelming enthusiasm inspired by the first photographs and France's rather chauvinistic usurpation of the invention. Photography itself, as the combination of chemical discoveries and long-established mechanical drawing aids, is defined as a new stage in an on-going quest for mimetic truth. Its simultaneous birth in several Western European countries is loosely related to a climate of positivism, industrialization, and democratization in which more consumers, cherishing the here-and-now, demanded more exact and cheaper records of the material world.

While these overarching theories of why photography appeared are generally valid, a closer, historical examination of the particular context in which Daguerre's success was constructed can better illuminate what values were invested in the medium. This paper will demonstrate that, like all technologies, photography was shaped in response to specific social and political programs. It was in no sense politically neutral, but was part of an ideology, a system of ideas intended to promote a given social order. This is not to say that Daguerre (or Niépce or Talbot or any other photographic innovator) necessarily ever thought of himself or his chemical dabblings as "political." But his very definition of "the problem" entailed perceptions of current needs, needs which had to be felt by persons other than the experimenter if the invention were ever to be made public. What is crucial to an understanding of technological change is the way in which external conditions, far from the laboratory or physics cabinet, force or facilitate the "birth" of a new discovery. It is on these external conditions that I will concentrate.[4]

The key figure in the public birth of photography is unquestionably François Arago, astronomer, mathematician, politician, scientific popularizer, internationally recognized polymath. Arago, as he is sketched in photographic histories, was in 1839 a perpetual secretary for the Académie des Sciences and a representative in the Chambre des Députés sitting with the "Republicans." As such, he was presumably ideally positioned to solicit state recognition for Daguerre (and Niépce). His behavior as the first photographic booster has rarely been questioned, and his motivations seem transparent: as a scientist who had himself engaged in optical experiments, he would naturally be impressed by Daguerre's breakthrough and would have wanted the state to honor what was acclaimed as a great invention (as history was to confirm). His dismissal of Talbot's claims to the invention could be understood as typical French nationalism, and his success in getting Daguerre and Niépce pensions attested to his own popularity as an eminent scientist.

Portrait of François Arago, 1840. Lithograph by Julien from Galerie de la Presse. Courtesy Boston Athenaeum.

Arago's involvement with Daguerre and his role in the story are by no means as straightforward and easily dismissed as the cursory mentions in the photographic literature would suggest. In the absence of a modern biography on Arago, it is difficult to piece together the various interests of this remarkable figure and to integrate his scientific and political accomplishments.[5] But we can, I think, get a good sense of his general principles through a close reading of his writings, speeches, and other primary sources that describe his behavior.

As a scientist, Arago distinguished himself while still a young man by traveling to Spain in 1806 with J. B. Biot to measure the earth's meridian for the Bureau of Longitudes, which used this figure as the basis of the metric system. This national service won him a seat in the Académie des Sciences at the precocious age of twenty-three. His major scientific research—on the chromatic polarization of light, the relationship between

magnetism and electricity, photometry, the causes of extreme meteorological conditions, and the nature of comets—was done during the Empire and Restoration. By the time that he succeeded Fourier as perpetual secretary of the Académie's mathematical section in 1830, he seems to have shifted his interests to problems in applied science, the popularization of scientific ideas, and politics.

Arago's late-blossoming role as a public educator is perhaps as important for our study as his contribution to physics and astronomy. In 1809 he was named to the board of the Ecole polytechnique, but he only began giving his own astronomy courses in 1813.[6] Opposed to the doctrinaire teaching of Greek and Latin, Arago believed that practical science should be a part of all classes' training. With the overthrow of the Bourbons in 1830 and the establishment of what was initially perceived as a more "liberal" constitutional monarchy, Arago seems to have extended his ideas of public education. He was the first to invite the press to meetings of the Académie, which resulted in regular newspaper coverage of its deliberations. He also initiated the weekly publication of the Académie's minutes in 1835.[7] At the Paris Observatory, which he directed, he had an amphitheatre constructed and gave popular lectures from 1841 to 1846. At the same time, he published several clearly written introductory texts including *Des Comètes* (1835), *Leçons d'astronomie* (1835) and *Astronomie populaire* (lectures published posthumously in 1854–57).

Arago's activities as a scientific popularizer provide a link to his political beliefs. Opposed to the Bourbon restoration, Arago entered into active political life only after the July Revolution of 1830. Initially a supporter of the new king, Louis-Philippe, he was elected to the Chambre des Députés from his hometown, Perpignan, in 1830. Like his friend, the banker Jacques Laffitte, Arago rapidly became disillusioned with the king's policies and by 1832 headed the Republican opposition along with Laffitte and Odilon Barrot.[8] Although there was no formal party system in France at this time and factions existed within the "Republicans," this term generally referred to men who saw the kingship of Louis-Philippe as a provisional appointment by the representative legislature and who envisioned a continual progression toward the fulfillment of the ideals of the 1789 Republic. Among their goals were universal manhood suffrage, freedom of the press, freedom of assembly, and support for other revolutionary movements in Poland, Belgium, and Italy.

One goal to be met before the transition to a free, representative, and egalitarian state was the education of the masses. Arago helped found several new societies ostensibly devoted to public instruction but also serving as rallying points for the opposition. He was the vice-president of the Association pour l'instruction gratuite du peuple (founded in 1832 and

reconstituted on January 18, 1833), which later became the Société pour l'éducation libre du peuple.[9] A believer, with Bacon, that "knowledge was power," Arago tried early in the 1830s to give a new public course on astronomy, meteorology, and basic physical phenomena similar to those offered by the Société. Even after Lafayette interceded on his behalf, Guizot, the Minister of Public Instruction, refused to allow the course because, as Arago claimed in a rather acrimonious exchange in the Chambre in 1834, "M. Lafayette and I adhere to a political opinion that is not in sympathy with the direction of the present government."[10] The state correctly perceived that scientific education was politically charged; the entire Académie des Sciences was in fact looked upon with some suspicion since many of its members were outspoken Republicans.[11]

Although Arago was clearly committed to Republican ideas,[12] he was by no means in favor of the violent overthrow of the government (as was Auguste Blanqui) or the abolition of private property. According to his friend and political ally, Louis Blanc, he was a man more impetuous than persevering who sacrificed more for a momentary passion than a long-term goal.[13] However, like many Republicans, he was strongly influenced by the writings of Saint-Simon and argued repeatedly for state intervention in industrial policy. The laissez-faire doctrine of the English classical economists led to unacceptable levels of unemployment and competition. In Arago's opinion, the state, under the leadership of industrialists, artists, and scholars like himself, should intervene to ease the transition from hand to machine production and should encourage all forms of progress, which ultimately led to improved living conditions for all classes.

Arago's most coherent statement on the importance of industrialization for the betterment of humanity can be found in a eulogy of the English inventor of the steam engine, James Watt. First read to the Académie on December 8, 1834, the speech contained a short section entitled "Des machines considérées dans leurs rapports avec le bien-être des classes ouvrières," which was added in response to comments made on the original discourse. Arago began by citing the familiar argument that "these marvelous mechanical combinations, whose regularity and harmony of movement and powerful and delicate actions we habitually admire, are only instruments of injury." Opponents of machines wanted to destroy them to give employment to the worker. But, he countered, machines were merely another kind of tool, and who would want to deny the value of the plow or the spade? Machines in fact led to cheaper production, increased demand for goods, and greater value of total production. The number of workers increased, he argued, as in the case of the invention of the printing press in which the number of employees rose from a few hundred to several thousand. Arago also cited the recent development of

steel engraving, which allowed 100,000 prints to be pulled from a plate rather than the 2,000 possible from copper plates. The lower cost per print resulted in more purchasers.

Turning to the British situation, Arago claimed that machines should not be blamed for the imposition of the unpopular Poor Tax (in 1834), and that cheaper goods and the resulting increase in standard of living would not result in a destructive population increase (as Malthus had predicted). Although temporary unemployment might occur after the introduction of machinery, this only meant that the state should impose restrictions on child labor and forbid the exploitation of workers driven to accept lower wages. In any event, Arago encouraged the people not to turn against machines.[14]

The reasons why Arago fashioned this elaborate defense of machinery in 1834 are not difficult to uncover. In a footnote to the text reprinted in his *Oeuvres complètes*, he stated that

> in writing this chapter, it seems that I can use without scruple many documents that I have gathered, either from several interviews with my dear friend Lord Brougham or in the works that he published or were published under his aegis. If I can answer the criticisms that several persons have printed since the reading of this biography, by trying to combat the opinion that machines are harmful to the working class, I will have attacked an old, groundless prejudice, a veritable phantom. . . . Unfortunately, the letters that courageous workers frequently send me in my capacity as academician or deputy, unfortunately, the recent dissertations *ex professo* of various economists, leave me no doubt as to the need to speak still today.[15]

Arago's concern in 1834 was that France was threatening to follow the path that England had already taken, both in terms of social policy and worker responses. Although French industrialization lagged behind English manufacturers, the country had already had a taste of Luddism in the wake of the 1830 revolution. Demonstrations had broken out in Paris and several manufacturing centers in which workers demanded higher wages and machines were vandalized. In 1831, the Lyons silkworkers rebelled, and 1834 saw extensive strikes and calls for trade union formation in Paris and Lyons.[16]

In January 1839, Arago's defense of machinery was reprinted in the first issue of the *Revue du progrès*, a magazine that Louis Blanc and he had founded.[17] Again, the timing was appropriate, because worker discontent was high and the economy was stagnant. Although there was not a marked depression, as in 1837, newspapers of various political persuasions reported on the high number of bankruptcies and unemployed in 1839. *Le*

National, the Republican paper published with Arago's backing, on April 5 announced that it was opening a subscription for the unemployed, and on April 9 noted the aggravation of the "crise commercial" with uneasiness everywhere. On June 15 the paper announced that "the most frightful misery exists at this time among the lithographic printing workers. It has been estimated that more than 1,200 are out of work." As late as November 28, the *Gazette de France* bemoaned "a commercial and industrial depression, work stoppages in production, a speculative tightening of capital, profound misery in the lower classes, discontent." Given these conditions, Arago may have felt that the leaders of militant socialist movements such as Constantin Pecqueur or the followers of the economist, Sismondi, needed reassurances that machines were not the cause of the impoverishment of the populace.[18]

Arago's reference to Henry Brougham as the source for many of his ideas is a telling one. Brougham, a prominent Whig politician, social reformer, utilitarian, amateur scientist, and Francophile who spent part of every year in Cannes, shared many beliefs with Arago. In 1826 he had been a founder of the Society for the Diffusion of Useful Knowledge, which published working-class reading material and was devoted to diluting violent dissent through the promotion of "useful knowledge." Brougham in 1831 published *The Working Man's Companion—The Results of Machinery, Namely, Cheap Production and Increased Employment, Exhibited*, which was the source for Arago's piece. Using the history of printing as an example of the way that machinery enhanced production, Brougham also referred to steel engraving, which he said could produce 20,000 prints (Arago claimed 100,000). Brougham, explicitly addressing the working man,[19] cited the continuity between traditional tools and machines and identified all advances in civilization with commercial activity. Although new machines might result in temporary unemployment, cheaper goods would yield increased consumption and comfort: "You will learn now, that it is useless in any way to struggle against that progress of society, whose tendencies are to make all of us more comfortable, more instructed, more virtuous and, therefore, more happy."[20]

The ultimate inspiration for both Arago and Brougham was, in fact, the work of French economist, J. B. Say. Arago owned Say's *Traité d'économie politique* (1803),[21] which defended machinery. Citing the familiar example of the printing press, Say made a point that Arago overlooked: machinery did not just replace human labor, but resulted in totally new and more perfect products: "Painters could undoubtedly execute with the brush or pencil the designs that ornament our printed calicoes and furniture papers; but the copperplates and rollers employed for that purpose give a regularity of pattern, and uniformity of colour, which the most skillful artist could

never equal."[22] To alleviate the hardships initially resulting from the introduction of machines, Say recommended that the public administration engage in public works programs to employ idled workers and also encourage colonization.[23]

Arago's commitment to industrial progress, which serves as a background against which his promotion of Daguerre must be understood, was also part of the Republican program during the 1830s.[24] Echoes of Arago's article can be found in the magazine that preceded the *Revue du progrès*, the *Revue républicaine*. Featuring many of the same writers,[25] this journal was staunchly in favor of state control of the application of machinery and the distribution of wealth. The author of an 1835 article, "Des machines et de leurs influences sur la production et les salaires," posited that machines resulted in greater profits that should be passed on to the workers. Present-day misery resulted from the reduction of salaries and the imposition of poor laws, which only benefited landowners. The remedy was the regulation of new prices so that they would only slowly decline.[26]

When the diorama artist and entrepreneur Daguerre approached Arago with his new invention in late 1838, the scientist was therefore predisposed to be enthusiastic about an image generated by a machine with less cost and labor. Daguerre's motivation for turning to members of the Académie, including J. B. Biot, J. B. Dumas, and Alexander von Humboldt, as well as the artists Paul Delaroche, Henri Grevedon, and Louvre curator Alphonse de Cailleux, was understandable.[27] In 1838 Daguerre had tried unsuccessfully first to sell his and Niépce's invention for 200,000 francs, and then to find subscribers willing to pay 1,000 francs each for a share of the process.[28] Despite the publication of broadsides, no takers were found, so Daguerre began his personal solicitations.

Daguerre's decision to approach members of the Académie des Sciences regarding an invention which had commercial potential but no clearly understood theory of action was undoubtedly inspired by that body's growing involvement with commercial activities and with applied rather than pure science. Arago and other members were often called upon to perform studies ranging from the causes of explosions in steam engines to the best way to extract sugar from beets. The chemist Gay-Lussac even directed the workshops of the Saint-Gobain glassworks at Chauny. The practice of a manufacturer or inventor soliciting endorsements from an academician must have been relatively commonplace, for it was parodied by Balzac in his novel tracing the tragic downfall of César Birotteau (published in 1838). Birotteau, an honest and overly ambitious perfumer, had made his fortune by seeking the assistance of M. Vauquelin, a chemist and illustrious member of the Académie des Sciences who helped him develop a cosmetic lotion. As the novel unfolds, Birotteau seeks out Vauquelin a

second time to get advice on a new hair oil. In a comic confrontation between the cunning bourgeois and the great scientist who spouts endless jargon about hair follicles, Birotteau asks for an endorsement: "'Do you think that the royal Academy of Sciences would approve of—' 'Oh! there is no discovery in all that,' said Vauquelin. 'Besides, charlatans have so abused the name of the Academy that it would not help you much. My conscience will not allow me to think the oil of nuts a prodigy.'"[29] Although it could be argued that Daguerre's invention *was* something of a prodigy, his social position must have been comparable to Birotteau's.

The series of steps that Arago took in 1839 reveal him as a masterful tactician who managed to adapt a preconceived plan to changing circumstances. His timing must be understood in relation to the chaotic political events of that year. That he decided to go forward at all with Daguerre's invention must have been inspired by the formation in late 1838 of a new opposition alliance among the Republicans (whom he led), the Legitimists, and various other groups ranging from Odilon Barrot on the left (the so-called dynastic left), Adolphe Thiers (center left), and Guizot (the "doctrinaires").[30] The goal of this group, known as the Coalition, was to undermine the power of the extant government led by Molé, who was a peer with little support in the Chambre des Députés and served as the king's mouthpiece. Despite major ideological differences and, more importantly, personality conflicts within the Coalition, these opposing factions had come together with the express aim of limiting the royal prerogative. On the day that Arago read his announcement of Daguerre's process to the Académie, Coalition deputies in the Chambre launched their first attack in the form of the traditional response to the king's speech that opens each session. Although Arago never spoke (representing the left fringe of the opposition and leaving the arguments to more centrist figures like Guizot and Thiers), he was undoubtedly encouraged by the attacks leveled against the king and the government: that it had a weak foreign policy, was too keen to preserve peace at all costs, and had allowed the alliance with England to weaken. After twelve days of debate, Molé maintained a slim majority of 221 to 208 votes and resigned. The king dissolved the Chambre on January 31, and new elections were scheduled for March.

In the absence of Chambre sessions, Arago divided his time between Académie meetings and electioneering. He could not continue soliciting governmental support for Daguerre because, in effect, there was no government. There was, however, an ideal opportunity to elect more Republicans in the coming elections. On February 26, Arago delivered a stirring address to the electoral meeting of the Parisian 12th arrondissement (the district around the Pantheon and one of the most radical areas in the city). Denying that he was a member of the Coalition and asserting that he

wasn't friends with Thiers or Guizot, he nonetheless defended their stances on foreign policy: "I repulse war but I don't want peace at any price . . . not long ago the English people were sincere allies of France; now their sympathies are weakening with a deplorable rapidity."[31] In late March, Arago accompanied Jacques Laffitte on an electoral mission to Rouen to muster further support for the Republican cause.

The March elections represented yet another defeat for the king and Molé's supporters, who lost their slim majority. Arago was overwhelmingly reelected in Perpignan. The Maréchal de Castellane (a Napoleonic officer of conservative political opinions who lived in Peripignan) observed in his journal that the elections were the occasion of some trouble: "M. Arago was elected in Perpignan; outside the electoral college, some people cried out on the place de la Liberté, 'Vive Arago!' . . . In the evening, forty rascals following two men carrying torches cried, 'Vive Arago!' In a street of the Fbg. St.-Mathieu, to which in 1830 was given the name, rue Arago, there were illuminations—a lithograph of Arago crowned with laurel flanked on his right by the bust of the Emperor Napoleon and on his left by the Duc de Reichstadt (Napoleon's son who died in 1832) was paraded. If the Emperor could have returned, he would be astonished to see himself on sentry with his son to honor M. Arago."[32]

Despite the defeat of the Molé forces, the Coalition was unable to seize effective control of the government, and Louis-Philippe failed to form a cabinet in April and May. On April 1, the press reported the nomination of a new ministry. The situation was chaotic, however, since Thiers agreed to head the government under conditions that were unacceptable to Guizot and the king.[33] It was only the outbreak of a violent uprising in Paris on May 12, led by Blanqui and Barbès, that forced the formation of an emergency government under the leadership of Soult. This government represented the victory of the king over the Coalition, but it was attacked by the press and had no clear support or platform.[34]

During the unstable summer of 1839, Arago made his move to get a law passed granting Daguerre a lifetime annual pension of 6,000 francs and Isidore Niépce 4,000 francs for the contribution of his father. Helmut Gernsheim has described this law as "the like of which not only France but no other country had ever passed before."[35] This overstates the case, but the award of a pension to an inventor was unusual. Pensions were regularly given to retiring government employees and military personnel, and special awards were occasionally made to former generals and their families or victims of political unrest. As a result of the expansion of the military during the Napoleonic era and the generosity with which the Restoration had rewarded faithful servants, July Monarchy representatives immediately tackled what was perceived as an unacceptable drain on the budget. A law of September 11, 1807, had allowed the government to give

up to 20,000-franc annual pensions to "grands fonctionnaires" of the state, their widows and children. This law was not absolute because certain conditions had to exist for a pension to be awarded: the services of the individual had to be truly distinguished and the recipient had to need the money.[36] By 1816, over 24 million francs per year were being paid out in pensions. A year later pensions accounted for one-sixth of total revenues. By 1832, this amount had risen to more than 85 million francs. Between September 1830 and February 1832, the Chambre hotly debated a proposal to amend the pension law and curb this "plague on the state."[37]

There were also special pensions occasionally voted to persons who were not civil servants or military personnel. For example, the Chambre awarded the Comtesse de Lipona (Caroline Murat) a life pension shortly before her death in 1839. The idea of giving a pension to an inventor was quite unusual, however. Celebrated men of science who had held prominent positions in state-funded institutions, such as the botanist Jussieu (whose widow received 6,000 francs per year) and the naturalist Cuvier (whose widow also got 6,000 francs), had been given honorific awards. But only two inventors between 1830 and 1839 were voted special awards. A mechanic named Emile Grimpé developed a way to machine-produce rifle barrels that promised to lower greatly their cost. After hearing the argument that this invention alone would save the state 54,780 francs per year and listening to Arago's defense of Grimpé, the Chambre voted to purchase the invention for 130,000 francs on April 21, 1836.[38] The second case was Edmé David, who in 1810 had invented a new kind of die mark that foiled the counterfeiting of gold and silver coins. David offered to sell this technique to the state for 50,000 francs, but the ministry countered in 1817 with 16,200 francs and a job in the Paris standards office that paid 2,400 francs per year. David accepted this post, which he held until illness forced his retirement in September 1835. At this point, the state offered him 3,000 francs and the management of a tobacco shop, which he refused. A law proposed and adopted on April 18, 1837, agreed to award him a lifetime pension of 2,400 francs which, it was argued, was not a retirement pension for a state employee but a compensation for his invention, which brought in 200,000 francs annually.[39]

Both of these cases were distinctly different from what Arago was proposing for Daguerre and Niépce. Daguerre's process yielded an interesting and more exact image, but the possibility of the state receiving direct financial benefits from it was nil. The issue of commercial profit had been the obvious motivation behind the Grimpé and David awards. Arago therefore would have to construct other grounds for the commitment of 10,000 francs per year to photography. This he carefully did during the first half of 1839.

What Arago in fact proposed was an award for national service to a man

he constructed as a disinterested scientist nobly sacrificing his money and time for a higher cause. The idea that the state, rather than the free market, should encourage invention was part of the Republican program and was inspired by the writings of Saint-Simonians and English utilitarians. Jeremy Bentham, generally suspicious of state invention, acknowledged that "there are cases in which, for the benefit of the public at large, it may be in the power of government to cause this or that portion of knowledge to be produced and diffused."[40] The state, he held, should encourage the study of useful sciences, give prizes for discoveries, publish processes used in industry, and protect inventors against plagiarism. Say was even more insistent that the government should provide support to men of science who work long hours with little reward: "it is from a sense of this injustice, that every nation, sufficiently enlightened to conceive the immense benefits of scientific pursuits, has endeavored, by special favors and flattering distinctions to indemnify the man of science, for the very trifling profit derivable from his professional occupations and from the exertion of his natural or acquired faculties."[41] Biot, the scientist who seconded Arago in his promotion of Daguerre, had reached similar conclusions in 1836, although his appeal to the state was pragmatic rather than idealistic: ". . . experience has shown, when those who govern know how to read it, that now science is a cause of production, a source of wealth, an instrument of power. Skillful and well-directed monarchs develop from it the most noble applications in their own interest."[42]

By the time of Arago's first press release prior to January 7, he had clearly decided that a pension for Daguerre, despite its unusual nature, would be consistent with his concepts of appropriate government action and could possibly be approved in the unstable political climate that prevailed. The other major possibility—taking out a patent—was ideologically rather than practically unacceptable. The line that Arago fed to the press was that a patent was unfeasible because the process was too simple.[43] As many early photographers discovered, however, the process was anything but simple. Prosper Merimée complained in 1841: "I am almost completely discouraged with the daguerreotype, because yesterday someone showed me views of Damascus and Saint-Jean d'Acre that are so ugly they look like children's toys ("Pantins"). Furthermore, I've been told that you need a month of practice to learn to succeed with the instrument."[44] The process was simple, perhaps, in comparison with drawing, but it was certainly more complicated than the procedures covered by most patents.

Patenting an invention was objectionable to many Republicans because it resulted in benefits for a small number of individuals rather than the general good and bred unfair competition.[45] Arago's friend, Louis Blanc,[46] defined the patent laws as contributing to the problematic condition of the

workers in his influential *Organisation du travail* (1840). Deploring the dog-eat-dog environment of unleashed capitalism in which big factories drove small ones out of business, Blanc called for an end to monopolies and the formation of workers' cooperatives. Patents were just another guarantor of monopoly: "In a system of association and solidarity, there will be no more patents. The inventor will be recompensed by the state, and his discovery immediately put to the service of all."[47] Similarly, the Saint-Simonian Michel Chevalier saw patents as limits on freedom and called for their abolition.[48] Arago himself in 1835 expressed misgivings about patents, because in most cases the inventions were worthless, and guileless inventors lost all the money paid in patent fees.[49]

The response of the Legitimist paper, the *Gazette de France*, to Arago's pension proposal is telling, because it confirms that the entire process was politically charged. An anonymous writer argued that a national recompense was inappropriate and cynically painted a picture of a self-interested and corrupt government:

> National awards can only be discerned by the monarchial principle representing the nation, or by an assembly of national origin. Would our chambers be able to make this gift to France and Europe? That's at least doubtful. There is nothing there of politics, nothing that can add one voice to a minister. The countess of Lipona had 100,000 francs from the French treasury, through considerations that are here without influence. M. Daguerre is an artist outside of party battles. His works are neither of the ministerial coalition or the parliamentary coalition. People say that M. Arago will speak for the daguerreotype; that will perhaps be enough for the juste-milieu to vote against it. It's a pity, nonetheless, that light, optics and drawing have to contend with the minutes, the third party, and the *doctrinaires*. . . . If at least one could fix a system and a ministry like M. Daguerre fixed images! But all is fugitive and ungraspable in the *chambre obscure* of the Palais Bourbon.

The article then proposed a subscription as the best solution.[50]

Undaunted, Arago constructed the argument in favor of a photographic pension that he planned to present to the Chambre. First, Daguerre had to be established as a man of genius who had made substantial contributions to the French state over a long period of time. Since he had founded the diorama in 1822, Daguerre had been known to the public as a master of trompe-l'oeil, a skilled artist who amused the populace with his clever lighting effects and visual recreations of Alpine thunderstorms and mysterious chapels. In 1824, the new Bourbon king, Charles X, awarded him the Légion d'honneur ostensibly for a mediocre painting of Holyrood Chapel exhibited in the salon of that year, but probably in response to a diorama

painting glorifying the efforts of the Duc d'Angoulême (Charles's son) to reinstate the despotic Ferdinand VII to the Spanish throne.[51] Although this political subject would have gained him no credit in the eyes of the Orléanist government, Daguerre was at least established in the popular imagination by 1839 as an important "artiste" and had successfully used puffs in the press to spread this opinion.

Daguerre's standing as a serious artist was, however, rather low. He rarely exhibited in the salon and was not on the same level as members of the Académie des Beaux-Arts, who extolled history and religious painting above Daguerre's crass, popular illusionism. Therefore, the references to "ce grand artiste" that fill press reports in 1839 seem to be pointed efforts to shape public opinion rather than reflections of the views of the high art establishment.[52] For example, when Daguerre's show burned on March 8, 1839 (conveniently establishing his need for a pension and ridding him of an increasingly unprofitable business), various papers lamented: "the loss of paintings will be strongly felt by all artists, all men of taste, and by the public. The work of M. Daguerre was not the isolated speculation of an artist among his fellow citizens, but a monument that Paris could boast of and the French arts were proud of having founded."[53]

Gaining the support of the scientific establishment was accomplished by repeated references to Daguerre's years of experimentation and the new medium's contributions to natural science and spectroscopy. Arago had to be somewhat cautious, because certain quarters were critical of the Académie's involvement with technological development rather than disinterested research. In fact, after Daguerre's pension was approved, the science writers of *Le National* criticized the Académie as a moribund institution: "The Académie sleeps; all the good scientific activities, which ought to have long continued the glory of this illustrious assembly, have been prematurely extinguished, on the one hand in professorial functions that were not intended for them, and on the other in political functions for which they were never intended, and for the majority in the leisure of an anticipated old age." The Académie's time was spent in "insignificant reports, sterile lectures, vain debates over priority."[54] Anticipating the charge that the Academy should concentrate on scientific breakthroughs, Arago first announced Daguerre's process as useful in the photometric analysis of moonlight.[55] Subsequent reports to the Académie on Daguerre's 1826 and 1834 experiments on phosphorescence suggested that he performed controlled experiments with no explicit commercial uses in mind.[56]

Biot addressed the scientific community directly in two articles published in March and April in the *Journal des Savants*. The first, entitled "Sur les effets chimiques des radiations, et sur l'emploi qu'en a fait M. Daguerre, pour obtenir des images persistantes dans la chambre noir," starts with a

description of Daguerre's marvelous drawings and a telling defense of troubling the magazine's readers with such creations: "No matter how remarkable these productions were, if the perfection of drawing was their only merit, perhaps we would not have dreamed to talk about them to the readers of the *Journal des Savants*, or at least it wouldn't be the author of this article who should describe them. But the process by which they were obtained, even though it's still secret in its details, is essentially founded on a chemical effect of which we have already several examples." Biot noted that the invention "was not the chance result of happy accident," but that Daguerre had spent fourteen years studying "the different sensibilities of impressionable substances, their predilections for this or that element of total radiation, the modifications brought to their sensibility by chemical agents." He concluded: "We have no hesitation that the publication of these processes will not fail to enrich chemistry and molecular physics with a host of results as fecund as unexpected."[57]

The award of a state pension naturally implied that the recipient had honored his country. In Daguerre's case, his real political allegiances were unknown, but Arago could argue that the diorama had already attracted the praise of foreign potentates and that the new process was attracting international offers.[58] The issue of nationalism became all the more important when Talbot suddenly emerged with a rival process in letters written to Biot and Arago on January 29.[59] Arago and Daguerre had, of course, not counted on an English challenge to the invention, but Talbot's businesslike missive and standing as an English gentleman and amateur scientist required a response. Arago immediately traced, for the first time, the history of the Daguerre/Niépce partnership back to 1829 and claimed Niépce had begun working in 1814.[60] He also boasted at the Académie meeting on February 4 that Daguerre had already shown his process to everyone: "French, English, Germans, Italians, Russians daily find themselves reunited in his office."[61]

That Talbot was English made it all the easier to define Daguerre's breakthrough in terms of French nationalism. The English had looked with some nervousness at the 1830 coup, but the pacific promises of Louis-Philippe reassured them enough to recognize the new government on August 31, 1830. During the early 1830s, a cordial *entente* with England had been maintained, but there were growing tensions in 1838–39 as a result of both foreign and trade policies.[62] Despite attempts by the Duc de Broglie to discourage protective tariffs between the two countries, negotiations again failed in 1839. The French responded by accusing the British of wanting to strangle already inferior French industrial production: "the commerce of a people and its politics are not, in effect, two things that can willfully be separated. Of two industrial nations, the stronger on sea and land tries

always to excel its rival in production on the world's markets. England, it is banal to repeat as much as it is uncontestable, is the most egotistical and greedy nation of the world. . . . One looks in vain in its acts for a thought of civilization, of human fraternity; it only thinks and acts in view of its commercial and industrial interests."[63]

More inflammatory, however, was the Middle Eastern crisis that erupted in the summer of 1839. In 1832 Mahomet Ali, the Egyptian pasha and a French ally, had invaded Syria and threatened Constantinople; a treaty in 1833 temporarily settled the conflict, but established Russia as an ally of the Ottoman sultan against future invasions. In June 1839, the sultan provoked a crisis, resulting in the Turks' defeat in Syria by the armies of Mahomet Ali's son. France, afraid that Russia would intervene, called a congress of the European powers in late June. England, under Palmerston, wanted to protect its Middle Eastern commercial interests (including access to India) and also wanted the Egyptians out of Syria. After being approached by Russia (which wanted to break up the Franco-British alliance), the British proposed that Mahomet Ali be allowed to keep only southern Syria, which France refused. By the end of 1839, relations between the two countries were tense, and the crisis dragged on until 1841.

It would be an error to attribute the promotion of the daguerreotype as a French idea to Arago's personal, aggressive nationalism. Arago had to contest Talbot's challenge: he did this first by emphasizing Daguerre's long service to France and then by touting the laudatory comments of an English committee which visited Paris in May.[64] As relations with England deteriorated during the summer, popular Anglophobia crept into the debate, prompting Minister Duchâtel in his proposal of the pension law on June 15 to open his address: "We hope that you will concur in a sentiment which has already awakened universal sympathy, and that you will never suffer us to leave to foreign nations the glory of endowing the world of science and of art with one of the most wonderful discoveries that honor our native land."[65]

Nonetheless, Arago, as a Republican who opposed the wishy-washy policies of Louis-Philippe, may have felt a particular aversion to England. In the absence of explicit statements by him on this subject, we can again turn to Louis Blanc, who lambasted England in *Organisation du travail*. England was a prime example of unbridled free competition and madly produced for foreign markets: "No one can ignore the evil that its avidity has done to France." As a result of its economic system, England had an unacceptable concentration of wealth in which aristocrats controlled industry. The move to gain Syria was in fact based on Palmerston's attempt to open up the Middle East to British markets. In short, economic competition would lead to "a war to the death between France and England."[66] Arago in large part probably shared these sentiments.

The last group that Arago had to appease to effect a groundswell of support for photography was artists, who might worry that the medium would replace them. In all the early reports on photography, no one, to my knowledge, asserted that photography itself *was* an art; the celebrated cry, "From today painting is dead!," could not have been made by Delaroche or anyone else.[67] The dominant esthetic remained that of Victor Cousin and his followers, which placed man's creativity above nature: "Nature has only made things, that is, beings without value; man in giving them the form of his own personality, has elevated them into images of liberty and intelligence." The beauty of art was therefore superior to natural beauty, and the center of genius lay in individual imagination and not mimetic skill.[68]

Arago repeatedly assured artists that their skills (unlike those of, say, handloom weavers) would not be threatened by the new mechanical images. On January 7, he predicted that "you will see how much your pencils and brushes are far from the truth of the Daguerreotype. But let not the draftsman and the painter despair; the results of M. Daguerre are something other than their work and in many cases cannot replace it."[69] According to an anonymous evaluator of the impact of photography on the fine arts, there would always be room "for genius, invention, skill, talent. The Daguerreotype will not make history paintings, battles, grand scenes; it has no palette and brush, no movement, no relief. . . . Birds won't pluck the grapes of the Daguerreotype like those of Apelles."[70] On the contrary, the medium could only improve art by providing studies for artists. According to Arago's January 7 speech, Paul Delaroche thought that "such designs could give, even to the most able painters, useful lessons on the ways that one could, by means of light and shadow, express not only the relief of bodies but the local color. The same bas-relief in marble and plaster would be represented differently in two plates, so that one could recognize at first glance which was the image of plaster."[71] Continuing the argument that he had introduced in his Watt eulogy, Arago dismissed the idea that the process could create hardships "any more than there was for engravers when steel plates replaced copper. All that happened was that there were engravings in a flood of works where there hadn't been before."

Previous events during the July Monarchy made artists and critics particularly wary of anything that smacked of industrial production and the degradation of their skills. Saint-Simonians had already lamented that art in contemporary society was being reduced to "manoeuvre" (or unskilled labor) rather than given its appropriate high rank.[72] On the other side of the political spectrum, a Legitimist review of the 1839 Salon complained that "contemporary society wants fast and especially economic pleasures. . . . Art, for its part, has wanted to popularize itself and, like literature, the theater, typography and industry, it has looked for expedient

and easy processes."[73] Considering the precariousness of artists' positions—faced with declining patronage for grand history painting and an onslaught of industrial processes for reproducing sculpture and paintings—it is not surprising that Arago chose to address their concerns.[74]

Arago's soft-pedaling of any possible negative impact of photography on artists sprang from a heartfelt belief in the infallibility of progress and the need for Republicans to reconcile artists to the coming egalitarian state. During the 1830s, the Republican press was full of admonitions to artists to address the masses with their art and preach progress and social harmony.[75] Arago's brother, Etienne, in 1834 published a manifesto entitled "La République et les artistes," which lambasted art for art's sake and proclaimed that all great art was born in Republican eras and expressed social ideas. In his opinion, an example of an ideal artist was Senefelder. Despite living under a monarchy, this poor Bavarian musician, "who lacked money to have his music engraved, invented lithography, opened, without a doubt, a large path to the art of drawing, and facilitated the infinite reproduction of works of our painters."[76] New techniques, like lithography and presumably photography, familiarized a broader public with art and nature, improved their taste and education, and reduced the uncomfortable labor associated with handwork.

Despite the press campaign to sell the daguerreotype to various segments of the public, there were a few skeptics. One was Charles Blanc, Louis's twenty-six-year-old brother who had studied engraving with Luigi Calamatta. In a Feburary 1839 review of engraving, Blanc introduced an argument that he was going to repeat for the next forty years: "What will prevent M. Daguerre from making of this mirror an engraving? Oh! if chemistry invades us, I fear that all the mysteries will disappear and poetry with them. Pray to God that art isn't confounded one day with science. . . . What there is at the base of modern invention is always the great word: everyone. This word, is it anything else than democracy? While waiting for this noble future, let's thank and encourage engravers."[77] Blanc saw no reason to bankrupt men already committed to popularizing art in order to promote science, and he in this case came out against the agenda of the magazine's directors.[78]

Other reservations about the claims made for photography surfaced on the pages of *La Presse*, Emile de Girardin's successful, mass-circulation paper founded in 1836. In January 1839, a columnist intimated that photography might threaten artists in the representation of human figures, even though the process could not yet yield portraits.[79] After the revelation of the details of the technique on August 19, Jules Pelletan, the paper's science reporter, expressed disappointment that the process was so expensive and complicated and predicted that Daguerre would be the only

practitioner. The medium's impracticality could prove a blessing, however, because "art reduced to a simple tracing of nature would have lost the charm and prestige of its most charming caprices, whereas the Daguerreotype, having only a costly, difficult and exacting application, will stay in the studio and physics cabinet like a precious instrument of study."[80] In this case, the paper's known hostility to the group associated with *Le National*, sympathy for the Molé camp, and de Girardin's private investment in a physionotrace machine in June 1838 may have influenced Pelletan's report.[81]

The overwhelming response to the daguerreotype, however, was positive. After a new government was formed in May, events proceeded without a hitch. On June 14, the Minister of the Interior Duchâtel signed an agreement with Daguerre and Niépce setting forth the terms of the pension. The following day, the proposed law was read to the Chambre des Députés amid cries of "très bien, très bien." The press noted that Daguerre had been named an officer of the Légion d'honneur on June 17, and on June 18 a commission headed by Arago was set up in the Chambre des Députés to evaluate the invention.

With remarkable alacrity, Arago deposited his report in the Chambre on Wednesday, July 3, but did not read it. Duchâtel, in his capacity as president of the Chambre, stated that it would be printed and distributed and asked that a discussion be held the following Saturday. On Saturday, there was no talk of the pension, but several plates, including "a head of Jupiter Olympian, a view of the Tuileries, a view of Notre-Dame, and several views of an interior," were displayed in a room adjacent to the meeting hall.[82] The vote in the Chambre des Députés was taken on July 9, after no discussion, and the law was passed, 237 to 3. On July 17, a similar procedure was initiated in the Chambre des Pairs, with Gay-Lussac heading the evaluating commission. The final, perfunctory vote confirming the deputies' decision took place on July 30.[83]

Arago's triumph, culminating in his final revelation of Daguerre's secret at the Académie on August 19,[84] was as much a victory for Republican values as a technological breakthrough. Taking advantage of a divided legislature and Franco-British tensions, he was able to advance the diorama artist as a national hero. Appeasing both artists and scientists, he created a groundswell of popular interest and posited widespread applications by all segments of society. And, finally, Arago fulfilled the Republican goal of substituting state awards for monopolistic patents that only encourage competition.

More broadly, Arago's vigorous promotion of Daguerre was consistent with his belief that industrial progress was the route to an ideal, democratic state. As Pierre Leroux, a former Saint-Simonian and father of democratic

socialism, proclaimed, the goal was "to converge more and more science, art and politics toward the same goal; to introduce more and more in science, as in art, as in politics, the notion of change, of progress, of succession, of continuity, of life."[85] The daguerreotype, which promised further to mechanize image-making, lower its cost, and make exact information available to a wider public, represented one step in such a progression to the just, egalitarian society that Arago desired.

Notes

1. All French translations are by the author unless otherwise noted.

2. Henri Gaucheraud, "Beaux-Arts—Nouvelle Découverte," *La Gazette de France* (January 6, 1839): 1.

3. Gaucheraud failed to mention the silver coating on the copper plate and the sensitization and development stages. A comparison with other newspaper stories that appeared only after the Académie meeting reveals that Arago's lecture was circulated in advance to the papers. For example, *Le National*, in its January 9 coverage of the Académie des Sciences meeting, stated that "*M. Arago annonce que M. Daguerre, peintre du Diorama, vient de faire une découverte qui déconcerte les théories de la science, et qui est appelé à faire révolution dans les arts du dessin.*" The images produced are described by both papers as possessing "*toutes ses nuances de jours, d'ombres et demi-teintes.*"

4. Other studies that attempt to define the social climate in which inventions or theories are born include Thomas S. Kuhn, *The Copernican Revolution* (New York, 1959); Morris Berman, *Social Change and Scientific Organization—The Royal Institution, 1799–1844* (London, 1978); and Stephen Shapin and Simon Schaeffer, *Leviathan and the Air-Pump—Hobbes, Boyle, and the Experimental Life* (Princeton, 1985).

5. The most recent biographies of Arago, barely more than expanded dictionary entries, are Horace Chauvet, *François Arago et son temps* (Perpignan, 1954) and René Audubert, *Arago et son temps* (Paris, 1953). Arago's autobiography, *Histoire de ma jeunesse* (Paris, 1854), deals with his early adventures in Spain and North Africa and stops shortly after his return to Paris and election to the Académie des Sciences in 1809. Arago's writings were published posthumously as the thirteen-volume *Oeuvres complètes de François Arago* (1854–62), but there is no published collection of his correspondence.

6. Audubert, *Arago et son temps*, 15.

7. Conservatoire des Arts et Métiers, Paris, *Histoire et prestige de l'Académie des Sciences, 1666–1966* (Paris, 1966), 181.

8. Laffitte was in part responsible for advancing the Duc d'Orléans to fill the political vacuum left by the overthrow of Charles X and headed the new government from November 2, 1830, to March 12, 1831. For more information on Laffitte and the formation of the opposition, see André Jardin and André-Jean Tudesq, *Restoration and Reaction, 1815–1848* (Cambridge, 1983), 104–7; Jacques Laffitte, *Mémoires*

1767–1844) (Paris, 1934); and Charles Marchal, *Souvenirs de J. Laffitte raconté par lui-même* (Paris, 1846), 3 vols.

9. Gabriel Perreux, *Au temps des sociétés secrètes* (Paris, 1934), 54. This group by 1833 had an estimated 3,000 members, including 60 deputies. Arago's brother, Etienne, in June 1832 helped to found the Association pour la liberté de la presse, which also advanced Republican ideas.

10. J. Mavidal and E. Laurent, *Archives parlementaires de 1787 à 1860* (Paris, 1911), 2e série, v. 87, 711. In the Chambre des Députés session of March 21, 1834, Arago participated in a discussion of a change in the law governing the right to assemble that threatened the formation of scientific associations. He claimed that his public lectures drew 2,000 people and that he had asked for the construction of a larger amphitheatre. When Lafayette approached Guizot on Arago's behalf, the minister said, "I don't want agents of your opinion making friends in the working class." (Guizot denies this during the debate.)

11. In addition to Arago, the mathematician, physicist, and astronomer Biot (1774–1862) had been an avid Republican during the Bonapartist period and continued to harbor similar, albeit less demonstrative, beliefs under Louis-Philippe. The physiologist Flourens, perpetual secretary for the physics section of the Académie and elected in 1838 as a deputy, has also been described as a Republican. See Jardin and Tudesq, *Restoration and Reaction*, 184.

12. Arago was apparently even involved with one of the most radical secret societies, the Société des droits de l'homme, which was founded in 1832–33. This group, inspired by Jacobin and socialist ideas as well as the writings of Henri de Saint-Simon, had a large following in the Pyrénées-Orientales and over 300 members in Arago's home, Perpignan. Jardin and Tudesq, *Restoration and Reaction*, 248.

13. In a physiognomic portrait, Blanc described Arago: "His imposing stature, his sparkling eyes under large, mobile eyebrows, the constant alternation of his features, his aquiline profile, the radiance of his brow, all in him expresses intelligence in force and an indescribable, violent propensity to dictate." Louis Blanc, *Histoire de dix ans* (Paris, 1846), v. 5, 256–59.

14. François Arago, "Des machines considérées dans leurs rapports avec le bien-être des classes ouvrières," *Revue du progrès* (January, 1839): 15–23.

15. *Oeuvres complètes de François Arago* (Paris, 1854), v. 1, 431, note 1.

16. Jardin and Tudesq, *Restoration and Reaction*, 115.

17. This magazine ran from 1839 to 1842 and represented the opinions of the left wing of the Republicans. Its editorial board also included Théophile Thoré, Charles Blanc (Louis's brother), Louis Reybaud, Luigi Calamatta, Alexandre Decamps, and Félix Pyat. Etienne Arago wrote theatrical reviews, and other eminent Republicans such as sculptor David d'Angers and Godefroy Cavaignac contributed articles.

18. The 1839 publication of this section of Arago's eulogy to Watt was also undoubtedly in response to numerous sociological studies of the working class that began appearing in the late 1830s and painted grim pictures of living conditions. In 1833 Rubichon published a comparative study of conditions in France and England which concluded that during the process of industrialization, England lost one-fifth of its subsistence. M. Rubichon, *Du mécanisme de la société en France et en*

Angleterre (Paris, 1833). Dr. Villermé in 1835 undertook a ground-breaking survey of working conditions that reported that industry was an admirable phenomenon, but economic crashes resulted in frightful hardships. In 1838, the recently (in 1832) reconstituted Académie des Sciences morales et politiques opened a contest for the best essay on the definition of misery. The winner, Eugène Buret, published his findings in 1840 in a book strongly critical of classical economics and supportive of Sismondi's *Les Nouveaux Principes*. For Buret, any machinery that cut costs was in principle good, but the immediate effects were to replace workers. As a consequence, domestic production disappeared, large factories with clear divisions between capitalists and workers were built, and morality declined. Like Sismondi, he believed that production could not be infinitely expanded. Buret concluded by advocating charity, mutual aid societies, improved education, greater personal savings, a graduated income tax, and free trade. Eugène Buret, *De la misère des classes laborieuses en Angleterre et en France* (Paris, 1840).

19. Whom Arago thought he was addressing in the first reading of the speech in 1834 is unclear. Surely Académie members did not need to be warned not to break machines. The readers of the *Revue du progrès* were bourgeois Republicans and intelligentsia rather than workers.

20. Brougham's formula of greater comfort and happiness for more people was, of course, derived from the essential utilitarian thesis that "that Action is best, which accomplishes the Greatest Happiness for the Greatest Number." For a history of Bentham's ideas and utilitarianism in Great Britain, see Elie Halévy, *The Growth of Philosophic Radicalism* (Boston, 1966).

21. An inventory of Arago's library made after his death in 1853 reveals that he owned the works of many English political economists as well as French social thinkers. Among these were Charles Babbage's *Reflection on the decline of science in England* (1830), Ure's *Philosophy of Manufactures* (1835), Adam Smith's *Essays* (1799), Comte's *Cours de philosophie*, and other writings by A. Barbet on political reform, and Baron Dupin on the application of industry and science to the arts. *Catalogue des livres composant la bibliothèque de M. François Arago* (Paris, 1854).

22. J. B. Say, *A Treatise on Political Economy* (Boston, 1821), 43.

23. Ibid., 39.

24. An interesting insight into the sources of Republican economic theory is provided by Théophile Thoré's attack on the Republican paper, *Le National*, in 1840. He claimed that the paper's writers had no instruction in political economy and printed apologies for Say. He also found that the paper represented the middle-aged, democratic bourgeoisie rather than the Republican working class and did little to promote social organization. *La Vérité sur le parti démocratique* (Brussels, 1840, 2nd ed.).

25. The *Revue républicaine*, launched in 1834, contained articles by Thoré, Louis Blanc, Etienne Arago, Decamps, the lawyer J. F. Dupont, Raspail, Cavaignac, Marrast, and even the Italian nationalist Joseph Mazzini.

26. Hte. D., "Des machines et de leurs influences sur la production et les salaires," *Revue républicaine* 5 (1835): 7–26.

27. The names of persons first approached by Daguerre are presented in the Gernsheims' biography, but the source of this information is unknown. Helmut

and Alison Gernsheim, *L. J. M. Daguerre* (New York, 1968, 2nd ed.), 81. Biot, Dumas, and Humboldt were eminent scientists, and Delaroche was celebrated for his Salon paintings of English history, but Grevedon was a minor painter who had shifted to sentimental, feminine lithographic keepsakes and reproductions of paintings during the Restoration.

28. Gernsheim, *Daguerre*, 74–76. A contract between Daguerre and Isidore Niépce, dated June 13, 1837, agreed that a public subscription should be announced between March 15 and August 15, 1838.

29. Honoré de Balzac, *The Rise and Fall of César Birotteau* (Boston, 1896), 132.

30. For a description of these parties and the formation of the Coalition, see J. P. T. Bury and R. P. Tombs, *Thiers, 1797–1877: A Political Life* (London, 1986), 59ff; Jardin and Tudesq, *Restoration and Reaction*, 119–21; and Louis Girard et al., *La Chambre des Députés en 1837–1839* (Paris, 1976).

31. *Le National* (March 1, 1839): 2.

32. *Journal du Maréchal de Castellane, 1804–1862*, v. 3 (Paris, 1897, 3rd ed.), 187–88. On the popularity of Napoleon during the July Monarchy and the use of visual imagery to perpetuate the Napoleonic myth, see Michael Marrinan, *Painting Politics for Louis-Philippe*, Part IV (New Haven, 1988). According to Castellane's journal entry on Sept. 27, 1840, Arago's Perpignan supporters were mostly undistinguished bourgeois.

33. Bury and Tombs, *Thiers*, 61.

34. The government in fact only lasted until February 22, 1840, when Thiers was able to organize the opposition and, on March 1, become the head of a new cabinet.

35. Gernsheim, *Daguerre*, 98.

36. The original pension law dated from August 3, 1790, and had set aside 12 million francs for military pensions. The new law stipulated that military pensions should not raise the recipient's income above its former level. A summary of the history of pensions was presented in the Chambre des Députés on February 7, 1832. Mavidal and Laurent, *Archives parlementaires*, v. 75.

37. Boissy d'Anglas proposed the repeal of an 1817 law governing the award of pensions on September 9, 1830. See ibid., v. 74, 669ff. for debates on this issue in February 1832.

38. Arago spoke on Grimpé's behalf on May 13, 1835. Ibid., v. 96, 65, and v. 102, 367.

39. Ibid., v. 109, 345–46 and 729.

40. Quoted in Halévy, *Growth of Philosophic Radicalism*, 109.

41. Say, *Treatise on Political Economy*, v. 2, 69.

42. J. B. Biot, "Détails historiques sur Flamsted" (1836), reprinted in *Mélanges scientifiques et littéraires* (Paris, 1858), 292.

43. The argument in *Le National* is typical: "You may ask, of what utility is this for the public? But the second question is, of what utility is it to the inventor, who pursued it for long years, who hunted for it by means of costly experiments and neglected more profitable work? To take out a patent isn't practical, because the process is so simple, and copies can't be prevented. To open a subscription, like Mesmer did when he communicated to 100 persons, each paying 100 louis, the secrets of animal magnetism, is one means, but Daguerre certainly won't use it,

since in our time it might not be successful. The most natural means, the most meritorious for our country, would be for the government to buy his secret to make it public." "Invention de M. Daguerre," *Le National* (January 11, 1839): 2. No paper that I read mentioned that Daguerre had, in fact, tried and failed with a subscription.

44. Prosper Merimée, *Correspondance générale* (Paris, 1942), v. 2, 112, letter to Albert Stopfer dated August 14, 1841.

45. The French patent laws in effect in 1839 had been passed in 1790 and 1791 and were not functioning terribly well, in the opinion of many writers. To obtain a patent, an individual merely had to deposit his demand, a description of the device and supporting documents, pay the requisite fee (500 francs for a five-year patent, 1,000 for ten years, 1,500 for fifteen years), and promise to put the invention to some practical use. The state did not guarantee the originality of the patent, so the burden was placed on contesting inventors to take their claims to court. A new patent law was put into effect on October 9, 1844, but it changed only the mode of payment and other subtle wording without changing the essential idea. See H. Truffaut, *Guide pratique des inventeurs et des brevets contenant le texte ou l'analyse des lois en vigueur sur les brevets d'invention* (Paris, 1844).

46. Blanc's relationship with Arago was friendly, although during the 1830s Arago was more conservative and cautious than Blanc. After 1840, when the Republican opposition became more vehement, Arago seems to have shifted more to Blanc's position. In the speech that he gave in the legislature in May 1840, where he raised the issue of electoral reform, his ideas were close to those expressed in Blanc's *Organisation du travail* (1840).

47. Louis Blanc, *Organisation du travail* (Paris, 1841), 86.

48. Chevalier, writing much later in 1878 but expressing ideas that he had held since the 1830s, cited the case of Daguerre and Niépce as proof that patents were artificial because inventions were not unique. Although he was careful not to contest Daguerre's contribution, he claimed that "there are good reasons to believe that at the same time other persons were occupied, not without success, to resolve the same problem." *Les Brevets d'invention examinés dans leurs rapports avec le principe de la liberté du travail et avec le principe de l'égalité des citoyens* (Paris, 1878), 45–47. That patents were defended by business interests is confirmed by a pamphlet printed by J. B. A. Jobard in 1844. Jobard, dedicating his study to the Comte de Mélus, governor of the Société générale pour favoriser l'industrie nationale, supported lifetime patents and upheld that intellectual property should be treated exactly like land. *Nouvelle économie sociale, ou monoautopole* (Paris, 1844).

49. Mavidal and Laurent, *Archives parlementaires*, v. 95, 755, discussion in the Chambre on May 13, 1835.

50. A., "Beaux-Arts," *Gazette de France* (February 19, 1839): 2.

51. Gernsheim, *Daguerre*, 27–28.

52. Heinz Buddemeier has traced press reactions which show that a clear distinction was made between true art and the illusionism of the diorama, which appealed to the basest tastes of the multitude. See articles in the *Globe* and *Journal des Artistes* reprinted in Buddemeier, *Panorama, Diorama, Photographie* (Munich, 1970), 181–86. Nonetheless, King Louis-Philippe was interested in the diorama and visited

the opening of the show depicting "The 28th July, 1830, at the Hôtel de Ville." Daguerre's choices of subjects obviously were calculated to appeal to the dominant political party at the time. See Marrinan, *Painting Politics for Louis-Philippe*, 53.

53. "Nouvelles diverses," *Gazette de France* (March 11, 1839): 3. The same exact phrases were printed on March 9, in *Le National*. Arago, along with the mayor of the 5th arrondissement, was apparently among those assembled at the scene of the fire.

54. D. and Jsph G., "Académie des Sciences" *Le National* (December 11, 1839): 1.

55. "Invention de M. Daguerre," *Le National* (January 11, 1839): 2.

56. "Académie des Sciences," *Le National* (February 27, 1839): 1.

57. Biot, "Sur les effets chimiques," *Journal des Savants* (March 1839): 182. Biot, assisted by the son of Edmond Becquerel, also undertook experiments to determine the effects of light of different colors and emitted by various burning materials on Daguerre's paper, which was similar to Talbot's sensitized paper. *Comtes-rendus des Séances de l'Académie des Sciences* (February 25 and March 4, 1839), v. 8.

58. *Le National* (March 9, 1839): 3, noted foreigners' visits to the diorama.

59. Talbot first showed his works after a lecture by Michael Faraday at the Royal Institution on January 25, wrote the French, and then read a paper to the Royal Society on January 31, which was covered by the *Literary Gazette* in its February 2 issue.

60. Jules Pelletan, "Feuilleton de la Presse," *La Presse* (February 13, 1839): 2.

61. *Comtes-rendus* 8 (February 4, 1839): 172.

62. Alexandre Walewski noted the breakdown of the *entente* in his pamphlet, *L'Alliance anglaise* (Paris, 1838). See also Jardin and Tudesq, *Restoration and Reaction*, 150.

63. "France, Paris, 26 octobre," *Le National* (October 27, 1839): 1.

64. The committee consisted of John Herschel, James Watt (son of the inventor), Robinson (secretary of the Royal Society of Edinburgh), Forbes (professor of physics), Murchison (professor of geology), Brisbane, and Pentland. Herschel is reported to have exclaimed on this occasion that his friend Talbot's images were "child's play" next to Daguerre's. See *Gazette de France* (May 30, 1839): 2, and *Le National* (May 29, 1839): 1.

65. Cited in Gernsheim, *Daguerre*, 95.

66. Blanc, *Organisation du travail*, 50, 61–62.

67. Gernsheim states that the earliest source for this statement is Gaston Tissandier, *Les Merveilles de la photographie* (Paris, 1874). Gernsheim, *Daguerre*, 95, note. I have not found any primary source confirming that Delaroche made this statement. What Delaroche is reported to have said in response to the daguerreotype, that it could give lessons to artists, makes it impossible that he could have feared that it would kill painting.

68. Cousin, *Course of the History of Modern Philosophy*, v. 1 (New York, 1852, based on lectures given in 1828–29), 17–20. On Cousin's art theory, see Frederick Will, *Flumen historicum—Victor Cousin's Aesthetic and its Sources* (Chapel Hill, 1965). Cousin's most famous esthetic statement was the book, *Du vrai, du beau, et du bien*.

69. *Gazette de France* (January 6, 1839): 1

70. A., "Beaux-Arts," *Gazette de France* (February 19, 1839): 1.

71. *Le National* (January 11, 1839): 2.

72. Jules Lechevalier, "Questions politiques dans l'intérêt de l'art et des artistes," *Revue du progrès social*, v. 1 (1834), 453.

73. O., "Salon de 1839," *Gazette de France* (May 4, 1839): 2.

74. Although there is as yet no sociological study of artists' social positions during the July Monarchy, preliminary evidence suggests that they were already under the kinds of stresses more often associated with the Second Empire. Salon reviews during the 1830s regularly noted the severity of the jury and (on the left) the negative effects of bourgeois rather than state patronage. In 1840, artists drafted a petition to the Chambre de Députés highlighting their plight: "In our age, an artist is nothing. He can only be something by the public exhibition of his works in the gallery of the Louvre. . . . The position of artists is unlike others in society—a doctor, a lawyer are doctors and lawyers for their academy and schools, for the government, for the public, for everyone, after having fulfilled certain conditions, after having proven their science and capacity. But painters are never painters, sculptors and architects are never sculptors and architects, in the eyes of the admission jury, who can call their talent into question each year." G. Laviron, "De la petition des artistes à la Chambre des Députés," *L'Artiste* 1 (1840): 375–78.

75. For example, see "Mission de l'art—Avenir des artistes," *Revue républicaine* 1 (1834); Victor Schoelcher, "Salon de 1835," *Revue de Paris* 15 (1835): 330, and 16: 49–50. Another Republican reviewer of the 1834 Salon defined two trends in contemporary art: art with a social goal (dogmatic) vs. art for art's sake (eclectic). Eclecticism was identified as a German import born of Protestantism and was advanced by the men who now govern art and politics. The eclectics claimed that only exceptional people produced and could judge art; the Republicans believed that the artist should teach and reach out to the people. *Revue républicaine* 1 (1834): 123–27.

76. Etienne Arago, "La République et les artistes," *Revue républicaine* 2 (1834): 23.

77. Charles Blanc, "Beaux-Arts—Gravure—La Madone de l'Arc et les Moissonneurs," *Revue du progrès* (February 15, 1839): 14.

78. It would be revealing to know how Arago responded to this seeming attack on both chemistry and Daguerre from within his own camp. Printmaking, as a medium that stood between art and industry, proved to be particularly threatened by photography. Printers were notoriously active in Republican movements and, as a special interest group, needed particular reassurances that they would not be replaced by new technologies. In late December 1838 Arago deposited at the Chambre a petition on behalf of 700 printers calling for a revision of the bookselling rules. He must have, therefore, been particularly sensitive to their concerns. "Faits divers," *Le National* (January 3, 1839): 2.

79. "Feuilleton de la Presse—Découverte de M. Daguerre," *La Presse* (January 24, 1839): 1.

80. Jules Pelletan, "Variétés—Daguerréotype," *La Presse* (August 24, 1839): 3.

81. De Girardin had killed *Le National*'s editor, Carrel, in a duel. On June 16, 1838, de Girardin formed a partnership with Frédéric Sauvage to exploit Sauvage's physionotrace, a mechanical aid for making portraits. Photography obviously

threatened any possible financial success of this venture. Pierre Pellissier, *Emile de Girardin* (Paris, 1985), 136.

82. "Faits divers," *Le National* (July 7, 1839): 2.

83. This chronology differs somewhat from the Gernsheims', who wrote that Arago's report was read on July 3 and the deputies voted the same day. The Gernsheims also cited the 237 to 3 vote as occurring in the Chambre des Pairs. See the Chambre minutes for these days in Mavidal and Laurent, *Archives parlementaires*, vols. 125–27. A notice in *L'Artiste* claimed that the three black balls found in the Chambre des Députés' voting urn were there by mistake, and that the real vote was unanimous. "M. Daguerre," *L'Artiste* 3 (1839): 181.

84. That the glory was more Arago's than Daguerre's is shown by Daguerre's timidity during the August 19 meeting. Although Arago excused Daguerre's absence on the grounds that he had a sore throat, later descriptions of the public demonstrations held by Daguerre on September 7, 11, and 14 noted his nervousness in front of a crowd. The reporter for *Le National* claimed that during his first appearance, Daguerre merely operated and did not explain his process: "one felt that a kind of timidity, the embarrassment that one has when one doesn't have the habit of public speaking, made him a little chary of explanations."

85. Cited in J. F. Dupont, "De la doctrine du progrès continue," *Revue républicaine* 2 (1834): 373.

PARISIAN VIEWS

SHELLEY RICE

Old Paris is gone
(no human heart changes half so fast as a city's face)
Baudelaire, "The Swan"[1]

THE FOLLOWING IS AN ESSAY ABOUT VISION, A SERIES OF SPEC-
ulations about the changes in perception that accompany
the changes in a society's visual space. The essay itself is
a "Parisian view," a look across time at a Paris in the process
of transforming itself, destroying its old material and spir-
itual form and creating one which, for better or worse, was
a reflection of the industrial age. As the physical structure of the city
disappeared, as its buildings, shops, neighborhoods, and interlocking so-
cial relations were obliterated, and as new ones took shape, Parisians'
images of the city, their habits, interactions, memories, and perceptions,
underwent drastic and often discomforting metamorphoses. It is in their
discomfort, and in the shifting images and patterns of Second Empire Paris,
that we in the twentieth century can view ourselves, can witness the
psychological, spiritual, and physical birth pangs of an urban image which
was to become the foundation of our own. So this "Parisian view" is one
which, though looking backward, points forward toward the making of
the contemporary world.

I. Eyes

Between 1855 and his death in 1867, Charles Baudelaire composed a
series of fifty prose poems. During his lifetime, some of these short pieces
were published as *feuilletons* for the daily or weekly mass-circulation Pa-
risian papers; after his death, the completed works were collected and
published as *Paris Spleen* in 1868. These prose poems are not only Bau-
delaire's richest and most radical literary expressions; they are also among

the great urban writings, growing out of a tradition including Villon, Diderot, Balzac, Hugo, and Eugène Sue and yet drastically altering the traditional terms of their discussion of the city. For Baudelaire's prose poems, in both form and content, were the first literary works to be inspired by the modern urban environment. Even as Baudelaire composed the fifty pieces in *Paris Spleen*, Georges-Eugène Haussmann, working under the authority of Emperor Napoleon III, was systematically demolishing the old, medieval Paris of Baudelaire's youth and building in its place the city of today. The prose poems are about this process—about the dramas of the death and rebirth of a city, and the traumatic upheavals such profound physical changes create in the souls of those who live through them.

One of the most poignant, and one of the latest, of these short pieces was "The Eyes of the Poor," written in 1864. It chronicles an encounter: between two lovers, and between these lovers and a poor family. As a basis for a discussion of the changing social—and visual—relations in Haussmann's Paris, the piece is worth quoting in full:

> Ah! So you would like to know why I hate you today? It will certainly be harder for you to understand than for me to explain, for you are, I believe, the most perfect example of feminine impermeability that exists.
>
> We had spent a long day together which to me had seemed short. We had duly promised each other that all our thoughts should be shared in common, and that our two souls henceforth should be but one—a dream which, after all, has nothing original about it except that, although dreamed by every man on earth, it has been realized by none.
>
> That evening, a little tired, you wanted to sit down in front of a new café forming the corner of a new boulevard still littered with rubbish but that already displayed proudly its unfinished splendors. The café was dazzling. Even the gas burned with all the ardor of a debut, and lighted with all its might the blinding whiteness of the walls, the expanse of mirrors, the gold cornices and moldings, fat-cheeked pages dragged along by hounds on leash, laughing ladies with falcons on their wrists, nymphs and goddesses bearing on their heads piles of fruits, patés and game, Hebes and Ganymedes holding out little amphoras of syrups or parti-colored ices; all history and all mythology pandering to gluttony.
>
> On the street directly in front of us, a worthy man of about forty, with tired face and greying beard, was standing holding a small boy by the hand and carrying on his arm another little thing, still too weak to walk. He was playing nurse-maid, taking the children for an evening stroll. They were in rags. The three faces were extraordinarily serious, and those six eyes stared fixedly at the new café with admiration, equal in degree but differing in kind according to their ages.

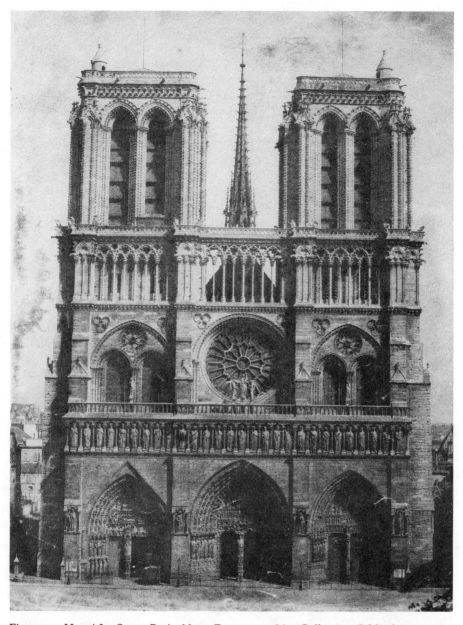

Figure 1. Henri Le Secq, *Paris: Notre Dame,* ca. 1860. Collection Bibliothèque Nationale, Paris.

The eyes of the father said: "How beautiful it is! How beautiful it is! All the gold of the poor world must have found its way onto those walls!" The eyes of the little boy: "How beautiful it is! How beautiful it is! But it is a house where only people who are not like us can go." As for the baby, he was much too fascinated to express anything but joy— utterly stupid and profound.

Song writers say that pleasure ennobles the soul and softens the heart. The song was right that evening as far as I was concerned. Not only was I touched by this family of eyes, but I was even a little ashamed of our glasses and decanters, too big for our thirst, I turned my eyes to look into yours, dear love, to read *my* thoughts in them; and as I plunged my eyes into your eyes, so beautiful and so curiously soft, into those green eyes, home of Caprice and governed by the Moon, you said: "Those people are insufferable with their great saucer eyes. Can't you tell the proprietor to send them away?"

So you see how difficult it is to understand one another, my dear angel, how incommunicable thought is, even between two people in love.[2]

This is a poem about change: about shifting emotional and social dramas acted out within the context of a city-in-transition, in a café whose showy splendor rises from the contrasting rubble of a town in ruins. The situation is perceived from only one person's point of view, but that point of view encompasses a far broader range of experiences and interactions than would have been possible even ten years before. Haussmann's rebuilding of Paris aimed, first and foremost, at eliminating congestion in the center city, and freely promoting the circulation of traffic to all parts of Paris. To this end, Haussmann, Napoleon III's Prefect of the Seine, "pierced" (his word)[3] streets through the crowded heart of the old city, in the process demolishing the homes, shops, studios, meeting places, and settled lives of countless inhabitants. These old Parisian neighborhoods, overcrowded and unsanitary, had grown up haphazardly from the time of the Middle Ages; narrow streets, short and winding, with buildings blocking the way at every turn, discouraged movement through the city, and in *L'Assomoir*, set in the 1850s, Zola could describe the lives of denizens who rarely, in a lifetime, traveled more than a few blocks from home. With the wholesale destruction of these tightly packed neighborhoods and the creation of large boulevards throughout the city, Haussmann, as Marshall Berman wrote:

> opened up the whole of the city, for the first time in its history, to all its inhabitants. Now, at last, it was possible to move not only within neighborhoods, but through them. Now, after centuries of life as a cluster of isolated cells, Paris was becoming a unified physical and human space.[4]

Yet in unifying these "isolated cells" and making possible the free flow of their inhabitants, Haussmann permanently altered the interactions possible for city residents. One of his first priorities had been to cut through and destroy the unhealthy, unsightly, and economically underprivileged areas which had been growing wildly and, in their horrific overpopulation, overtaking the heart of the town.[5] By so doing, the prefect hoped to roust the poor (who posed, he felt, a threat to both the city's health and the stability of its government) to the outlying *banlieues*. But in opening up circulation in Paris, Haussmann also opened up the whole of the city to the poor—who for the first time became visible on the streets and boulevards, constant reminders of the squalor that lurked behind the wealth of the dazzling cafés and shops designed for the bourgeoisie. The narrator's confrontation with the "eyes of the poor," the central incident in this prose parable, was made possible by Haussmann's *"grands travaux."*

These great works also served to change the face of love in the big city. The narrator and his girlfriend are involved in a love affair which unfolds in the context of the crowded and glittering urban streets. They also are not "isolated cells," but people whose emotional bonds are forged and broken within the political, social, economic, and physical structures that provide the backdrop for their interaction. This modern, urban environment allows these two people to spend an enchanted day wrapped up in each other, alone in a crowd and yet enjoying the beauties and amusements the city has to offer—but it also, inescapably and unavoidably, intrudes on their relationship, forcing their private love into a public domain which would not have existed for them a decade before. They, like the café, are part of the street's irresistible spectacle, an amorous display for the passerby whose presence helps to ignite the sparks of their passion. But the streets, in turn, by compelling them to face the contrast between their own privilege and the deprivations of others, have forced them to grapple with the larger context of their emotional life, and to see each other in the harsh light of the city's economic realities. Their love, as Baudelaire realizes, is no longer solely their own; this private emotion, in the course of the poem, becomes part of a social fabric larger than the individuals involved, and out of their control.

"The Eyes of the Poor" is, first and foremost, about an emotional movement: a shift from love to hate, from fantasy to reality, from closeness to alienation. The narrator sees his lover within the context of her politics, and realizes through this "how difficult it is to understand one another . . . , how incommunicable thought is, even between two people in love." The urban environment has provided the backdrop for the fantasies of their affair, and at the same time it has provided the circumstances which prove its limitations. Love has encountered the social world—and it has been vanquished.

Yet this emotional drama is enacted, not through events or actions or even dialogue, but through the interactions of *eyes*. The prose poem describes, in great detail, what the narrator "sees" both in terms of his literal and his perceptive vision; and his readings of the four other people present are based solely on his sensitivity to their eyes. The eyes of the poor, the father and his two children, reflect three different responses to the splendor of the café: the father's admiration and bitterness for "all the gold of the poor world," the eldest child's admiration and his understanding that such places are not for "people . . . like us," and the baby's "joy—utterly stupid and profound." Seeing these reactions, and feeling himself touched by the "family of eyes" which allows people to penetrate deeply into each other's souls, the narrator "plunges" his eyes into the "beautiful and so curiously soft" eyes of his lover, assuming he will "read [his] thought in them." And yet, with the one line of dialogue in the entire poem, his girlfriend destroys his fantasies—about her, about their relationship, and about the "family of eyes" which, by providing windows onto each other's souls, might give human beings access to the profoundest thoughts of others.

The sociologist Georg Simmel has remarked that

> interpersonal relationships in big cities are distinguished by a marked preponderance of the activity of the eye over the activity of the ear. The main reason for this is the public means of transportation. Before the development of buses, railroads and trams in the nineteenth century, people had never been in a position of having to look at one another for long minutes or even hours without speaking to each other.[6]

This new form of purely visual social interaction created a peculiar and very modern form of uneasiness, which was mitigated in part by the "*physiologies*," small paperbacks which were the most popular form of literature in Paris in the first half of the nineteenth century. These books were user-friendly and trivialized versions of the scientific physiognomies written by Johann Kaspar Lavater and Ferdinand von Gall in the eighteenth century, and they benignly described the various "types" of people that one might encounter on the city streets. By making it clear that everyone could be "read" and "assessed" by virtue of his or her physical characteristics, the *physiologies*, in Walter Benjamin's words:

> assured people that everyone was, unencumbered by any factual knowledge, able to make out the profession, the character, the background, and the life-style of passers-by. . . . If that sort of thing could be done, then, to be sure, life in the big city was not nearly so disquieting as it probably seemed to people.[7]

Yet in "The Eyes of the Poor," Baudelaire's narrator discovers that life in the new social world, the world of Haussmann's Paris, is not so simple and clearcut: one can never be sure of one's readings of one's intimates, let alone of strangers. One may "see" more people in Haussmann's Paris—but in spite of the increased circulation, people are still "isolated cells." Five pairs of eyes "talk" in this prose poem; but since they are all registering different responses to the same situation, these eyes are babbling in tongues. We "see" only through the eyes of the narrator, but throughout the course of the poem his vision alters radically. At first he sees a world united by the "family of eyes," and carried away by the prose, we accept his interpretation of people, places, and events. But as soon as his girlfriend speaks, the picture changes—and all of his perceptions are called into question. We are left with a scene of multiple and shifting perspectives: viewpoints as unstable as a city which disappears and is rebuilt, and as isolated as the eye of a man or a woman behind a camera. For Baudelaire's writing reflects the turmoil of an era, the era which gave us not only Haussmann's *"grands travaux"* but also the legacy of a socially functional photography. The modern urban environment and the modern image-form came of age hand-in-hand on the streets of Baudelaire's Paris during the Second Empire.

II. Vistas

In Baudelaire's narrator, we see the individual struggling to come to terms with himself—and others—within a rapidly changing social world. We witness events, interactions, and emotions from the point of view of one person, a person whose perceptual possibilities were being vastly enriched by the newly created street life in Haussmann's Paris. This individual *voyeur* reached archetypal proportions in the person of the *flâneur:* the solitary stroller, meandering through the crowd, who was to become such a staple in nineteenth-century French art and literature. This dawdling people watcher, the prototype of the contemporary street photographer, was in his heyday during the Second Empire, and Haussman's reconstruction of the city was a major reason for his ascendency. The prefect's demolition of the impacted old *quartiers;* his building of scenic boulevards lined with sidewalks which made promenades both possible and fashionable; his encouragement of local businesses on the new streets; and his installation of 15,000 gas lights which stimulated nocturnal strolling by making it safer and allowing shops to remain open until 10:00 P.M.; all contributed to the formation of the street life for which Paris is today famous.[8]

Haussmann's Paris was, above all, a bourgeois and a capitalistic city, dedicated to ostentation, consumption, and display. Shops and cafés sprang

up on the new boulevards; shopping arcades and then, during the 1860s, the first department stores (like Bon Marché) provided centers of both pleasure and commerce where those lucky enough to profit from investments, speculation, or job opportunities created by the rebuilding could spend their money, and the Universal Exhibitions held in Paris in 1855 and 1867 encouraged the mingling of merchandise and men from diverse nations. As Walter Benjamin has pointed out, the Paris of the Second Empire marks the emergence of the commodity culture—a culture in which the display of goods was surpassed only by the display of the people in the street who came to look at them and at each other.[9] By encouraging this circulation of the crowd, Haussmann's Paris opened up new images and interactions, and guaranteed that the boulevards would become the focal point of Parisian life.

The boulevards were also the core of Napoleon III's urban plan, which was conceived and carried out during the miraculously short span of seventeen years between 1853 and 1869. The story, told by Haussmann in his *Mémoires* and repeated countless times since, is that the day the prefect of the Seine took office, the emperor presented him with a map of Paris, upon which were marked all of the streets that he proposed to build.[10] Haussmann goes to great lengths to give his emperor the credit for originating the idea and the general plan for the transformation of Paris. Yet it was the prefect who carried out these plans and who, in the process, conceptualized and realized what Sigfried Giedion has called "the metropolis of the industrial era."

Haussmann was faced with a massive and unprecedented task. As David Pinkney points out: "Parts of cities, even entire new cities like Versailles, Karlsruhe or Saint-Petersburg, had been planned and built, but no one before had attempted to refashion an entire old city."[12] The prefect faced technical problems that had never before been an issue; for instance, when he took office there was no accurate survey map of Paris, and one had to be made before he could even begin the transformation process. Such a mundane but critical example points up the most "modern" aspect of Haussmann's accomplishment: no one before him had considered the city as a single organism, a unit which could be conceptualized, planned as a unified system, and realized through technical, scientific, and mechanical means. Urban planning, *"urbanisme"* in French, did not yet exist; as Françoise Choay points out in *Histoire de la France Urbaine: La Ville de l'Age Industriel:* "The birth of urbanism is dated 1867, the year when the monumental work of the Spanish engineer Ildefonso Cerda, the *General Theory of Urbanization* which gave the discipline its name, appeared in Madrid."[13] Yet over a decade before that, Haussmann was realizing, in practice rather

than in theory, the same general principles in his restructuring of the capital of France.

The boulevards that were the life blood of this new urban organism, were, as Marshall Berman put it, "arteries in an urban circulatory system."[14] The wide (up to 100 yards across) streets built by the prefect were designed to allow traffic to flow through the center of the city and the heart of Paris to the outlying areas; to clear the slums and thus eliminate a health and crime hazard; to open up tree-lined, light-filled vistas, punctuated by green *places* and squares which could provide health-enhancing breathing space to city inhabitants; and to make it possible for troops to travel quickly throughout the city and impossible for revolutionary barricades to be erected. Complemented by the systems of parks, of sewers, and of water supply constructed during the same period, these boulevards transformed the Old Paris, a city of individual buildings, monuments, and neighborhoods, into a vast and unified urban network—one which became regional in scope after the outlying suburbs were annexed in 1859.

Thus the same boulevards which had one meaning for an individual like Baudelaire had quite another when viewed from the perspective of Haussmann's urban plan. Like the love of Baudelaire's narrator, the streets had two faces which co-existed in an uneasy tension, a tension that could, with a slight shift in point of view, turn into a contradiction. The boulevards which so vastly enriched the individual experience of the numerous *flâneurs* of Paris were, at the same time, the structural underpinnings of a city which, by rejecting human scale in favor of a larger conceptual scheme, began to threaten both the primacy and the independence of the individual. In creating their networks of boulevards, Napoleon III and Haussmann thought only peripherally about the comfort and welfare of the people who were to live on them. One example: residential apartments were built exclusively by private companies and speculators, and although Haussmann dictated their outward appearance in conformity with the esthetic effect he wished to create, there were few regulations about the insides, and he ignored the fact that many buildings with fine exteriors had slumlike interiors.[15] In other words, city residents were, more and more, forced to come to terms with physical spaces created in response to other more abstract exigencies, and conceived in relation to large-scale technical or economic questions rather than in relation to human beings.

Haussmann's systemic approach to the city, for instance, demanded not only the demolition of buildings but also the suppression of local color in both the neighborhoods and the terrain of Paris. In piercing through the old *quartiers,* the prefect destroyed not only medieval buildings but also diverse ways of life and work, and he replaced the multiplicity of classes

and lifestyles with a homogeneous and bourgeois order, both economic and physical.[16] Definitely a man of his time, Haussmann had a passion for geometry, uniformity, and measurement which causes contemporary historians like Françoise Choay to term his programs "the urbanism of regularization."[17] Short, narrow, winding, and picturesque old streets were replaced by straight roads leading off into the distance farther than the eye could see, and lending an air of regularity to everything. An accurate survey map was necessary because Haussmann demanded that his new boulevards be not only absolutely straight, but also absolutely level; in numerous instances, for example the present Avenue Victor Hugo, hilly ground was significantly lowered and leveled in order to fit into his visual plan.[18] The circular or rectangular *places,* conceived to offer light and air and greenery in the midst of traffic, serve as points of exchange between streets which often intersect on the diagonal. The more points of exchange, the better Haussmann liked it, and the prefect was fetishistic about the *places'* symmetry; on the Place de l'Etoile, for instance, he assured symmetry by creating uniformly shaped building lots between every pair of radiating streets, and by decreeing exactly the way the buildings upon them could be constructed.[19]

Such an imposition not only changed the face of the city but also dictated the ways in which people could live within it—and Parisians had much to say, both pro and con, about the "urbanism of regularization" during the years of Haussmann's administration. While city denizens seemed aware that something had to be done about the capital, agreeing with Maxime Du Camp that "after 1848, Paris was about to become uninhabitable,"[20] there was much controversy about Haussmann's ultimate achievement. Vociferously heard among the prefect's critics were those who felt that he had created the "neutered city of civilized people."[21] His "straight line," they said, "has killed the picturesque, the unexpected. The Rue de Rivoli is a symbol; a new street, long, wide, cold, frequented by men as well dressed, affected and cold as the street itself. . . . The street existed only in Paris, and the street is dying."[22] One of the most amusing comments, however, is from *Maison Neuve,* a play put on by Victorien Sardou in 1866, in which an older man argues with his niece and nephew about the new Paris. He ends his speech by saying: "[I] beg leave to think it fortunate that God himself was ignorant of this marvelous municipal system, and did not choose to arrange the trees in the forest in rows . . . with all the stars above in two straight lines."[23]

Haussmann's passion for straight lines was part of an esthetic which, though Neo-Classical in conception, was significantly different by virtue of its scale, and its aims. One of old Paris's problems, as the prefect saw

it, was that too often the old and venerated monuments—the churches, the state buildings, the columns and statues—had become so enmeshed in the dense and overpopulated fabric of the city that they were almost invisible. Among his first priorities was the disengagement of these monuments—the demolition of all that stood in their way—and the creation of "vistas" which could set these prized jewels in their proper perspective. His boulevards were constructed to provide just these perspectives. Whenever possible, he built streets which terminated in a pre-existing monument; when that was not possible, he built a church or a new monument which could serve as the culmination point of a promenade down one of his paved roads.[24] His boulevards, therefore, were conceived as Parisian "views"; his shaping of the visual space of the urban environment was goal and object oriented. The trees lining the boulevards, the uniform buildings which faced the streets, and the straight lines of the roads themselves: all of these were designed to enhance the "vistas" so central to Haussmann's planning of Paris, the vistas which were supposed to channel the vision of the *promeneur* as effectively as the lens of a camera.

And yet this Neo-Classical insistence on streets terminating in monumental vistas begins to break down in Haussmann's Paris, for no longer was the prefect working with short streets which could be taken in at a glance by the pedestrian. The older model of the city had been built to human scale, a scale which was transcended in the New Paris of the industrial age. This new city was regional in conception, and its structure was based on what Sigfried Giedion calls "the cannonshot boulevard, seemingly without end."[25] Some of the streets are three miles long—a length which can be conceptualized but not readily perceived by the senses. So his vistas were often lost by a *promeneur*, who perceived as his point of reference only the endless street. The esthetic order which Haussmann imposed on his capital, therefore, could only be grasped on a map, or by a visual overview (which makes panoramic and aerial photographs particularly relevant to this period). In his systemic planning of the city, in his insistence on a scale and range beyond human sense perceptions, Haussmann began, therefore, in spite of his fetish for monuments and vistas, to destroy the primacy of objects. In his Paris, the street—the means of transport, the channel of relationship between objects—becomes dominant.

This can be seen more clearly in Haussmann's nonmonumental architecture. The prefect found early on that architects, trained to design single structures for specific sites, were of little use to him in his planning of Paris. His was a city built by technicians and engineers, men like Adolphe Alphand, Eugène Belgrand, and M. Deschamps, who were committed to working with mechanical means and perceiving problems on a larger scale.[26]

Most of the buildings lining the boulevards were built by private companies and real estate speculators, and yet these companies were bound by imperial decrees which required uniformity of construction. Napoleon III's and Haussmann's insistence on uniformity lies within the tradition of classical city planning. But on such a large scale, and in the context of these "cannon-shot boulevards," the repetition of forms served to create a sweeping rhythm which negated the self-containment of individual structures and instead emphasized and enhanced the visual dynamism of the street itself.

Such a shift—from a point of view which focused on objects to one which emphasized the relations between them—completely altered the human experience of the urban environment. The city had once been a physical structure based on units—people, buildings, neighborhoods; it was now a place in which these units were subsumed into a broader relational context whose range far exceeded that of its inhabitants. And the street, which had once served as simply a link between stable buildings and *quartiers*, burst into motion—became not only the means of circulation but the end. In this context, the boulevards which provided enriched experience for the individual also called into question not only his/her primacy, but also the primacy and stability of all his/her reference points; the streets which were the stomping ground of the *flâneur* simultaneously began to threaten him with his negation, for in them the point of view of the *promeneur* was superseded by the larger extra-human systemic overview. Those who lived through the transformation of Paris were, therefore, living through an era of multiple and shifting perspectives, a time when the confrontation between human experience and the artificial range of large-scale visual spaces was causing vistas to break down, objects to lose their solidity, and people to redefine not only their habits and lifestyles but also their very perceptions of their physical selves within the environment. In Haussmann's Paris, everything was in motion—except, of course, photography.

III. Views

In this context, a photograph—especially one produced with the prolonged exposure times necessary in the early years of the medium's history—seems like a still point in a turning world. In some ways, photographs did function as a means to stop time—a time that, during the Second Empire, seemed to be moving too fast. But in other ways, photography itself was part of the movement and change, seminal to forging the new sense perceptions and defining the new visual spaces that mark this period in Parisian history. Photography was simultaneously the apotheosis of individual, subjective vision and the systematization of vision within a

larger, intra-individual cultural context. It was both a tool to reflect the particular "eyes" of Baudelaire's narrator and a mechanical means of mass communication which, like Haussmann's circulatory scheme, forced subjective vision out of the realm of the idiosyncratic and personal and into the realm of the social. As such, photography embodies within itself the paradoxes and the multiple perspectives inherent in life during the Second Empire.

Photography came of age as a socially functional medium of representation in Paris during the years of Haussmann's administration, so these early accomplishments of the medium must be seen as inextricably intertwined with the equally revolutionary birth of the modern urban environment. The same historical period which gave us the city of the industrial age also gave us the efficient and inexpensive means to reproduce and disseminate permanently fixed photographic prints. While Daguerre's announcement of his daguerreotype process had startled the world and officially initiated the photographic age, certain technical advances made in Paris in the early 1850s served to transform photography from a limited personal image-making form into a socially viable one. Daguerre's process, until then in vogue, yielded single direct positives on a metal plate; Louis-Désiré Blanquart-Evrard's newly perfected process, based on the calotype of William Henry Fox Talbot and possibly also on improvements by David Octavius Hill and Robert Adamson, made it possible for multiple prints to be made (and permanently fixed) on paper from a single paper negative.[27] And men like Blanquart-Evrard, in choosing to exploit the industrial possibilities of this advance, laid the groundwork for the image-systems which circulated photographic prints to the public just as Haussmann's plan of Paris circulated traffic.

Blanquart-Evrard, referred to by Isabelle Jammes as "the Gutenberg of Photography," was born in Lille in 1802, and studied chemistry and painted miniatures on ivory and porcelain before turning to photography in the 1830s. Between 1847 and 1851, he succeeded in creating rich, permanent prints that were not subject to fading—a major stumbling block both in the production and the commercial viability of photography until that time. His process involved the use of albumen, which worked to adhere the silver salts to the surface of paper; the washing of prints in pure water; and the application of gold salts as a toning agent: not new inventions, but new uses of older methods intelligently applied. From his earliest involvement with the medium, Blanquart-Evrard had pushed for its industrialization, and by 1849 had figured out ways to make glass negatives from paper ones for this purpose. In 1851 he opened the doors of his imprimerie at Lille, which in the five years of its existence printed 100,000 negatives for commercial purposes.[28]

Three types of activities went on at Lille. Negatives were printed there, for a fee, for artists, publishers, and amateurs. Albums of photographs were produced by the imprimerie itself, and the plates for larger, more elaborate book works, edited by the firm of Gide and Baudry, were made under Blanquart-Evrard's direction. This was the first successful fee printing business (Talbot's had failed in England in the 1840s), and its impressive list of published books and albums includes, besides the famous *Egypte, Nubie, Palestine et Syrie* by Maxime Du Camp, editions documenting religious art, contemporary art, Belgium, Brussels, and the monuments of Paris.

Blanquart-Evrard had rivals in the photographic publishing business by 1851, when Eugène Piot produced a portfolio entitled *L'Italie Monumentale* (which actually appeared *before* the publication of Du Camp's book). Other competitors were active by 1853–54, including H. de Fonteny, who produced Felix Teynard's *Egypte et Nubie, sites et monuments les plus interessants pour l'étude de l'art et l'histoire,* and the lithographic printer Joseph Lemercier, who in preparing the prints for Charles Blanc's *L'Oeuvre de Rembrandt reproduit par la photographie* essentially created the first photographically illustrated art history book.

The importance of such editions should not be underestimated, for they made photographs widely accessible to a broad public—and Blanquart-Evrard made considerable efforts during the five years of his imprimerie's existence to lower prices in order to make the works even more commercially viable. The subject matter of these books and albums is relevant as well, for in their emphasis on foreign countries and exotic landscapes and art they reflect an important preoccupation of the Second Empire. These were the years when France, catching up to other European countries, constructed its railroads, and expanded its maritime fleet. The speed of messages began to exceed the speed of physical travel when telegraphic apparatus began operating at the Bourse in 1852. Internal expansionism was matched by a change in foreign policy: Napoleon III aggressively involved France in various escapades in countries as far flung as the Crimea and Mexico.[29] The preoccupation with travel, which could only be undertaken by some, was satisfied for all by the distribution of photographic imagery, which therefore played a great role in expanding the sensory perceptions and global knowledge of the populace. Suddenly architectural monuments, "views" of foreign cities, documentary records of exotic landscapes and art objects from numerous countries—physically inaccessible to the average person—become, through photography, part of the cultural image-bank, and filtered directly into the mainstream of Western society.

Photography's ability to telescope space—to bring objects and places closer to people by way of reproduction—was intimately related to its

ability to confound time: to freeze a moment, to bring the past into the present and transform the present into history. Photography's relationship to time was brought into the foreground of public consciousness after Frederick Scott Archer's 1851 introduction of the wet collodion process, which shortened exposure times and became widely used in France and elsewhere for portraiture and outdoor work, including "street" photographs. The Second Empire was also the period during which Disdéri, who took out a patent for cartes-de-visites in Paris in 1854, succeeded in developing a time and labor efficient business for the cheap mass production of portraits.[30] As Max Kozloff wrote in his article "Nadar and the Republic of Mind":

> People [of the Second Empire] rendered homage to a then grand ideal—
> Progress. A marvelous index of progress was speed, the increased
> rapidity with which things could get done, and space could be
> traversed. One has only to look at that great public castle or temple, the
> 19th century railroad station, to see how arrivals and departures—mass
> movement in short—were glorified. And wasn't the photograph itself a
> characteristic witness of the age's lust for accelerated record and
> communication, power and efficiency? What once took weeks or
> months to limn by hand could now be accomplished in minutes,
> mechanically. So urgent was the need for progress that photographic
> exposures were reduced to seconds. Time, in 1860, was burning up.[31]

Speed, and the telescoping of time and space, were dominant characteristics of this new, mechanical visual medium—just as they were central to the new Paris, which was designed by Napoleon III and Haussmann with the rapid transversing of time and space in mind. Just as photography brought the large, physically inaccessible world closer spatially by reproduction, Haussmann's broad boulevards "pierced" through the city and connected disparate parts of Paris which until then had been separated by a chaotic mass of medieval streets. But there are other points of similarity as well. Walter Benjamin, in his essay "The Work of Art in the Age of Mechanical Reproduction," describes how photography destroys the "aura" of a work of art, or even a landscape, by undermining the physical presence, duration, and authenticity of objects and substituting a plurality of copies for a unique original.[32] Books like Du Camp's *Egypte, Nubie, Palestine et Syrie* and Blanc's *L'Oeuvre de Rembrandt reproduit par la photographie*, and widely disseminated single images of objects, landscapes, cities, and even persons began, during the Second Empire, to destroy the primacy of physical objects just as surely as did Haussmann's circulatory scheme. By increasing circulation—in one case of traffic, in the other of reproductions—both the new Paris and the new visual medium vastly expanded individual

perceptual capabilities while simultaneously undermining the physical base of sensory experience.

Given this spiritual kinship, it is not surprising that, from the first, photography was involved in Napoleon III's administration, and that it played a significant role in the Haussmannization of the city. Like the technicians and engineers who accomplished the rebuilding of Paris, photographers were, by definition, modern men working with mechanical means, and during the Second Empire the lines between artists, amateurs, and commercial photographers had not yet been clearly drawn. As a consequence, many of the people, like Henri Le Secq and Gustave Le Gray, who were known as major photographic artists during these years, also did major work on commission for the government. And a number of the photographers who were attracted to documenting Paris—sometimes on their own initiative, sometimes for a speculative market, and sometimes on assignment—were trained as, and often continued to be, salon painters, interested in exploring and expanding the possibilities of a new medium of representation.

Several critics and historians, most notably Walter Benjamin in "A Short History of Photography"[33] and Gisèle Freund in *Photography and Society,*[34] have remarked on the quality of photographic work produced during the 1850s—a quality which, they feel, was lost when photography became heavily industrialized and commercialized in the 1860s. And while this point of view is well taken, it must be said that photography itself is a child of the industrial age, and that it was only through its industrialization that it could truly come into its own. Photography's relationship to Haussmannization represents one step in this complex process of maturation. As the various photographers worked to come to terms with the transformation of Paris, to shape a vision of both the old and the new environment which could orient them and their audience to a changing world, they forged remarkably diverse—and often conflicting—images of a city in transition, on its way to becoming the space of modernity.

The first project which must be mentioned in this respect had nothing to do with Haussmannization at all, yet it set the stage for all subsequent architectural photography in France. This is the Mission Héliographique, the first photographic survey of historical monuments in France, which was commissioned by the governmental Commission des Monuments Historiques (probably with the assistance of the newly established Société Héliographique) in 1851, the year before Napoleon III announced the *coup d'état* which established the Second Empire. After examining portfolios, the commission sent five men—Edouard-Denis Baldus, Hippolyte Bayard, Henri Le Secq, Gustave Le Gray, and O. Mestral—to photograph in five different provincial centers of France. Though the Mission seems to have

faded out for mysterious reasons (most probably because at that time Blan-quart-Evrard's process for making rich, permanent prints was not yet per-fected), and only 300 paper negatives survive (along with very few prints; it seems that many of the negatives were never even printed, and were simply stored away),[35] in commissioning the project the government, as Weston Naef has commented, "permitted some of France's most important photographic artists to gain valuable field experience."[36]

Yet although the mission ensured that France possessed the most ex-perienced architectural photographers in the world, its aim must be em-phasized. The mission's function was, essentially, conservative. The numerous negatives produced under its auspices were designed to pre-serve France's ancient architectural heritage—a heritage that was being threatened not only by industrialization but also by restoration. A large percentage of the buildings photographed on assignment by these five men had either been restored, been proposed for restoration, or were at that point in time undergoing restoration. The restoration issue, and France's medieval architectural landmarks, became public concerns in the 1830s, after the publication of Victor Hugo's *Notre Dame de Paris,* whose sympathy toward the dilapidated Gothic architectural heritage of France helped to create a vogue for the romanticism of ruins. As a consequence, throughout the 1830s there developed a science of medieval archeology, which led to the formation of both the Société Français d'Archaeologie and the Com-mission des Monuments Historiques. The restorer Eugène-Emmanuel Viol-let-le-Duc, who attempted to reconstruct these hallowed monuments in what he called "a complete state such as might never have existed,"[37] became a major source of controversy during the 1840s and 1850s. The mission photographs, and the considerable number of images of ancient monuments extant from the period of the Second Empire, must be seen in this context. Their primary function was to "preserve" the old structures and record the changes that had already occurred in the country's archi-tectural patrimony.

The numerous and well-known photographs of historic Parisian build-ings and monuments taken during the Second Empire by mission photog-raphers as well as by such eminent artists as Charles Nègre, the Bisson brothers, and Charles Marville, which now make up such a prized part of the collections in art museums which exhibit and preserve photography, must be considered in this light. These photographs might have been produced by a modern mechanical medium; but at the same time they must be perceived as nostalgic in intent. Their production was synchronous with Haussmann's demolition of the old, historic city and his creation of a new and modern one, and their popularity (as evidenced by the number of surviving prints) during this period is a testament to the French people's

need to hold on to a past that seemed to be in the process of being lost. In these particular pictures, photography became, during the Second Empire, the still point in a turning world, the agent of visual and temporal preservation for a century that also invented hygienic and medical measures for the preservation of health, new methods for the conservation of food, and, of course, public museums for the conservation of art.[38]

Formally, one often sees the same disjunction in the pictures, the same reliance on old patterns of perception at a time when new patterns, recognized by artists as diverse as Baudelaire and, later, the Impressionist painters, were being forged in the immediate environment every day. It must be emphasized, once again, that most of these early photographers were painters trained in the salon style, and their methods of constructing their pictures attest to these conservative ways of seeing. The series of "views" in the "Monuments of Paris" album edited by Blanquart-Evrard in 1853 and photographed by Fortier, for instance, aim to showcase individual buildings and monuments, focusing on their physical form and architectural or ornamental detail. The environs, though pictorially well integrated, are incidental to the pictures which are, first and foremost, oriented toward specific and self-contained objects. Their emphasis on physical structures, at exactly the point in time when Haussmann was commencing the construction of a network of boulevards which would shatter the primacy of objects, is telling.

The confusions and ambiguities inherent in this type of photography were, however, inherent in Haussmann's urban planning as well. The historicism of the prefect's taste in architecture is well known; but the conflicts between the old and the new are evident even in the projected aims of his overall scheme for the city, and it is here that the parallels with this form of photography become striking. Just as Haussmann attempted, using thoroughly modern technical and conceptual means, to create neoclassical "vistas," so many of the most important French photographers of the Second Empire used their new medium to create "views" based on older patterns of seeing which were rapidly becoming outmoded. And, just as Haussmann's systemic overview, with its cannon-shot boulevards, ultimately undermined his monument-oriented vistas, so the new vision put forth by photography, with its foreshortenings, truncations, sensitivity to changes in form based on light and shadow, and ability to manipulate points of view, began to suggest new perceptual patterns which would undermine object-oriented ways of seeing.

A good example is Le Secq's *Flying Buttresses of the Cathedral, Reims* (Fig. 2), taken in 1852 and described by Weston Naef as "among the most advanced [compositions] of its time."[39] In choosing his point of view for this eccentric print which would serve as a harbinger of things to come, Le

Figure 2. Henri Le Secq, *Flying Buttresses, Reims*, 1860. Collection Bibliothèque Nationale, Paris.

Figure 3. Delmaet and Durandelle, *Construction of the Opéra*, 1865–1872. Collection Bibliothèque Nationale, Paris.

Secq negated the cathedral-as-object, and focused instead on the details of its structural elements: the lines of force, the relational lines, which were the architectural "network" underlying the building's construction, and which visually served to create a two-dimensional, abstract design of straight and curving lines, light, and shadow. Such views became more common during the last quarter of the nineteenth century, as more photographers began documenting the *"grand travaux."* Notable among the few photographers doing this type of work during the Second Empire were the partners in the little known studio of Delmaet and Durandelle, active from 1860 to 1890, which specialized in documenting construction sites like the new Opéra and the Hôtel-Dieu. In choosing points of view which focused on the structural skeletons of architectural works-in-progress, Delmaet and Durandelle created pictures which were simultaneously abstract and documentary, and which transformed metal beams, scaffolds, and pillars into forceful architectural anatomies celebrating the technical ingenuity of nineteenth-century engineers.[40] In their fascination with the process of construction, these studio partners were joined by A. Collard, who recorded

works on bridges around Paris during the 1860s, and P. Petit, who documented the building of the Universal Exhibition on the Champs de Mars in 1866 and 1867.

Sometimes various styles and attitudes would co-exist within a single artist's production, as is the case with Baldus. Born in Westphalia, Baldus trained as a painter and (after living for a while in New York in the 1840s) was a practicing photographer in France by 1849. The photographer achieved much official recognition,and was hired by the government on several occasions to do major commissions. Judging by the quality of his surviving work, Baldus's fame was not misplaced; his mastery of composition and technique and his ability to choose unusual and visually interesting points of view make his prints one of the delights of Second Empire photography. Among his best known bodies of work is the project he did on commission for the Ministry of the Interior: a documentary record of work in progress on the Louvre, which included both its renovation and its union with the Tuileries. The series was published in a five-volume set after the construction was completed in 1857.

By necessity, given the assignment, most of the pictures are very much object-oriented works; much of the series, in fact, consists of hundreds of straightforward architectural details of the Louvre's new facade. But an image from about 1855, of the *Louvre from the Pavillon de la Bibliothèque to the Pavillon de Marsan* (Fig. 4), which is a view of the building from an oblique angle which emphasizes its endless length, its perspectival distortions and foreshortenings, suggests another way of seeing: a way of seeing which transforms the solid mass of a building into a seemingly infinite sweep of lines into deep space whose dynamism is enhanced by the repetition of architectural forms. Here Baldus's Louvre visually recreates the modernist aims of Haussmann's urban plan—a match of sensibilities made even more evident in the volume the photographer created for Baron James de Rothschild documenting the route of the new railroad line from Paris to Boulogne. Some of the pictures focus on "views" of buildings along the path of the train; others, however, have as their central subject the tracks: those measured, relational channels of movement which became dominant in Baldus's pictures the way the streets became dominant in Haussmann's Paris.

This connection with Haussmann's streets leads us naturally to Marville, whom Maria Morris Hambourg has termed "Haussmann's man."[41] During the early 1850s, Marville did much of the photographic work for Blanquart-Evrard's editions. Around 1856, he began to use Archer's new collodion-on-glass process, and at about the same time started documenting the parts of Paris that would be, or were already being, demolished by Haussmann. The prefect felt strongly that the old streets and buildings, as well

as their destruction and rebuilding, should be documented as part of the city's historic records—and as a way to make sure that all could recognize the extent of his own accomplishments. For this purpose he hired several archivists whose association took the official name of City Council Permanent Subcommittee on Historic Works in 1865. These archivists, in turn, advised Marville, who became the official "Photographe de la ville de Paris."[42]

As Maria Hambourg has pointed out, we have tended to see Marville's work through the glow of nostalgia, since the few pictures known in this country have generally been of the narrow streets of Old Paris so beloved by Atget.[43] But Marville, unlike Atget, was not a *conservateur;* as Marie de Thézy of the Bibliothèque Historique de la Ville de Paris has shown, he photographed systematically according to Haussmann's plan, and his pictures include before, during, and after shots of the areas in question.[44] His oeuvre, therefore, includes not only pictures of the old city but also numerous documents of the parks, and urban furnishings such as street lights and public urinals. Thus he functioned as a dispassionate observer, an impartial recorder of the old, the new, and the process that came between them. And like Haussmann, from whom he took both his cues and his meal ticket, Marville tended to emphasize the streets—rather than buildings or objects—in his photographs. Most of them have, as their main subject centered in the picture plane, some kind of road or passageway. Often in his pictures of the old city, Marville chose low vantage points which emphasized the claustrophobia, irregularity, and ill repair of the ancient roadways, or viewpoints which were clearly designed to point up the obstacles to movement and the clogged passageways and gutters which, of course, justified Haussmann's rebuilding project. Yet in spite of their modern pictorial structure and their obvious understanding of, and sympathy with, the prefect's aims, Marville's photographs of old Paris were still done for the purpose of preservation, and they are still infused with a notable patina of history. Speaking about the old Paris poised on the brink of Haussmannization, Walter Benjamin, in *Charles Baudelaire: A Lyric Poet in the Era of High Capitalism,* wrote: "Anything about which one knows that one soon will not have it around becomes an image."[45] Marville's photographs of the ancient streets have, for us, become that "image."

The same convergence of the old and the new evident in Marville's photographs—and evident in concrete terms in Haussmann's Paris, where wide new streets pierced through old neighborhoods whose remnants still exist—can be found in the genre pictures of Charles Nègre and Disdéri. Both men looked to the streets for their subjects, and focused on urchins, beggars, and vagrants—members of the lower class then being popularized as subjects of literature and painting by controversial realists like Edmund and Jules de Goncourt and Gustave Courbet. Given the long exposure

Figure 4. Edouard-Denis Baldus, *The Louvre, from the Pavillon de la Bibliothèque to the Pavillon de Marsan, Paris*, ca. 1855. Collection Bibliothèque Nationale, Paris. Gift of the Government 1860.

Figure 5. Charles Negre, *The Organ Grinder*, 1853. Collection Bibliothèque Nationale, Paris.

times necessary during the early 1850s, both men were required to pose their pictures; but Nègre deliberately sought the illusion of the candid snapshot by having his sitters, like his Organ Grinder and his Chimney Sweeps, posed in mid-step. Nègre, a painter by profession and training, tended to emphasize the overall composition of his pictures and to place his subjects in environments structured by lights and shadows. On the other hand, Disdéri (who abandoned this type of photography after his patenting of the carte-de-visite process in 1854) focused primarily on the sitters themselves, who were often seen from low angles which made them as heroic as Courbet's *Stonebreakers*. The decision to work in the streets was a radical one in those years, and one which, in spite of the technical limitations imposed by their cameras, would seem to bespeak a recognition of the changing street life prophesied by the new urban plan. But that is not really the case. Unlike Adolphe Braun, whose extraordinary street photographs of the early 1850s focus on the boulevards and the hustle and bustle of traffic upon them, both Nègre and Disdéri fell back on the conventions of paintings in the realization of their photographs. Their choice of subjects goes back as far as the seventeenth century's Louis Le Nain, and their insistence on posing these archetypal street characters—rather than more obviously contemporary social types who could reflect, in Baudelaire's words, "the heroism of modern life"[46]—in central positions in environments which play only a nondescript or compositional role, places these images more squarely within the genre tradition of Salon painting than within Second Empire Parisian life.

This incongruity is evident in many of the photographs that we have termed "masterpieces" of early French photography. At the period in history when artists like Courbet, Edouard Manet, and their followers were challenging academic painting, were insisting that art must reflect contemporary life rather than the conventions of the Academy, the most esteemed photographic artists were often aping those very conventions that were in the process of being overthrown. Art history has, over the past century, developed a series of standards which heroicizes the painters who accomplished this revolution. But photographic history has not established a parallel standard of judgment, and has actually deified just those image-makers and images which reflect a more academic and conservative approach rather than a modernist one.[47] By looking at Second Empire photography from the point of view of its relation to Haussmannization, this article is attempting to establish another point of view on the medium's history, and possibly redress an imbalance.

One such imbalance that must be redressed is the obscurity which has befallen the work of Hippolyte Bayard. For some unknown reason, the problem of obscurity has plagued Bayard since his lifetime. Born in 1801

in Breteuil-sur-Noye, he moved to Paris to work as a clerk in the Ministry of Finance, and in 1839, while thus employed, created the first direct positive photographs on paper made in the camera. Though Bayard exhibited his work before the official announcement of Daguerre's invention, the French government protected the other man's glory by paying Bayard a token tribute to keep his mouth shut. So his contribution to the medium's invention went unrecognized during his lifetime—and his substantial contribution to its subsequent development has remained obscure ever since.

Bayard's works are, however, among the most truly radical of their time. By the 1840s, in spite of severe technical limitations, Bayard was producing "street" photographs, pictures which depicted Parisians in their everyday environments: on the streets, sitting in cafés, lounging by grocery stores. Though somewhat stilted due to their long exposure times Bayard's images are an early attempt to directly, almost prephotojournalistically, explore photography's relationship to life-in-progress. Yet this photographer's interests were not exclusively or even primarily in the people of Paris. For much of his oeuvre of the 1840s to 1860s consists of high vantage point panoramas of the city rooftops and radically foreshortened "views" of individual streets, in which these roadways are so centrally and dynamically positioned that they far overshadow the buildings which line them. These perspectives, with their obvious relationship to the *zeitgeist* of Haussmannization, link Bayard also with the stereographic photographers of Paris—those commercial image-makers who, by the 1860s, were shaping the popular vision of Haussmann's city.

Technical advances made so-called "instantaneous" views possible during the 1860s, at about the same time that Haussmann's *grands travaux* were far enough along to have made a substantial change in the face, and the street life, of the city. The convergence of these two phenomena gave rise to a plethora of new types of popular photographs, taken by commercial image-makers and widely distributed to the general public rather than to a more sophisticated or elitist audience. In fact, the original "art" community of photographers seems to have dissipated, or at least lost much of its impetus and many of its members, by the 1860s, when Le Gray had already left for Egypt, Le Secq had retired to work on his iron works collection, Nadar's studio had gone commercial, etc. Into this void stepped the popular image-makers like Disdéri and the stereo street photographers, who went on to make their fortunes and to shape a new, and heavily commercialized, vision of their society.

By keeping their fingers on the pulse of the populace, the new street photographers like Jouvin and Houssin produced pictures which were a clear reflection of the new Paris. In many cases, these photographs were taken from a high vantage point, often looking down at an intersection where two boulevards converged on the diagonal. The image-makers,

Figure 6. Houssin, *Instantaneous view: Place de Chateau D'eau*, 1860s. Collection Bibliothèque Nationale, Paris.

therefore, chose to emphasize Haussmann's newly constructed streets in their pictures—generally for the purpose of depicting traffic upon them. The stereographs record pedestrians, horses, shoppers, and wagons: those anonymous crowds, just passing by, which play such an important role in Baudelaire's poetry. Due to technical limitations, often this street traffic is transformed into a blur of movement on the wide new boulevards, the blur of movement which has been seen by some historians, like Aaron Scharf, as inspirational for the work of the Impressionists.[49] In their emphasis on the streets, on the relationships between the various thoroughfares, and on traffic flow and movement rather than on individual people, landmarks, or objects, these pictures are clearly the image of Haussmann's Paris, the celebration of the new city and all that it stood for. The photographs were heavily formularized—often if you've seen one you've almost literally seen them all—and yet it was by conventionalizing this representation of the city that these popular image-makers helped tourists and residents alike to comprehend the dynamics of, and feel comfortable within, the Paris of the industrial age.

One of the first photographers to exploit the possibilities of "instantaneous" views of Paris was Charles Soulier, who excelled especially in the new panoramic photography. Sweeping overviews taken from high vantage points, panoramic photographs focused on no central objects, but

Figure 7. Charles Soulier, Panorama of Paris, before 1867. Collection
Bibliothèque Nationale, Paris.

instead depicted the relationships between various monuments, land-
marks, buildings, and neighborhoods that together make up the inter-
locking fabric of the city. Bayard was producing panoramas as early as the
mid-1840s, and such "views" showed up frequently in the albums and
exhibitions of the 1850s; by 1855 the Bisson brothers had won a first prize
medal for works, which included panoramas, exhibited at the Universal
Exhibition and the painter Clausel had created a 360° panorama of the city
composed of twenty-one plates.[50] But this type of imagery became an
important part of the popular mainstream by the 1860s—at exactly the
point when the effects of Haussmann's new network of boulevards, many
of them completed or in the process of completion by this time, were being
strongly felt in the life of the city. In these overviews, which focused not
on isolated or specific parts but on the total spectacle of the urban envi-
ronment, Haussmann's panoramic urban scheme found its image-form.

It found its form also in the experimental works of Nadar, works which
clearly indicate that this artist understood the broad ramifications of the
new city. Nadar's portraits are among the most celebrated images of the
Second Empire; but it is in his aerial and subterranean photographs that

Figure 8. Nadar, *First Aerial Photograph of Paris*, 1858. Collection Bibliothèque Nationale, Paris.

this image-maker truly showed himself to be another "Haussmann's man" (a thought that would have appalled him; a staunch Republican, he remained anti-Empire throughout Napoleon III's reign, and refused all official recognition). As is well known in both photographic and aviation circles, Nadar was heavily involved with aeronautics, and indeed once managed to lose much of his money on a venture involving the construction of a gigantic flying balloon. In the late 1850s, he united his passions for photography and aviation by attempting to take the first aerial photographs— an extremely difficult endeavor, given the technical problems as well as the fact that one had to carry large amounts of equipment, glass plates, and even a portable darkroom. (Nadar handled the weight problem by discarding not only unnecessary baggage but also his own clothes).[51] The photographer failed in his first four attempts; as he explains it in his memoirs, gas escaping from the balloon ruined his plates.[52] But in the fall of 1858 he succeeded in taking the first bird's-eye views of Paris.

Lacking horizon lines and flattening deep space, these images show us the geometric sweeps of the grand boulevards, as they demarcate the land and unify monuments, buildings, and neighborhoods. Much detail is lost, but the broad overview is gained, and Haussmann's conceptual scheme is made accessible to the human eye. The prefect, it should be remembered, did not only systematize the land of Paris; he also, in building the impressive network of sewers still functioning in the city, constructed an underground system which Charles Kunstler, author of *Paris Souterrain*, refers to as the City of Shadows.[53] The photographer who ascended into the skies also descended into these shadows, and emerged in 1861 with photographs of the sewers and the catacombs. The first experiments with artificial light in photography, the pictures were made with the aid of Bunsen batteries, and required 18-minute exposures.[54] They are both fascinating and beautiful, and the prints of the sewer system—which emphasize the clean geometries of the underground passageways built for this subterranean traffic flow of water—are among the most abstract and "modern" produced during the Second Empire. In photographing the newly-built systems, both above the ground and below it, Nadar used his camera to expose the real skeletal structures of Haussmann's Paris.

Seen together, these photographs represent a range of interpretations of one city caught in a time warp between two very different states of being. Each of these photographers was struggling to come to terms, not only with a new urban environment, but also with a new medium of expression. So it is small wonder that as a group these image-makers have left us no single, fixed point of view. These photographs, in fact, represent a remarkable record of shifting visions, a series of "views"—from progressive

to nostalgic, from avant-garde to retrograde—which provide us with multiple perspectives on a world that was in the process of coming into being. They make manifest for us Baudelaire's "family of eyes": a plethora of individual perceptions, of fragments of vision which even a subtle alteration in point of view could, and did, transform into something radically different.

This symphony of personal viewpoints, upon entering the mainstream, concretized and indeed apotheosized individual vision, and vastly enriched the perceptual possibilities of the average person just as Haussmann's boulevards did. But by freezing and objectifying these subjective visions, photography also codified perception, and transformed the individual eye into a material part of a communications network as systemic, and as suprapersonal, as the prefect's own. Through exhibition, reproduction, and sales, personal perception became a generalized part of the public domain, subject to the vagaries of a dominant system of image production, distribution, and consumption. In Haussmann's Paris, sight—like the love of Baudelaire's narrator—was no longer one's own; and the point of view of the individual *voyeur*, like that of the *flâneur*, basked in its glory just at the moment when the seeds of its extinction were being sown.

Notes

1. Charles Baudelaire, "The Swan," in *Les Fleurs du Mal* (Boston: David R. Godine, 1983), 90. Translation by Richard Howard.

2. Charles Baudelaire, "The Eyes of the Poor," in *Paris Spleen* (New York: New Directions, 1970), 52–53. Translation by Louise Varèse.

3. This is a word Haussmann characteristically used throughout his *Mémoires* (Paris: Victor-Havard, 1893, 3 volumes) to describe his demolition work.

4. Marshall Berman, *All That Is Solid Melts Into Air* (New York: Simon and Schuster, 1982), 151. My thanks to Marshall Berman, not only for his social interpretation of his poem to which I owe much, but also for the inspiration his book gave me in pursuing my own research.

5. For the definitive discussion of overpopulation in nineteenth-century Paris before 1848, and its effects on the population, see Louis Chevalier, *Classes Laborieuses et Classes Dangereuses* (Paris: Hachette, 1984).

6. Georg Simmel, *Soziologie* (Berlin: 1958), 486. Quoted in Walter Benjamin, *Charles Baudelaire: A Lyric Poet in the Era of High Capitalism* (London: Verso, 1983), 38. Translation by Harry Zohn.

7. Ibid., 39.

8. David H. Pinkney, *Napoleon III and the Rebuilding of Paris* (Princeton: Princeton University Press, 1972), 72.

9. This is a general issue elaborated in Walter Benjamin, *Charles Baudelaire*.

10. Haussmann, *Mémoires*, volume 2, 53.

11. Sigfried Giedion, *Space, Time and Architecture* (Cambridge, Mass.: Harvard University Press, 1978), 739.

12. Pinkney, *Napoleon III and the Rebuilding of Paris*, 4.

13. Françoise Choay, "Pensées sur la ville, arts de la ville," in Maurice Agulhon, editor, *Histoire de la France Urbaine: la ville de l'âge industriel*, Tome 4 (Paris: Editions du Seuil, 1983), 165. My translation.

14. Berman, *All That Is Solid*, 150. For a detailed discussion of the street networks, see also P. Lavedan, *Histoire de l'Urbanisme à Paris*.

15. Pinkney, *Napoleon III*, 93.

16. *For an excellent discussion of these changes—and their impact on the various classes and occupations of Paris—see Jean Gaillard, Paris, La Ville 1852–1870* (Paris: Editions Honoré Champion, 1977).

17. Choay, "Pensées sur la ville," 168. My translation.

18. Pinkney, *Napoleon III*, 63.

19. Haussmann, *Mémoires*, volume 3, 74–76; and Pinkney, *Napoleon III*, 63.

20. Maxime Du Camp, *Paris, ses organes, ses fonctions et sa vie dans la seconde moité du XIX siècle* (Paris: Librarie Hachette, 1893, 6 volumes), vol. 6, 253.

21. Daly, "Etude Générale," quoted in T. J. Clark, *The Painting of Modern Life* (New York: Knopf, 1985), 43.

22. Charles Yriarte, "Les Types Parisiens—les clubs" in *Paris-Guide* 2, 1867; quoted in T. J. Clark, ibid., 43–44.

23. Victorien Sardou, Maison Neuve, in *Théâtre Complet de Victorien Sardou*, 9; 274–75. This reference is cited in T. J. Clark, ibid., 42 and also in G. N. Lameyre, *Haussmann: Préfet de Paris*, 281–82.

24. For further discussions of these vistas and the disengagement of monuments, see Choay, "Pensées sur la ville," and Giedion, *Space, Time and Architecture*.

25. Giedion, *Space, Time and Architecture*, 739.

26. For a fascinating discussion of the men who worked with Haussmann, see Giedion, *Space, Time and Architecture*, 762–65.

27. Weston Naef speculates on the possible relationship between Blanquart-Evrard and Hill and Adamson in *After Daguerre*, ex. cat. (New York: Metropolitan Museum of Art in association with Berger-Levrault, Paris, 1980), 17.

28. Much of my information on Blanquart-Evrard comes from Isabelle Jammes's excellent book, *Blanquart-Evrard et les Origines de L'Edition Photographique Française* (Genève-Paris: Librairie Droz, 1981).

29. There is, of course, a vast literature available in both French and English on the Second Empire. For an overview of Napoleon III's life and a basic introduction to the period, see John Thompson, *Napoleon III and the Second Empire* (New York: Norton, 1955) and Alain Plessis, *De la fête impériale au mur des fédérés 1852–1871* (Paris: Editions du Seuil, 1979).

30. For a background on Disdéri's life and work, see Elizabeth Anne McCauley's *A. A. E. Disdéri and the Carte-de-Visite Portrait Photograph* (New Haven: Yale University Press, 1985).

31. Max Kozloff, "Nadar and the Republic of Mind," in *Photography in Print*, editor Vicki Goldberg (Albuquerque: University of New Mexico Press, 1988), 130.

32. Walter Benjamin, "The Work of Art in the Age of Mechanical Reproduction," in *Illuminations*, edited by Hannah Arendt (New York: Schocken Books, 1969), 221. Translation by Harry Zohn.

33. Walter Benjamin, "A Short History of Photography," in *Classic Essays on Photography*, editor Alan Trachtenberg (New Haven: Leete's Island Books, 1980), 200. Translation by P. Patton.

34. Gisèle Freund, *Photography and Society* (Boston: David R. Godine 1980), 43ff.

35. This information, and much else of interest, comes from Phillipe Néagu and Jean-Jacques Poulet-Allamagny, *Anthologie D'un Patrimoine Photographique* (Paris: Caisse Nationale des Monuments Historiques et des Sites, 1980), 18.

36. Weston Naef, *After Daguerre*, 22.

37. Both the Viollet-le-Duc quote, and the preceding historical information on the history of architectural preservation, can be found in Joel A. Herschmann and William W. Clark, *Un Voyage Héliographique à Faire: The Mission of 1851*, ex. cat. (New York: Godwin-Ternbach Museum at Queens College, 1981).

38. A. M. Vogt, *Art of the Nineteenth Century* (New York: Universe Books, 1973).

39. Weston Naef, *After Daguerre*, 22.

40. Elvire Perega, "Delmaet et Durandelle, ou la rectitude des lignes," *Photographies* 5 (July 1984), 54–73.

41. Maria Morris Hambourg, "Charles Marville's Old Paris," in *Charles Marville*, ex. cat. (New York: French Institute/Alliance Française, 1981), 10.

42. Ibid., 9.

43. Ibid., 7ff.

44. Marie de Thézy, "Charles Marville, Photographer of Paris Between 1851 and 1879," in *Charles Marville*, 67.

45. Walter Benjamin, *Charles Baudelaire*, 87.

46. Charles Baudelaire, "The Salon of 1845," in *Art in Paris 1845–1862*, translated and edited by Jonathan Mayne (Ithaca: Cornell University Press, 1981), 32. For further information on Nègre and genre photography, see Heilburn with Néagu, *Charles Néagu, Photographe*, ex. cat. (Arles: Musée Réattu, 1980).
One notable exception to this assessment of Nègre's work is an extraordinary picture which the Museum of Modern Art, New York, has titled *Rubberneckers*. Taken around 1851, the photograph depicts a street incident involving a fallen horse and numerous spectators, and both its subject matter and its seemingly candid style make it a precursor of modern photojournalism.

47. There has, of course, been some exceptionally fine work on Second Empire photography done from this point of view, for instance E. Janis and A. Jammes, *The Art of the French Calotype* (Princeton, N.J.: Princeton University Press, 1983).

48. There is very little information available on these aspects of Bayard's work as of now, though Nancy Keeler, a graduate student at the University of Texas, Austin, is working on a dissertation which will examine the oeuvre of this photographer, and a major exhibition is now being planned in France. This show will draw works for the wonderful collection of Bayard prints preserved by the Société Française de Photographie in Paris, and their two publications, *Les Trésors de la Société Française de Photographie* (Paris: 199) and *Une Invention du XIX Siècle: la pho-*

tographie (Paris: Bibliothèque Nationale, 1979) reproduce a selection of these.

49. Aaron Scharf, *Art and Photography* (Baltimore: Penguin Books, 1974), 170.

50. Information on the historical background of French panoramic photography can be found in Néagu and Poulet-Allamagny, *Anthologie d'un Patrimoine Photographique*.

51. Nigel Gosling, *Nadar* (New York: Knopf, 1976), 16.

52. Nadar, *Quand J'étais Photographe* (Paris: Editions d'Aujourd'hui, 1979), 91.

53. Charles Kuntsler, *Paris Souterrain* (Paris: Flammarion, 1953).

54. Many of these photographs are reproduced in *Le Paris Souterrain de Félix Nadar*, ex. cat. (Paris: Caisse Nationale des Monuments Historiques et des Sites, 1982) and in volume 1, *Photographies*, of *Nadar* by Phillipe Néagu and Jean-Jacques Poulet-Allamagny (Paris: Arthur Hubschmid, 1979).

ELECTRICAL EXPRESSIONS: THE PHOTOGRAPHS OF DUCHENNE DE BOULOGNE

NANCY ANN ROTH

Introduction

ON ITS FIRST PUBLICATION IN 1862 THE FRENCH PHYSIOLOGIST Duchenne de Boulogne's *Mécanisme de la Physionomie Humaine*, with its atlas of seventy-one photographs, caused a sensation.[1] It was reviewed in both medical journals and in general circulation publications, its author's name even coming to mean a sudden change of expression.[2] The book's reception, certainly unusual for what was ostensibly a textbook of physiology, had much to do with its underlying premise, namely the existence of one, discoverable mechanism to account for the whole vast range of human facial expression. But, however challenging this idea in itself, it was surely the accompanying photographs—odd, humorous, and ironic images—which captured the contemporary imagination.

Today these photographs still exert a curious force, and although they have surfaced from a nearly complete obscurity from time to time, for example in notes on particular rarities in the book market,[3] or more recently as properties for Karel Reisz's 1981 motion picture *The French Lieutenant's Woman*,[4] it is clear from a more systematic examination that their deeper significance has not been plumbed. These pictures were, for example, among the first photographs used for medical documentation of any kind, and the first anywhere to use them as medical book illustrations, matters of at least antiquarian interest.[5] Further, as a figure of some considerable stature in medical and physiological history, Duchenne ventured uncharacteristically into the arts—he considered the *Mécanisme* a reference book for artists—and the results offer a unique perspective on both the art and science of his time. Finally, Duchenne understood very early, and it would seem through intuition alone, both the persuasive potential of the photographic

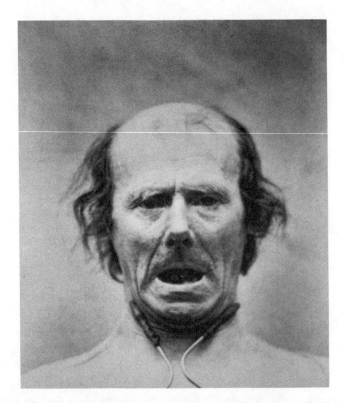

Figure 1. Duchenne de Boulogne, Plate 65 from the *Mécanisme*. The Muscle of Fear, Terror (Platysma Muscle). All photographs by Duchenne de Boulogne are reproduced courtesy of The Bakken Library of Electricity and Life, Minneapolis, MN.

image as a "witness" to reality, and the possibility of manipulating it to serve specific ends. In this, he anticipates a whole range of imagery, including advertising, which has become so familiar in recent decades.

The *Mécanisme* consists of the background, method, data, and interpretation of a physiological experiment made between 1852 and 1856 in Paris. The text of the *Mécanisme*, originally published without photographs in the prestigious French medical journal, *Archives générales de la médicine*, includes a summary of previous literature on the subject of facial expression, a description of the experimental method used, and an elaborate theoretical discussion based on a one-to-one correspondence between muscles and emotions. The text later appeared in a separate volume, accompanied by a second volume of photographs. This atlas, as Duchenne referred to it, contains the experimental data. The faces of human subjects were submitted to carefully controlled electrical stimuli. The results of the procedure, defined as the appearance of the face at precisely the moment of muscular

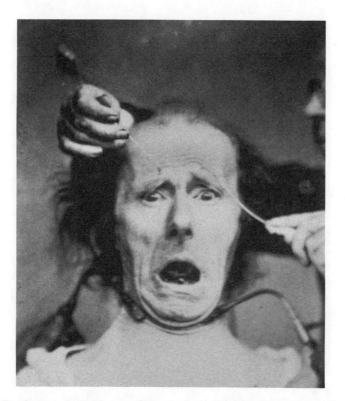

Figure 2. Duchenne de Boulogne, Plate 64 from the *Mécanisme*. ". . . The contraction of the lid is more energetic on the left than on the right; looking at each half of the figure in succession, a gradual increase in pain and fear becomes noticeable."

contraction, were recorded photographically. The atlas includes a legend designating the emotion depicted in each photograph.

Published well before the introduction of photolithography, the *Mécanisme* photographs are actual albumen prints, individually developed and tipped on the appropriate pages.[6] The original edition may have been very small—perhaps as few as a hundred copies. Certainly the work is rare today, and not easily accessible. Neither André Jammes in his discussion of Duchenne and Nadar nor Judith Wechsler in her recent study of caricature in nineteenth-century Paris was able to consult a complete edition.[7]

No doubt because the photographs have been so inaccessible, most studies of the *Mécanisme* to date have concentrated on the text. The text allows an appreciation of Duchenne's exacting research as well as his original scientific contributions to the study of facial expression, gratefully acknowledged by Charles Darwin in a work on facial expression, *The Expression of the Emotions in Man and Animals,* published a decade after the *Mécanisme.*

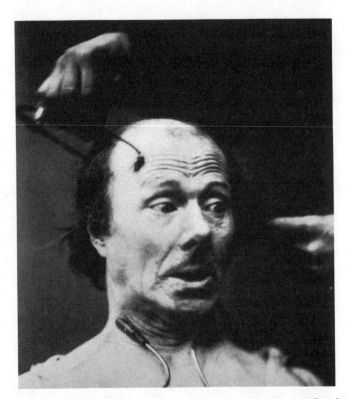

Figure 3. Duchenne de Boulogne, Plate 60 from the *Mécanisme*. "Combined electrical contraction of the platysma muscles and frontalis muscle: fear."

Other literature pertaining to the *Mécanisme* has attempted to evaluate it rather strictly in terms of developments in physiology,[8] as a footnote to Darwin in the area of study of theoretical psychology,[9] or as a milestone in early photography.[10] Only Jammes has picked up the threads of one contemporary esthetic discussion relevant to Duchenne's work, namely whether beauty resides in the active or reposing face and figure.[11]

An overview of the scope and style of the photographs, however, suggests that they deserve to be placed in quite a different context. Their formal resemblance to contemporary photographic portraiture, for example, proves to have only limited meaning. On the other hand, it is clear from Duchenne's purposes and working methods, particularly in contrast to those of Charles Darwin as he worked on the same subject a decade later, that the *Mécanisme* photographs fit only uncomfortably in any scientific tradition. Instead, Duchenne blended the current scientific hypothesis of a "mechanism" with the concept of a human catalogue, or "tableau vivant" bor-

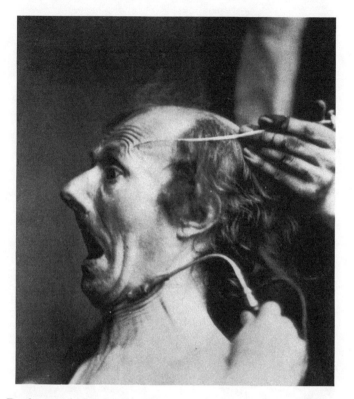

Figure 4. Duchenne de Boulogne, Plate 63 from the *Mécanisme*. "Electrical contraction of the eyelids, the forehead with voluntary lowering of the jaw: terror. . . ."

rowed directly from the arts. He arrived at a definition of art not only as imitation, but as manipulation of life. Science became, for these purposes, the means to adequately understand, and so to effectively control this "art" of manipulation.

The scientific ideas Duchenne advanced in the *Mécanisme* appear to have had some small influence, largely as a result of Darwin's admiration for them. The artistic influence of the photographs was no doubt smaller still; yet his early grasp of the photograph as a tool of persuasion is remarkable, and the progress of his ideas offers an unusual insight into the original ingredients, the "natural history" of the manipulated photographic image.

The Style

On first examination, the *Mécanisme* photographs bear a strong resemblance to contemporary portraiture, and in fact, as Duchenne embarked

Figure 5. Adrien Tournachon, *Gérard de Nerval*.

on his project, he sought the assistance of an established portraitist. His choice was Adrien Tournachon, the younger brother and employee of the much celebrated portrait photographer and caricaturist Gaspard Félix Tournachon, known as Nadar. The best information on this collaboration between Duchenne and the Nadar studio offers proof that Duchenne and Nadar knew one another, but the documentation is thin, and finally it is impossible to guess what transpired.[12] There is, in any case, a certain formal resemblance between Duchenne's pictures and Adrien's:

> From the few authenticated examples of this work which have
> survived, it is clear that Adrien had genuine talent as a photographer.
> His pictures have a slightly theatrical flavor very different from Félix's
> straightforward confrontations, while his use of direct sunlight, without
> a protective screen, often produces striking contrasts.[13]

The portrait of Gérard de Nerval (Fig. 5), for example is attributed to Adrien by Nadar himself, and does in fact very much resemble, technically,

Figure 6. Adrien Tournachon, *Unknown Girl.*

Duchenne's portraits. The dark background and sharply contrasting elements of skin, hair, and clothing achieve a dramatic effect. In pose, lighting, drapery, even loose, flowing hairstyle, the portrait of an "Unknown Girl" (Fig. 6), taken about 1855, resembles Duchenne's portraits of women, particularly those in the eleven additional plates that were added to the *Mécanisme* (Figs. 8–10) sometime shortly after the 1862 edition. The pronounced theatrical flavor of these may owe something to Adrien's special touch, but the evidence is unclear.

It is also possible that artistic influence proceeded in the opposite direction. Whether inspired by Duchenne's work or not, for example, Félix and Adrien collaborated on an exhibition entitled "Les Têtes d'Expression de Pierrot" in 1855, featuring the celebrated mime, Charles Debureau (1829–73) (Fig. 7). The exhibition of photographs portrayed a range of expressions, accompanied with appropriate gestures and props. Since Duchenne states in his preface that the photographs for the *Mécanisme* were taken between 1852 and 1856, it is possible that Adrien got the idea from Duchenne and carried out the work, willingly or not, in conjunction with his brother. It

Figure 7. Adrien Tournachon, from the series *Têtes d'Expression de Pierrot*.

was at this time, too, that Adrien found himself involved in a series of
lawsuits with his brother over the rights to use the name *Nadar*. This is
probably why, in the preface, Duchenne refers only to Adrien Tournachon
and not to the more familiar name Nadar.

In the absence of adequate information regarding the relationship, one
imagines that Adrien found Duchenne's coldly analytical approach to the
sitters incomprehensible or even distasteful. For the Tournachons, what-
ever their differences, both subscribed broadly to the portrait painter's
centuries' old ideal, a single image that yet presents its subject as a unique,
complex, many-faceted being, Duchenne, by contrast, was concerned with
eliminating his sitter's personality as a factor in the picture. Rather than
complexity, he sought maximum simplicity in the presentation of the face.
In short, the formal parallels that may exist between Duchenne's pictures
and contemporary photographic portraiture are largely superficial. More
meaningful stylistic parallels must be sought elsewhere.

The photographs, all of which have the human face as a subject, break down into three distinct groups. The first and largest, designated Plates 3–65 in the *Mécanisme*, contains busts of single individuals, 70 percent of them of one elderly man. The second group, Plates 66–73, shows the head and neck of three classical sculptures, the *Arrotino* (Plates 66–69), the *Laocöon* (Plates 70–72) and the *Niobe* (Plate 73). The third group, Plates 74–84, shows a young blind girl in various costumes and poses, enacting selected scenes from literature. Because they differ so significantly in both format and content, these three groups are more easily considered separately before generalizing about the opus as a whole. The accompanying figures here are representative selections from these groups, and are numbered as follows: first group (busts) Figs. 1–4 and 11–14; sculptures, Figs. 15–17; literary scenes, Figs. 8–10. Figures 5–7 are images by Adrien Tournachon included for comparison.

Within the first group, Duchenne made every effort to facilitate comparison among the images. The size of the photographs as well as the scale of the subject within the frame has been kept uniform. Some variation in the lighting and focus is disturbing. This appears to be unintentional, however, and perhaps related to the considerable technical difficulty of producing these pictures. Not only were lenses suitable for such short exposures difficult to find, but also, it was necessary to coordinate the shutter precisely with the delivery of the stimulus to his subject. In general, Duchenne's attempt at a formal consistency among these pictures was successful, and some slight deviations should be considered inadvertent. Alternations in pose can be ascribed to a desire for maximum clarity. In the vast majority of cases, the subject is posed exactly frontally. A few are in profile, and fewer still are posed at an angle to the lens. In these last cases the purpose is to show the contraction of a muscle which cannot be seen in its entirety in a front view. The general repetitiousness in formal composition calls attention to differences in detail in much the same way a catalogue or an inventory would. But at this point a certain confusion arises concerning which variation in detail is being stressed. On the one hand, there are six different subjects, representing both sexes as well as various ages. A viewer might easily find the differences among the six the most proper object of his attention. But well over half the pictures in this group are of just one subject—a thin, elderly man—and among these it is the variety of facial expression which stands out.

Inasmuch as he tried, via his six subjects, to encompass the variety of human types in his opus, Duchenne may be said to anticipate the direction of August Sander. Sander set out in the 1890s to document the whole of German society, concentrating on occupations and noting the faces and attitudes that so often accompanied them. Duchenne paid decidedly less

attention to social class. He doesn't even mention the matter in his text. But with the possible exception of a young man whom he describes as an "artist," clothing and hairstyle suggest that his subjects were drawn from the lower middle class. He suggests that he chose subjects that had regular though not exceptionally attractive features. His goal was to demonstrate that the appearance of even very ordinary-looking people can be ennobled through art. He assumes, then, not only a physiological uniformity among human beings, but also a common capacity to express emotion, the theme made most famous in photography by Edward Steichen's 1955 *Family of Man* exhibition. A young man (Fig. 11), an old man (Fig. 12), the very well-represented retarded man (Figs. 1–4), a child (Fig. 14), a young woman (Figs. 8–10), an old woman (Fig. 13) all fit into the scheme. All are, at a superficial level, susceptible to the electrode's animating touch. And they are all, by extension, capable of at least physically expressing, if not necessarily experiencing, the full range of human emotion.

It is hard to guess how deliberately Duchenne pursued such themes as "the dignity and beauty of the common man" or "the universality of human experience." It may be that the study of his main subject—the retarded man—was well progressed when these ideas occurred to him, and that the other subjects were added later more or less as an afterthought. In any case, the *Mécanisme* as a view of humanity is far from inspiring. *The Family of Man* made every effort to balance the number of images from different ages, occupations, and geographical areas, and thereby to suggest a cross-section. In the *Mécanisme*'s "world," by contrast, 70 percent of the images are of a mentally retarded person. In only about one percent does the subject express emotion without electrical prodding. No one works, no one plays, no one speaks or touches or interacts with another person. There is no history, no future, no indication of change, in fact no clues as to space or time at all. In this sterile setting there are facial expressions which represent only changes in musculature. Almost all of them are induced by the invisible force, electricity, in accordance with some unknown plan, devised by an unseen mastermind. The expressions bear labels like "pain," "joy," and "fear," but what they mean in terms of human experience we cannot guess.

The forty-five pictures of the retarded man, easily the largest consistent group of images in the *Mécanisme*, invite other kinds of comparison when taken up in isolation. They no longer make any pretense of reviewing the variety of the human condition, but instead examine the range of one expressive possibility. In this attempt, they recall more recent attempts to document the variety of one personality. Stieglitz's *Portrait of Georgia O'Keeffe* may serve as an example. The idea of multiple images has become familiar in the twentieth century. It ordinarily triggers an attempt on the part of

the viewer to distill from the variety among such collections a single, hypothetical substrate—quite possibly not even a visual one—that is common to all. The individual images come to represent possibilities, so many allowable configurations within the established confines of face, experience, and personality. But the forty-five images under consideration here do not actually show possibilities of this face under the voluntary control of a personality. Thus the series is not, as it is in the case of the O'Keeffe portrait, an attempt to overcome the natural limits—one instant, one place, one aspect—of the single image. Rather they show the extremes to which the face can be artificially forced, and so achieve almost exactly the opposite effect. The varieties of facial expression, made to occur *per se*, devoid of context, lose their individuality and fade into a single image. The pictures all show the same man in the same clothes in (apparently) the same setting. Whatever has happened over the time of the picture-taking is not apparent to us. From the evidence the photographs themselves provide, it seems all could have been taken in the same instant. The facial changes thus are reduced to just themselves, stripped of their capacity to convey meaning.

Particularly in this isolation of facial expression from its context, Duchenne's pictures resemble the extensive "self-portrait" in sculpture by Franz Xavier Messerschmidt (1737–84). In both cases, the work proceeds from the idea of an emotion to its physical appearance, rather than the other way around. In the prominence of the ambiguous, forced "grimace," too, the two bodies of work seem to have parallels. Ernst Kris has presented Messerschmidt's sculpted self-portraits as the attempt of a disturbed psyche to heal itself, and the strong parallels with Duchenne's work might suggest a similar conclusion.[14] But there is no evidence that Duchenne suffered from any emotional instability, and his interest in facial musculature, far from a morbid symptom, is completely understandable in the context of his career in physiology.

A second group of photographs of selected ancient sculpture (Figs. 15–17) and a third group of certain contrived theatrical-looking "scenes" (Figs. 8–10) make up the remainder, the "partie esthétique" of the *Mécanisme*. In comparison to the body of portrait-like pictures, the "partie esthétique" more consciously addresses artistic questions.

Both the series dealing with classical statuary and the reenactments of "great moments" in art and literature suggest some adherence to classical values. Duchenne has actually presented the ancient sculptures as emblems to stand for art altogether. He then proceeds, however, to discredit the idols by curious means, namely the arguably "classicist" standards of rational science. He points out where the musculature of the sculptured figures is "impossible" and, not content with an astute observation, proceeds to the conclusion that the forms are, therefore, flawed in terms of

their beauty as well. One of Duchenne's contemporary critics, Amédée Latour, saw in this conclusion a link between Duchenne and the controversial Realist movement of the time as represented most forcefully by Gustave Courbet:

> It's remarkably convenient that physiology would suit itself so well to the sentiments of art. We believe, however, that the real objection to be leveled at M. Duchenne is not this; he's rather to be reproached for stripping art of its every ideal, reducing it to an anatomical realism every bit in keeping with the tenets of a certain modern school. In fact his treatment of three celebrated antiques—the *Arrotino*, the *Laocöon* and the *Niobe*, whose orthographic errors he alleges to correct, appears rather brutal to those who cherish the ideal. So the masterpieces suffer a blow. M. Courbet would jump for joy. But M. Ingres and the whole Ecole des Beaux-Arts![15]

It's clear that Duchenne admired accuracy in representation, and it appears that he made no distinction between "beauty" and "accuracy" as positive ideals in visual art. And yet to align Duchenne with the Realist movement is surely to misunderstand Realism as well as to overestimate Duchenne's awareness of contemporary culture. Courbet's realism, for example, was largely defined by his subject matter rather than his manner of representation. Duchenne's brand of "realism" is so narrow as to scarcely apply to any artistic platform. He proceeds on the assumption that accuracy, a precise illusion of things seen, is the artist's—any artist's—overriding concern. Having impugned the perfection of classical sculpture, he continues his attempt to resolve the question. "If these are not perfection," Duchenne seems to ask, "what is?"

The next group of photographs ventures an answer (Figs. 8–10). Here, he has very deliberately aped conventions of painting. In his text, in fact, he refers to specific works which he particularly admires, and which clearly suggest to him the specific emotions he wished to depict in the pictures. He describes the expression in his Plate 77 (Fig. 8), for example, as a combination of "human love" with "celestial love," and likens it to the expression on Bernini's sculpture, *St. Theresa in Ecstasy*. Again, three of his pictures reproduce expressions appropriate to specific scenes in *Macbeth*, for example an expression of "extreme cruelty" as befits the moment when Lady MacBeth murders Duncan [sic].

The fact of these pictures being so closely tied to literature would suggest an especially close connection to Romantic "narrative" imagery, and more specifically to that genre of nineteenth century painting which Gombrich describes as "anecdotal":

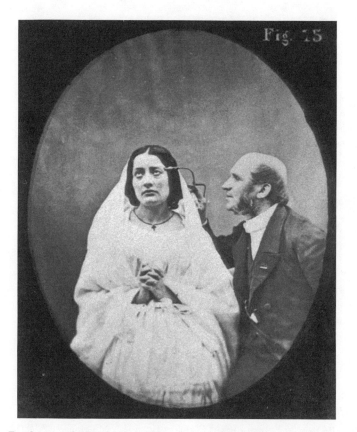

Figure 8. Duchenne de Boulogne, Plate 75 from the *Mécanisme*. "Nun pronouncing her vows; pain, resignation on the left and simple sadness on the right. . . ."

> . . . there must be a great difference between a painting that illustrates a known story and another that wishes to *tell* a story. No history exists of this second caegory, the so-called anecdotal painting which flourished most in the nineteenth-century salon pictures. . . .[16]

It is this kind of story-telling picture which, as Gombrich further suggests, lends itself for use to specific purposes, to serve social or commercial goals:

> Advertising, for instance, frequently demands the signalling of rapturous satisfaction on the part of the child who eats his breakfast cereals, the housewife who uses a washing powder, or the young man

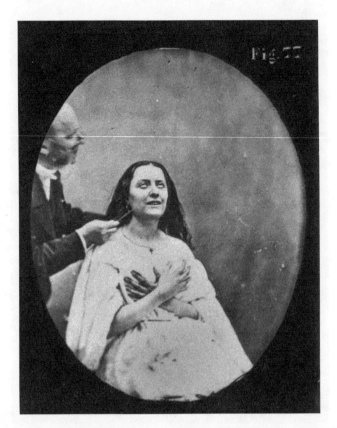

Figure 9. Duchenne de Boulogne, Plate 77 from the *Mécanisme*. "Earthly love on the right, celestial love on the left. Ecstasy of human love, if the left half of the face is covered; sweet ravishment of divine love (St. Theresa in Ecstacy) if the opposite side is covered."

 smoking a cigarette. . . . Clearly the commercial artist and the commercial photographer are likely to know a great deal about the degree of realism and stylization that produces the optimum results for this purpose. . . .[17]

Whether or not Duchenne's pictures are fairly seen in this context, as rough forerunners of the persuasive images that surround us today, the level of contrivance in these pictures is probably their most salient characteristic. Unlike the contemporary photographic portraiture that they very superficially resemble, Duchenne's pictures make no attempt to capture an existing, if fleeting reality. The manipulation of subjects into a range of gestures and expressions well beyond that encountered in everyday experience contrasts sharply with the idea of documentation, even that of a

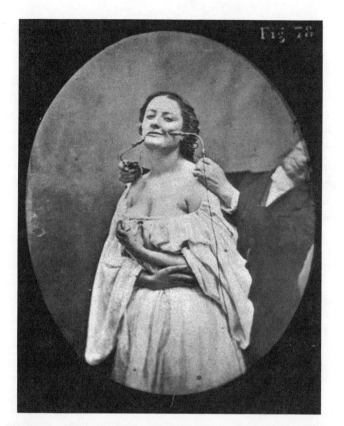

Figure 10. Duchenne de Boulogne, Plate 78 from the *Mécanisme*. "Scene of coquetry, with different expressions on left and right sides. Covering the lower part of the face gives it an offended air; covering the lower left quadrant there is a disdainful look; a mocking smile when the lower right quadrant is covered."

composite document sought by portraitists. Duchenne wants to document something. This is clear from his discussion of the camera as witness, the recital of the "straight" photographer's credo with regard to printing and touch-up. But that "something" is not any part of common experience, anything he and the viewer might have in common. Rather it is something of his own making. It is as if, by means of his "art," Duchenne would persuade us that his electrically fabricated illusions are real.

The Mécanisme *as Science*

What few historical judgments have been made at all of Duchenne's *Mécanisme* have come almost exclusively from the perspective of the physiologist, neurologist, or psychologist. The work was originally presented

as science. It has been judged as such and, whether fairly or not, has been found wanting in various ways. The reasons are not obscure. For one thing, electrical stimulation had never really become legitimate medicine.[18] A quick association of the technique with quackery was never far in the background. Further, the science of psychology, into whose territory Duchenne had clearly crossed, was so young as to have no independent existence at all, and hardly commanded much respect. Finally, even a casual observer might have noted that the *Mécanisme* did not *look* like a work of science; Duchenne's professional peers traced the problem more specifically to experimental design. The peculiarly "unscientific" nature of the *Mécanisme* becomes clearer in contrast to Charles Darwin's *The Expression of the Emotions in Man and Animals*, published a decade after the *Mécanisme* in 1872. In the preface to his work Darwin wrote:

> In 1862 Dr. Duchenne published two editions, in folio and octavo, of his 'Mécanisme de la Physionomie Humaine,' in which he analyses by means of electricity, and illustrates by magnificent photographs, the movements of the facial muscles. He has generously permitted me to copy as many of his photographs as I desired. His works have been spoken lightly of, or quite passed over, by some of his countrymen. It is possible that Dr. Duchenne may have exaggerated the importance of the contraction of single muscles in giving expression; for, owing to the intimate manner in which the muscles are connected . . . it is difficult to believe in their separate action. Nevertheless, it is manifest that Dr. Duchenne clearly apprehended this and other sources of error, and as it is known that he was eminently successful in elucidating the physiology of the muscles of the hand by the aid of electricity, it is probable that he is generally in the right about the muscles of the face. In my opinion, Dr. Duchenne has greatly advanced the subject by his treatment of it. No one has more carefully studied the contraction of each separate muscle, and the consequent furrows produced on the skin. He has also, and this is a very important service, shown which muscles are least under the separate control of the will. He enters very little into theoretical considerations, and seldom attempts to explain why certain muscles and not others contract under the influence of certain emotions.[19]

Darwin understandably admired the precision in Duchenne's study, his careful delineations of the muscles and nerves involved in each part of the "tableau," as well as the stupendous effort represented by the photographs. It must have at least offered a refreshing antidote to those muddy observations by such popular authors as LeBrun, whose course for artists had gained much attention, or Lavater, whose guide to human physiognomy was presented and viewed rather like a "self-help" book.[20] It seems possible,

too, that Darwin instinctively sympathized with Duchenne's deductive approach to science, an approach very like his own. Both investigators proceeded from theory—in Darwin's case, the evolution of species, in Duchenne's the "grammar" of expression—to observations. But whereas Duchenne is concerned with reproducing the external form of an emotion, Darwin attempted to document a biological purpose and hence an evolutionary history for the phenomenon of expression. Darwin makes no attempt to present a comprehensive catalogue of expressions, nor is there anything like the concern with pose, lighting, in short, with the form of the illustrations that is to be found with Duchenne. Broadly speaking, Darwin's book is a text expanded and clarified with photographs; the *Mécanisme* is a collection of pictures accompanied by elaborate captions.

Darwin sought not simply the exact form of various expressions, but their meaning and origin. To this end he felt he needed to overcome the inherent biases of an observer's "sympathy" with the subject matter. His attempt to devise an objective investigation had a number of aspects: he included infants in his study as sources of emotion "purely" expressed; he studied the insane for similar reasons; he sought information about expression in non-European cultures; he attempted to draw parallels between expression in humans and in animals. His conclusions are expressed as principles, and he offers some broad speculation as to how the muscle configurations of various expressions might have been acquired over the course of centuries.

In contrast to Darwin, Duchenne starts not with an idea of historical continuity, nor even really with the idea of a mechanism, by which the "stimulus" of particular emotion produces a specific "response" in the form of an expression. He actually begins with the idea of "joy" or "fear" and a notion, drawn from visual experience, of how the idea can be conveyed. The investigator then proceeds to re-present this "vision" not with paint or pencil, but with the "canvas" of willing subjects, the appropriate "shade" of induced current, and an impassive witness, the camera.

Nowhere is the contrast with Darwin more evident than in Duchenne's choice of subjects. The subject in most of the pictures (Figs. 1–4), for example, is an elderly retarded man, on whose very thin face muscular contractions were relatively easy to see. This man had other important assets as well. An extensive facial anesthesia had rendered him almost completely insensitive to the pain of electrical shocks; further, he had a very "inoffensive" disposition. Duchenne remarks approvingly that, "I was able to partially contract his muscles with as much precision and confidence as on a still-responsive cadaver."[21]

Duchenne was not unaware of the problem of studying expression in the absence of emotion, but he thought he had solved the problem by

Figure 11. Duchenne de Boulogne, Plate 4 from the *Mécanisme*. Portrait of the control subject. "His physiognomy is at rest, his features are pleasing and regular."

introducing a control subject (Fig. 11). This man did not receive artificial stimulus, but reportedly was able to induce the desired emotions in himself on cue:

> He is both a talented artist and an anatomist with sufficient curiosity to make such a study on himself. Drawing on his feelings, he reproduced exactly the majority of the expressions governed by each of the forehead muscles. He obliged me by subjecting himself to the experiment and authorizing me to present the results in photography.[22]

Duchenne remarks that the project would not have been complete without this subject's having provided *"movement expressifs naturels,"* to serve as a contrast to the artificially produced ones. His reason is not, as one

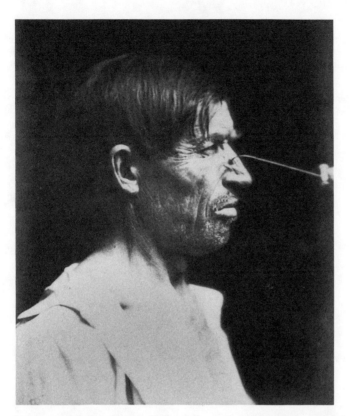

Figure 12. Duchenne de Boulogne, Plate 41 from the *Mécanisme*. "Muscle of Lasciviousness (nasalis muscle). . . . The movement imprinted on the sides of the nose by the nasalis muscle . . . and the form it takes when the nose is aquiline. . . ."

might expect, a desire to compare the expression of actual emotion with expression *per se*. Rather he is interested in the fact that in some muscles, the external stimulus cannot produce partial contraction, only complete contraction. Partial contraction can in these cases only be produced through voluntary control.[23] The live cast of *Mécanisme* is rounded out with representatives of various ages and both sexes. In none of these cases is the name or any personal data included. Despite the presence in the photographs of the electrodes and in some cases of the hands holding them, Duchenne writes in conclusion, "the expressions I photographed are not any less realistic for their being artificial."[24]

Certainly the scientific contributions of the *Mécanisme* should not be underrated. Duchenne's correlation of specific nervous and muscular effects with specific expressions, although inaccurate in some respects, was

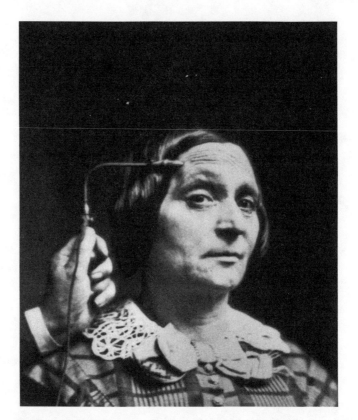

Figure 13. Duchenne de Boulogne, Plate 11 from the *Mécanisme*. ". . . Secondary lines . . . produced by strong electrical stimulation of the frontalis muscle in a forty-one-year-old woman whose skin has been burned by the sun. . . ."

unquestionably original. The *Mécanisme* also presents for the first time anywhere the interesting phenomenon of "filling in" an incompletely viewed expression: an observer will instantly judge the tenor of an expression based on the sight of only a small part of it. Further, Duchenne noticed and described in some detail marked differences he had observed between the right and left sides of the face in various expressions, thereby suggesting, if not actually stating some difference between the two sides in nervous and muscular control. Finally, Duchenne's employment of photography in the study of expression was prophetic. Only much later, in studies quite different in experimental design, were the possibilities explored more fully. Darwin had himself noticed the diversity of answers he received when he circulated some of Duchenne's photographs among friends and asked them to name the expression represented. Through photogra-

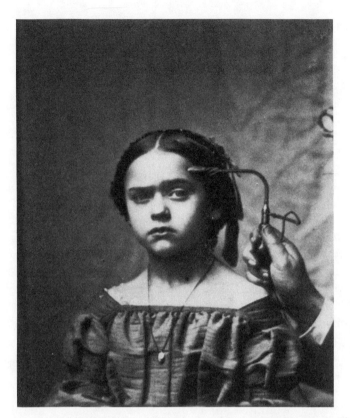

Figure 14. Duchenne de Boulogne, Plate 10 from the *Mécanisme*. ". . . The expressive lines of the frontalis (forehead) muscle in a young girl. On the right, electricalisation of the brow line (elevation and curving of the eyebrow) without producing lines in the forehead."

phy, at least the raw visual data could be fixed, leaving only the interpretation to vary. This kind of experiment later proved valuable for various kinds of psychological evaluations.[25] Still, however well Duchenne manipulated the facial musculature to desired effect, the investigation at no point had anything to do with actual emotions. It thus must be considered a study of external forms.

The Tableau Vivant

Whenever the spirit is moved, the human face becomes a *tableau vivant* (living picture), where the passions are shown with delicacy as well as energy, where each change is expressed as a mark, each action by a

character whose swift and lively impression outstrips the will, we
betray and expose, through involuntary signals, pictures of our most
secret emotions.

George-Louis Leclerc, Compte de Buffon, *Histoire naturelle* . . .
1749–1804.

Buffon was among the first scientists since the Renaissance to attempt
a comprehensive description of the natural world. The recurrent themes
in his monumental, forty-four volume *Histoire naturelle* included the exis-
tence of natural hierarchy among diverse beings, and the discoverability
of principles governing the chaotic world of appearances. These ideas
appealed strongly to the generations that immediately followed, and the
Histoire naturelle numbers among the most influential books of the nine-
teenth century. His approach was that of a surveyor; his goal, to present
a master scheme into which every detail one might observe, now and
forever, could be made to fit. His treatment of human expression, well in
keeping with these themes, introduced two distinct notions: first, a sweep-
ing, comprehensive catalogue of "tableaux vivants," and second, an un-
derlying principle, a mechanism which registers the states of the soul upon
the human face. The same quotation, significantly, introduces the *Mécan-
isme*.

Even without such a direct tribute, however, Duchenne's admiration for
Buffon's thought would be apparent, for the *Mécanisme* attempts both to
analyze the process of expression, that is the function of the nervous and
muscular systems that control it, and also to actually present, in photo-
graphs, Buffon's figurative "tableaux vivants." The first of these goals fits
quite comfortably with the prevailing concerns of nineteenth-century sci-
ence, its broadly mechanistic view of nature, its willingness to subject any
phenomenon whatsoever to its scrutiny. The second goal, however, be-
longs more properly in the general sphere of art, for it is concerned less
with how expressions occur than with exactly how they look and how they
may be reproduced.

The *tableau vivant* reflects a pervasive goal of the arts of the mid-nine-
teenth century, namely the building of an all-inclusive scheme, an ordering
of the world into a rational system. In her recent book, *A Human Comedy:
Physiognomy and Caricature in Nineteenth Century Paris*,[26] Judith Wechsler
points to the vast influx of provincials and foreigners into the city as a
possible cause for such intense interest. An unprecedented diversity of
languages, habits, and traditions existing side by side encouraged the elab-
oration of a nonverbal code, a "language" made up of facial types, gestures,
and expressions.[27] Possibly offering a means of comprehending an other-

wise confusing variety of cultural impressions, the coding process extended to humans themselves, their faces, their postures, gestures, and expressions. The notion of generic "types" offered slots into which strangers could be fit, and quickly grasped, understood, made "safe." A parallel interest in the codification of gesture, the linking of movements with precise meanings, is reflected in mid-century enthusiasm for mime.

It is quite natural that Duchenne, living in Paris at just the time when the Parisian public's fascination with urban "types," with caricature, and with the "science" of physiognomy was at its peak,[28] should have taken an interest in such matters, at least in a general way. Nor is it particularly surprising that he would consider expression a suitable topic for scientific investigation. The text of the *Mécanisme* includes a "coup d'oeil historique" (historical overview) in which Duchenne reviews the works of his scientific predecessors in the study of the emotions. These, together with Darwin's later interest in the subject, suggest that even if the topic was not exactly at the center of scientific interest at the time, neither was it obscure. But that Duchenne would adopt the concept of the *tableau vivant* for purposes of his study is remarkable.

It is clear from Duchenne's published statements as well as from the photographs themselves that an esthetic motivation was very strong, if not primary in making the pictures. Scientific photographs were by no means unknown at the time, although the difficulty of reproducing them in quantity had discouraged their use until after 1855.[29] Photographs had also been made as documentation in the medical histories of patients.[30] Duchenne's photographic ideas seem not to have sprung from any such source, however. In his own description, they more closely resemble an artistic vision:

> In photography, as in painting or sculpture only what has been
> profoundly felt can be profoundly expressed. Art does not arise from a
> practiced dexterity alone. In regard to my research, one must know
> how, by means of a judicious distribution of light, to highlight one or
> another expressive line. This cannot be accomplished by even the most
> skillful artist; he would not understand the physiological facts to be
> demonstrated.
> It was therefore necessary for me to learn the art of photography.[31]

Apparently he was, furthermore, satisfied with his results on esthetic grounds:

> . . . one observes that in general the light in the photograph
> harmonizes perfectly with the emotions presented by the expressive

lines. Thus those that portray somber, inward emotions: aggression, spite, suffering, pain, fear, torture mixed with terror; profit particularly in energy under the influence of chiaroscuro; they recall the manner of Rembrandt (see Figures 18, 20, 60, 65). For other figures made in full sunlight, a very short pose sufficed, details are very sharp, shadows well-defined; there are other chiaroscuros, in the manner of Ribera (see, among others, Figures 22, 40, 41, 42). Finally, there are a number of very bright photographs, evenly illuminated: these are primarily the ones showing astonishment, amazement, admiration, gaity (see Figures 11, 31, 33, 56, 57).[32]

As he embarked on his project, he sought the assistance not simply of a technician, but of an established portraitist. Ultimately, however, he insisted on taking all of the pictures himself.

I took most of the photographs myself, or oversaw their execution. M. Adrien Tournachon, a photographer whose skill is known to all, put his talents at my disposal for several shots, and, so as to leave no doubt whatsoever as to the authenticity of the events depicted, I did not allow the photographs to be retouched in any way.[33]

In turning abruptly, about 1850, from pathological physiology to the *Mécanisme*, he was no doubt seeking a radical change of activity. Clearly he felt that the artist, probably in contrast to the scientist, led a life dominated by strong emotion, its rewards being great independence and spiritual, if not financial, riches. It is not unusual for a scientist, especially after a long career in a narrow discipline, to seek out some field traditionally considered creative, such as music, literature, or visual art. It is easily understood that Duchenne, in his mid forties, would have needed such a change, and easily believed that he was neither so fully aware of it nor, therefore, so well able to articulate it as others have been. His social isolation goes far toward explaining his willingness to venture forth from the familiar confines of research physiology and live, however briefly, the "artist's life."

In his working method, his choice of subjects and collaborator, but above all in his adoption of the *tableau vivant* as an ideal, Duchenne exposed his own artistic pretensions. Probably without recognizing it, he fused the two concepts of mechanism and tableau into one. The original purpose of delineating facial nerves and muscles slid quietly into the production of beautiful—that is, convincing—pictures. The very term *mechanism*, having originally meant the means through which actual emotion becomes visible on the human face, became a mechanism for controlling the face, inducing it to convey on cue some prefabricated "reality."

Figure 15. Duchenne de Boulogne, Plate 66 from the *Mécanisme*. "Side view of the *Arrotino* [in which] the lines extending across the entire width of the forehead could not be present with either the slope or the sinousness of the brow since the two muscles . . . function in opposition to each other."

Conclusion

At the time it was made, Duchenne's *Mécanisme* stood in glorious isolation from its own intellectual climate. As a work of science, it contained much that was original. Yet its premises were internally contradictory, its thrust too diffuse to really mark an advance in either physiology or psychology. As art it was illegitimate, for it consisted of photographs—still suspect by the standards of Duchenne's time—made to serve an external, that is, a nonvisual objective. At more than a century's remove, however, the *Mécanisme* looks very much the product of its time and place and, at a more basic level, a harbinger of things to come. The photographs incorporate a great many of the picture-making clichés of their time—theatrical

Figure 16. Duchenne de Boulogne, Plate 73 from the *Mécanisme*. "Head of *Niobe*, which with flat forehead and the uninterrupted brow line, does not correspond to the modeling produced by the movement of pain."

props, gesturing, lighting—in combination with the will to comprehend and catalogue the world and to find in it one comprehensive structure.

It may be that the *Mécanisme* most closely resembles one of the handbooks of mime, popular at the time, in which an attempt was made to match expression, for the most part isolated from any context, with specific meaning. Duchenne's approach to the subject as natural science, however, substantially heightened both the authority and the absurdity of the proceedings. Duchenne speaks of the expressions as a universal and immutable language instituted, as part of nature itself, by God:

> The Creator . . . did not have to concern Himself with mechanical requirements, He was able, in His wisdom, to activate this or that muscle, one alone or several at a time, for the wanted characteristic marks of the emotions, even the most fleeting, to be briefly written on

Figure 17. Duchenne de Boulogne, Plate 71 from the *Mécanisme*. "Head of *Laocöon* at Rome, in which the side of the forehead has been remodeled true to the nature, as it should have been in Figure 70 [the actual sculpture]."

the human face. Once created, the language of physiognomy was adequate for Him to render universal and immutable, to give each human being an instinctive capacity for always expressing emotions with the same muscles.[34]

Unlike contemporary "self-help" books, artists' manuals, or mime in-structors, the *Mécanisme* went beyond custom, habit, or accidents of nature, and dealt with a physical truth as rigid as blood or bones. "Scientific," then perhaps as much as now, meant something very close to "true." But Duch-enne had thrown the weight of such authority behind a concept too fragile to bear it. The tableau of human expression, ostensibly a more appropriate title for the work, was limitless in its scope, infinitely subtle in variation. It could not bear quantification, and the attempt to do so looks, in retro-spect, ironic. The secondary idea, a mechanism of human expression, did

present a testable theory. It was the idea which earlier Charles Bell and later Darwin pursued, and which, though roundly criticized for nearly a century, has recently regained a degree of acceptance.[35]

In attempting to merge the fundamentally visual idea of the *tableau vivant* with the essentially scientific idea of a physical and chemical mechanism of expression, Duchenne cut himself off from both mainstreams. He did, however, produce some remarkable images. Their crazy, funny, ironic quality is matched only in very recent photography, where the uncomfortable union between form and content deliberately disorients, shocks, or amuses the viewer. Unlike his modern counterparts, Duchenne certainly did not intend to convey the picture of a strange, confusing, and arbitrary world; he did so as a natural consequence of merging disparate goals.

He could not have known that fabricated pictures, displaying the same play of emotions, the effort to persuade, the appeal to noble ideals of science, art, and nature would become ubiquitous a century later. Not only in much recent art, but in the idea of the "media" personality, in the whole grand "science" of advertising the same principles are at work. Duchenne was certainly naive, both in his simplistic conception of the artist's "problem" and his faith in the power of science to solve it. But his naiveté fitted him to prepare a unique document. In addition to its scientific contribution, the *Mécanisme* presents a curious "medical" perspective on mid-century art. It illuminates the limits of mid-century neurology and psychology, the issues under discussion, and the route that speculation was taking. The pictures' resemblance to some recent photography, too, raises some puzzing questions about the deeper roots of current photographic esthetics.

Strictly on their own terms, these photographs are unsuccessful: Duchenne tried to reduce art to a formula, expression to a predictable pattern, and these efforts were inevitably doomed to failure. Given the presence of the electrodes and the authors' explanations of how the images were fabricated, the pictures cannot persuade at an emotional level. They do not engender empathy. They are, however, persuasive of a *possibility*. The appearance of emotion, Duchenne implies, can be manipulated precisely. Essentially any effect is possible, given the appropriate techniques and skills. What is more, the possibility is not given only to the rare artistic genius, but to anyone who cares to learn a method. He offers, then, a reliable rule for creating persuasive images, the sort of rule apparently better suited to the purposes of advertising than to those of painting or sculpture.

To all appearances, Duchenne wasn't advertising anything. But the cast of his text is nevertheless polemical. He argues for a methodical, accurate, in short, for a scientific—as he perceived it—approach to the production of images. He seems to understand well enough the emotional power of

the photograph and to sense that this power should not be wielded sloppily or piecemeal. It should rather be subjected to disciplined study, its underlying principles exposed, recorded, and transmitted to the generations to come. Duchenne set out to establish the natural laws of an art that "works," principles of visual cause and effect that would stand for all time. From the design of his experiments it is clear that he had sensed a fundamental irony in the photographic image, a tension between the "truth" the camera records and the limitless artifice possible on both sides of the lens. In his pictures he began an experiment with that irony, an investigation of its expressive possibilities that is still in progress today.

Notes

1. Duchenne de Boulogne, Guillaume-Benjamin-Amant, *Mécanisme de la physionomie humaine; ou analyse électro-physiologique de l'expression des passions.* Paris: Vve de Jules Renouard, 1862, avec un atlas avec 74 figures électro-physiologiques photographiées. The work exists in two quite distinct parts: the text, which appeared first in *Archives générales de la médicine*, Ve serie, 19 (1862) 29–47 and 152–74, was published later that year as a separate volume. It contains a historical review of literature and a lengthy theoretical discussion, including tables of the expressions and the muscles that control them, but there are no illustrations. This text volume is relatively common; the atlas, however, consisting of a preface, legend to the figures, and a stack of unbound pages, each with a tipped-in photograph, all tied in a cardboard wrapper, is quite rare. The subtitle refers to seventy-four "figures électro-physiologique photographiées"; in fact there are seventy-one photographs. Three drawings in the text, labeled Figures 1, 2a, and 2b, of Duchenne's induction coil and of front and side views of the facial musculature probably figure in the total. The publications I examined for this study included a complete 1862 edition, text and atlas; the text in *Arch. gén. méd.* (1862); the plates for a subsequent, though not actually the second edition, probably from early 1863, which contains eleven more photographs in the "partie esthétique" and nine composite plates, published by J.-B. Ballière et Fils; and the text only of the second edition, 1886. All are in the collections of the Bakken Library, Minneapolis.

2. André Jammes, "Duchenne de Boulogne, la grimace provoquée, et Nadar," *Gazette des Beaux-Arts* 92 (December 1978): 218.

3. Stephen White, "The Photographically Illustrated Book," *AB Bookman's Yearbook* (1982): 21–22. White estimated the price roughly three times higher than that quoted by two different dealers within the past three years.

4. In the film, the photographs appear as the property of the doctor, Charles's friend, and are shown to Charles as evidence of the alienation and estrangement suffered by the emotionally disturbed. Although the photographs probably serve their purpose adequately in the context of the film, the original intention was quite different.

5. Alison Gernsheim, "Medical Photography in the Nineteenth Century," *Medical and Biological Illustration* 11:2 (Arpil 1961): 85–92.

6. Thanks are due to Christian Peterson, Department of Photography, Minneapolis Institute of Arts, for his assistance in identifying the photographic process.

7. Judith Wechsler, *A Human Comedy: Physiognomy and Caricature in Nineteenth Century Paris* (Chicago: University of Chicago Press, 1982), 190; André Jammes, "Duchenne," 215.

8. The most detailed account of Duchenne's life appears in Paul Guilly, *Duchenne de Boulogne* (Paris: Librarire J.-B. Ballière et Fils, 1936). The most extensive notes in English are in J. Collins, "Duchenne de Boulogne," *Medical Record*, 73 (1908): 50–54. Shorter notes appear in *Bibliographisches Lexikon der hervorragender Ärtzte aller Zeiten und Völker* (Munich-Berlin: Verlag von Urban & Schwarzenberg, 1862), vol. 2, 322–25, and in "Duchenne de Boulogne: Sa vie scientifique et ses oeuvres," *Archives générals de la médicine* (July 1875): 687–715. Duchenne is also mentioned in Raymond Adams, *The Founders of Neurology*; John H. Talbott, *A Biographical History of Medicine*; V. Robinson, *Pathfinders in Medicine*; H. M. Gardiner, Ruth Metcalf, John G. Beebe-Center, *Feeling and Emotion: A History of Theories.*

9. Duchenne's role in the history of psychology has been taken up by George Dumas, *La Sourire* (Paris: Alcan, 1906) and *Nouveau Traité de la Psychologie*, t. III (Paris: Alcan, 1933). Also Th. Ribot, *The Psychology of the Emotions* (New York: Charles Scribner's Sons, 1911).

10. For photographic history, see especially Gernsheim, "Medical Photography" and White, "The Photographically Illustrated Book," cited above, and Rolf H. Krauss, "Photographs as Early Scientific Book Illustration," *History of Photography* 2:4 (October 1978): 291–314.

11. Jammes, "Duchenne." Abigail Solomon-Godeau ["Calotypomania: A Gourmet Guide to Nineteenth-Century Photography," *Afterimage* 11:1 and 2 (Summer 1983): 7–12] also cites Jammes as the only investigator to consider Duchenne in an esthetic context. She incorrectly notes that the photographs depict "(primarily) women in asylums" (p. 11). In fact, fewer than half are of women, and only one subject—not a woman—had been institutionalized. In any case, whether or not the photographs have any esthetic value in their own right—and her assessment of them as "horror pictures" does not seem too wide of the mark—they do make quite deliberate references to visual art.

12. Ibid.

13. Nigel Gosling, *Nadar* (New York: Knopf, 1976), 40.

14. Ernst Kris, "A Schizophrenic Sculptor of the Eighteenth Century," *Psychoanalytic Explorations in Art* (New York: International Press, 1952). Kris describes in passing the particular psychology of the grimace as, roughly, "crossed signals," either a momentary (or, in abnormal conditions, longer) loss of control over the expressions or a deliberate, conscious mixing of expressions for some purpose, for example, posing. Duchenne, too, quite precisely describes a grimace, providing the exact conditions under which he produced one in his experimental subject. Referring the reader to a schematic illustration of the facial muscles, he explains how too strong a stimulus at a certain point on the face caused more than one

muscle to contract at once. Thus more than one expression is produced, and the result is "ne qu'un grimace" (*Mécanisme* atlas, 12).

15. Amédée Latour, "Mécanisme de la physionomie humaine," *Union médicale*, Paris, 15:100, 103 (26 August, 2 September, 1862): 422.

16. E. H. Gombrich, "Action and Expression in Western Art," *Non-Verbal Communication* (Cambridge: Cambridge University Press, 1972): 391–92.

17. Ibid., 392.

18. Duchenne was certainly not, as Gernsheim ("Medical Photography") suggests, the "founder of electrotherapy." France in particular could already trace a lively history of electrical medicine, including the faith healer Franz Mesmer and his opponent Benjamin Franklin, the revolutionary figure Jean-Paul Marat, and the Abott Sans (Bertholon).

19. Charles Darwin, *The Expression of the Emotions in Man and Animals* (London: John Murray, 1872), 5.

20. Johann Caspar Lavater, *L'art de connaître les hommes par la physionomie* (Paris, 1806–9), in Dr. Moreau de la Sarthe, ed., *Essay on Physiognomy for the Promotion of the Knowledge and the Love of Mankind* (London, 1789); Charles LeBrun, *Conférence de M. LeBrun sur l'expression générale et particulier des passions* (Amsterdam, 1698).

21. Duchenne, *Mécanisme*, Album, 7.

22. Ibid., 8–9.

23. Ibid., 8.

24. Ibid., 7.

25. Paul Ekman, *Darwin and Facial Expression: A Century of Research in Review* (New York: Academic Press, 1973), 9.

26. Wechsler, *A Human Comedy*, 13.

27. Ibid., 20.

28. Ibid., 24.

29. Krauss, "Photographs as Early Scientific Book Illustration."

30. Gernsheim, "Medical Photography."

31. Duchenne, atlas, vi.

32. Ibid., viii–ix.

33. Ibid., vi.

34. Duchenne, *Mécanisme* (1876), 31.

35. Ekman, *Darwin and Facial Expression*.

Bibliography

Antal, Fredrick. *Classicism and Romanticism with Other Studies in Art History.* New York: Basic Books, 1966.

Bell, Charles. *Essays on the Anatomy of Expression in Painting.* London, 1806.

Bertholon (l'Abbe Sans). *De l'Electricité du Corps Humaine dans l'Etat de Santé et de Maladie.* Paris, 1780, 1784.

Billeter, Erika. *Malerei und Photographie im Dialog von 1840 bis Heute.* Bern: Benteli, 1979.

Cerise. "Critique sur le méchanisme de la physionomie humaine." *Journal des Debats* (August 29, 1863).

Collins, J. "Duchenne de Boulogne." *Medical Record*, N.Y., 73 (1908): 50–54.

Darwin, Charles. *The Expression of the Emotions in Man and Animals*. London: John Murray, 1872.

Depardon, Raymond and Lauren Shakeley. "Asylum." *Aperture* 89 (1982).

Duchenne de Boulogne, Guillaume-Benjamin-Amant. *Mécanisme de la physionomie humaine; ou analyse électro-physiologique de l'expression des passions*. Paris: Vve de Jules Renouard, 1862, avec un atlas de 74 figures électrophysiologique photographiées.

Eitner, Lorenz. *Neoclassicism and Romanticism*, vol. I. Englewood Cliffs, N.J.: Prentice Hall, 1970.

Ekman, Paul, ed. *Darwin and Facial Expression: A Century of Research in Review*. New York: Academic Press, 1973.

France, *Rapport des commissaires chargés par le roi, de l'examen du magnetisme animale*. Paris, 1784.

Gernsheim, Alison. "Medical Photography in the Nineteenth Century." *Medical and Biological Illustration* 11, no. 2 (April 1961): 85–92.

Gombrich, E. H. *Art and Illusion*, 3rd ed. London: Phaidon, 1968.

———. "Action and Expression in Western Art." *Non-Verbal Communication*, R. A. Hinde, ed. Cambridge: Cambridge University Press, 1972.

Gosling, Nigel. *Nadar*. New York: Knopf, 1976.

Guilly, Paul. *Duchenne de Boulogne*. Paris: J.-B. Ballière et Fils, 1936.

Jammes, André. "Duchenne de Boulogne, la grimace provoquée et Nadar." *Gazette des Beaux-Arts* 92 (December 1978).

Killian, Hans, *Facies dolorosa: das schmerzenhafte Antlitz*. Leipzig: G. Thiese, 1934.

Krauss, Rolf H. "Photographs as Early Scientific Book Illustrations." *History of Photography* 2, no. 4 (October 1978).

Kris, Ernst. *Psychoanalytic Explorations in Art*. New York: International Press, 1952.

Latour, Amédée. "Mécanisme de la physionomie humaine." *Union médicale*, Paris, 15:100, 103 (26 August, 2 September, 1862).

Lavater, Johann Caspar. *L'art de connaître les hommes par la physionomie*. Paris, 1806–9, in *Essay on Physiognomy for the Promotion of the Knowledge and the Love of Mankind*, edited by Dr. Moreau de la Sarthe. London, 1789.

Magendie, F. *On Galvanism, with Observations of its Chemical Properties and Medical Efficacy in Chronic Diseases*. London, 1826.

Malcolm, Janet, *Diana and Nikon: Essays on the Aesthetic of Photography*. Boston: David R. Godine, 1981.

Nochlin, Linda. *Realism and Tradition in Art, 1848–1900. Sources and Documents*. Englewood Cliffs, N.J.: Prentice Hall, 1966.

Parsons, J. P. "Human Physiognomy Explained in the Croonian Lectures on Muscular Motion," for the Year 1746 before the Royal Society, being a supplement to the *Philosophical Transactions* for that year.

Peckham, Morse. *Romanticism: The Culture of the 19th Century*. New York: George Braziller, 1965.

Piderit, Theodor. *Grundsatze der Mimik und Physiognomik.* Detmold: Verlag der Meyer'schen Hofbuchhandlung, 1858.

Prinet, Jean and Antoinette Dilasser. *Nadar.* Paris: A Colin, 1966.

Sarlandière. *Mémoires sur l'Electropuncture Considerée comme Moyen Nouveau de Traiter Efficacement la Goutte, les Rheumatismes, et les Afflictions Nerveuses.* Paris, 1825.

Verneuil, A. "Mécanisme de la physionomie humaine." *Gazette Hebdomadaire de Médicine et de Chirurgie* 28 (July 11, 1862).

Wechsler, Judith. *A Human Comedy: Physiognomy and Caricature in Nineteenth Century Paris.* Chicago: University of Chicago Press, 1982.

White, Stephen. "The Photographically Illustrated Book." *AB Bookman's Yearbook* (1982).

ALMOST NATURE:
THE TYPOLOGY OF
LATE NINETEENTH-CENTURY
AMERICAN PHOTOGRAPHY

MILES ORVELL

 OUR UNDERSTANDING OF LATE NINETEENTH-CENTURY PHO-
tography in America has been shaped inevitably by our
predilection for "straight photography," which we think of
as an "honest" use of the medium; thus we have found in
the earlier period exemplars for our own time—the makers
of unvarnished portraits; the visual journalists of the Civil
War; the great descriptive photographers of the western landscape and of
the geological expeditions; the documentary photographers of the city; the
scientific students of motion. We have put off to one side the practitioners
of illusion, of staged tableaux, and of table-top photography, relegating
them to a minor facet of the popular interest in photography, not central
to the medium's destiny as a realistic form, a medium of truth and reve-
lation. Yet gradually, over the past ten or fifteen years, our confidence in
the veracity of the photographic record has been eroded; slowly we have
come to realize, with detailed studies of Timothy O'Sullivan, of Alexander
Gardner, of Eadweard Muybridge, of Edward Curtis, that what we have
taken to be "truth" may be rather less, or more, than that.

Yet, proceeding from case to case, treating each on its own terms, we
have not reformulated our understanding of nineteenth-century photog-
raphy as a whole to accommodate what appear to be mere anomalies. I
want to offer here, accordingly, an overview of the practice of photography
in the nineteenth century, with an effort to understand how the community
of American photographers themselves understood their craft. How can
we explain, for example, how writers on photography might one moment
celebrate the capacity of the medium to create a seemingly literal imitation
of reality, in which "truth itself will be embalmed and history cease to be

fabulous," and the next moment elaborate on its use as a vehicle for fantasy, for "spirit" photographs, for historical costume dramas, phantom pictures, decapitated figures, etc.?[1] My intention is to posit a view of photography that accepts the diversity of practice, from mimesis to artifice, as part of a continuum, underlying which is a set of shared assumptions about the nature of the medium, assumptions most fully articulated in the literature of the Pictoralist movement in the latter decades of the century.

My argument builds on A. D. Coleman's formulation of "photography in the directorial mode" to describe works in which the photographer manipulates the subject in front of the camera, as distinguished from works of straight photography, in which the implicit claim is that the image is a record of untouched reality.[2] Coleman posits as well an intermediate category, wherein the photographer stands ready to seize a moment from the flux of time, thus blending his subjective sensibility with the "facts" of nature, but this mode depends on a technology of instant photography that was largely beyond the nineteenth-century photographer. All three strategies do overlap, as Coleman explains, but where his concern is with tracing the distinctions among the practices, as background to an understanding of the self-conscious directorial mode of the twentieth century, my own effort is to stress the core assumptions *shared* by virtually all practitioners of late nineteenth-century genres, whether artistic, documentary, or portrait.

But before exploring photographic practice itself, I want to propose that the photograph was part and parcel of a middle-class culture in which replications of all sorts were becoming a common feature of popular entertainment and the household environment. The theatre, for example, in the last half of the century was invaded increasingly by real objects and simulated events—everything from real food eaten on stage to military battles enacted with ships and horses—that were often the *raison d'etre* of the stage piece in search of an audience. Outside the legitimate theatre, much else in popular entertainment reflected this same fascination with replicas. P. T. Barnum was of course the great innovator in such eclectic presentations, and he featured during the mid-century not only the usual jugglers and gypsies, giants and dwarfs, but also ventriloquists and automatons, and other forms that evinced the growing taste for representations—"dioramas, panoramas, models of Niagara, Dublin, Paris, and Jerusalem," as the promotional literature put it.[3]

The apotheosis of the Barnum trend came late in the century, at the grandest occasion for national self-definition the country had yet known— the 1893 Chicago Columbian Exposition. The fairgrounds featured two different types of displays: a Midway Plaisance, with shows and rides, pleasures and excitements; and the huge, impressive replica of classical

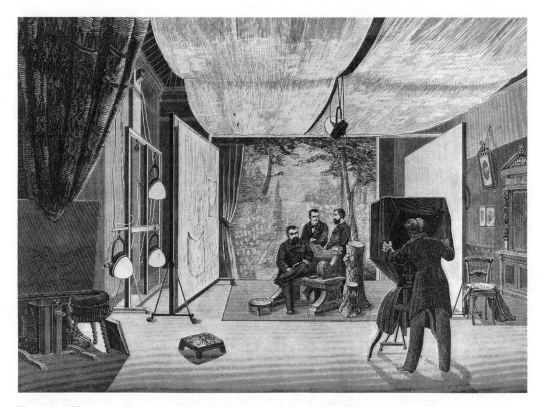

Victorian Photographic Portrait Studio, engraving, n.d. from *Harter's Picture Archive*.

architecture, the great Court of Honor, which was the "official" exposition. John Cawelti has justly seen in the court a monument to elite taste and in the midway the messy vitality of popular culture, with the distance between the two an anticipation of the split that would characterize modern society.[4] Yet both the popular midway and the elite court shared a similar esthetic of replication: in the midway, for example, the visitor might find replicas of German and Turkish villages, a street in Cairo (with dancers), a Moorish palace, a Viennese cafe, villages from Algeria, Tunisia, Austria, and Dahomey, and a Japanese bazaar. But the official exposition grounds also had their share of such architectural shams. These included not only the court itself, a set of palatial structures made out of staff (an ephemeral building material), but also replicas of home-grown structures: a reproduction of St. Augustine's Fort Marion offered by the state of Florida, and a replica of the clock tower of Independence Hall—including the actual Liberty Bell—

displayed by Pennsylvania. Meanwhile, moored at the Lake Front, were replicas of the *Nina,* the *Pinta,* and the *Santa Maria,* built in Spanish naval yards.[5]

One dominant mode in the popular culture of the late nineteenth century was thus the tendency to enclose reality in manageable forms, to contain it within a theatrical space, an enclosed exposition or recreational space, or within the space of the picture frame. For it was precisely the replica—with its pleasure of matching real thing and facsimile—that fascinated the age. Nothing better illustrates this pleasure in replication than the Victorian parlor itself, with its artificial flowers and marble fruit; and nothing was more at home in the Victorian parlor than the stereograph collection, inevitably including an abundance of still life images.[6] Photography must be seen within this broad context of replicated forms and was arguably the most widely experienced and therefore most influential of them all. At the risk of oversimplifying the diversity of genres in late nineteenth-century photographic practice, I will describe a continuum of modes, with frank artifice at one end and mimetic realism at the other. Across the continuum is the shared assumption within the photographic community that all images were a kind of replication, that the photographer actively constructs the image, thus creating what we might call an "artificial realism."

At one end of the continuum is photography in which artifice predominates. These images are essentially re-creations, using dolls or human figures, to replicate fantastic scenes that might be illustrations from an artist's book of fancies. After the Civil War, the stereograph, with its spectacularly believable three-dimensional depth, was a favorite format for such enactments, which might range from a stuffed animal version of an Aesop fable to a skeleton dance of death or a series of doll-children journeying to outer space (Fig. 1). Less fantastic, but no less artificial, were the popular cabinet photographs by the great master of the posed picture, Napoleon Sarony, whose reputation was based on his theatrical photographs of actors or actresses in their famous roles, complete with props. But he might also on occasion carry artifice to the point of *trompe l'oeil,* drawing on the theatrical tradition of the *tableau vivant:* Sarony's portrait, *Miss [Mary] Anderson as Galatea* (1883), for example, shows a white-skinned, literally statuesque woman, draped in Greek costume, and standing on a pedestal. *The Butterfly* shows a young girl with angel's wings sitting naked on a stone balcony, holding a butterfly aloft in one hand; the costume and pose are modeled exactly on Adolphe William Bouguereau's painting, *The Captive* (1891), which was itself, as Ben L. Bassham points out, based on a model of photographic realism.[7] These were all clearly *imagined* creations, whose artifice was transparent to the viewer.

Figure 1. *Eight-little Maidens Series*, no. 8 of 12 views: "Revels Among the Icebergs," 1895, stereograph.

Also at this end of the continuum were those illusions that strived to be convincing representations of *realistic* tableaux—a miniature ship tossing upon an oil-cloth ocean, for example.[8] Perhaps the most extravagantly imagined of such scenes was that proposed by William Louis Sonntag, as reported by Theodore Dreiser in his profile of the popular illustrator in *Twelve Men*. Among Sonntag's many dreams, he wished to stage a mock train wreck, using carefully wrought scale models, and then photograph it: "I propose to let the people see the photographic representation of an actual wreck—engine, cars, people, all tumbled down together after a collision and no imitation, either—the actual thing."[9] Sonntag's contrived catastrophe anticipates the studio miniatures of the motion picture industry, and in fact much of the artificial in nineteenth-century photography was displaced by cinema at the turn of the century as photography had earlier taken over some of the functions of realistic painting.[10]

At the opposite end of the continuum, the desire to produce a replica was just as strong, but here the photograph was based not upon a facsimile creation but upon reality itself. Here we might place the whole range of landscape, travel, and expeditionary photographs, all of which offer the armchair viewer an experience tantamount to the real thing. Photographs of this sort were produced for a huge market in various popular formats— stereograph, card, and paper prints; and the ontological claims made on

their behalf all rested on the essential credibility of the photographic image. One writer found in Carleton Watkins's landscapes, for example, that "Each pebble on the shore of the little lake at the foot of the throne may be as easily counted as on the shore in nature itself."[11] But few claims were as bold as the one made in 1894 by James William Buel, in advertising his record of the Chicago Exposition. When Buel commenced publication of *The Magic City: Portfolio of the Chicago World's Fair*, a series of consecutive weekly numbers consisting of sixteen to twenty photographs, he billed it as a "permanent re-opening of the Grand Columbian Exposition."

> In some respects this splendid portfolio is better and more to be desired than an actual visit to the Exposition, for through the magic agency of photography the scenes are transferred in marvelous beauty and permanent form to the printed pages, while the accompanying historical descriptions make plain and clear myriads of intricate and wonderful things, many of which were not comprehended by those who saw them.[12]

Putting aside the slight exaggeration typical of such notices, there is still something daring and prophetic in Buel's pitch, a metaphysical challenge, almost, to our common sense: the photograph is "better" than the real thing.

Such were the extremes of the continuum of photographic realism during the late nineteenth century—replication at one end, where the artifice was usually transparent, and documentary realism at the other end, where the credibility of the image was taken for granted by the viewer. I'll return to the documentary mode in more detail later on, in order to demonstrate its affinities to the typological, but let me quickly suggest here that the notion of a continuum can help explain what may otherwise appear to be anomalous incidents in the careers of two seemingly preeminent "straight" photographers: thus we find William Henry Jackson, one of the great recorders of the western landscape, constructing a model replica of a Southwest pueblo for display at the Philadelphia Centennial, where he served as "tourguide" for visitors. And, some years later, Eadweard Muybridge, who had returned to his native England after earning a reputation as the world's greatest scientific student of animal motion, was building a scale model of the Great Lakes in his backyard at the time of his death.

Until now we have been discussing photographs in which, generally speaking, the viewer's assumption about the ontological status of the image was in little doubt: whether the "replication" was based on reality or based on a staged mock-up, was more or less clear. But at the center of the

Victorian photographic continuum lay a synthesis of the two extremes of artifice and mimesis, the synthesis of pictorial photography, in which the ontological ambiguity of the image was tolerated, even relished. In the 1860s, for example, the famous Montreal photographer, William Notman, published a series of photographs depicting a caribou hunt, including photographs taken in a snowy, nighttime landscape. These were technically "impossible" outdoor shots, each separate scene depicting a distinct phase of the hunt—going out in the snow, exhausted in a snowstorm, arriving at camp, shooting the animals, sitting around the campfire, among others.

Notman's caribou sequence was enthusiastically reviewed by the *Philadelphia Photographer* in May of 1866, and the terms of the discussion move us closer to an understanding of how the photographic community conceived of the relationship between camera image and reality. The writer—probably the editor, Edward Wilson—was ecstatic about the effects achieved, admitting, for example, that he could only guess how the storm was created, "but that the artist has given us a remarkable photograph of a snowstorm without snow, we cannot deny." And he concludes his detailed discussion, "No pains or expense have been spared to secure these results, and we have never seen anything more successful and true to nature, without being wholly nature itself. Oh! what a future is there for photography!"[13] "True to nature, without being wholly nature itself." Here we are near the heart of the Victorian photographic esthetic (and the center of the continuum). By examining the theory and practice of the Englishman Henry Peach Robinson, we can come closer to an understanding of the nature of photographic representation during this period.

Robinson is now known primarily for a few combination prints that appear regularly in standard histories of photography, where he is treated usually as an important though aberrant figure who proselytized on behalf of the sensational (in its day), but now vaguely disreputable, esthetic of pictorial photography. Yet Robinson is not, I would argue, peripheral to an understanding of nineteenth-century photography, but central to it. With the publication of his textbook *Pictorial Effect in Photography* (1869), which went through four editions in America by 1897, Robinson became among the most influential writers on photography in the latter part of the century.[14]

Robinson generally treats photographic compositional principles as similar to those in painting, but with certain differences observed—a respect for probability, for example—because photography is a more literal medium. Yet what is most interesting about his principles is that in defining the center of the pictorial esthetic, he excludes the extremes of pure documentary and transparent artifice discussed above. On the one hand, Robinson advises against the purely fantastic—cherubs or mermaids—

Figure 2. Henry Peach Robinson, *Carrolling*, 1887. Combination albumen print, and the sketch for its production.

claiming that "photographs of what it is evident to our senses cannot visibly exist should never be attempted." Yet, on the other hand, the bare presentation of facts alone constitutes an excess of literalism, a "tyranny of the lens."[15] The photographer should be free to *construct* an image using studio accessories such as artificial logs covered with ivy, tufts of grass, and painted backdrops; he might also pose his models to represent some particular dramatic moment, and he might add together different elements from two or more negatives to create what was called a combination print.

Thus at the heart of Robinson's practice was the careful balancing of mimesis and artifice to achieve a kind of general truth that evoked an esthetic frisson, as the observer caught on to the process. The peculiar refinement of Robinson's esthetic has not sufficiently been observed, yet it is consistent from the early *Pictorial Effect* to the later *Elements of a Pictorial Photograph*. As he says in the earlier book:

> A great deal can be done and beautiful pictures made by the mixture of the real and artificial in a picture. It is not the fact of reality that is required, but the truth of imitation that constitutes a veracious picture. Cultivated minds do not require to believe that they are deceived, and that they look on actual nature, when they behold a pictorial representation of it.[16]

And Robinson reminds us, using Ruskinian principles, that we prefer a marble figure to a waxwork: the former doesn't try to look like what it is not. Similarly, Robinson says in his later work, "we must know that it is a deception before we can enjoy it; it must be a gentle surprise, and not a delusion."[17] We have been condescending to pictorial photography for so long that we have forgotten that sophisticated viewers were well aware of the staging and in fact savored precisely the ontological ambiguity of the resulting image.

Robinson may have pushed pictorial effect to the brink of estheticism. As generally understood and practiced, however, Robinson's notion of pictorial photography defines a kind of "artificial realism" that was shared by a wide variety of photographic strategists. The Philadelphian Marcus A. Root, for example, whose book, *The Camera and the Pencil* (1864), preceded Robinson's volume by several years, enunciated principles that would anticipate Robinson's balancing of mimesis and artifice: "Although strictly obliged to imitate *reality*, the photographer may, nevertheless, sometimes unite the elements of the scene he would represent. He may, in fact, *compose* the scene he wishes to reproduce, by choosing the personages; giving them costumes. . . ."[18] Root would give temporal license to the photographer as well, calling for the reproduction of the pageant of history "with the vividness of living reality."[19] Even the great daguerreotypist Albert Southworth

(who is regarded as a master of literalism), stated while in a retrospective mood, "the artist, even in photography, must go beyond discovery and the knowledge of facts; he must create and invent truths and produce new developments of facts. . . . Nature is not all to be represented as it is, but as it ought to be, and might possibly have been. . . ."[20] And we find this flexibility again at the end of the century in articles appearing in the principal American photography journals. John Bartlett, for instance, argues that the photograph must be intensely realistic; yet despite this seeming expansion of the pictorialist sphere to encompass a grittier realism, Bartlett's own strategy remains embedded in a studio vocabulary and in an avoidance of the "commonplace" (i.e., literal record): his subjects are carefully positioned amidst artificial backgrounds in a manner recalling Robinson.[21]

The practice of photography during the late nineteenth century was raising questions about the nature of truth that would only gradually become fully articulated. If, at the center of the problem was the degree to which the camera—a mechanical instrument—could deliver a picture of reality that was truthful, the real issue was of course buried in the question itself: what was a "truthful" picture of reality? Was truth to be found in literal exactitude or in artistic generalization? The Pictorialist compromise was to place the answer somewhere in between the extremes, and to develop a practice that understood the photographic representation to be a *type* of reality. The practice of using human models, for instance, itself transformed the question of what was "truthful" to the question of what was "convincing." The photograph based on a model is not a proposition in the form of "This is an X"; rather it becomes a statement in the form, "This is a *representation* of an X." And once an image is accepted as a representation, then the question is no longer, "Is the representation more or less truthful?" but rather, "Is the representation more or less convincing?"

The strongest argument that it was the effectiveness of the picture that mattered—the degree to which it was *convincing* rather than *true*—was made by Robinson at the end of *The Elements of a Pictorial Photograph*. There he challenged his reader to examine seven of his rural genre photographs, and to guess in each case whether he had used a model or a "real" person as the subject. In fact, it is difficult to tell; but more important is the implication in Robinson's challenge—namely, the assumption that verisimilitude is as good as verity. The *effect* is all, the *means* nothing, Robinson claims: "The poet says, in default of the real thing, 'Tis from a handmaid we must paint our Helen.'" Of course Robinson is careful to warn his reader against dressing up just anyone; if he wanted a peasant represented,

for example, he would be careful to use old clothes on an intelligent, malleable model. Esthetic considerations are at issue, not questions of verifiability. Moreover, he scorns the detective camera's candid snapshots as producing unsatisfactory groupings.[22] Robinson is working within the genre of "art" photographs, and that, of course, is the key point: the kind of "truth" that is relevant to art, in Robinson's understanding, is a general truth, through which, in effect, the literal capacities of the camera are subverted.

The pictorial esthetic that Robinson represented offered a good deal of freedom, but it was nevertheless circumscribed by codes of probability and convention that would only become apparent when they were transgressed. And the transgressions served to define more clearly the core of the esthetic. The case of F. Holland Day is perhaps the most interesting, for Day was a photographer widely respected by both the art photographers who believed in freely manipulating the print and by the more purist of the pictorialists, such as Alfred Stieglitz (until their rivalry became a rift). Day was a master craftsman, a superb printer, a medievalist, and an esthete on familiar terms with the literary and art circles of his day; but he was also clearly an elitist, who, as Estelle Jussim puts it, "objected to the very accuracy of photography as catering to the demands of the masses for representationalism."[23] Day's studies of young women and men feature exotic costuming, sensitive posing, and dramatic lighting; they are representations of imagined inward states, often using a vocabulary drawn from mythology and religion.

Perhaps the culminating effort in this line was the *Crucifixion* series he undertook in 1898; after starving himself to perfection and growing a beard, Day featured himself in an elaborate, pre-Hollywood version of the Crucifixion, complete with imported cloth and cross from Syria (Fig. 3). Though Day was not without his defenders (notably the English photographer Frederick Evans), by and large people were outraged. At issue was not simply the blasphemous nature of the project (his critics thought it might have been better had he cast someone other than himself in the leading role), but what was seen as the failure of Day's art. Instead of transporting us to an esthetically sealed, imagined Crucifixion, we are made aware, through the clarity of Day's lens and the fully revealing distance from the figures, of the tricks and artifice. As a critic of the time wrote, "we are looking at the image of a man made up to be photographed as the Christian Redeemer, and not as an artist's reverent and mental conception of a suffering Christ."[24] Incidentally, just before the *Crucifixion*, Day had made a series, *The Seven Last Words of Christ* (1898), which depicted the agony of Jesus (F. Holland Day), exclusively in close-ups of the face, at dramatic

angles, using soft focus. It was felt to be a more "convincing" realization than the *Crucifixion*, chiefly because we are not aware of the physical actuality of the model.

Different factors might thus come into play in the viewer's response to a work of pictorialist art (how tasteful, how distracting, how suggestive, etc.), but these criteria cluster around the issue of whether the image is a convincing representation of its subject, regardless of whether or not it is a factually true picture. In fact, the whole spectrum of pictorialist photography—from Robinson's combination prints to the other uses of models by artistic and documentary and genre photographers—is based on the notion of the subject as "type." By type, however, we must understand not the scientist's abstract summation of a class; rather, the typology of nineteenth-century photography is—to borrow a word from poetic terminology—metonymic, whereby the pictured subject, with all its concrete particularity, *stands for* a more general class of like subjects. The individuality of the subject is thus presented on its own terms while it simultaneously serves the larger purpose of representing a class. (This kind of typicality is inherent to the category of artistic representation, as opposed to the typicality of, say, the medical text illustration.)[25] Understanding the typological synthesis of specific thing and general meaning allows us to comprehend what may otherwise appear to be, as a recent study has it, "the bewildering notion that the camera somehow extracts what amounts to a Platonic ideal form behind the shifting variability of Nature."[26] But that is precisely the point: with varying degrees of sophistication, the photographic community did accept a typological concept of the photo-representation, whereby the image was viewed as both a mimetic and an artificial construction, both specific and general.

By far the greatest number of photographs taken during the nineteenth century were portraits of individuals, and we must test this notion of the typological representation by examining the center of popular practice—the commercial portrait. At first glance the portrait would appear to be an exception to the rule I have been proposing. The goal of the photographer—if he prided himself on the "artistic" quality of his work—was to capture the living quality of his subject, "the *soul* of the original,—that *individuality* or *self*-hood, which differentiates *him* from all beings, past, present, or future," as put by Marcus Root.[27] The concept of truth expressed here thus seems quite different from the general truth of pictorial photography; rather it appears to be a truth that resides in the particular subject, and the effort of the photographer is to find that truth and reveal it. The greatest portrait photographers—Southworth and Hawes, Brady, Gardner—were those who could do just that, and the photographic journals were filled with practical

Figure 3. F. Holland Day, *Crucifixion with Roman Soldiers*, 1898.

advice on how to capture the sitter's unique personality—despite the encumbrances necessitated by a long exposure time.[28]

Yet in the process of discovering the sitter's "individuality," a kind of generalization was nevertheless aimed at. The advent of instantaneous photography in the 1870s and 1880s would eliminate the need for stiffly held poses.[29] But commercial studios were slow to adopt the new technology, and for reasons that go to the heart of how the portrait was conceptualized: for if the portrait was to capture the unique truth of the sitter, it was to capture it in the manner of a painting, to find the pose that might sum up—in effect, generalize—the sitter's personality, a posture of dignity and repose; the instantaneous moment was more likely to result in a distorted expression, rather than the more *typical* truth of individuality aimed at.

In fact, the portrait became even more of a generalized statement in the years following the Civil War, as the sharp-focused eccentric individuality of the early daguerreotype style gave way to a softer, more artificial ideal of self-representation. Although some, like John Moran, protested the loss of "personal identity" in the newer styles, the age demanded an image of its own grace. Along with the Victorian hall-stand—which allowed everyone coming in or leaving the house to check his appearance[30]—the studio portrait afforded an occasion for defining the self in conformity with prevailing norms of appearance and taste. Where the first daguerreotype portraits had sometimes featured some visible sign of the sitter's character or achievement (tools of the trade, for instance), the Victorian studios supplied a readymade background and social status for the patron in search of an image: the nearly universal accoutrements for the American portrait studio were the balustrade, column, and curtain in the 1860s, followed later by more bucolic and exotic settings—rustic bridges, hammocks and swings, palm trees, and parrots—for an increasingly urban audience.[31]

The misrepresentation of self and class that might result was not without its critics: one observed in the *Philadelphia Photographer* (1871) that a typical studio photographer entertains all social classes, "the aristocratic and educated" as well as the "uncouth and unlettered." And while the former might look at home amidst the marble hall background, with columns and pretty furniture (the writer is evidently not troubled by the contrivance of the setting), the lower-class customer is clearly out of place: "If you desire to place him in a position suitable to his style and condition in life, you had better fill up and make surroundings of rudeness, and a pig, horse, and bullock." He recommends finally a "plain, spotless, even background" as suitable for all social classes.[32] A few years later, another writer argued less invidiously that the aristocratic pretensions of the photo-background were simply inappropriate for a country claiming to be a democracy: "Old

style backgrounds, painted sharply and representing palaces and marble columns, etc., are inadmissible, and absurd to use in America, where such things do not exist, and doubt if they would appear in good taste in any place except with royalty for the subjects."[33] But these arguments for restraint and an appropriately egalitarian background in portrait photography were clearly running against the more popular practice of picturing the subject in front of an idealized, typified background.

The characteristic nineteenth-century interest in the *typical*, and its pursuit of the general truth of portraiture finds its most extreme expression in the theory of the composite portrait developed by the English scientist Francis Galton, who had a considerable following in America. Galton's composites are made by combining individual portraits into a single homogenized facial image, and are thus not to be confused with the composites of the pictorial photographers, who made combination prints using individualized images to compose a synthetic whole containing all of its parts (Fig. 4). By photographing an individual as many as twenty times and printing a single composite print at the end, Galton argued that he would avoid the hazard of the single image and would arrive at an averaged expression that was the sitter's true self. "A composite portrait represents the picture that would rise before the mind's eye of a man who had the gift of pictorial imagination in an exalted degree," Galton wrote.[34] (Note Galton's association of his method with the artistic temperament.) Put together twenty different photographs of twenty different individuals, Galton believed, and it was possible to reveal the purity of type: Italian, Pole, Jew.

Galton, a cousin of Charles Darwin and the founder of eugenics, had begun his composites at a time when immigrants were viewed by many in England and America with grave suspicion as a threat to the established social order. Knowing what the foreigner looked like (for it was believed all members of a given ethnic group did look alike) would help society defend itself against their potential criminality and radicalism. A camera enthusiast, George Iles wrote, "Just as truth has been substituted for tradition in the case of animal movement, so we shall here replace vague impressions of foreigners and of special classes at home by exact and easily compared pictures."[35] Yet Galton's approach was really diametrically opposed to the studies of animal movement by Muybridge to which Iles refers. Where Muybridge separated what was perceived as continuous movement into its constituent parts, Galton corralled individuals into a forced whole. Galton's notion of an ideal composite, anticipating the logic of racial purity of the twentieth century, had its vogue in the late nineteenth century. For example, in the Anthropological Building of the World's Columbian Exposition, there stood the twin statues of the ideal American male and the

Figure 4. *Twelve Boston Physicians and Their Composite Portrait*, ca. 1894, from *McClure's Magazine*, vol. 3, no. 4 (September 1894).

ideal American female.[36] Walt Whitman had sung longingly of his own "divine Average," his ideal mothers and robust men, but his vision had been at bottom an inclusive one, a vision of plurality, not of the monolithic purification of gender. In the name of science, Galton had carried photography far from its typological character, creating in his composites parodies of the type.[37]

I want finally to test the typological theory from another perspective by offering a more detailed discussion of works occupying the mimetic end of the continuum, works in which photography is used as a medium of historical record, and in which we would therefore least expect to find artifice in the service of a simulated picture of reality. In the early years of the medium, belief in the truth of the image was widespread; because the photograph was made by sunbeams, it was understood, as Joel Snyder put it, "to provide information of an unbiased kind"; it assured "the audience of the absence of a 'narrator,' or of an agent who is directing the attention of the audience."[38] Yet as photography was gaining popularity through the stereograph market (from the 1850s to approximately 1910), some viewers apparently did need assurance from a credible source, serving indeed as a kind of surrogate narrator, that the image was "truthful," as in this inscription to be found on the back of some early stereograph cards: "I have looked these views carefully over and find them very correct. I was present when they were taken. The pictures and statuary are in their original places."[39] The views are "very correct"? Does the need for such a statement indicate that photography is a believable medium, or that it is not? Photography was being taken, evidently, as a historian, yet a historian whose credibility might need authenticating. And as our understanding of nineteenth-century photography has grown in the last decade or two— as we have discovered that the practice of photographic documentation did not exclude manipulations of the image that seem more akin to the techniques of the pictorialists—our own need to authenticate the image, not to take it on face value, has also grown. Viewed in the perspective of the nineteenth-century's typological understanding of the medium, however, such practices cease to be anomalous and become instead a part of the overall practice of photography during the period.

What are we otherwise to make, for example, of Alexander Gardner's representations of the Civil War (Fig. 5)? Gardner presented his scenes of battlefields and encampments to the public in the *Photographic Sketch Book of the War* (1866), claiming their utter veracity: "Verbal representations of such places, or scenes, may or may not have the merit of accuracy; but photographic presentments of them will be accepted by posterity with an undoubting faith."[40] He was right, of course: posterity has accepted the

images with undoubting faith—until, that is, the meticulous studies of the images and the localities made by William Frassanito demonstrated that that faith had been misplaced. Thus, for example, Gardner had identified Union soldiers as, at times, Confederate soldiers; he had labeled one of his pictures "Field where General Reynolds Fell," even though the photographer had been nowhere near the field where Reynolds actually fell; he had dragged the same corpse from one location, where he had photographed it a first time, to another location (a sharpshooter's nest) for a second photograph and presented them both as records of different victims in different locales.[41] From a purely pragmatic point of view, Gardner's reasons for misrepresenting his images are not difficult to construe: given constraints of time and events, he could expose only a limited number of negatives on the battlefield; but he had many more stories to tell, and so he paired a plausible image with a convincingly written narrative, and the viewer could never tell the difference. The narrative in fact dictates the viewer's reading of the image. And what this suggests most notably for our purposes is that Gardner was playing upon his audience's beliefs in the veracity of the medium while taking for himself a much more flexible view of photographic practice, whereby the manipulations of the photographer were permissible in the interest of achieving a rhetorically convincing effect.

The example of Jacob Riis similarly straddles the categories of fiction and documentary, artifice and mimesis. It is symptomatic of our confusion over late nineteenth-century photography that recent commentators cannot agree on what Riis's virtues are. While one critic might applaud his style for being appropriately crude, direct, and honest, another might laud it for being deceptively artful, shrewdly calculating.[42] And the nineteenth-century response reflected a similarly divided sense of what Riis was after: witness the reviews of *How the Other Half Lives*, which celebrated the volume for the "accuracy" of its scenic descriptions, and also for its fictive vigor— "enormously more interesting than any novel that ever was written or that ever will be."[43] These inconsistencies in the response to Riis point to a photographic practice that was acceptable in its own time but appears inconsistent to us now.

For to Riis, the documentary mode was much less exacting in its purity than we would like to think; it allowed for a flexibility of practice in the field (similar to Gardner's on the battlefield) that places it within the same continuum of pictorialist practice, with its franker manipulations of staged subjects. True, Riis did not employ models to pose as the urban underclass; he did not, at least, clothe his subjects, or drag them into a studio in order to better control the content of the image, as did Sigmund Krausz, for example, in his *Street Types of Chicago: Character Studies* (1891).[44] Riis pho-

Figure 5. Alexander Gardner, *Home of the Rebel Sharpshooter*, Gettysburg, July 1863, from *Gardner's Photographic Sketch Book of the War*.

tographed the slum dwellers in what seem to be moments of their daily lives—the sweatshops where they worked; the crowded markets where they shopped; and above all where they lived: the trash-lined, narrow alleys, the rooms crowded with mattresses and other sleepers, the rooftops where they sought air in summer, the cellars where they set up house-keeping, the crevices and corners where they might seek shelter. More effectively than anyone before him, Riis revealed the environment of the urban poor and graphically enforced points that were radically new to the middle-class ethos—that the odds against making it out of the slums were great, that the slums were breeding grounds of misery and disease, that environment counted heavily in any reckoning of the causes of poverty. All this cannot be gainsaid. Yet we miss something important if we fail to see the degree to which Riis manipulated his representation of poverty to reflect a preconceived image of the poor, turning his subjects into objects before the eye of the camera.

Figure 6. Jacob Riis, *Showing Their Trick, Hell's Kitchen Boys*, ca. 1889. Courtesy Jacob A. Riis Collection, Museum of the City of New York.

This technique is most evident when Riis gains the cooperation of his subjects to *play themselves* for the camera. Riis was fond of staging "candid" shots in which he would position various street boys in a corner staircase, or in the crevice of a building, or in some other typically "forgotten" place, and ask them to feign sleep (one can see the smiles playing on their lips). The vulnerability of childhood, coupled with the vulnerability of sleep, was a doubly pathetic combination. Other times we see children working in a sweatshop or saluting the flag in a classroom, their eyes sneaking a look at the camera they were presumably to "ignore." We do not know how often Riis paid his subjects, but he does tell us that he offered a tramp ten cents to sit for a picture, and that the tramp demanded a quarter if Riis wanted the pipe in his mouth as well. Riis paid for the pipe.[45] And Riis reports that in several shots of a gang of youths, they enacted for his camera the mugging of a victim, and indeed they were excited at the prospect of photo-notoriety and themselves mugged for the camera's eye (Fig. 6). Another gang insisted on bringing a sheep into the picture. These images are interesting just because they reveal so much about the interaction between photographer and subject, reveal what Riis could not have intended—the degree to which he was creating an artificial image of the urban poor. Or, to use the terms invoked earlier to frame this discussion, Riis gives us, with the often willing and knowing collaboration of his subjects, a metonymic typology of urban slums, representing for us "the poor," "the miserable," "the other half." He is after the general truth of a general category, and the finer truths of individuals necessarily escape him. In the whole that is *How the Other Half Lives*—i.e., photographs and texts—it is often the text that serves to individualize his subjects, for there Riis offers us anecdotes of individual experience, actual people. The text also offers a parallel to the typology of the pictures, in the many racist stereotypes Riis so casually employs. But the photographs rarely match the text in a one-to-one fashion; instead, the visual images serve as examples of a theory of poverty and its effects on human beings.

A similarly illustrative use of photographs is made by Edward Curtis, whose sensibility was formed by nineteenth-century practices, and whose work spans the years from the turn of the century to 1930, when the final volume of his monumental *The North American Indians* was published. Curtis aimed "to picture all features of the Indian life and environment" with a kind of objectivity that he is careful to state at the outset: "being directly from Nature, the accompanying pictures show what actually exists or has recently existed (for many of the subjects have already passed forever), not what the artist in his studio may presume the Indian and his surroundings to be."[46] Yet as Christopher M. Lyman has shown, Curtis's representations were contrived in a variety of ways. They may not have

been taken in a studio, but they otherwise reflect the photographer's active mediation, his interposing of an idealized image of Indian life upon his subjects: by dressing them in the appropriate picturesque modes (supplying props—e.g., headdresses—where necessary); by eliminating artifacts from their immediate surroundings that may have been adopted from white culture (e.g., alarm clocks, brand names on canvas tenting); by changing day to night (in his darkroom) and adding other kinds of dramatic lighting in order to enhance the romantic aura of the Indian, and so forth.[47]

The examples of Gardner, Riis, and Curtis make clear that the assumptions held by the community of practicing photographers and by the community of consumers could sometimes differ, and that photographers not uncommonly exercised a kind of poetic license. Of course the photographer's license was absolutely clear in photographs of a frankly *artificial* kind (table-top and the like), and it was generally inferred by the serious amateur when it came to *artistic* photographs of declared pictorialist persuasion. Yet photographs in which the *documentary* impulse—the goal of conveying a "truthful" image of reality—was dominant, still allowed for manipulations justifiable to the conscience of the photographer, though these were not seen as manipulations by the layman viewer, who assumed, for this genre, that the medium did not lie. And the same held true for news photography, when the genre developed as a mass form in the 1890s. Writing in 1892 on "Some Phases of Contemporary Journalism," a commentator observed that illustrations sell newspapers, but that "pictorial veracity" was "absolutely unessential."[48] And more than a decade later another writer, after noting the widespread use of faked pictures to depict news events, nevertheless confirmed the value of photography in making vivid the news of the day, and in teaching us "that imaginative view of history in the making which means so much for social enlightenment and brotherhood."[49]

Likewise we have evidence now that even among expeditionary photographers like Timothy O'Sullivan, the camera was treated as an expressive, rather than as a strictly literal medium. This can be seen, for example, in O'Sullivan's practice of tilting the frame for emphasis and effect, or in his series of six photographs of the Green River in Colorado from the exact same vantage point at different times of the day.[50] (O'Sullivan's posing of human subjects in his pictures also seems to be expressive, and not simply for purposes of measuring space) (Fig. 7). And Martha Sandweiss has noted that William Henry Jackson on occasion would piece together separate negatives to compose an enhanced, more artistically attractive combination print of a given scene.[51] These practices point to a use of the medium that is consonant with the generally pictorialist sensibility of the nineteenth century I have been sketching. As such, they seem to qualify Rosalind Krauss's otherwise cogent argument that O'Sullivan and other landscape

Figure 7. Timothy O'Sullivan, *Hot Sulphur Springs, Ruby Valley, Nevada, 1868.*

photographers were merely producing "views" (to use the nineteenth-century terminology) of singular sights that together compose a catalogue of information for some institutional sponsor, whether governmental survey, stereo company, or railway line.[52] The expeditionary photographers may not have thought of themselves as artists, as Krauss argues, but even when seemingly most literal, the nineteenth-century professional was imaginatively striving for a rhetorical effect.

It is ironic and paradoxical that during a period in which active interventions of all kinds were routinely practiced by the photographer, the medium was regarded popularly as a passive mode. But the relative *slowness* of the picture-making process, in which exposures were not often under a second, dictated a stable, tripod-based camera that *looked like* merely a passive receiver of light rays. The geologist Clarence King, for example, who led Timothy O'Sullivan through the Southwest around 1870, offers a

typical formulation of this passivity when he recounts a pause in his own geological investigations:

> I was delighted to ride thus alone, and expose myself, as one uncovers a sensitized photographic plate, to be influenced; for this is a respite from scientific work, when through months you hold yourself accountable for seeing everything, for analyzing, for instituting perpetual comparison, and as it were sharing in the administering of the physical world.[53]

King's implied metaphor of the mind as a passive camera plate turns up as well in a more sophisticated form at the end of the century in the analogy between the mind and the camera: "Has the Brain a Photographic Function?" asks the *American Journal of Photography* in 1897, suggesting that visual images are "impressed" upon the brain, and later reactivated, in the same manner as the photographic process.[54]

But if there was any basis for thinking of photography as passive during the time when the camera was fixed on a tripod while the subject waited for the release of a shutter, that began to change with the development of new technologies of photography; and with these changes the whole set of assumptions held by the photographic audience slowly began to change.[55] With the faster shutter speed of the modern camera, the stream of time could be interrupted and motion could be broken down into its constituent parts. Muybridge led the way here, in the process undermining confidence in the unaided eye;[56] but Stieglitz's esthetic of instantaneous photography flowed from the same technical possibility and eventually made the contrived arrangments of the pictorialist photographer (however "active" in other respects) seem outmoded. Moreover, as the hand-held detective camera became popular among amateurs, what had been a passive historian, a witness to events after they had happened, became now an active intruder upon private and public life. Legal minds worried about the loss of the right to privacy, while psychologists spoke of the need to incorporate our previously hidden selves into our concept of being.[57]

The camera was becoming, at the turn of the century, the symbol of a kind of intrusive presence in society: a people that had been fascinated with spectacles and replications of reality, and that had brought myriad photographic microcosms into the parlor, were themselves becoming the spectacle. And the subject who had composed a self with the help of the knowing professional and in the safe confines of the photographic studio was increasingly subject to the more spontaneous efforts of the street photographer and the amateur enthusiast. As the camera became lighter, more portable, and faster, the typological continuum dissolved into separate practices with distinct assumptions: the metonymic typology of the studio

shot would yield to the autobiographical particularity of the family album; the pictorialist synthesis would gradually fall apart before the instantaneous esthetic of Stieglitz; and the documentary photographer would have to defend his practice in a community of viewers less likely to believe what they saw. To look back on the photography of the late nineteenth century from our own perspective is to see a world of artificial realism in harmony with a culture of replications, where what was offered as *almost nature* was sufficient.

"Almost Nature" appears in revised form in Miles Orvell's *The Real Thing: Imitation and Authenticity in American Culture, 1880–1940* (Chapel Hill: University of North Carolina Press, 1989).

Notes

1. Sir David Brewster, *The Stereoscope: Its History, Theory, and Construction* (1856) Hastings-on-Hudson: Morgan & Morgan, 1971), 181, 204 ff. Also see: Walter F. Eagleson, *Trick Photography* (Winterset, Ohio, 1902); and Walter E. Woodbury, *Photographic Amusements, Including a Number of Novel Effects Obtainable with the Camera* (New York: Scovill & Adams, 1898).

2. A. D. Coleman, "The Directorial Mode: Notes Toward a Definition" [1976], in Vicki Goldberg, ed., *Photography in Print* (Albuquerque: University of New Mexico Press, 1988), 480–91.

3. Quoted in Neil Harris, *Humbug: The Art of P. T. Barnum* (Boston: Little Brown, 1973), 40.

4. John Cawelti, "America on Display," in Frederic C. Jaher, ed., *The Age of Industrialism in America: Essays in Social Structure and Cultural Values* (New York: Free Press, 1968), 345.

5. See Stanley Applebaum, *The Chicago World's Fair of 1893: A Photographic Record* (New York: Dover, 1980), 95.

6. Arrangements of flowers or other decorative objects were especially popular, including, for example, skeleton leaves, which were dried plant structures bleached to a bone white (replications of plants, we might say), arranged with or without funereal overtones. See Edward W. Earle, ed., *Points of View: The Stereograph in America—A Cultural History* (Rochester, N.Y.: Visual Studies Workshop Press, 1979), 49.

7. Ben L. Bassham, *The Theatrical Photographs of Napoleon Sarony* (Kent, Ohio: Kent State University Press, 1978), 26–27; 20–21.

8. William C. Darrah, *The World of Stereographs* (Gettysburg: W. C. Darrah, 1978), 64–65.

9. Theodore Dreiser, *Twelve Men* (New York: Boni & Liveright, 1919), 353.

10. See Erik Barnouw, *The Magician and the Cinema* (Oxford: Oxford University Press, 1981).

11. *Philadelphia Photographer* 3, no. 28 (April 1866): 106; also see *The Philadelphia Photographer* 1, no. 11 (November 1864): 12.

12. James William Buel, *The Magic City: A Massive Portfolio of Original Photographic Views of the Great World's Fair* (Philadelphia: Historical Publishing Co., 1894).

13. *Philadelphia Photographer* 3, no. 29 (May 1866): 130, 131.

14. For a general discussion of Robinson, see Alan Vertrees, "The Picture Making of Henry Peach Robinson," in Dave Oliphant and Thomas Zigel, *Perspectives on Photography* (Austin: University of Texas Press, 1982), 78–101.

15. Henry P. Robinson, *Pictorial Effect* [1869] (Philadelphia: E. L. Wilson, 1881), 75; Robinson, *The Elements of a Pictorial Photograph* [1896] (New York: Arno, 1973), 15. On composite imagery and combination printing, see Robert A. Sobieszek, "Composite Imagery and the Origins of Photomontage, Part I: The Naturalist Strain," *Artforum* 17, no. 1 (1978): 58–65; Robert A. Sobieszek, "New Acquisitions: A Note on Early Photomontage Images," *Image: Journal of Photography in the George Eastman House* 15, no. 4 (1972): 19–24; James Borcoman, "Notes on the Early Use of Combination Printing," in Van Deren Coke, ed., *One Hundred Years of Photographic History: Essays in Honor of Beaumont Newhall* (Albuquerque: University of New Mexico Press, 1975); Sally A. Stein, "The Composite Photographic Image and the Composition of Consumer Ideology," *Art Journal* (Spring 1981): 39–45.

16. Robinson, *Pictorial Effect*, 109.

17. Robinson, *Elements*, 18–19. When, under the influence of Alfred Stieglitz, Charles Caffin published his *Photography as a Fine Art* (1901), Robinson's pictorial esthetic could be archly scorned as a crude crowd-pleaser: contrasting Stieglitz's actual pictures of moonlight with the merely pretty studio ersatz, Caffin wrote, "So these 'moonlights' pleased, and the discovery that they were faked lent a further zest. The 'Who'd have thought it?' followed on the 'Oh! my, how pretty!' and that curious trait of human nature, recognized by Barnum, was satisfied." Caffin, *Photography as a Fine Art* [1901] (Hastings-on-Hudson: Morgan & Morgan, 1971), 30.

18. Marcus A. Root, *The Camera and the Pencil* [1864] (Pawlett, Vermont: Helios, 1971), 445. Italics in the original.

19. Root, *The Camera and the Pencil*, 449.

20. Robert A. Sobieszek and Odette M. Appel, *The Spirit of Fact: The Daguerreotypes of Southworth & Hawes, 1843–1862* (Boston: David R. Godine, 1976), xxiii.

21. Bartlett urges the photographer to develop his powers of natural observation, but also to study the Dutch masters. And he quotes George Eliot's *Adam Bede* on the need to enlarge subject matter so as to encompass the whole range of society: "Paint us an angel, if you can, with floating violet robe, and a face paled by the celestial light; . . . but do not impose on us any aesthetic rules which shall banish from the region of art those old women scraping carrots with their work-worn hands. . . ." Bartlett, "On the Choice of a Subject Suitable for a Photographic Picture," *American Journal of Photography* 18, no. 210 (1897): 262. Yet only ten years later Lewis Hine would stand before a conference on charities and argue the value of photography to social uplift, speaking on behalf of a realism that would seek not a studio version, but the old woman herself of Eliot's quotation. In fact, he quotes the very passage from *Adam Bede* at the conclusion of his talk. Hine, "Social Photography: How the Camera May Help in the Social Uplift," *National Conference of Charities and Correction Proceedings* (June 1909): 358–59.

22. Robinson, *Elements*, 102, 94–100.

23. Estelle Jussim, *Slave to Beauty: The Eccentric Life and Controversial Career of F. Holland Day, Photographer, Publisher, Aesthete* (Boston: David R. Godine, 1981), 7. I am indebted to Jussim's study for the discussion of Day that follows.

24. *British Journal of Photography* (Nov. 2, 1900): 702; quoted in Jussim, *Slave to Beauty,* 134.

25. See John Tibbetts, "The Real Thing: Arguments Between Art and Science in the Work of P. H. Emerson and H. P. Robinson," *Journal of American Culture* 4 (Spring 1981): 149–72. Tibbetts argues correctly that Emerson and Robinson both favored the type as subject, though he then suggests, mistakenly I think, that "both these attitudes seem more scientific than artistic. The scientist's business, after all, is to classify and categorize" (167). Artists, too, classified and categorized.

26. Estelle Jussim and Elizabeth Lindquist-Cock, *Landscape as Photograph* (New Haven: Yale University Press, 1985), 45.

27. Root, *The Camera and the Pencil,* 143.

28. See, for example, Rev. H. J. Morton, "Photography Indoors," *Philadelphia Photographer* 1, no. 7 (July 1864): 104–6.

29. Experimentation with instantaneous photography was urged in the early 1870s. See, for example, A. A. Pearsall, "Instantaneous Portraiture," *Philadelphia Photographer* 8, no. 95 (Nov. 1871): 385–86.

30. Kenneth Ames, *Renaissance Revival Furniture in America* (Ph.D. diss., University of Pennsylvania, 1970), 212.

31. For examples of early portraits, see Richard Rudisill, *Mirror Image: The Influence of the Daguerreotype on American Society* (Albuquerque: University of New Mexico Press, 1971). Also see: Helmut Gernsheim, *Creative Photography: Aesthetic Trends 1839–1960* (New York: Bonanza, 1962), 70, 72; Bevis Hillier, *Victorian Studio Photographs* (Boston: David R. Godine, 1976), 32.

32. A. R. Crihfield, "Relation of Backgrounds to Subjects," *Philadelphia Photographer* 8, no. 86 (Feb. 1871): 55.

33. Lyman G. Bigelow, *Artistic Photography and How to Attain It* (Philadelphia, 1876), 13.

34. Francis Galton, *Inquiries into Human Faculty and Its Development* [1883] (New York: Dutton, 1907), 222–23.

35. George Iles, *Flame, Electricity and the Camera: Man's Progress from the First Kindling of Fire to the Wireless Telegraph and the Photography of Color* (New York: Doubleday and McLure, 1900), 319.

36. John J. Flinn, ed., *Official Guide to the World's Columbian Exposition in the City of Chicago* . . . (Chicago: The Columbian Guide Co., 1893), 38.

37. Frank Norris captures some of the windy vacuity of this notion in *The Pit* when he presents his heroine Laura Jadwin ruminating on the "duty" of doing one's work amid life forces that can overwhelm the individual: "'The individual— I, Laura Jadwin—counts for nothing. It is the type to which I belong that's important, the mould, the form, the sort of composite photograph of hundreds of thousands of Laura Jadwins. 'Yes,' she continued, her brows bent, her mind hard at work, 'what I am, the little things that distinguish me from everybody else, those pass away very quickly, are very ephemeral. But the type Laura Jadwin, that always remains, doesn't it?'" Frank Norris, *The Pit* [1903] (New York: Amsco, n.d.),

192–93. Laura's thoughts are a consolation to her, but also a form of irresponsibility, sanctioning the escapism of her life. Also see: H. P. Bowditch, "Are Composite Photographs Typical Pictures?" *McClure's Magazine* 3, no. 4 (September 1894): 331–42.

38. Joel Snyder, in Snyder and Doug Munson, *The Documentary Photograph as a Work of Art: American Photographs, 1860–1876* (Chicago: David and Alfred Smart Gallery, University of Chicago, 1976), 21–22.

39. John Baskin, in Hal Morgan and Andreas Brown, *Prairie Fires and Paper Moons: The American Photographic Postcard: 1900–1920* (Boston: David R. Godine, 1981), viii.

40. Alexander Gardner, *Gardner's Photographic Sketch Book of the War* [1866] (New York: Dover, 1959), preface, n.p.

41. See William Frassanito, *Gettysburg: A Journey in Time* (New York: Scribners, 1975).

42. For the former position, see Joel Snyder, "Documentary Without Ontology," *Studies in Visual Communication* 10, no. 1 (Winter 1984): 87–88; for the latter, see Peter Hales, *Silver Cities: The Photography of American Urbanization, 1839–1915* (Philadelphia: Temple University Press, 1984), 163–217. Also see Miles Orvell, rev. of *Silver Cities*, in *Studies in Visual Communication* 10, no. 4 (Fall 1984): 80–83.

43. See reviews by Eldridge T. Gerry and A. F. Schauffler, in Jacob Riis, *The Children of the Poor* (New York: C. Scribner's Sons, 1892), "Commendations."

44. For a discussion of Krausz, together with examples of his work, see Hales, *Silver Cities*, 224–33.

45. Jacob Riis, *How the Other Half Lives* [1890] (New York: Dover, 1971), 64–67.

46. Edward S. Curtis, *The North American Indians* (20 vols.) [1970–30] (New York: Johnson, 1970), vol. 1, xii–xiv.

47. Christopher M. Lyman, *The Vanishing Race; and Other Illusions: Photographs of Indians by Edward S. Curtis* (New York: Pantheon, 1982). See also Joanna Cohan Scherer, review of Lyman, *Studies in Visual Communication* 11, no. 3 (Summer 1985): 78–85, which emphasizes the frequency of ethnographic inaccuracies in anthropological photography of the period; Curtis's reconstruction of the past was "then accepted practice among anthropologists" (80).

48. John A. Cockerill, "Some Phases of Contemporary Journalism," *Cosmopolitan* 13 (October 1892): 701.

49. George D. Richards, "Pictorial Journalism," *The World Today* 9 (August 1905): 852. Such practices, and a similar rationale, remained acceptable through the 1930s. Yet clearly not all photographers approved the flexibility of the medium as it was often practiced, an attitude indicated by the scrupulous distinction drawn as early as 1909, when Lewis Hine said that "while photographs may not lie, liars may photograph." Lewis W. Hine, "Social Photography: How the Camera May Help in the Social Uplift," *National Conference of Charities and Correction Proceedings* (June 1909): 356–57.

50. Rick Dingus describes a wide variety of manipulative techniques in *The Photographic Artifacts of Timothy O'Sullivan* (Albuquerque: University of New Mexico Press, 1982); see especially 31–64. And see Weston J. Naef and James N. Wood, *Era of Exploration: The Rise of Landscape Photography in the American West, 1860–1885*

(Buffalo and New York: Albright-Knox Art Gallery and Metropolitan Museum of Art, 1975), 68–69.

51. Martha A. Sandweiss, *Masterworks of American Photography: The Amon Carter Museum Collection* (Birmingham: Oxmoor House, 1982), 6–10. Also see Peter B. Hales, *William Henry Jackson and the Transformation of the American Landscape* (Philadelphia: Temple University Press, 1988).

52. Rosalind Krauss, "Photography's Discursive Spaces: Landscape/View," *College Art Journal* 42, no. 4 (Winter 1982): 311–19.

53. Clarence King, *Mountaineering in the Sierra Nevada* (Boston: James R. Osgood, 1872), 126.

54. See John Bartlett, "Has the Brain a Photographic Function?," *American Journal of Photography* 18, no. 209 (May 1897): 195–200.

55. See William Crawford on the influence of photographic technology on esthetic "syntax": *The Keepers of Light: A History and Working Guide to Early Photographic Processes* (Dobbs Ferry: Dobbs Ferry, 1979), 1–16.

56. See Eadweard Muybridge, *Animals in Motion* (London: Chapman and Hall, 1899), 10–11.

57. See Samuel D. Warren and Louis D. Brandeis, "The Right to Privacy," *Harvard Law Review* 4 (Dec. 15, 1890): 193–220; and William James, "The Hidden Self," *Scribners* 7, no. 3 (March 1890): 361–73. Also: A. A. E. Taylor, "Photographic Views of the Inner Man," *Philadelphia Photographer* 3, no. 29 (May 1886): 138–39. Along with the hidden self, some tried to capture the hidden spirit: see Fred Gettings, *Ghosts in Photographs: The Extraordinary Story of Spirit Photography* (New York: Harmony, 1978).

EMPLACEMENT, DISPLACEMENT, AND THE FATE OF PHOTOGRAPHS

ROGER HULL

 THE PHOTOGRAPHER'S CONCERNS CANNOT "STOP SHORT AT the edges of the print,"[1] to use Charles Caffin's words, for the surroundings of a photograph affect it too strongly to be ignored. The photographic print is particularly (at times pathologically) responsive to its setting and context. It is susceptible to choices about matting and framing as well as to the resonance between it and the walls, pages, and politics of photography and even the history of photography—to be written in the photograph's future. Whether a photograph is exhibited in gallery or club rooms, published as halftone or photogravure, on newsprint or fine paper, as illustration or artistic image, or as a component in advertising layout or in a folio of fine prints—all of these are encoding factors which provide clues to the viewer on how to read the image, what to make of it, how to value it in relationship to others like it, and ultimately whether to receive it (and perceive it) with respect or disdain. A photograph, in short, is drastically dependent upon how it is positioned in its immediate format and in its larger contexts. Successful positioning, or *emplacement*, results in the artificial (but, for most photographers, desirable) situation of a photograph stabilized within the structure that later becomes the recognized history of photography. At the same time, mispositioning, or *displacement*, will accelerate the photograph's natural tendency over time toward anonymity and metamorphosis in ever-changing contexts.

These are my conclusions in light of the fate of certain American photographs made just before and after the turn of the century. It is my argument that choices about emplacement by Alfred Stieglitz, and by (and for) Rudolf Eickemeyer, Jr., and Edward Steichen, were as significant to

their assigned place or nonplace in photographic history as the choices they made in the photographic process itself.

In *Photography as a Fine Art*, published in 1901, Caffin noted a conscious and calculated attitude on the part of artistic photographers toward format, or *ensemble*. Whereas many painters, he said, were content to rely on manufactured frames, it was "no uncommon thing for a photographer to experiment for several months with the framing and mounting of a print; hanging it where he can see it frequently and study it with a fresh eye, gradually amending his original conception of the setting until it satisfies him."[2] Caffin explained this difference between painters and photographers on the basis of a quality in photographs that he saw as both a distinguishing feature and a limitation—the quality of *tone*, rich and subtle in a fine photograph but basically "limited to one color" so that photographers "must obtain variety and harmony by playing upon subtle gradations."[3] Mounting and framing were crucial to the effective enhancement of tone, Caffin argued, and this was the context of the quotation cited at the beginning: "The photographer's feeling for tone *does not stop short at the edges of the print*" (italics mine).

Caffin wrote *Photography as a Fine Art* upon the recommendation of and in consultation with Stieglitz,[4] who shared and probably informed Caffin's view. Stieglitz wrote in the same year that Caffin published his book: "The modern pictorial photographer is a man of detail as far as the presentation of his work goes." "After his print is finished, he studies his mounting and framing with a care which quite equals that put into the picture itself, for he realizes the important influence of these factors on the tone and color-scheme of the picture itself."[5] In this point of view shared by Caffin and Stieglitz hovers the unstated assumption that photographs *require* a carefully considered format if they are to be fully realized as esthetic objects. The photographer's concerns cannot "stop short at the edges of the print" for the surroundings of the print affect it and inflect it and have the potential even, as Caffin and Stieglitz did not quite say, to infect it. What they did not necessarily say either, but could be inferred, is that photographs are by nature mercurial things, quick to change in meaning and stature depending upon how they are, to use the term in its widest ranging sense, framed. (When set free from their frames, they can float and change seemingly forever.)

A book about photographs is a sort of frame, subject to decisions about what should and should not be enframed within it. Caffin's *Photography as a Fine Art*, a selective assessment of new photography at the turn of the century, devoted a full chapter to Stieglitz, to whom Caffin accorded "the

first place among American exponents of pictorial photography."[6] Caffin's book-as-frame, constructed under Stieglitz's influence as a highly visible volume in the bibliography of photography, still stands as a significant incidence of emplacement for Caffin as a critic as well as for Stieglitz and the photographers he championed, including the newcomer of the day, Eduard (later Edward) Steichen. It also stands as a significant incidence of *displacement*, a fact that would be invisible to us were it not for the survival of two different versions of *Photography as a Fine Art* (see Figs. 1 and 2).

The first six chapters of the book originally were serialized in the Wanamaker's organ, *Everybody's Magazine*, during 1901. The seventh chapter first appeared in *Camera Notes*, edited by Stieglitz. In chapter six of the *Everybody's* version, Caffin had discussed a photographer who in the 1890s was considered Stieglitz's equal as an American representative of international artistic photography but who only now is emerging from the oblivion that gradually overtook him. This was Rudolf Eickemeyer, Jr. By the time Caffin published *Photography as a Fine Art*, Stieglitz and Eickemeyer both had earned a stunning record of successes in photographic salons worldwide. "We were practically the 'only pebbles on the beach,'"[7] Eickemeyer later wrote to Stieglitz, who by that time, never having thought of himself as a pebble, was becoming a mighty boulder. Eickemeyer, too, was more than a pebble, but Caffin took one of the first steps to write him off as a geological formation of any sort. When it came time to publish the *Everybody's* manuscript as a book, the substantial section on Eickemeyer was entirely excised,[8] and thus began the long, slow process of Eickemeyer's deletion from the publications that gradually became recognized as key documents in the standard history of photography.

In the *Everybody's* version, Eickemeyer shared Caffin's chapter on "The Landscape Subject" with Steichen. For Caffin, this was the juxtaposition of the old guard in American artistic photography with the new, although in 1901 Eickemeyer (the slightly older contemporary of Stieglitz) was not yet forty. Steichen, described as the "enfant terrible" of the American school by Robert Demachy,[9] at the age of twenty-two was establishing his reputation in this country and abroad as the leading figure in a new generation of creative photographers. Caffin praised Steichen's *The Pool, Evening* as "one of those prints which emphasizes the wide gap there is between the average photograph and genuinely artistic work,"[10] but found that Eickemeyer's photographs "represent the rather obvious, expressed with somewhat more than usual skill."[11]

Despite his unflattering text, Caffin included six reproductions of Eickemeyer's photographs in the course of the chapter's fourteen pages in *Everybody's*, so that, visually, Eickemeyer was provided with a situation of

Figure 1. Title page for chapter six, "The Landscape Subject," in *Photography as a Fine Art*, by Charles H. Caffin, as published serially in *Everybody's Magazine* (September 1901), p. 321.

prominent emplacement. The header photograph for the essay was Eicke-meyer's *The Day's Work Done*, the scene of a laborer passing through a landscape toward his cottage, titled and attributed at the top edge and emplaced directly above the words "PHOTOGRAPHY AS A FINE ART" (Fig. 1). The photograph's proximity to this line of words immediately signified *it* as fine art. The next pages of the essay were illustrated by Steichen's photographs, followed by a sequence of four nearly full-page reproductions

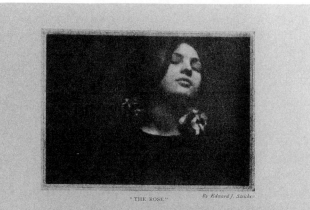

"THE ROSE" *By Edward J. Steichen*

CHAPTER VI

The Landscape Subject

Illustrated by Reference to the Work of Edward J. Steichen

S a preliminary to the Landscape Subject in photography, let us briefly glance at the pedigree of landscape in painting, for the latter has developed along certain motives which are still in force, and belong as much to photography as to painting.

The landscape in art was first studied and used as a background to figures. So we find it in the works of the Italians, where the painter's motive was to furnish a decorative pattern of form and color behind the figure, to surround the figure with atmosphere, and to contrast its

145

Figure 2. Title page for chapter six, "The Landscape Subject," in *Photography as a Fine Art*, by Charles H. Caffin, as published in book form (New York: Doubleday Page and Co., 1901, and Hastings-on-Hudson: Morgan and Morgan, 1971), p. 145.

of Eickemeyer's work. All the reproductions by both photographers were boxed by double-ruled black lines, and although the illustrations in both versions of *Photography as a Fine Art* were halftone ("merely halftone," as we shall see), Eickemeyer's pictures in *Everybody's* commanded the pages effectively. In fact, the clarity of detail that Eickemeyer was beginning to be faulted for in some quarters held up well in halftone reproduction (although in Caffin's opinion Steichen's work did not: "One utters a prayer

for the safe delivery of this delicately subtle print [*The Pool, Evening*] from the perils of the half-tone process!"[12]). As purely visual emplacement, Eickemeyer's position in *Everybody's* was strong. In deleting Eickemeyer, Caffin buried his criticism of Eickemeyer but also did him the disservice of dislodging him from a position of prominence. By displacing the photographs along with the criticism, he removed the opportunity for Eickemeyer's work to be seen and reseen as the book was read and reread (and in the 1971 reprint, which did not reemplace Eickemeyer, reseen and reread again).

Successful emplacement depends partly upon opportunity, partly upon informed initiative. Emplacing one's photographs in a prestigious exhibition, for instance, requires the good fortune of having them accepted by a jury *for* emplacement there. The photographs of both Stieglitz and Eickemeyer were emplaced prestigiously by the juries of the salons of the 1880s and 1890s. Emplacing *oneself*, accompanied by one's photographs, in the membership of an honorable association of photographers requires the good fortune of having one's bid for membership accepted; Stieglitz and Eickemeyer were emplaced as the first and second American members of the Linked Ring Brotherhood of London. Emplacing one's photographs on the pages of the leading photographic journals requires the good fortune of having them accepted by an editor, and the work of both Eickemeyer and Stieglitz appeared regularly in the best periodicals in the field, including the sumptuous *Die Kunst in der Photographie* in Berlin and the elegant *Camera Notes*.

It is here, in the wake of these parallels, that we come upon the difference. *Camera Notes* in the years 1897 through 1902 was the site of emplacement of photographs both by Eickemeyer and Stieglitz, but only Stieglitz was its editor. And as Stieglitz proceeded in the years after 1900 to place his photographs in situations of ever greater prestige, he did so from the empowering positions not only of editor but also of impresario (of the Photo-Secession) and gallery director (of 291 and the later "little spaces"). From such positions, Stieglitz exerted tremendous control, including control over the invisible matter of displacement. For reasons to be explored, Eickemeyer was plausibly an early casualty of Stieglitz's power to displace—as reflected not only in Eickemeyer's fate in *Photography as a Fine Art* but also in a fundamentally more significant exclusion two years later.

Eickemeyer was never an editor, but in 1900 he set about publishing books of his own photographs, producing four by the end of 1903. Each of these was, in a way, a portable and permanent presentation of his work. Eickemeyer was never an impresario, but he was a respected judge of

photographic quality and as such frequently held the power to emplace the photographs of others. It was he, along with C. Yarnall Abbott and William F. James, who awarded Stieglitz's photograph *The Street, Winter* the grand prize in the Bausch & Lomb Quarter Century Photographic Competition in 1903, for instance, and thereby emplaced the photograph in a sumptuous catalogue and contributed, in a minor way, to the installation of Stieglitz himself in the pantheon of photographers. Eickemeyer's power to emplace his own work and that of others would never equal Stieglitz's, but in 1903 that was not entirely clear. With four books to his credit, continued success in positioning his work in important exhibitions, a reputation as a respected juror, and a flourishing Fifth Avenue portrait studio that drew a clientele of potential art patrons and collectors, Eickemeyer's powerful position to insert his work permanently in the annals of photographic history would seem to have been assured.[13]

What were those books he published? The first two came out in 1900 as *Down South*, a compilation of photographs he had made of black farmworkers in Alabama in 1894 with an introduction, tellingly, by Joel Chandler Harris, and *In and Out of the Nursery*, which interspersed poems by his sister about children with Eickemeyer's photographs of his nieces and nephews. (The counterpart to this children's photography in Stieglitz's contemporary work was the on-going series known as the "Photographic Journal of a Baby," which Caffin drew upon to illustrate his chapter on Stieglitz in *Photography as a Fine Art* published the next year.) The third Eickemeyer book was *The Old Farm* (Fig. 3), published in 1901 with an introduction by the photographer, and the fourth was *Winter*, published in 1903, introduced with an essay by Sadakichi Hartmann, who in this period was also collaborating with Eickemeyer on a series of nature essays published in national magazines and illustrated with some of the same photographs that Eickemeyer used concurrently in *The Old Farm* and *Winter*. Meanwhile, photographs that had appeared in *Down South* in 1900 also showed up in 1901 as illustrations for Joel Chandler Harris's story in *The Cosmopolitan* entitled "Flingin' Jim and His Fool-Killer" ("Illustrated by photographs taken especially for *The Cosmopolitan*, by Rudolf Eickemeyer, Jr.").[14] One of these, in turn, served simultaneously in 1901 as an example for discussion in *Everybody's* version of Caffin's *Photography as a Fine Art* (here alone it was captioned with a title of its own, *Return from the Fields*, signifying its status as art).

Whether practiced by Eickemeyer or by others, such inconsistent framing, such versatility of emplacement for particular photographs in different contexts, came to be seen by Stieglitz as a form of indiscrimination, dangerous to the cause of photography as art. It was dangerous from the

Figure 3. Cover of *The Old Farm* (New York: R. H. Russell, 1901), by Rudolf Eickemeyer, Jr.

conservative point of view of stabilizing and valorizing one's photographs. In revealing the extremes of photographic presentation by showing a prestigious photograph in such drastically different positions as illustrational subservience on the one hand, and artistic status on the other, an example like Eickemeyer's made all too clear the susceptibility of a print to its surroundings and threatened to unravel the mystique of avant-garde photography as an art form. Eickemeyer was prepared to take advantage of what Walter Benjamin later described as "the natural alliance . . . between photography and the crowd."[15] But from this, and from the entrepreneurial approach to photography, Stieglitz retreated in alarm.

Eickemeyer published his four volumes at the height, or just slightly past the height, of his career as an international salonist, when his studio must have bulged with his famous, award-winning photographs, home from the salons of the nineties. It was a crucial moment in these photographs' histories. Their emplacement so far had been in contexts of prestige—in exhibitions in London and Paris, Hamburg and Brussels, Calcutta and Toronto, and New York. The question that occurred to Eickemeyer, and it was a question of profound implication about the nature and fate of photographs, was this: Can photographs be reincarnated to lead new lives in a new era? Can the nineteenth-century art photograph be reseen in terms of a twentieth-century commodity?

The son of a practical-minded inventor, Eickemeyer was never quite comfortable with the Stieglitz-Caffin assertion that photography was a fine art, and he had always felt the need to make his life in photography monetarily profitable if he was to allow himself such a life at all. If Stieglitz (with his modest but definite independent income) was the impresario, Eickemeyer of necessity and by temperament was the entrepreneur, seeking ways to market and remarket his works, to find new and expanding audiences for the same images in different and widening contexts. His inclination was to take advantage of photography's propensity, as Benjamin later phrased it, to be "at home [in] the marketplace."[16] With his picture books, Eickemeyer came upon a format so successful that it entirely erased the pedigree he had earlier, in a different sector of his experience, worked hard to establish for each of his photographs (see Figs. 4 and 5). This erasure allowed the photographs to be born again for a mass audience indifferent to pedigree and unschooled in looking at photographs except as pictures in a story. Capitalizing upon the propensity of the photograph to accompany and illustrate words, Eickemeyer wrote an introduction to *The Old Farm* that never mentions the word *photograph* but focuses on dreams by the fireside of some "ideal spot to which we might some day retire, there to live out the remainder of our days in peacefulness and quiet

Figure 4. Rudolf Eickemeyer, Jr., *The Path Through the Sheep Pasture* (1897), exhibited in 1900 at the Royal Photographic Society of Great Britain and at the London Salon of Photography. Courtesy, Division of Photographic History, National Museum of American History, Smithsonian Institution.

Figure 5. Page from *The Old Farm*, showing *The Path Through the Sheep Pasture* and other photographs as untitled illustrations printed in halftone with letterpress.

contemplation."[17] In this discourse of reverie and escape, Eickemeyer lulls us into seeing his photographs as the mild accompaniment to nostalgia.

Eickemeyer's books, in short, are a study of the transformation of famous photographs into anonymous illustrational cues. The books reframe the photographs and entirely revise the context in which we receive and evaluate the images. Eickemeyer's *Sweet Home,* a scene of footprints in a field of granulated snow with a house on the horizon, earned seven medals in international exhibitions of pictorial photography in the years 1894 to 1898.

In *The Old Farm*, it appeared as an untitled illustration, shorn of its illustrious exhibition record and even its title, and it was printed in what was beginning to be considered "mere" halftone. The preferred way to reproduce photographs in the world of fine art photography was by photogravure; it is significant that when Stieglitz published a book of his photography, *Picturesque Bits of New York* (1898), he limited the number to twelve photogravures, in contrast to Eickemeyer's eighty-five halftones illustrating *The Old Farm*. The number of images and the methods of reproducing them set up strong contrasting messages: Stieglitz presented the art of photography; Eickemeyer presented an illustrated storybook. As modes of emplacement, halftone and photogravure implied entirely divergent intentions and resulted in radically different readings. Although Eickemeyer's books were, in their way, exemplary of good-quality mechanical book reproduction, the perception of halftones as *merely* halftone gradually made Eickemeyer's books seem ordinary and unexceptional—and forgettable.

An innovation of the 1880s, the halftone reproduction of a photograph could be set directly with type and the laid-out page could then be printed as a unit. Eickemeyer made use of this compatibility of typeface and photographic image in the layout of his books, and in *The Old Farm*, his photographs, excerpted from his prestigious oeuvre, are intermingled with excerpts from famous poems about nature. Words and images ostensibly become unified by the halftone process as a kind of verbal-pictorial text based on quotation (of famous poetry, of Eickemeyer's oeuvre) and combination—words and photographs recontextualized in a new, technological unit in the service of evoking memories of the past. Elsewhere I have pointed out that neither Eickemeyer's photographs nor the poetry he quotes from Shelley, Keats, or Shakespeare cohere as any traditional narrative about old farms or anything else.[18] Instead, the book presents excerpts from poems and photographs unified only by the broad theme of rural nature, the fact of proximity to one another between the covers of the book, and the insistent integrative power of the halftone process itself, by means of which words and pictures share the shiny pages and appear to merge into oneness.

Photogravures, meanwhile, derived from a process invented before the halftone revolution. An engraving of the photographic image is made on a metal plate and from the plate, ink reproductions are formed. For no less eminent a photographer than P. H. Emerson, photogravures could be of the quality of an original photograph; by 1900 the photogravure had become imbued with the symbolism of prestige. Photogravure was a process for the printing of (high-quality) images, not words. When photogravures

appeared with letterpress, they were luxuriously conspicuous as separately worked insertions, often printed on different, higher quality paper than the rest of the publication and sometimes (Stieglitz became the famous practitioner of this) were printed on separate fine papers and tipped into a journal or book by hand. Whatever the particular manner of presentation, photogravure tended to avoid the peculiarly twentieth-century merger of word and image that Eickemeyer was pioneering with his halftone publications.

The difference between halftone and photogravure and the difference in contextual meaning these modes of photographic reproduction took on, was clearly demonstrated within a single entity in *Camera Notes*, the journal of the Camera Club of New York, edited by Stieglitz during the period 1897–1902. In his chapter on Stieglitz, Caffin described *Camera Notes* as "the most dignified, and probably most influential, of all photographic journals."[19] As a setting for the emplacement of photographs, it was virtually unparalleled. On its pages, both halftone and photogravure were regularly published, and a sort of instructional example—we owe much of how we read photographs to the lessons of Alfred Stieglitz—was offered on the lush superiority of photogravure over the work-a-day practicality of the halftone.[20]

In halftone, the photograph was used for routine, illustrational reproductions and was allowed the freedom to merge with lettering (superimposing the first letter of an essay on a halftone of a photograph was a commonplace decorative touch in *Camera Notes*; see Figs. 6 and 7) or to appear as a part of itself, in a detail excerpted and reduced in scale to fill a void in the magazine layout. Photogravure, in contrast, never entered into this cooperative interdependence with letterpress and in fact interrupted the unified format by appearing as the special insertion with a tissue paper overlay, signifying a precious, easily damaged surface.

The works of many photographers were published in *Camera Notes* as both photogravures and halftones, as both prestigious art, that is, and as decorative or informational components. Eickemeyer was featured most expansively in 1898, when his illustrated essay, "How a Picture Was Made," was the lead article explaining the process of the making of his genre photograph entitled *The Vesper Bell*, presented in photogravure as the frontispiece. Individual photographs (some in photogravure) by Eickemeyer were included from time to time in later issues, but by 1901 Stieglitz's taste had veered strongly from the matter-of-fact clarity epitomized by Eickemeyer's work to the more painterly and expressive effects of Robert Demachy, of France, and Steichen. Steichen's work featured heavily in Stieglitz's last issues of *Camera Notes*.

Figure 6. Rudolf Eickemeyer, Jr., *Fleur-de-Lis* (1894), a widely exhibited photograph described by the critic Sadakichi Hartmann as "only second to Stieglitz's 'Winter Fifth Avenue'" among pictorial photographs (*The Photographic Times*, April 1900). Courtesy, Division of Photographic History, National Museum of American History, Smithsonian Institution.

Figure 7. Page from *Camera Notes* (October 1898) showing *Fleur-de-Lis* as an untitled (but credited: "R. Eickemeyer, Jr.") decorative panel for typography.

Stieglitz first met Steichen, fifteen years his junior, in 1900 and was so impressed with the work of the young man from Milwaukee that he bought three of his prints on the spot, thus beginning a long association that probably was as significant to Stieglitz's eventual position in the history of photography as it was to Steichen's. Steichen, a painter as well as a photographer, was en route to Europe, from where he would provide Stieglitz (with his ambition for the recognition of photography as a fine art) direct contact with modern nonphotographic art. Stieglitz courted Steichen by sending him copies of *Camera Notes* in France to show him what it was like to have one's photographic work prestigiously emplaced.

In the issue for January 1901, Steichen found six of his prints reproduced, one in photogravure, and in July 1901 he read of "Steichen's Success in Paris" in an unsigned note congratulating him on having a painting accepted in the Salon of the Champs de Mars in Paris ("his success in painting means much for pictorial photography"). Also included was the reminder that Steichen as a painter fully acknowledged the artistic potential of photography. "This at all events was the opinion he expressed to us prior to his departure for Paris twelve months ago,"[21] concluded the note, in transatlantic query of Steichen's current attitude toward photographs. Clearly, Stieglitz saw in Steichen, as he did in Caffin (with his reputation as a legitimate art critic), an agent for the proper institutional emplacement of photography—"as a fine art" in the company of paintings.

When Steichen returned to New York, he joined the Camera Club and affiliated himself with the inner Stieglitz circle, which increasingly separated itself from the larger membership of the club. Stieglitz's ambition for photography had outgrown the limited world of camera clubs, and in 1902 Stieglitz announced that he and his editorial board were resigning from the journal. Stieglitz's valedictory issue of *Camera Notes* exalted Steichen. "Over a year ago," he wrote in an introduction to an essay on Steichen by Hartmann, "we had decided to devote an entire number of *Camera Notes* to Steichen and his ideas. In view of the extreme sublety of his originals, it was deemed advisable to await his return from Europe, so as to enable him personally to supervise the reproduction of his pictures and *thus do the greatest possible justice to himself and to ourselves*" (italics mine).[22] The implication was clear that correct emplacement, by means of the subtleties of photogravure, required the personal supervision of the artist himself and that correct emplacement of particular works cast prestige upon (did "justice to") not only the artist himself but to the like-minded workers of his circle. Steichen's emplacement in an "entire number of *Camera Notes*" never took place. But this turned out to be a case of delay rather than displacement. Within a year, Stieglitz and Steichen crafted the most prestigious site for emplacement yet conceived, the successor of *Camera Notes* called *Camera Work*. It represented Stieglitz's next major chapter in what he described as the "merciless" fight to stabilize the mercurial medium of photography as art.

In the pro-Steichen valedictory issue of *Camera Notes,* a final Eickemeyer photogravure appeared (with none by Steichen, presumably because of the complexity of making high-quality gravures of such subtle work), but it was Eickemeyer's last photograph to see emplacement under Stieglitz's aegis. Eickemeyer represented the world being left behind, and his photographs never appeared in any form in *Camera Work* despite discussion of

an Eickemeyer issue in 1903.[23] The effect of this exclusion was drastic, for it was on the basis of *Camera Work* that the canon of early twentieth-century artistic photography was written. Deletion from *Photography as a Fine Art* was a major displacement for Eickemeyer, but the missed opportunity for emplacement in *Camera Work* was displacement of graver consequence.

The great monument to gravure (and gravure-like) reproduction, *Camera Work,* appeared in its first issue in 1903, the year Eickemeyer published his last halftone picture book. Steichen designed the cover, the lettering, and the format for *Camera Work,* which made even *Camera Notes* seem miscellaneous in content and cluttered in layout. Published quarterly until 1917, *Camera Work* was the apogee of Stieglitz's skill in positioning photographs so as to take advantage of the inflections of fine papers, photogravure, separation of letterpress from image, and in many cases the separation even of image from page—the result of Stieglitz's practice of printing the reproductions on separate fine papers and attaching them by hand to the heavy, textured pages of the journal.

Whereas *Camera Notes* had been tied to the Camera Club of New York, *Camera Work* was founded by Stieglitz as an independent publication, funded by subscription, elegant advertising, and Stieglitz's own sources (ideal emplacement and independent funding go hand-in-hand, as Eickemeyer was probably aware). It, too, was the journal of a group, but instead of the membership of a camera club the immediate audience for *Camera Work* was the Photo-Secession, the photographers Stieglitz and Steichen organized in 1902. In the word *secession* inheres the essence of Stieglitz's strategy of emplacement after 1900: disengagement from the norm; construction of ideal planes for emplacement (the pages of *Camera Work* and their extensions on the walls of the Photo-Secession gallery at 291 Fifth Avenue, beginning in 1905); the establishment of a new society to create and appreciate the photography of secession. As the recognized head of journal, gallery, and society, Stieglitz controlled the context in which his photographs were seen and reseen, and reseen, for *Camera Work,* even more than *Camera Notes* and *Photography as a Fine Art,* was to be a lasting monument. Stieglitz realized instinctively that it is the reseeing of photographs in an on-going context of prestige that valorizes them and elevates them to the level of classic examples.[24]

The first issue of *Camera Work* (dated January 1903) was devoted to the work of Gertrude Käsebier, the second (April 1903) to Steichen. This issue presented eleven full page reproductions of Steichen's prints—seven in photogravure and four in halftone, all printed separately and set into the magazine by hand. Stieglitz and Steichen saw to it that in *Camera Work* the halftones were perceived as being incidentally rather than merely halftones

by never combining image and text on a single page and by keeping each halftone separate from the page itself, to which it was attached by corner touches of paste in the manner of the photogravures.[25] The halftone's capacity to merge informationally and decoratively with words was avoided entirely. Instead, beautifully composed segments of letterpress alternated with sequences of inserted photogravures and halftones, set apart from the text in a separate salon within the journal. Steichen had designed the journal as a kind of gallery in which he and Stieglitz literally installed the prints, and though it rapidly became a shrine to Stieglitz, it sheltered the most impressive ensemble of emplacement that Steichen's work had yet enjoyed. It was an arena largely separate from the photographic dogfights of the day and definitely separate from the technical minutiae of camera club photography. It was the arena, that is, of secessionism.

Secessionism had its opponents, and some of them (notably Hartmann, who for a time turned against Stieglitz) attempted to emplace Eickemeyer as an egalitarian alternative, seeking broad support for him from the non-secessionist camera club photographers of America. For a time the strategy worked and Eickemeyer's popularity flourished, but in the long run Stieglitz, assisted by Steichen, proved to be the master architect of prestigious structures of emplacement. Outspoken rivals of Stieglitz, the editors of the magazine *Photo Era* featured (in halftone) the work of Eickemeyer in many different issues over the years, but as it turned out one is about as apt to discover *Photo Era* as the *Everybody's* version of *Photography as a Fine Art*. An alternative emplacement became, in the long run, another version of displacement.

Stieglitz's and Steichen's secession exemplified what Kate Linker recently has called "the radical retreat" of the avant-garde "into aesthetic autonomy as a means of preserving the values of established culture" and "stripping art of the character of the commodity."[26] Avant-garde though he always has been described as being, Stieglitz in this sense was conservative, and he made it his mission to sidestep the pressure of mass culture and its counterpart, modern technology—so prone, as Stieglitz surely knew, to absorb its offspring of photography into rhythms of mass production. It was for emplacement against *this* fate of displacement that Stieglitz so relentlessly worked after the turn of the century, and it was a great disappointment to him when Steichen in later years took photographic advantage of the world of mass culture. Steichen was preceded in this, of course, by Eickemeyer.

Eickemeyer did not secede from conventional photography after 1900, although Stieglitz would have charged him with something far less forgivable: abdication. Eickemeyer's open-armed embrace of the new technology must have appalled Stieglitz, and to the extent that he had a hand

in excising Eickemeyer from the documents of photographic significance, the reasons for Eickemeyer's demise are clear. While I have suggested that certain decisions affecting Eickemeyer were made for him, however, other fateful decisions were made by Eickemeyer himself. Eickemeyer, as entrepreneur of photographs in an age of technology, took a look at his award-winning photographs home from the salons of the nineties and recognized as instinctively as Stieglitz may have done that in pictorial photography there was potential commodity. For Stieglitz, this was a hazard, for Eickemeyer an opportunity. He thought more in terms of using and disseminating photographs profitably than he did in terms of preserving their privileged but unprofitable status as high art. Having seen them through one life, he embarked with them on another, and the age of mass reproduction swept them up and away into ever more anonymous contexts— total displacements from the point of view of Stieglitz but, looked at differently, total emplacements in the sense of fusion with the culture bank of American images (see Fig. 8).

Eickemeyer accepted the mass production of halftone and the integrative potential of this new technology, which not only set his images in combination with words but in combination with other whole or partial images and, of course, in combination with new audiences. The new life his photographs led in the world of mass production must have seemed magical to Eickemeyer as he watched them revitalize and recontextualize again and again: first as scenes from "the old farm" and the "winter" of American nostalgic myth, then as illustrations from the high-brow nature essays by Hartmann, then as scenes on the front of gift calendars; first as the potentially documentary photographs of black farmers, then as "down south" genre, then as untitled illustrations "taken especially" for the dialect story by Harris in *The Cosmopolitan*. Reprinting, reformatting, representations, revision, reseeing the same thing as something else: in this laying bare his photographs to technology's power of endless metamorphosis lies the explanation of Eickemeyer's fate.

Thanks to technology, Eickemeyer's photographs could be transformed into novelties, and perhaps these were the most remarkable and at the same time, from the secessionist point of view, the most debased of the extensions of Eickemeyer's photographic art. What began as a photograph of a whistling barefoot boy on a country road become a mass-produced "art print"—one of A. S. Campbell's best-selling images for over fifteen years, appearing in textbooks, postcards, and advertisements; according to a salesman, "you could not kill it with an axe."[27] Entitled *And Thy Merry Whistled Tune* or *Happy Days*, it still eddies in the backwaters of commercial exchange. The version I have seen for sale, framed in a secondhand store for $35.00, was literally sculptural, pressed and shaped so that the figure of the boy stood out in relief, the features of his face distorted and bloated.

It was an item of curiosity more than art, a product to be profited from, the use of photography to please the crowd and exploit the marketplace. Perhaps in the end it was the recycling of photographs as kitsch that most offended the defenders of photography as fine art. Eickemeyer, meanwhile, continued to show his work successfully in the waning world of salon exhibitions, emplaced (or displaced) his photographs in now little-known books of the period, remained in demand as a well-paid photographer of socialites, continued to be recognized as a juror, and acted as a pioneer in advertising photography, notably for the Eastman Kodak Company.

Steichen, too, did advertising photography for Kodak and, of course, was to become an exemplar of making photographs for profit as the twentieth century proceeded. When he began to work for Condé Nast and later the J. Walter Thompson advertising agency, Stieglitz abandoned him. Thanks partly to Stieglitz himself, Steichen's emplacement in the annals of photographic history was strong enough to withstand desertion, and in fact Steichen managed to emplace himself and his accomplishments ever more gloriously in the decades after he and Stieglitz parted ways—in the decades, that is, when he was dramatically pushing his photography into the commercial realms that for Eickemeyer meant oblivion.

But the difference that explains the contrasting fates of these two men's photographs has little to do with the difference between "artistic" and "commercial" photography, for Steichen proved that commercial photography can be perceived as artistic. The difference in fate is, again, a matter of differences in the strategies of emplacement for photographs in general. Though Steichen parted ways with his old mentor Stieglitz, he had learned this valuable lesson from the older man: the photograph always must be held in check and framed with utmost discrimination. Its life must be kept pure and simple. Once identified and honored as an art photograph, it must live out its life as that, making guest appearances later in life but always as the classic star—in the museum collection, in the sumptuous portfolio, in the *Camera Work* of the day. Steichen followed these lessons in his own way. His turn-of-the-century art photographs were always kept in place, emplaced, as they originally had been. Unlike Eickemeyer, he never recycled old images in new contexts but instead made new images for new texts, and then kept them emplaced as the epitome of fashion photography, for instance, or as the quintessential advertising photograph for J. Walter Thompson. Surely it is the greater artistic accomplishment to forge new forms for new situations. While Eickemeyer did make new photographs throughout his career, his practice of reusing and thus recontextualizing his old works (unmaking them as art) sheds fascinating, if alarming, light on the nature of photographs even as it reflects Eickemeyer's fateful indifference to preserving his work as art.

In unframing his photographs and feeding them into the technological

Figure 8. Front of Literary Guild brochure, ca. 1973, with detail of a photograph by Eickemeyer at upper left.

systems that, after all, they were scientifically a part of, Eickemeyer set his images free in an endless universe of possibilities for new and partial lives. He encouraged them to combine with words, to be seen as excerpts and thus fragmented, to join with other more or less related images to imply the telling of temporary tales, and even to aspire to the world of three-dimensional kitsch (for Steichen, the photograph was never a novelty). Most of all, Eickemeyer let his photographs metamorphose, and encouraged them in this, from high art to anonymous, generic, nostalgic American imagery. The eventual result of this setting photographs free can be seen in the advertising brochure for the Literary Guild (Fig. 8) that, propelled

Figure 9. Edward Steichen, Alfred Stieglitz with *Camera Work*. From a color photograph reproduced in *The Century Magazine*, January 1908 (facing page 323), where it was printed in reverse.

by the gyrations of an industrialized marketplace, was deposited in American mailboxes in the late twentieth century. In the upper left is an excerpt from a once-famous Eickemeyer photograph, previously the cover illustration for *The Old Farm* (Fig. 3), before that a work of art, but now an anonymous photograph afloat in the public domain. I contrast it with a photograph by Steichen showing Stieglitz holding tightly to *Camera Work* (Fig. 9), the journal in which images were emplaced with an absolutism that completely prevented escape. Inside *Camera Work*, the photographs Stieglitz championed have been arrested forever as art.[28] The fate of Eickemeyer's images has been the more lowly life of photographs, always subject to the fundamentally photographic characteristics of endless reproduction, continual rebirth in representations, salability in the marketplace, and the propensity for absorption into popular, mass culture.

In memory of J. Carson Webster

Notes

1. Charles H. Caffin, *Photography as a Fine Art* (1901; rpt. Hastings-on-Hudson, N.Y.: Morgan & Morgan, 1971), 39.

2. Ibid.

3. Ibid, 38.

4. Thomas F. Barrow, Introduction to the reprint edition of Caffin's *Photography as a Fine Art*, n.p.

5. A[lfred] S[tieglitz], "Numbering Frames at Exhibitions," *Camera Notes* 5, no. 2 (October 1901): 124.

6. Thomas F. Barrow in *Photography as a Fine Art*.

7. Letter from Eickemeyer to Stieglitz, October 5, 1903, Alfred Stieglitz Archive, Collection of American Literature, Beinecke Rare Book and Manuscript Library, Yale University.

8. I am indebted to Barbara L. Michaels for bringing this fact to my attention.

9. Quoted in Sidney Allan (Sadakichi Hartmann), "Eduard J. Steichen, Painter-Photographer," *Camera Notes* 6, no. 1 (July 1902): 15.

10. Caffin, "The Landscape Subject," no. 6 in the series "Photography as a Fine Art," *Everybody's Magazine* 5, no. 25 (September 1901): 332.

11. Caffin, *Photography as a Fine Art*, 334.

12. Ibid., 158, 329.

13. For an overview of Eickemeyer's career, see: Roger Hull, "The Traditional Vision of Rudolf Eickemeyer, Jr.," *History of Photography* 10, no. 1 (January–March 1986): 31–62, and Mary Panzer, *In My Studio: Rudolf Eickemeyer, Jr., and the Art of the Camera 1885–1930* (Yonkers, N.Y.: The Hudson River Museum, 1986).

14. Joel Chandler Harris, "Flingin' Jim and His Fool-Killer," *The Cosmopolitan* 30 (February 1901): 356–71.

15. Walter Benjamin, "A Short History of Photography," in Alan Trachtenberg,

ed., *Classic Essays on Photography* (New Haven: Leete's Island Books, 1980), 214.

16. Ibid., 200.

17. Rudolf Eickemeyer, Jr., *The Old Farm* (New York: R. H. Russell, Publisher, 1901), n.p.

18. My comments on Eickemeyer's book *The Old Farm* and the effect of halftone in contrast to photogravure are based in part on my paper "Rudolf Eickemeyer, Jr., and the Photography of Nostalgia," read at the Pictorial Photography Symposium at the Hudson River Museum, Yonkers, N.Y., on February 7, 1987.

19. Caffin, *Photography as a Fine Art*, 27–28.

20. In the first issue of *Camera Notes* (July 1897), the "Publication Committee" wrote: "It is proposed to publish with each number two photogravures representing some important achievement in pictorial photography; not necessarily the work of home talent, but chosen from the best material the world affords. In addition to this feature, articles of interest, illustrated by half-tone prints, will from time to time appear. *In the case of the photogravures the utmost care will be exercised to publish nothing but what is the development of an organic idea, the evolution of an inward principle; a picture rather than a photograph, though photography must be the method of graphic representation* (italics mine). In the second issue (October 1897), three photogravures in fact appeared, and in the issue for April 1899, four.

21. "Eduard J. Steichen's Success in Paris," *Camera Notes* 5, no. 1 (July 1901): 57.

22. Editorial Note, *Camera Notes* 6, no. 1 (July 1902): 15.

23. Letter from Eickemeyer to Stieglitz, (October 5, 1903), Alfred Stieglitz Archive, Yale University.

24. For further discussion of *Camera Work* as a frame for discourse, see also: Allan Sekula, "On the Invention of Photographic Meaning," *Artforum* 13 (January 1975): 36–45.

25. Halftone occasionally had been given elevated status in *Camera Notes*. In "Our Illustrations" (2, no. 4 [April 1899]: 146), for example, it was noted that "besides the four photogravures, this number of *Camera Notes* contains three full page half-tone supplements." These were presented separately from letterpress as featured works of art, but this was a rare use of halftone in *Camera Notes*. Neither halftones nor photogravures were tipped in by hand, as they would be in *Camera Work*.

26. Kate Linker, "Abstraction: Form as Meaning," in Howard Singerman, ed., *A Selected History of Contemporary Art 1945–1986* (New York: Abbeville Press Publishing, 1986), 32.

27. Mary Panzer, *In My Studio: Rudolf Eickemeyer, Jr. and the Art of the Camera*, 55.

28. They have been arrested forever as art, but they have not necessarily stayed inside *Camera Work*. If Stieglitz installed the photogravures in *Camera Work* as if on the walls of a gallery, others have removed the prints from their portable gallery to remat and reframe them as separate art objects. This has been less displacement than reemplacement—to the print salesroom, the private collection, the museum. "From *Camera Work*" on the label signifies a pedigree of prestige. *Camera Work* as a monument is in danger of demolition, despite Stieglitz's tight hold upon it, but the parts, like the Elgin marbles, are preserved and revered in an on-going life of honor.

THE TWENTIETH CENTURY

DOCUMENTARY PHOTOGRAPHY IN AMERICAN SOCIAL REFORM MOVEMENTS: THE FSA PROJECT AND ITS PREDECESSORS

MAREN STANGE

 MY STUDY OF THE FARM SECURITY ADMINISTRATION (FSA) photography project considers the project primarily as the culmination of a powerful and distinct photographic tradition—the social documentary tradition—that first emerged in America around the turn of the century as a highly successful way of organizing and presenting topical social facts and problems. It continued in this function until World War II and the advent of television.

As a series of illustrations will demonstrate, social documentary, a unique conjunction of representational devices, consists not of photography alone but of four elements: these are the realist photograph, its caption, its associated written and graphic texts, and its authoritative presenting agency—such as, in the teens, the National Child Labor Committee, or, in the case of the FSA, the federal government. In the seminal Tenement House Exhibition of 1900, the Charity Organization Society, a private charitable organization in New York and other cities, organized an exhibition of over 1,000 photographs (such as Fig. 1) combined with models and maps (Fig. 2) showing the specifics of bad housing conditions in New York to demonstrate the need for legislation to regulate the construction of new tenements on the Lower East Side. Many of these images were made by amateur photographers, among them Jacob Riis, in New York and other cities. Lawrence Veiller, the exhibition's director, solicited the photographs by letter, explaining to prospective contributors that the New Yorkers were "taking small photographs and later on having them enlarged; [and] this method would probably be the best for you," and noting in a later description of the exhibition that:

Buildings, courts, airshafts, closets, roofs, and fire-escapes all have been caught just as they are. Where the photographer's tripod could not be placed, the Kodak has done duty, and the result enlarged to the scale on which other photographs have been made.[1]

In the teens, Lewis Hine photographed steel workers in Pittsburgh for the six-volume sociological classic *The Pittsburgh Survey*, providing what survey director Paul Kellogg called "graphic interpretation" of an industrial community which was, in Kellogg's words, "the social expression of one of the few master industries in the country."[2] In 1909, the year Hine worked in Pittsburgh, the city could claim not only America's three greatest fortunes to date, but also such "prime measures of civic neglect" and "industrial irresponsibility" as the country's highest rates in industrial accidents and typhoid outbreaks, as well as a standard twelve-hour work day, six or seven days a week in the steel industry, steadily falling wages, no unions, and a massive influx of highly exploitable, unskilled immigrant laborers. Seeing the steel city as exemplary of, and instructive to, the industrializing nation, the reformers suggested that Pittsburgh "bore somewhat the same relation industrially to the nation at large that Washington did politically."[3]

Hine, of course, also photographed child labor conditions during the campaign for national and state child labor legislation and, particularly in this work, he used the pages of reform journals such as *Survey Graphic* to experiment with montage and poster forms that would combine image, text, and caption in the most effective ways (shown in Fig. 3).

During the New Deal as well, the government-sponsored Resettlement Administration (RA) and FSA projects combined photographs into elaborate exhibitions (Fig. 4) and made them available as illustrations for books and magazine articles on topics related to rural relief programs and land use reform.

The existence at all of a photographic project within the RA and its better-known successor agency the FSA was certainly the result and the continuation of a collaboration that began in the 1920s at Columbia University between Rexford Tugwell, then an economics professor, and Roy Stryker, his student and teaching assistant and soon to become the director of the FSA's Historical Section-Photographic.[4] Under Tugwell, whom Franklin Roosevelt had appointed assistant secretary of agriculture and who became the RA's first administrator in 1935, the agency's activities were fourfold and included: national land-use planning, rural rehabilitation, which administered loans and grants to individuals and groups of farmers, and rural resettlement and suburban resettlement, two experimental programs which developed planned communities, among them the famous Greenbelt towns. The photography file, which continued under Stryker's direction until 1943

Figure 1. From *The Tenement House Problem,* ed. De Forest and Veiller (New York: Macmillan Company, 1903).

AN EXISTING BLOCK OF TENEMENTS IN 1900 ON THE LOWER EAST SIDE OF NEW YORK.

Figure 2. From *The Tenement House Problem*.

and which grew to include some 270,000 prints and negatives, was intended to publicize not only the long-standing rural distress which had necessitated such unprecedented federal intervention, but also the ameliorative effects and unique long-range goals of agency programs.

Considered thus, as a tradition of some fifty years' standing, social documentary can be seen as part of the long reformist response to industrial society which began to organize and gather strength after the Civil War and which succeeded, over the course of the twentieth century, in erecting the structure of regulatory and "welfare" legislation that is under such heavy attack today. In the documentary mode, photography is composed and presented in a manner that particularly exploits the photograph's status as *index*—that is, as a symbol fulfilling its representative function "by virtue of a character which it could not have if its object did not exist," in a standard semiotic definition—in order to assert more or less explicitly that the photograph presents its viewers with the truth.[5] Since this brief explication of the photograph's relation to reality may not be entirely clear, let me add to philosopher Charles Sanders Peirce's terminology art historian Rosalind Krauss's more recent, and more specific and homely, examples. "Photography," Krauss writes:

> is an imprint or transfer off the real; it is a photochemically processed
> trace causally connected to that thing in the world to which it refers in a

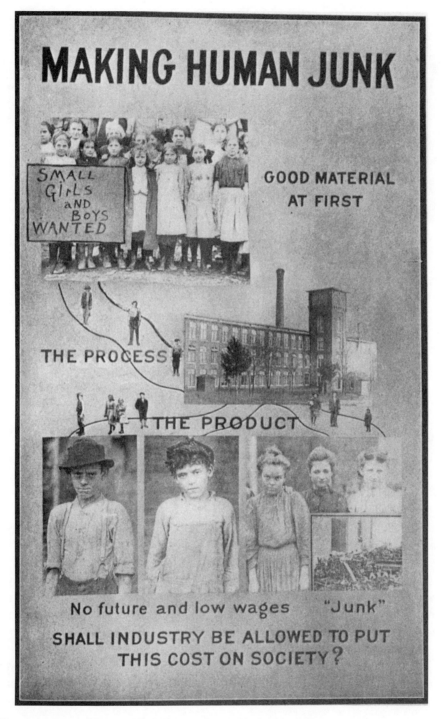

Figure 3. Lewis Hine, NCLC Poster. From *Child Labor Bulletin*, 3 (1914–15).

One of the exhibits prepared by the Committee on Exhibits. This is displayed at the Texas Centennial Exposition at Dallas.

Figure 4. From Resettlement Administration, *First Annual Report of the Resettlement Administration* (Washington, D.C.: U.S. Government Printing Office, 1936), p. 99.

> manner parallel to that of fingerprints or footprints or the rings of water that cold glasses leave on tables. The photograph is thus generically distinct from painting or sculpture or drawing. On the family tree of images it is closer to palm prints, death masks, the Shroud of Turin, or the tracks of gulls on beaches. . . . Technically and semiologically speaking, drawings and paintings are icons, while photographs are indexes.

In this, Krauss continues, consists photography's "special status with regard to the real."[6]

Perceptions about photography such as Krauss's are not, of course, absolutely new, although her language may be original. Much less often have critics and historians been concerned to connect the realist photograph's unique and indexical status to its documentary function. An early commentator on exactly this connection, however, was Lewis Hine. In 1909, in his position as "staff photographer," "director of exhibitions," and "special agent" for the National Child Labor Committee, Hine addressed the National Council of Charities and Corrections on the subject of "Social Photography":

> The photograph has an added realism of its own [he said]; it has an

> inherent attraction not found in other forms of illustration. For this
> reason the average person believes implicitly that the photograph
> cannot falsify. Of course, you and I know that this unbounded faith in
> the integrity of the photograph is often rudely shaken, for while
> photographs may not lie, liars may photograph. It becomes necessary,
> then, in our revelation of the truth, to see to it that the camera we
> depend upon contracts no bad habits.[7]

The "added realism" to which Hine referred rested simply on the fact
that the claim to, or proof of, having photographed something was equally
a claim to have been in its presence—for without the proximity of pho-
tographer and subject no image could have been made. Thus, implied in
the photographic claim is a further claim that *that subject has actually existed*.
As, however, Hine also acknowledged in these early remarks, even in 1909
advances in printing technology and newspaper and magazine distribution
were disseminating photography to ever wider audiences. As documentary
photography became an element of mass communications, the question
of the photographer's integrity as social witness became at once more
important to the growing reform movement intent on using photography
to "educate and direct public opinion," as Hine wrote, and also more
difficult to convey to the new, larger audience. One reason for the pho-
tograph's "inherent attraction" is its ambiguous, or polysemous, character:
photographs present by their nature a variety of meanings, and the reac-
tions they provoke can be those associated with art, and with imagination
and desire, as well as with practical discourse. Thus, as Hine foresaw, the
documentary use of photography posed for reformers a never-ending set of
decisions to be made about the means to authorize the documentary pho-
tograph and to control its meaning with text, captions, and identification
of the agency presenting the image.[8]

As the reform movement grew and changed, it drew upon new kinds
of cultural authority in its effort to legitimize the documentary image. When
then Governor of New York Theodore Roosevelt delivered the opening
address at the Tenement House Exhibition in 1900, he spoke of the need
to "succeed through this exhibition in upbuilding the material and moral
side of the life which is fundamentally the real life of the greater New
York. . . . When you look on the disease and poverty charts downstairs,"
he continued, "you will notice that they include the most densely populated
districts—where the greatest number of votes are cast. Then ask yourselves
how in a popular government you can expect a stream to rise so very high
when the source is so very low." And in his Albany address two months
later urging the state legislature to pass tenement reform measures, Roose-
velt again cited the exhibition's "striking features," which showed the ten-
ement house to be, as he said, "in its worst shape a festering sore on the

civilization of our great cities. We cannot be excused if we fail to cut out this ulcer; and our fault will be terribly avenged, for by its presence it inevitably poisons the whole body politic and social."[9]

However, in the scheme of the Pittsburgh Survey made by Paul Kellogg only nine years later (and shown in Fig. 5), there seems to be no room for moralism such as Roosevelt's. The governor's rhetoric implied that special attention to, and cultivation of, moral as well as physical health, decency, and cleanliness constituted the chief virtue and authority of urban reformers who were prompted by what philosopher William James called "civic courage" to penetrate, with or without tripods, the tenement iniquity. But Kellogg's schematization of social inquiry—outlining forces including newspapers, churches, social settlements, city officials, labor unions, manufacturers, and, of course, an "efficient staff of investigators preparing an unbiased presentation of facts"—remains scientifically neutral right down to the question of results to be expected from this equation of social forces and social inquiry. In the few years since the Tenement House Exhibition, the urban reform movement had grown and changed with startling speed, and the Pittsburgh Survey, which used Lewis Hine as its staff photographer and probably its picture editor, and which succeeded in replacing the rhetoric of moralism with that of sociology and economics, was the great contribution of its hopeful maturity. As reform editor Edward Devine wrote, with what now seems extreme naiveté, of Pittsburgh the year of the survey: "Since [Pittsburgh's hardships and misery] are due to haste in acquiring wealth, inquity in distribution, [and] to the inadequacy of the mechanism of municipal government, they can be overcome rapidly if a community so desires."[10]

Looking back on the survey in 1929, Kellogg described the undertaking as "an adventure on the high seas" between the census and yellow journalism. "The effort was," he explained, "to make the town real to itself; not in goody-goody preachment of what it ought to be; not in sensational discolouration; not merely in a formidable array of rigid facts." That effort was the reason why, he wrote, "industrial biographies of roll hands and furnace tenders were collected," and "why the group picture of child life in a glass town" was included "alongside the analyses of labour legislation and compulsory education laws." And that was why, he continued, "in this city of engineers, maps, charts and diagrams were used as modern hieroglyphs to reinforce the text, why the camera was resorted to as a luminous and uncontrovertible transcript of life, why Lewis Hine's 'work-portraits' told their story of human wear and tear. . . ." And, he concluded, that was why "the 'piled up actualities' of the reports were visualized in a civic exhibit" that included maps, charts, diagrams, pictures, and a "huge death calendar."[11]

SCHEME OF THE PITTSBURGH SURVEY.
From Pittsburgh Civic Exhibit, Carnegie Institute, November–December, 1908.

Figure 5. From Paul U. Kellogg, "The Pittsburgh Survey," *Charities and the Commons,* XXI (January 2, 1909).

Kellogg, like Hine, seemed to believe in the authority and reform efficacy of graphic and particular information about working people, and the survey's presentation of documentary photographs implied that exact information about people created and carried its own sufficient authority. Thus, in the survey volumes, there is a complicated and dialectical relation between image, caption, and text which provides a very complete reading of Hine's "work portraits," and one specific to working-class life in Pittsburgh in 1909. The photograph in Figure 6, showing a woman who is "Head of the Checkroom," appeared in Elizabeth Butler's survey volume, *Women and the Trades.* The subject's pleasant expression, her workmanlike concentration, and her fresh clothes and neat hair suggest she has achieved some pinnacle of modest success; she seems to be a well-rewarded, even complacent forelady. But this illusion is shattered when the reader encounters a paragraph on the page facing this portrait which explains that

> Here [in the laundry checkroom], men and women are competing for
> work which requires no physical strength, but which does require a
> common school education, intelligence, accuracy and speed. Nine years

Figure 6. Lewis Hine, *The Head of the Checkroom*. From *Women and the Trades*.

ago the work was exclusively in the hands of men. The one plant which had the prestige of a chain of laundries in several cities, began to employ women checkers, and women have now wholly displaced men in fifteen out of twenty-six laundries, and partially displaced men in five others. The reason for this is not, as we have seen, that women have proved quicker or more accurate. The reason is financial: women are cheap. From the South Side to the East End you hear it said that "You can get two women where you got one man; get twice as much work done, and done just as well."[12]

The Head of the Checkroom is, in fact, as exploited as any newly immigrated day laborer or office cleaning woman, and this despite her brave show, her title, and her generous attention to her work. In this instance, by presenting her exact job title, the *caption* reinforces the progressive idea of social publicity, connoting the technical and social expertise and special sociological knowledge by whose authority social facts are discovered, captured by the camera, and brought into legitimate public existence. However, the third element of the documentary mode, the *text*, announcing the bad news of apparently unrestrainable female exploitation, contradicts both the *photograph* and the *caption*. Having read this text, we can read neither image nor caption in the same way as we did before. Showing us not only the reformers' technology and technique, but also the unpredictable strengths and qualities of the human subject of exploitation—and object of reform—Hine prods us to think more deeply about the meaning of reform. By arranging the four-part documentary mode so that its elements contradict each other in a way analogous to the contradictions we experience in everyday life, Hine gives us a means to connect with, to perceive, and to react to, the actual processes of social change. Hine presents here not a map of reform ideology, but rather a historical and social document: *The Head of the Checkroom* is a photograph—an *index* of what it denotes—whose meaning is formed by language, and our reading of that language, and whose content is specific to what was current and immediate in working-class life in Pittsburgh in 1909.[13]

However, despite the extraordinary density and complexity of the information which often was made to surround a photograph in the survey and other prewar social documentary projects, the larger rhetorical framework in which Hine's images were presented concentrated not on denoted content but rather on the "scientific" exactitude connoted by the photograph's indexical status, linking that status metaphorically with the supposed neutrality of technical expertise in the social sciences. The graphic power of Hine's affecting work portraits was used to mobilize support for political candidates and policies that gave scope to the new expertise of city planners, sociologists, economists, and progressive businessmen—the

forces outlined in Kellogg's chart. This contradiction between an almost obsessive concern for the telling details that a complex and sensitive particularity can yield, and the determination in the larger textual rhetoric to authorize the photograph—and the progressive reform movement itself—by an association with the trained neutrality of social scientific expertise was both an ideological incoherence and a stylistic contradiction in prewar social documentary presentations. That it existed already before World War I, and that it governed the presentation of Hine's deeply human photographs, suggests the facility with which FSA photography—public relations on a national scale—could cease to present or to concern itself with an authentic representation of working-class life.

In his effort to authorize and valorize the "truth" of government-sponsored documentation of poverty and reform, Roy Stryker did not hesitate to encourage the claim that documentary photography was art as well as a way of organizing and expressing social knowledge. Widely and popularly known, the FSA appeals because of its seemingly uncommercial values and procedures—so different from those that characterize the opportunities usually offered to young photographers—and because of the urgently humanitarian rhetoric of its images. The FSA is generally seen as the exemplar of documentary photography, rather than the inheritor and culminating phase of a tradition, and energetic attention of various kinds continues to be paid to it even today.

Although its size, scope, and talented photographers entitle the FSA project to attention, it is not these qualities alone that have ensured its preeminence. In the 1930s, the newly established mass-circulation picture magazines such as *Life* and *Look* worked actively and successfully to encourage a public view of photojournalists as reliable and professional communicators. At the FSA and in his later corporate public relations work for the Standard Oil Company, project chief Roy Stryker, proving himself the right man at the right time, perceived that by annexing the emergent prestige of professional photojournalism to the already established "scientific" reliabilty of experts in social science, he could popularize and glamorize the public image of social science and social work—including, of course, the government's. But, equally important, Stryker's file of apparently substantial and socially concerned photographs, supplied free of charge, offered to pictorial journalism a significant way to counteract accusations that commercial photojournalistic ventures such as *Life* or *Look* were socially or professionally irresponsible. As project chief, Stryker provided editorial guidance for a team of a dozen-odd talented photographers. Equal achievements, however, were the establishment of a file of useful and authoritative photographs and the construction of an extensive network among publishers to ensure that the photographs were widely used.[14]

In the agency's early months, photographers Walker Evans, Arthur Roth-

stein, and Carl Mydans, beginning its work, were soon joined by Ben Shahn and Dorothea Lange. FSA records show that in 1935 Stryker distributed only a total of 965 pictures for publication during a five-month period—an average of 193 a month. Russell Lee replaced Mydans in the summer of 1936 and other photographers, including Jack Delano, John Vachon, Marion Post Wolcott, and John Collier, were hired as the project continued. By the end of 1936, Stryker had placed photographs in *Time, Fortune, Today, Nation's Business,* and *Literary Digest,* and he had prepared twenty-three exhibits, including one at the Museum of Modern Art and another at the Democratic National Convention of 1936. In 1937 and 1938, when neither Evans nor Shahn remained on the FSA payroll and Dorothea Lange, working on a per diem basis, was on her way out, the books and magazines that used FSA photographs ranged from *Look, Life,* and *The New York Times* to the *Junior Scholastic,* the Lubbock (Texas) *Morning Avalanche,* and the *Birth Control Review.* In 1938, Edwin Rosskam was hired solely to design exhibits and to promote and supervise the use of FSA photographs in books and articles. And in 1940, the Photographic Section could claim an average picture distribution of 1,406 images per month, and the number of published books illustrated with FSA photographs approached a dozen, including among the most notable Walker Evans's *American Photographs,* Archibald MacLeish's *Land of the Free,* and Dorothea Lange and Paul Taylor's *An American Exodus.*[15]

A formidable bureaucracy and clerical staff were necessary merely to maintain the FSA file; to caption, record, and distribute an average of seventy prints a day (as indicated by the 1940 figures) involved substantial additional work. Despite some opposition, the operations of such "ponderous machinery," as Edwin Rosskam called the office procedures, affected the content and controlled the interpretation of images in the picture file.[16]

The FSA program divided America into eleven administrative regions. As correspondence shows, photographers in the field depended on local FSA officials and other knowledgeable and concerned people such as health officials, social workers, journalists, and farmers themselves to guide them to their subject matter. However, all FSA negatives, no matter where they were made, were sent to Washington for editorial selection, printing, and captioning based on photographers' field notations, and all distribution was centralized in Washington. Unwieldy at best, this arrangement became a source of friction when regional needs for local and topical photographs conflicted with Roy Stryker's emerging policy preferring national publication over all other picture uses. "The [Dorothea] Lange negatives which you mentioned in your letter . . . have arrived and are now being catalogued in the files," wrote executive assistant Grace Falke in 1936 to Jonathan Garst, FSA regional director for California and the West, and, she added, "it will be a few days before we will be able to send any of this

material on to you." But there was, she continued, "one additional fact" which Garst needed to consider:

> The Information Division [of which the photography project was a part] has found it very desirable to offer such magazines as LIFE and MID-WEEK PICTORIAL and the large metropolitan dailies the exclusive use of certain sets of pictures, provided they are published within a certain length of time. Some of the material in Miss Lange's set seems most desirable to be used in this manner.

In view of this policy, she continued, Garst would not be able to receive for "local circulation" all of the photographs he wanted until after "they have been used by these magazines with national circulation."[17]

As Karin Ohrn has shown in her biography of Dorothea Lange, difficulties with Roy Stryker arising from Lange's desire to control her negatives and to use her photographs in relation to regional current events led eventually to her dismissal from the FSA in 1939. Although its details are beyond our scope here, a case can be made that similar and related issues contributed to Walker Evans's dismissal in 1937 and Ben Shahn's resignation in 1938. For Lange, Evans, and Shahn, photographers and artists who had each achieved a mature style and defined an individual project by the 1930s, bureaucratic impositions were inevitably deeply provoking, but even in the work of younger and less established photographers a contradiction is implicit between the social photographer's role as creator of graphic records of people in a particular time and place and the agency's need to use photography as publicity—as manifest emotional and intellectual symbols of a powerful, and professional, nationally coherent reform program.[18]

According to Paul Vanderbilt, the photographic archivist responsible for the current organization of FSA files in the Library of Congress, a

> change in the point of view came about gradually, partly as photographers themselves began to turn in pictures not strictly in line with their program assignments, and partly as the program assignments themselves began to be based upon possibilities for publication.

"It was doubtless a publisher's demand," Vanderbilt claimed, "which caused the concept of the survey to go beyond its limitation to rural America and depressed conditions and [to include] the urban areas and [more] sophisticated activities."[19] As we have seen in earlier illustrations, published photographs were often presented with a minimum of caption information, a fact which suggests that publishers might favor photographs which (like Fig. 7) could stand on their own without captions. Despite Vanderbilt's

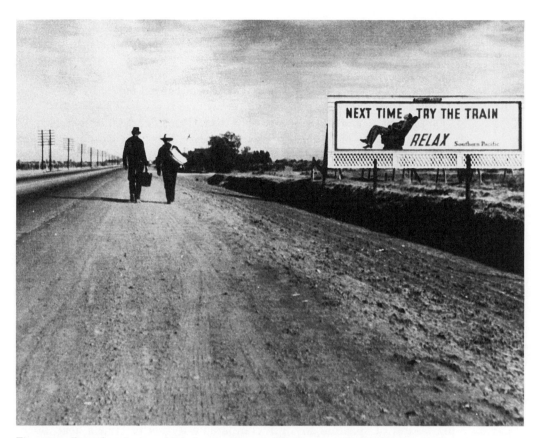

Figure 7. Dorothea Lange, *Near Los Angeles, California, 1939*. From Stryker and Wood, *In This Proud Land*. Courtesy Prints and Photographs Division, Library of Congress.

claim, however, the caption material actually turned in with their photographs suggests that most FSA photographers, little concerned with "possibilities for publication," took their documentary function seriously. In examples of pages from caption books written by photographers and intended only for internal use, they referred in their captions to what had been powerful and engaging about the actualities they confronted in their work. Garnering details that celebrated their opportunities, as social photographers, to perceive what Hine had called "the beautiful and the picturesque in the commonplace," they expressed with intensity and occasional lyricism an appreciation that is certainly comparable to Hine's.[20]

Thus, a draft of captions written by Ben Shahn in 1938 for a set of

photographs of Plain City, Ohio, includes with a straightforward caption a dry recitation of a relevant tale heard locally:

> Hard-pressed farmer came to banker for loan. Farmer not a "good risk." Banker refused coldly. Farmer pleaded. Banker, moved by the plea, makes a sporting offer—"one of my eyes is glass. Guess which eye is glass, and I'll let you have the loan." Farmer gazed intently at both eyes. Finally pointed at left eye, saying, "This is the glass one." Banker, amazed: "How did you guess?" Farmer: "It looked kinder."

In Figure 8, we see the original caption that Dorothea Lange provided for her photographs of Nettie Featherston, the "Woman of the High Plains" who is shown in Figure 9 in a reproduction from *An American Exodus*. Poor captioning was not one of the faults that Roy Stryker found with Lange's work practices, and, on the contrary, he held her up as exemplary to other photographers. As this caption suggests, she often tried to reproduce verbatim what her picture subjects had said to her. It is interesting to see from the full caption that its last lines—"If you die, you're dead—that's all," which are used in the book—mean something different from what the book implies. Nettie Featherston is talking about her hard life in Childress County, Texas—"a hard county," where "you can't get no relief . . . until you've lived here a year," and where "they won't help bury you"—and about her thwarted desire to leave it. The bleak assessment—"if you die, you're dead"—is not Mrs. Featherston's view, as the book implies. Rather, showing a kind of spiritual strength comparable to that of Hine's head of the checkroom, Mrs. Featherston, controlling her outrage with dry irony, uses her phrase to characterize the callousness of arrogant county relief authorities who might be expected to justify their refusal of a pauper's grave to the poor by simply denying that there was any possibility of afterlife for them.[21]

Implicit in Mrs. Featherston's dissatisfaction is a poignant subtext which was in fact the subject of *An American Exodus:* farmers' foreclosures and forced migrations in the 1930s resulted not only from drought and soil erosion, but also from the introduction of mechanized methods which required less labor and which encouraged large-scale operations at the expense of small farmers. In addition, government-offered incentives for acreage reduction further decreased the demand for labor. As we now know, the FSA, despite its proclamations of "greater obligation to poorer farm families" and "successful rehabilitation through better farm and home practices," was in effect an agent of modernization which had no stake in upholding the autonomy of farming traditions or local attachments which might oppose or challenge technological progress.[22] As Rexford Tugwell explains in his memoirs, agriculture, though "the most individualistic of

LANGE JUNE 1938

18283 C Migratory laborer's wife with 3 children.
 Near Childress, Texas.
 "We made good money a pullin' bolls, when we
 could pull. But we've had no work since March
 When we miss, we set and eat jest the same.
 The worstthing we did waswhen we sold the
 car, but we had to sell it to eat, and now we
 cant get away from here. We'd like to starve if
 it hadn't been for what my sister in Enid sent
 me. When it snowed last April we had to burn
 beans to keep warm. You cant get no relief here
 until you've lived here a year. This county's a
 hard county. They wont help bury youhere. If
 you die, you're dead, thats all."

18284 C Campaign posters in garge window, just before
 the primary. Waco, Texas.

18285 C J.R. Butler, president of the Southern Tenant
 Farmer's Union, Memphis, Tennessee.

18286 C Mechanization in the Arkansas Bottoms was
 beginning to expel farm people by 1937, adding
 to the refugees to the West coast. There are many
 vacant cabins. Near England, Arkansas.

18287 C Fruit jars being sterilized on Old Lady Graham's
 back fence in berry season. Near Conway, Ark.
 "We just gather and can --peas, beans, berries,,
 and sausage when we butcher a hog in the winter.
 We put up 75 quarts of berries, 60 qts of beans,
 60 qts of kraut, 30 qts of grapes, and 20 qts
 of peaches. I swapped 2 bushels of grapes and got
 2 bushels of peaches, --and I swapped one bushel
 of grapes for one bushel of apples."

18288 C Colored field hands hoe cotton from 7 A.M. To
 6 P.M. for 60¢ a day. Near Menippe, Arkansas.

18289 C An"Arkansas Hoosier" , born in 1855.
 Conway, Arkansas.
 "My father was a Confederate soldier. He give his age
 a year older than it was to get into the army. After the war
 he bought 280 acres from the railroad and cleared it. We
 never had a mortgage on it. In 1920 that land was sold,
 and the money divided. Now none of my children own their
 land.
 "It's all done gone, but it raised my family"
 "I've done my duty --Ifeel like I have. I've raised 12
 children, 6 dead and 6 alive-- and 2 orphans.
 "Then all owned their farms. The land was good and there
 was free range. We made all we ate and wore. We had a loom
 and a wheel. The old settlers had the cream. Now this hill
 land has washed, and we dont get anything for what we sell.
 We had two teams when this depression hit us. We sold one,
 we had to to get by, and we sold 4 cows.
 "In 1935 we got only 50 and60¢ a hundred pounds for
 picking and in 1936 only 60 and 75¢, and we hoe for 75¢ a day.
 "Then the govt reduced the acreage, and where there was
 enough for 2 families now there's just one. Some of the land
 owners would rather work the cotton land themselves and get
 all the govt. money. So they cut down to what they can work,
 and the farming people, they go to town on relief. The
 sharecroppers are just cut out.
 "Then the lord took a hand init, and by the time he'd
 taken a swipe there was drouth and army worm. I dont know
 for sure whose work it was, the lord's or the devil's, but
 in 3 days everything wilted.
 "Folks from this part has left for Calif. the last yr. Two
 My 2 grandsons went to Calif tohunt work. It was a case of "haf to".
 When you see 'em out there tell 'em you were talkingto OldLady

 GRAHAM, IN ARKANSAS

Figure 8. From "General Captions" folder, Library of Congress.

all industries," was nevertheless the most promising one of all on which
to experiment with large-scale centralized planning and national manage-
ment. A long history of government support for and cooperation with
farmers had constructed a far-flung system of agricultural colleges, county
agents, and a centralized Bureau of Agricultural Economics; the result of
their extensive data gathering over the years was that "more was actually
known about agriculture, collectively, than about any other widespread
activity carried on in America." In his suburban resettlement Greenbelt

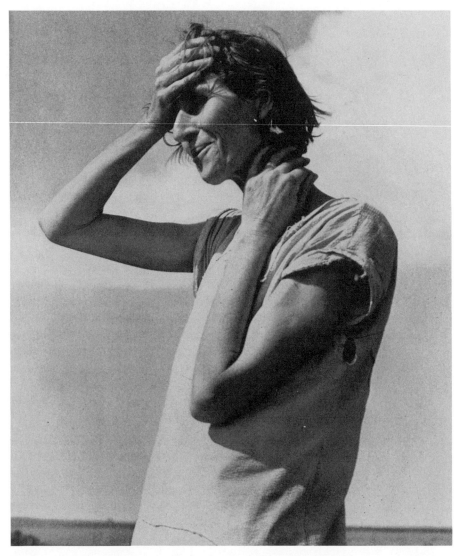

Figure 9. "If you die, you're dead—that's all." From Dorothea Lange and Paul Schuster Taylor, *An American Exodus: A Record of Human Erosion*, rev. ed. (New Haven, Conn.: Yale University Press, 1969).

towns, Tugwell anticipated the social and economic effects of the agribusiness methods he advocated. Realizing that "the population in commercial agriculture will continue to decrease, once a functioning industry is re-established to absorb the excess workers," and believing that only "exceptional persons" would want to exist permanently as subsistence homesteaders, as he wrote in 1934, Tugwell conceived the Greenbelt towns as suburban centers to absorb both city dwellers and erstwhile farmers into "our general industrial and urban life," which he called "the more active and vigorous mainstream of a highly complex civilization."[23]

In a prophetic diary entry made in 1935, Tugwell seems to have foreseen the role of photography in FSA work. Because "there is very little public sympathy" for the "poorest agricultural folk" whom the FSA intended to "help out," as he wrote, "it must be one of our first considerations to try always to conciliate public opinion so that we may go ahead in the effort to lift the levels of living of these people."[24] As Tugwell's comment implies, FSA photography, intended to legitimize, rather than criticize, the state, worked to create a documentary imagery which evoked resonant popular ideas of America's rural past, eschewed local particularities, and used representations of *material* waste such as dustbowl erosion or drought as easily read symbols of *social* waste putatively caused by outmoded and inefficient methods of production. Ideologues for the FSA proclaimed in the 1930s (as they still do today) that the inevitable abstraction and for-malization of meaning in the photographs that they saw signified a new, transcendent, "social art which cannot be silenced," with "the integrity of a style," and with a special "Americanness," a quality that linked FSA work to "the continuity of American life and tradition" which, they claimed, photography preserved and continued just as the economic aid and ex-pertise of the FSA program itself claimed to preserve and continue rural productivity.[25]

Not long before his death, Roy Stryker praised the image shown in Figure 10 as an eloquent statement of the notion, "These are the hands of Labor." In 1939, Elizabeth McCausland, an active and influential leftist art critic and collaborator with the photographer Berenice Abbott on the Fine Arts Project–sponsored *Changing New York* series, had described Russell Lee's photograph as "a human and social document of great moment and moving quality." She went on to say: "In the erosion of these deformed fingers is to be seen the symbol of social distortion and deformation: waste is to be read here, as it is read in lands washed down to the sea by floods, in dust-storms and in drouth bowls. . . ." McCausland was writing in *Photonotes*, the publication of the Photo League, a New York–based organization of talented young photographers which included Paul Strand, Aaron Siskind, and Jerome Liebling, and which was apparently funded in part by the

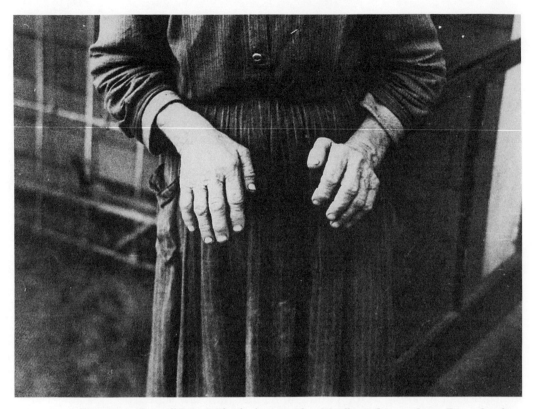

Figure 10. Russell Lee, *Wife of a homesteader, Woodbury County, Iowa*. From Stryker and Wood, *In This Proud Land*, p. 27. Courtesy Prints and Photographs Division, Library of Congress.

Communist Party. In her article, titled "Documentary Photography," Lee's photograph is used as an example to support the conclusion that "the best sponsor of knowledge" about "social themes," as well as about (and these are McCauland's comparisons) "soil erosion and flood control, highway engineering, agricultural experiment stations and numerous other important technical activities" has been "the government."[26]

The most obvious quality in Lee's photograph is, of course, its subject's lack of a head. There is the further absence of an original caption that refers to that lack, such as, *à la* Stieglitz, "The Hands of Labor," or something of the sort. Thus it would seem that the immediate meaning of the image, which, as McCausland's reference suggests, was widely reproduced

in the 1930s, resides in its important departure from the portrait convention to which it partially subscribes in its frontality, single subject, and detailed rendering of dress. Perhaps we can say initially that it is exactly this bafflement, or deflection, of the partially engaged convention that makes this image quintessentially "documentary art"—according to two reliable ideologues—rather than a "work portrait" like Hine's or a personal record portrait bought and paid for. Lee's photograph includes within itself no reference to the circumstances of its making, to the human interaction that occurred between the woman who was subject and the man who was photographer at the moment of the picture's making. Specifically, we cannot know, or even imagine, from this image whether this woman was in the process of posing for a portrait—unaware, of course, of how the image was actually being framed by the photographer—or whether she was caught while in conversation, perhaps with Lee, perhaps with someone else. Nor does any caption or text make the missing human connection. If this were in fact a full-blown commercial portrait, it would signify, by pose, costume, or studio setting, its implicit registration of the economic transaction between the sitter and the photographer that brought the image into being. However, the unusual framing seems to direct our notice, as it were, to the lack of anything in the picture's content to reveal the economic or other kind of motive that sparked the picture-making and set in motion the camera work represented here. Although the photograph does not tell us, we do, of course, know what that motive was. As a rural person, this woman stood in some relation to the FSA. Like the ruined and wasted rural land with which she was equated, she was, or soon would be, or, at least, ought to be, an FSA client under FSA management. In fact, Mrs. Andrew Ostermeyer, aged seventy-six, and her husband, eighty-one, as the Library of Congress file captions tell us, had been among Iowa's original homesteaders. However, since having lost their farm to a loan company they have worked and lived on their son's farm in an area of exhausted Iowa farmland that had been hard hit by drought and that did include numerous rehabilitation loan clients and applicants. The picture that became popular, as well as several other images of the Ostermeyers, such as the one shown in Figure 11, were taken on Lee's first major trip for the FSA. In two letters to Roy Stryker sent from the field in December 1936 and January 1937, Lee described the conditions that he found in Woodbury and Crawford counties, the "worst hit district of the [Iowa] drought counties." "Today I have talked with township chairmen of drought committees and they have shown me several places," Lee wrote. He had seen "several destitute families" and learned that there was "practically no feed for the hogs, cattle and horses, and what there is is supplied through the [FSA]

which is flooded with applications for loans and grants." "In the opinion of these local men," Lee continued:

> there is danger of an uprising unless immediate aid is forthcoming. . . . In Crawford county as well as Woodbury county, I have heard some threats of uprising. That is one of the strongholds of the Farmers Holiday Association and there is quite a bit of agitation in these two counties. In Crawford county a Farmer-Labor paper is published. I am sending you 2 copies of it together with a statement of conditions one farmer who showed me around voluntarily prepared and presented to me.[27]

Comparing the two Ostermeyer images, we can see why one and not the other became popular. Far from noble, seeming both agitated and disoriented, the aged couple, posed near the headboard of a brass bed, piques our curiosity and cries out for explanation. Lacking artful composition, the photograph seems more connected to real life, and the questions it provokes draw us directly into the Ostermeyers' social world. We wonder if they speak English, if they are healthy and well cared for, and what exactly they had been doing when Lee decided to photograph them. By contrast, the image of Mrs. Ostermeyer's hands seems to state in its careful framing an intention to be significant, by itself, in a transcendent realm apart from topical and current events. It encourages categorical, rather than particularizing, interpretations, and the actual circumstances of the social and political reality that Lee experienced in his camera work are exactly what the image represses and conceals. Unlike the double portrait, the "hands" image does not engage current and painful contradictions between such rural aspirations and traditions as were embodied in this woman and her family and neighbors and—not only drought and erosion on submarginal land—but also the inevitable human inadequacy of the social and technological "progress" and change for which the FSA was agent. Because representation of these crucial social facts is missing, the popular image seems somehow unmoored, isolated, and open to irresponsible interpretation.

But on the other hand it also seems unlikely that McCausland, knowing the facts, would have read this photograph as she did. It seems doubtful that she would have described as "waste" the Ostermeyers' life of homesteading which, after all, constituted the original and courageous importation of agriculture and its way of life to Iowa. Nor do the printing and distribution of a militant farmer-labor newspaper in two isolated Iowa counties, the formation of drought committees, and the preparation of a statement of conditions to the government seem like examples of "social

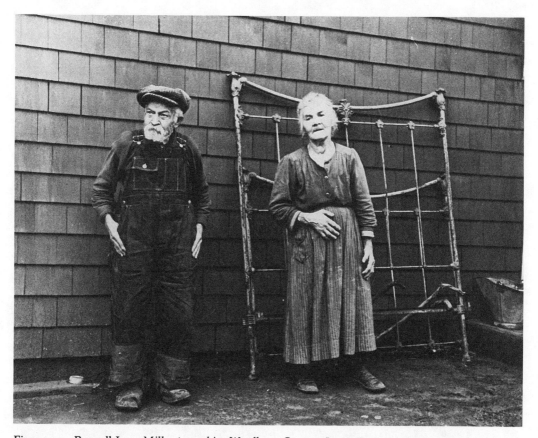

Figure 11. Russell Lee, *Miller township, Woodbury County, Iowa. Dec. 1936. Mr. and Mrs. Andrew Ostermeyer, homesteaders. They have lost their farm to a loan company.* Courtesy Prints and Photographs Division, Library of Congress.

deformation." Responding to the photograph as it was represented to her, however, McCausland gives it an "artistic" reading which makes a metaphorical equation of human and social distortion and deformation with geological erosion and waste. The crux of her reading, however, rests on an implicit technocratic assumption which underlies and makes possible her metaphor: just as soil erosion and waste can be controlled by land management, so the putative *social* deformation and waste shown in the photograph can be controlled by social and cultural management. If we take McCausland's reading of Lee's image as a caption, we see that it truly

captures the image, annexing its very realism to a set of ideological as-sumptions that could hardly be more detached from, and antithetical to, the social reality of this woman homesteader.

By 1937, Ben Shahn told an interviewer in the 1960s, children he met in the field had become "very sophisticated," enough so to be sure that the documentary photographer's presence among them was commercially mo-tivated and that his interest in their lives meant that he "work[ed] for Life magazine."[28] In the next year, 1938, FSA Information Division Director John Fischer sent a memo to all regional information advisors explaining a "re-organization of the . . . photographic program" undertaken in the wake of budget cuts because "the Washington photographic staff has never been able to provide entirely satisfactory service for the regions." Fischer asked regional advisors—many of whom, according to his memo, were "already . . . competent photographers"—to do all their own photographic work of a "special regional character," while "the Washington photographic staff will continue to handle most material of national interest, or which covers a number of regions," taking whenever possible not "single, isolated shots" but rather picture sequences, a practice which, as Fischer wrote, "the best picture editors everywhere are developing."[29]

The "unsatisfactory service" so clearly at issue for Dorothea Lange and for officials in California is given further example in correspondence from the South and the Southwest. Although the agency's most popular trav-eling exhibit, the exhibit on migrants, was requested over eighty times in a three-year period, none of these requests came from Oklahoma, Arkan-sas, or Texas; and, equally telling, the southern states did not make a single request for the next most popular exhibit on sharecroppers.[30] Nor did the FSA's well-known documentary film about the dustbowl go uncriticized in the region it portrayed. He saw "no reason why the picture shouldn't be used as is, outside of the region," wrote Ralph Bray, a southwestern official, about Pare Lorentz's film *The Plow That Broke the Plains*. But he believed that the film's oversimplified presentation of the dustbowl prob-lem ignored the plains region's agricultural successes and slighted its farm-ers' recent cooperative efforts with government erosion control projects, so that, unless changes were made in its content, the film would not "leave a good taste in the mouths of the people within the plains area . . . some of [whom] think that it is the finest country on earth."

In these same years, James Agee, composing the text for *Let Us Now Praise Famous Men*, claimed for the camera preeminent status as "the central instrument of our time," and he went on to proclaim his "rage" at a "misuse" of photography which had, he wrote, "spread so nearly universal a cor-ruption of sight that I know of less than a dozen alive whose eyes I can trust even so much as my own." Foremost among those whom Agee trusted

was, of course, Walker Evans, his friend and collaborator on *Famous Men*, and the same photographer of whose work Paul Vanderbilt was to write in the early 1940s that it "was never quite divorced from an instinctive cynicism or even the hatreds inherent in his personal philosophy," and was thus of little use to FSA "programs."[32]

Suggesting the outlines of a discourse which engages crucial questions of art, politics, and commerce, this set of quotations seems to offer a glimpse behind the scenes at the contending forces which work to shape the more public and notable statements produced by a particular era and by which we think we know it. Although FSA photography exploited the conventions of documentary *style*, such as black-and-white prints and uncontrolled lighting, that signified topicality, social concern, and social truth, the project marks the moment in the social documentary tradition when administrators and ideologues, trading away documentary's intrinsic authority for the external authority of a government agency, for the commercial cachet of "professional" photojournalism, and for an "artistic" connotation offered by some cultural critics, formalized documentary photography and divorced the style from the particularity inherent in photography's indexical relation to reality. Although in the thirties Elizabeth McCausland, the Photo League, and countless others proclaimed the "Documentary Movement" to be "a social art which cannot be silenced," the development they celebrated was in actuality the moment of documentary's decline, when the documentary mode began to deny and belittle the historicity and currency—the *social proximity*, as it were—which had given documentary its authentic authority and richest significance.

"The word 'documentary' is a little misleading," Walker Evans said in 1971. "Literally, documentary is a police photograph of an automobile accident which says nothing and is not supposed to say anything. What we conscious photographers now think of as documentary has a personal style to it, in this guise of objectivity which some of us fell in line with."[33] Certainly it is appropriate that the last word be Evans's. But equally fitting is an impulse to resist the casually proffered interpretation of his own work, to remain unsatisfied with Evans's deceptively offhand comment on the style he created in the course of a long career, and to wonder in what might consist our best-informed reading of a body of camera work such as Evans's. For even if the thirties saw a change in culture and in communications modes which shifted the boundaries that defined and differentiated artistic and political discourses and which continue to do so today, and even if in the 1950s television effected an incalculably larger devaluation of realist imagery than had any previous esthetic or technological development, the questions of meaning and integrity in the realist image, and the human connections that need to be acknowledged, still wait to be

addressed anew. As historians of those concerns and connections, we can recover what is truly social in photography and we can learn how best to appreciate the documentary and esthetic intelligence that it bears.

"Documentary Photography in American Social Reform Movements" appears in revised form in Maren Stange's *Symbols of Ideal Life: Social Documentary Photography in America, 1890–1950* (New York: Cambridge University Press, 1989).

Notes

1. Lawrence Veiller, "The Tenement House Exhibition," *Charities* (February 17, 1900), clipping held in the Archives of the Community Service Society, New York (hereafter cited as CSS).

2. Paul U. Kellogg, "The Pittsburgh Survey of the National Publication Committee of Charities and the Commons," *Charities and the Commons*, 19 (March 7, 1908): 1665; see *The Pittsburgh Survey*, ed. Paul U. Kellogg, 6 vols. (New York: Russell Sage Foundation, 1909–14).

3. Paul U. Kellogg, "Appendix E. Field Work of the Pittsburgh Survey," *The Pittsburgh District: Civic Frontage*, ed. Paul U. Kellogg (New York: Russell Sage Foundation, 1914), 496–97.

4. See Rexford Guy Tugwell, Thomas Munro, Roy E. Stryker, *American Economic Life and the Means of Its Improvement*, 2nd ed. (New York: Harcourt, Brace and Company, 1924), 3rd ed. (New York: Harcourt, Brace and Company, 1930). For an account of Tugwell's intellectual and personal development during his years at the Wharton School of Business and Finance and at Columbia, see Rexford G. Tugwell, *To the Lesser Heights of Morningside: A Memoir* (Philadelphia: University of Pennsylvania Press, 1982).

5. *Collected Papers of Charles Sanders Peirce*, ed. Charles Hartshorne and Paul Weiss (Cambridge, Mass.: Harvard University Press, 1934), 5, 50–51.

6. Rosalind Krauss, "The Photographic Conditions of Surrealism," *October* 19 (Winter 1981): 26.

7. Lewis Hine, "Social Photography," in *Classic Essays on Photography*, ed. Alan Trachtenberg (New Haven: Leete's Island Books, 1980), 11. For a bibliography of articles by Hine, see Walter Rosenblum, Naomi Rosenblum, and Alan Trachtenberg, *America and Lewis Hine* (Millerton, N.Y.: Aperture, 1977), 138–42.

8. Hine, "Social Photography," 110. Two brilliant and important articles on the relations of the photographic image and text are Roland Barthes, "Rhetoric of the Image," in his *Image—Music—Text*, trans. Stephen Heath (New York: Hill and Wang, 1977), 32–51, and, about Hine in particular, Alan Trachtenberg, "Camera Work: Notes Toward an Investigation," *Massachusetts Review* 19 (Winter 1978): 834–58.

9. *New York Tribune*, February 11, 1900; *New York Tribune*, April 2, 1900, CSS.

10. William James, from an address of 1902, quoted in George M. Fredrickson, *The Inner Civil War: Northern Intellectuals and the Crisis of the Union* (New York: Harper

and Row, 1965), 234; Edward T. Devine, "Pittsburgh the Year of the Survey," *The Pittsburgh District: Civic Frontage*, 4.

11. Paul U. Kellogg and Neva R. Deardorff, "Social Research as Applied to Community Progress," *First International Conference of Social Work* (Paris: Imp. Union, 1929), I, 792–93.

12. Elizabeth Beardsley Butler, *Women and the Trades* (New York: Russell Sage Foundation, 1909), 190–91.

13. Although few records apparently exist to document the exact nature of Hine's participation in the picture editing, layout, and writing of the *Pittsburgh Survey*, there is ample evidence that he worked closely with editors and writers to ensure that his own and others' texts and captions were used effectively with photographs. For more detail on this point, see my "American Documentary Photography: The Mode and Its Style, 1900–1943," Ph.D. diss., Boston University, 1981, 98–111.

14. Although there have been as yet no studies of American photojournalism that take an institutional approach such as that usefully taken to the related field of advertising in Otis Pease, *The Responsibilities of American Advertising: Private Control and Public Influence, 1920–1940* (New Haven: Yale University Press, 1958), see Carol Squiers, "Looking at Life," *Artforum* 20 (December 1981): 59–66; also *Picture Magazines Before LIFE* (Woodstock, N.Y.: Catskill Center for Photography, 1982); also Karin B. Ohrn and Hanno Hardt, "Camera Reporters at Work: The Rise of the Photo Essay in Weimar Germany and the United States," unpublished paper presented at the Eighth Biennial Convention of the American Studies Association, Memphis, October 1981. See Steven Wright Plattner, "How the Other Half Lived: The Standard Oil Company (New Jersey) Photographic Project, 1943–1950," M.A. thesis, George Washington University, 1981; see F. Jack Hurley, *Portrait of a Decade: Roy Stryker and the Development of Documentary Photography in the Thirties* (Baton Rouge: Louisiana State University Press, 1974); see Sidney Baldwin, *Poverty and Politics: The Rise and Decline of the Farm Security Administration* (Chapel Hill: University of North Carolina Press, 1968).

15. Picture distribution figures and magazine titles for 1937 and 1938 are from unidentified file containing monthly and biweekly reports from the Historical Section-Photographic to John Fischer, director of information, uncatalogued materials, Prints and Photographs Division, Library of Congress, Washington, D.C. (hereafter cited as LC); see also Hurley, Ch. 6; see Karin Becker Ohrn, *Dorothea Lange and the Documentary Tradition* (Baton Rouge: Louisiana State University Press, 1980), 109; see interview with Ben Shahn by Richard Doud, April 14, 1964, Archives of American Art, Smithsonian Institution, Washington, D.C., New York, Boston, and Detroit (hereafter cited as AAA).

16. Edwin Rosskam, "Not Intended for Framing: The FSA Archive," *Afterimage* 8 (March 1981): 11.

17. Grace E. Falke to Jonathan Garst, December 21, 1936, unidentified file, uncatalogued materials, LC; see also Hurley, Ch. 9; see correspondence between Roy Stryker and photographers in the field in Roy Stryker papers, AAA.

18. Ohrn, *Dorothea Lange*, Ch. 6; Shahn-Doud interview, 2, 4, 13–15, 26; Hurley, 55–76.

19. Paul Vanderbilt, "Reorganization Reports," 12, typescript in Paul Vanderbilt papers, AAA.

20. Lewis W. Hine, "Photography in the School," *The Photographic Times*, 40, 8 (August 1908): 231.

21. Shahn and Lange captions from "General Captions" folder, uncatalogued materials, LC.

22. United States Department of Agriculture, *Toward Farm Security, The Problem of Rural Poverty and the Work of the Farm Security Administration, Prepared Under the Direction of the FSA Personnel Training Committee, for FSA Employees, by Joseph Gaer, Consultant, Farm Security Administration* (Washington, D.C.: U.S. Government Printing Office, 1941), 66–67.

23. Tugwell, *To the Lesser Heights*, 184, 188; Rexford G. Tugwell, "The Place of Government in a National Land Program," *Journal of Farm Economics*, 16 (January 1934): 64, 65. To a very considerable extent, the FSA reflected in its programs and policies the complexities of Tugwell's social thought. As Tugwell realized in the 1930s—indeed as the photography project is testament—the public did not easily understand the philosophy and the several purposes of the new agency. Historians have debated its merits in the ensuing decades. For essentially favorable accounts and explanations of Tugwell's ideas and of FSA programs, see Baldwin, *Poverty and Politics*; Paul K. Conkin, *Tomorrow a New World: The New Deal Community Program* (Ithaca: Cornell University Press, 1959); Richard S. Kirkendall, *Social Scientists and Farm Politics in the Age of Roosevelt* (Columbia: University of Missouri Press, 1966); and Bernard Sternsher, *Rexford Tugwell and the New Deal* (New Brunswick, N.J.: Rutgers University Press, 1964). For more specifically critical perspectives, see Pete Daniel, "The Crossroads of Change: Tobacco, Cotton, and Rice Cultures in the Twentieth Century," unpublished paper read at the Woodrow Wilson Center, Washington, D.C., July 1982; Walter J. Stein, *California and the Dust Bowl Migration* (Westport, Conn.: Greenwood Press, 1973); and William J. Brophy, "Black Texans and the New Deal," and Stephen S. Strausberg, "The Effectiveness of the New Deal in Arkansas," both in Donald W. Whisenhunt, ed., *The Depression in the Southwest* (Port Washington, N.Y.: Kennikat Press, 1980), 117–33, 102–16. These critics claim that the FSA offered too little too late to have any real effect on economic trends (Whisenhunt, 115), that New Deal agricultural policies as a whole actually encouraged mechanization that displaced small farmers (Whisenhunt, 113, 126, and Daniel, 10–23), that the FSA promoted a "visionary and antiquated Jeffersonianism," and its plans were "poorly funded, inadequate, and outdated" (Whisenhunt, 126–27), and that the notions of democracy and community cooperation that it fostered in migrant camps and resettlement communities were naive and unrealistic (Stein, Chs. 6, 7, and Conkin, Chs. 8, 9).

24. Rexford G. Tugwell, diary entry, May 7, 1935, Box 17, Tugwell Collection, Franklin D. Roosevelt Presidential Library, Hyde Park, N.Y.

25. Elizabeth McCausland, "A Generation Rediscovered Through Camera Shots of Pioneer in 'Photo-Stories,'" Springfield *Sunday Union and Republican* (September 11, 1938): 5E; Elizabeth McCausland, "Documentary Photography," *Photonotes* (January 1939): 6–9; Beaumont Newhall, "Documentary Approach to Photography," *Parnassus* (March 1938), 3–6.

26. Roy Emerson Stryker and Nancy Wood, *In This Proud Land: America 1935–1943 as Seen in the FSA Photographs* (Boston: New York Graphic Society, 1973), 7; McCausland, "Documentary Photography," 7.

27. Russell Lee to Roy Stryker, December 24, 1936, and January 2, 1937, Roy Stryker papers.

28. Shahn-Doud interview, 6.

29. Memo, John Fischer, Director of Information, to All Regional Information Advisors, May 4, 1938, unidentified file, uncatalogued materials, LC.

30. Richard Doud, "An American Portrait: Photodocumentation by the Farm Security Administration," 1965, unpublished typescript, 73, AAA.

31. Ralph G. Bray, "Criticisms of the Resettlement Administration Picture," n.d., "Motion Picture" file, uncatalogued materials, LC.

32. James Agee and Walker Evans, *Let Us Now Praise Famous Men* (Boston: Houghton Mifflin Company, 1941), 11; Vanderbilt, "Reorganization Reports," 12.

33. Walker Evans, *Still/3* (Rochester, N.Y.; dist. Light Impressions, 1973), 2; see also Leslie Katz, "Interview with Walker Evans," *Art in America*, 59 (March 1971): 87.

THE WORKER PHOTOGRAPHY MOVEMENT: CAMERA AS WEAPON

LEAH OLLMAN

*Photography has become a formidable weapon
against truth in the hands of the bourgeoisie.
The enormous quantity of picture material spit out
daily by the printing press, that consequently
appears to possess the character of truth, actually
serves only to obscure the facts. The camera can
lie just like the type-setting machine.*
Bertolt Brecht[1]

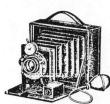 RECONSTRUCTING WEIMAR GERMANY THROUGH ITS PHOTO-graphs, one sees a culture invigorated by the Bauhaus's new perspectives, new techniques of representation, and new modes of perception. One sees a world with a charming surface, all things rendered with the uniform, unjudgmental vision of *Neue Sachlichkeit* (New Objectivity) photographers Albert Renger-Patzsch and Karl Blossfeldt. And, through the photographs of Erich Salomon, one sees a Germany slow to shed the trappings of its fallen empire, a government persisting in the grandeur of its aristocratic forebears.

Written accounts of the period, as well as many accounts produced in other visual media, convey an overriding cultural tension utterly absent from these photographs. The clarity and control evident in these images reflect none of the turmoil precipitated by Germany's defeat in the First World War, its further humiliation in the terms of peace, the rough birth of a republic and its fifteen-year struggle to define itself through seventeen governments. Germany's disgruntled left, suffering acutely from the country's spells of rampant unemployment, and eager to follow in revolutionary Soviet footsteps, seems to belong to a different society than that pictured; the economic and political flux of their world belies the other's calm and elegant beauty.

What accounts for the disparity between actual and represented reality? Were the photographers lying about their world? Yes, an adamant yes, according to a group whose own photographic work—relatively unknown in the United States—attempted to level the disparity. Calling themselves "worker photographers," thousands addressed the issue of truth in pictorial

representation and reporting, amending the bourgeoisie's strategically neutralized vision of society with an equally selective view of society's prevailing injustices. Representing a coalition of leftist party sympathizers, and receiving initial impetus from the German Communist Party, worker photographers formed a collective dedicated to combating the proliferation of *burgerlichen Bildlugen*, bourgeois picture-lies.

At the Third Congress of the Communist International (*Comintern*) in 1921, the Communist Party adopted a new strategy that subordinated growth of the party to progress of the workers movement in general. In Germany the "United Front" campaign, developed three years after an aborted attempt at revolution, signaled acknowledgment that capitalism would neither bend nor break from the pressure exerted by a party deemed too radical for mass support. Devised to appeal to "fellow-travelers," those sympathetic to the workers movement but whose commitment fell short of Communist Party membership, the strategy (and its slogan, "To the Masses") manifested itself in the formation of numerous Communist front organizations. Each advanced a particular cause within the Communist platform, united a professional group or mobilized specific segments of the community. The Association of German Worker Photographers, established in 1926, evolved as part of this trend toward reinforcing working-class unity through personal involvement.

"Innocents clubs," labeled as such by their chief proponent, Willi Münzenberg,[2] resembled the sports and nature groups that had been a dynamic component of the workers movement for decades, and were experiencing unprecedented growth during the Weimar years. The Workers League for Gymnastics and Sports (*ATS—Arbeiter Turn und Sportsbund*), which grew from 40,000 members in 1918 to over 650,000 in 1923, was the largest of these and claimed to be the oldest proletarian mass organization. The *ATS* and another such group, the Nature Friends Movement (*Naturfreundbewegung*) stressed the solidarity and collective power of the working class by imbuing physical activity with ideological significance; physical and political power became interdependent. For the worker, hiking was not to be regarded as an end in itself, an escapist recreation, but rather as a means of affirming a strong will toward the class struggle. As physical activity came to operate as a function of class consciousness, so did sight for the worker photographers.

Münzenberg founded his first organization, the Workers International Relief (*IAH—Internationale Arbeiterhilfe*) in 1921, at Lenin's urging, to assist victims of a drought-induced famine in Russia. It soon expanded to embrace workers and their families internationally, supporting striking workers and victims of natural disasters with social services, clinics, and nurseries.

Münzenberg encouraged members of the *IAH* to contribute in ways that would involve them personally, by donating a day's wages or the products of one's workplace, or by attending *IAH*-sponsored cultural events. Rather than passively donating to charity, members became actively engaged in a movement. A common humanitarian intent united all participants, regardless of party affiliation,[3] and membership became a gesture of solidarity with the young Soviet state and struggling workers internationally.

The United Front strategy found an ideal vehicle in the photographically illustrated magazine, a phenomenon flourishing in Weimar Germany with such publications as the *Berliner Illustrierte Zeitung* (*Berlin Illustrated News*) and the *Münchner Illustrierte Presse* (*Munich Illustrated Press*), which peaked with circulations of two million. As photography surpassed writing as the medium of utmost credibility, visual literacy became essential to the comprehension of current events. Photography's new popularity evolved in synchrony with the newly affordable lightweight, compact equipment that began to democratize the medium in the 1920s.

Willi Münzenberg published a biweekly, *Sowjet Russland im Bild*, as an organ of the *IAH*. It was distributed through *IAH* groups internationally and appeared in the United States as *Soviet Russia Pictorial*. Following the United Front strategy, *Sowjet Russland im Bild* appealed to a spectrum of readers, and could not be dismissed as a Communist Party organ. After twelve issues, the publication assumed the name *Sichel und Hammer* (*Sickle and Hammer*), and in 1924 became the *Arbeiter Illustrierte Zeitung* (*Workers Illustrated News*), reflecting an expansion of the magazine's content beyond its Soviet focus to issues of international origin. By 1926, the magazine had become a weekly, and its contents regularly included features about the contemporary life of workers worldwide, the history of the workers' movement, and coverage of German art, cinema, satire, and sports. Articles on artists engaged in social commentary appeared frequently, featuring George Grosz, Heinrich Zille, Kathe Köllwitz, Honoré Daumier, and Otto Nagel. Passionate accounts of the heroes of the Paris Commune, great historical resistance fighters and revolutionary women aimed to strengthen the self-confidence of the working class by firming its bond with workers of all ages and nations. Photographs accompanying an article on workers' resistance, for example, reiterated the internationalism of the movement by depicting the German Red Army alongside photographs of the French antifascist youth brigade and armed Chinese worker-guards.[4]

In 1926, Heinrich Mann declared the *Arbeiter Illustrierte Zeitung* "one of the best current illustrated magazines":

It is rich, technically good, however above all it is unusual and new. It

brings to view the proletarian world, which, remarkably, appears to be unavailable in the other illustrated papers, although it is the larger world. What is happening in life is seen here with the eyes of the workers, and it is time that it is seen so.[5]

For pictorial material, the editors of the *AIZ* relied on contributions from an informal cooperative of workers in Berlin and Hamburg, but primarily on the established photo agencies such as Keystone, AP, Dephot (*Deutscher Photodienst*), and Worldwide. The agencies thrived in the new boom of photojournalism, but the images they produced were generally of little value to the workers' press. "Mostly they represented the sunny side of life," recalls worker photographer Erich Rinka, "according to the view that capitalist society was the best of all. We on the other hand, were interested in the shady side of that system."[6] It was the bourgeoisie's propagation of the "sunny side of life" that led photomontagist John Heartfield to the conclusion that "those who read bourgeois papers will become blind and deaf. Away with these debilitating bandages!" (Fig. 1).

To inspire production of the desired images of working-class life, showing not only the development of technology in the workplace, but also its limits within the capitalist system, the editors of the *AIZ* announced a photo competition, through which they hoped to gather a variety of photographic material as well as to identify potential photo correspondents for the paper. The competition and subsequent formation of the Association of German Worker Photographers (*VdAFD—Vereinigung der Arbeiter Fotografen Deutschlands*) mobilized a segment of the community in ideal United Front manner. Identification with the working class and an interest in photography were sufficient to join disparate individuals into an operating collective. The formation of this new innocents club transformed the *AIZ* into an even more powerful vehicle for Marxist ideals. As Ute Eskildsen has noted, Münzenberg had created a truly collective form of journalism, in which the producers and the consumers of the periodical were one and the same.[7] "By workers, for workers," as Erich Rinka describes it, the *AIZ* bound all involved, from editor to carrier, in powerful union.

The 1926 competition encouraged workers to submit photographs of their own living and working conditions, aspects of modern technology and the revolutionary workers movement. Münzenberg's prolific and profitable publishing company, the *Neuen Deutschen Verlag*—which published several illustrated magazines of popular appeal, distributing them under the auspices of the Communist Party—awarded classic volumes of revolutionary literature to winners of the competition, and provided the financial basis for the formation of the *VdAFD*. Within months, Münzenberg, dubbed the "patron saint of fellow-travelers," began publishing *Der Arbeiter Fotograf* (*The Worker Photographer*) as an organ of the new association.

Figure 1. John Heartfield, *Those who read bourgeois newspapers will become deaf and blind, AIZ* 9:6 (Feb. 1930).

During its first year, the *VdAFD* established headquarters in Berlin and chapters in Hamburg, Leipzig, and Dresden, while cultivating contacts abroad to internationalize the movment. The *VdAFD*'s first conference, held in 1927, occurred simultaneously with the *IAH* meeting, with some *IAH* delegates acting as representatives for worker photographers of their countries. Collaboration between the *IAH* and the *VdAFD*, manifesting the United Front campaign across nations and party lines, continued until the *IAH*'s dissolution in 1935. Although all written and pictorial material produced in this campaign was admittedly political, the worker photography movement remained relatively free of party politics. Each chapter of the association represented a coalition of Social Democrats, Communists, anarchists, and unaffiliated workers that seemed to operate more productively than the series of coalitions running the nation's government.

According to the *VdAFD*'s first statute, all worker photographers professing a socialist world view and not belonging to a bourgeois photo organization were invited to join. Membership allowed the worker use of darkrooms and communally purchased equipment, and provided access to counsel and literature designed to enrich—politically and technically— photographic pursuits. With unemployment levels in some chapters reaching 60 to 70 percent, time, rather than strong ideological commitment, was the members' most valuable resource. "Most workers with photographic interests did not come to us with the intention of fighting with their camera," Rinka remembers. "They came to practice photography and to learn the technique. This is why we had to lead them to class-conscious photography above and beyond the practice of the medium."[8]

Der Arbeiter Fotograf's aggressive recipes for fighting with the camera were adapted to the political apathy of most workers. One method of integrating political and technical instruction involved assigning small groups of workers to solve an appointed problem. The group leader evaluating their results would seize the opportunity to explain a working-class approach to subjects. As a result of this training, "many politically indifferent workers gradually came to recognize the large extent to which the value of a photo was determined by the question: 'Who benefits?' They came to understand that it should not only be of use to themselves but also to their class."[9]

In a 1930 article for *Der Arbeiter Fotograf*, a contributor, Edwin Hoernle, developed the concept of the "class eye." If a German factory owner travels to America, Hoernle asked:

> What do you think he sees? The Ford works at Detroit, the Chicago slaughterhouses, Standard Oil derricks, the White House, Fifth Avenue;

but do you think his eye, the eye of a keen German businessman
gorged with profits and eager for more—do you think it sees the six
million starving unemployed, the human wrecks at the Ford works who
are not yet forty years old, the tiny anaemic children worked to death
at seven years of age in the textile and canned goods factories . . . ?[10]

One needs the eye of a particular class, Hoernle argued, to perceive how
prevailing social conditions manifest themselves in actual human lives. The
bourgeoisie does not see the world of the worker, but, he lamented, neither
does the majority of the proletariat. For even though the eyes of different
classes differ ("just as the eyes of cats, elephants, and people differ"), the
proletarian eye must be trained. When the worker sets out to photograph,
nine times out of ten, Hoernle estimated, he will do exactly as his bourgeois
neighbor does, and make beautiful pictures of landscapes and pretty women,
preserving only pleasant memories, remote from the class struggle and the
need and filth of daily life. Nudes, landscapes, and still-lifes were not
deemed entirely inappropriate subjects for the proletarian camera, but they
failed to demonstrate the distinctiveness of the proletarian eye, instead
succumbing to the romantic or sensational qualities favored by the
bourgeoisie. Whereas a ragged shepherd might supply a romantic touch
to a landscape photograph, the *VdAFD* insisted that the worker look behind
the scene to ask, "Why is he in rags? A ragged appearance is in no way
romantic but a concrete indication of a social situation."[11] Only a very few
have the discipline to exercise their class vision at all times, even on hol-
idays and at leisure. According to Hoernle, worker photographers must
tear down the facade created by bourgeois imagery. "We must proclaim
proletarian reality in all its disgusting ugliness, with its indictment of so-
ciety and its demand for revenge. We will have no veils, no retouching,
no aestheticism; we must present things as they are, in a hard, merciless
light."[12]

Particularly victimized by this proletarian wrath toward bourgeois "pic-
ture-lies" was Albert Renger-Patzsch's 1928 book, *Die Welt ist Schön* (*The
World is Beautiful*). Advertised as the "gift book for everyone," celebrating
sight as "a pleasure that everyone, the rich and poor alike, can share,"[13]
the book and the concept applied to it by its promoter blatantly contradicted
all that the worker photographers advocated. In Renger-Patzsch's avowed
objectivity, the workers saw only bourgeois escapism and idealism. "The
world is beautiful," sneered a writer in *Der Arbeiter Fotograf:*

. . . At least bourgeois photography of our time tries, by means of a
vast investment of resources in sophisticated technical means, to make
us believe that things in this world are lovely in the garden. . . .

> Because we want the world to be "beautiful" we say that it is still ugly today and we call by our artistic means for decisive changes by means of a revolutionary struggle.[14]

The importance to worker photographers of showing people and things in a social context was violated by those photographers working in the *Neue Sachlichkeit* style, which tended to isolate elements from their environment. Helmar Lerski's ennobling, monumentalized portraits of workers were lauded in *Der Arbeiter Fotograf*, but with serious reservations, for "the human face, separated, as it were, from the body and from the social environment becomes a mask and a matter of physiology, whereas the worker photographer should present the expression of a human being as the result of his class situation. . . ."[15]

László Moholy-Nagy's 1928 book, *Malerei Fotografie Film* (*Painting Photography Film*), received mixed praise as well, though the workers scorned the Bauhaus as a bourgeois institution. A review in *Der Arbeiter Fotograf* urged local groups to acquire Moholy-Nagy's book noting of course that it was far too expensive for the individual to own. The book can teach the worker photographer a great deal about the quality of an effective photograph, stated the reviewer, but the book also deals at length with those spheres of photography of little interest to the worker photographer, who is "explicitly not an artist."[16] Such warnings against artistic aspiration filled the pages of the magazine, discouraging heroic individualism in favor of using the camera as a weapon of collective strength. Esthetic concerns were deemed valid only as they affected the impact of an image's content upon viewers. To gauge the effects of their pictures, the Berlin and Dresden groups mounted showcases on the street and monitored public response.

Exploiting the urgent tone of revolutionary rhetoric by exhaustive use of such phrases as "we must all," "now is the time," and "more than ever," spokesmen for the worker photography movement emphasized social change as their primary commitment. "For us, there was no art," describes Eugene Heilig, a worker photographer from Stuttgart:

> Technical competence was a means, not an end. We learned to use the camera as a weapon in the class struggle and, quite simply through the most realistic presentation, to strive for the greatest expressiveness and vividness in photographs. . . . Like the workers press, photography was to assist in organization, propaganda and agitation. . . . We hardly concerned ourselves with discussions about aesthetics and art, as they were eternally going (on) in the aimless bourgeois photo-clubs. Our limited means and lack of time did not allow us to make expensive payments for distracting trivialities.[17]

The movement's esthetic (or antiesthetic) dictate was inextricably linked with its political function. Franz Höllering, chief editor of the *AIZ*, expressed the hierarchy of priorities by declaring that form results naturally from content.[18] The *"Bilderkritik"* ("Picture Critic") section of *Der Arbeiter Fotograf* scrutinized particular images according to Höllering's edict for true content. Technical considerations—light conditions, exposure times, type of camera and film used—were also discussed, and this information would appear sporadically beneath captions in the magazine.

A pointed attack on photomontage emerged amidst warnings against artistic inspiration and obsession with technical and formal issues. Höllering again issued the party line on the matter, insisting that,

> Less is often more. Just as an apple, an egg or a piece of bread is more
> healthful and pure than an adulterated mix of ingredients that tickles
> the palate in its unnatural, over-saturated combination, so is a small
> clear photograph more than a glued-together jumble of a hundred
> photos. The worker photographer has documents of the time to create,
> not worthless frivolities.[19]

Exception was made for John Heartfield, whose montages frequently provided the necessary cover appeal for newsstand sales of the *AIZ*. The proletariat artist Heartfield, continued Höllering, understands the meaning of his time, and the modern technical means of photography serve his artistic will. In its dependence on public familiarity with bourgeois press images, Heartfield's work testifies to the prevalence and power of press photography in Weimar Germany. Without popular acceptance of this imagery, Heartfield's adept manipulations would lack their immediacy and critical edge, their ability to expose fallacies within commonly held truths.

The worker photographers' wariness about art derived from a common association of art with pleasure, escapism, idealism, and beauty—the last a condition deemed impossible while there still exist oppressors and oppressed. They sympathized with George Grosz (who helped judge the 1926 photo competition) and his declaration of art as "a bourgeois concept implying self-indulgent withdrawal from the world of politics."[20] The *AIZ* praised Grosz, citing a French art critic's descripton of him as "the Daumier of Germany."[21] Both Grosz and Kathe Köllwitz, however, were chastised in the official Communist Party press (*Die Rote Fahne*) for being overly negative, for depicting the workers' plight as hopeless. In its zeal to emulate the young Soviet state, the German Communist Party pressed artists to show the "positive ideal," to satisfy Lenin's edict for uplifting art, encouraging transcendence of oppressed circumstances. Despite the apparent conflict of means, the *VdAFD*, which advocated exposure of the ugly and

unacceptable, looked with reverence and inspiration upon Soviet photography of the positive ideal. Delegations of German worker photographers traveled to Russia from 1927 on to contact their comrades and develop files of Russian photographs, which were much in demand for their "good symbolic images."[22] The Soviet photographs were considered helpful in developing the worker photographers' political vision. "We were struck by the directness with which Soviet photographers saw their own reality," Erich Rinka recalls. "It was clearly evident that the process of deformation by bourgeois photography and trashy post cards, etc., had not yet touched them. They saw their world so plainly that no words of explanation were necessary."[23]

The clarity and plainness with which the Soviets saw their world was no more clear or plain than the vision of Erich Salomon; the Soviet vision was simply used toward ends that corresponded to the ideals of the German workers movement. The Soviet photography, being post revolutionary, celebrated the purity and collectivity of the new state through images of cooperation, productivity, and abundance (Fig. 2). The German worker photographers aspired to just such social conditions, and in reverence of the Soviet images, they produced many with comparable attributes. However the Germans, confined to an earlier stage in the Marxist (r)evolutionary process, were compelled to illuminate their miserable actuality to reveal the need for change. Thus while some followed the Russian model, producing illustrious images of labor, the majority of the German worker photographers concentrated on the misery of the present: the unsanitary, dangerous working conditions, and the exploitation of the proletariat by the bourgeoisie (Figs. 3 and 4).

Though Erich Rinka remembers the Soviet photographs as so explicit that they needed no words of explanation, the worker photographers in Germany were not naive to the power of word and image in combination. They relieved what they regarded as the individual photograph's inherent ambiguity by creating a context for it, through captions and/or juxtaposition. "The ultimate political effect produced by a combination of several pictures with their captions and accompanying texts . . . is the decisive point," wrote Willi Münzenberg in his 1931 statement on the tasks and objectives of the worker photography movement. "In this way a skillful editor can reverse the significance of any photograph and influence a reader who lacks political sophistication in any direction he chooses."[24]

Captions provided a potent addition to the most passive images, applying class-conscious content where the photographer may have tread dangerously close to pure form. A study of billowing steam against the impenetrable mass of factory smoke stacks is deestheticized with the cap-

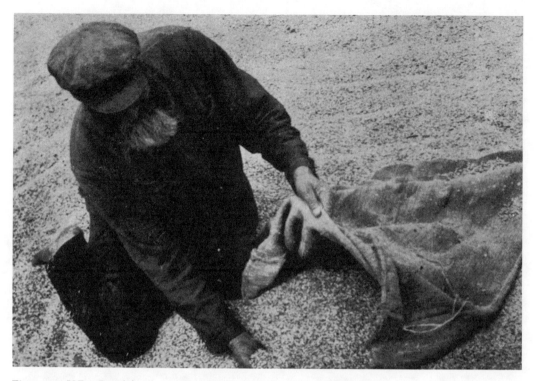

Figure 2. V.B., *Bread for Everyone*, Moscow, *Der Arbeiter Fotograf* V, 1931.

tion, "Work begins." The family picture could just as easily be redeemed, using captions such as "Quiet, little Bolshevik" to politicize an image of a mother calming her child (Fig. 5). *Der Arbeiter Fotograf* published several of Tina Modotti's photographs, substituting revolutionary slogans such as "We are building a new world" on the image of a worker's hands holding a shovel, for her straightforward descriptive titles. Street scenes and working scenes gained great propaganda boosts from only a few accompanying words. The caption, "My daddy doesn't have work either," transforms a charming scene of children surrounding a street performer or peddler into a sorrowful lament (Fig. 6). A photograph of a crippled beggar (Fig. 7), powerful with or without accompanying words, assumes an indicting tone with the caption, "Gratitude of the Fatherland"; a photograph about misfortune thus doubles as a cynical response to the effects of war and the state's neglect of its veterans.

Figure 3. F.B., *The Boss*, Breslau, *Der Arbeiter Fotograf* V, 1931.

Captions empowered the single photograph to pose crucial questions and to pointedly reveal the conditions requiring change. Those photographs depicting dangerous, unsanitary, or otherwise unfavorable working conditions placed the photographer at risk of retribution by incriminated employers. As a precaution against this or the constant threat of police aggression, which often entailed confiscation or destruction of photographic equipment, published photographs carried only the worker photographer's initials, rather than full-name credits. This near-anonymity also reinforced the notion of a class eye, by diverting attention away from individual identity.

The preferred solution to the individual photograph's malleable meaning was the photo-sequence or photo-report, a group of images which made the workers' situation more coherent by showing certain conditions in

Figure 4. H.S., *Daily he risks his life—for what?*, Essen, *Der Arbeiter Fotograf* V, 1931.

relation to each other. "That was the only way," Erich Rinka believes, "in which the broad public could be shown these connections and have explained its own situation as a class."[25] Photo-reports produced by more than one photographer were especially prized as true products of collective, class vision. The most prevalent type of series represented a chronological progression, as ambitious as that tracing a day in the life of Berlin, or the entire life of a young worker (Fig. 8). Though text/image montages became the trademark of the *AIZ*, editors of the bourgeois press, namely Stefan Lorant of the *Münchner Illustrierte Presse*, also took credit for the concept, and in 1933 Hitler and Propaganda Minister Goebbels adopted the successful format for the Nazi press. Their *Arbeiter Bild Zeitung* (*ABZ—Workers Picture News*) imitated the *AIZ*, though the workers in the Nazi press were shown in adoration of their new leader, and "solidarity" now referred to

Figure 5. B.G., *Quiet, little Bolshevik*, Britz, *Der Arbeiter Fotograf* V, 1931.

Figure 6. G.P., *My daddy doesn't have any work either*, Berlin, *Der Arbeiter Fotograf* V, 1931.

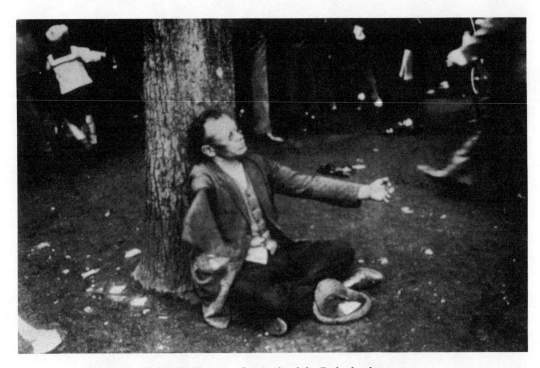

Figure 7. Walter Ballhause, *Gratitude of the Fatherland*, 1930–33.

the strength of the *Volk* and its allegiance to the fatherland. The *AIZ* editors were persecuted as Communists and driven to self-imposed exile in Prague (where they continued to publish until 1938, and in Paris until 1939), but some efforts were made to recruit worker photographers for the Nazi press. Walter Ballhause, who was not a member of the *VdAFD* but worked under similar precepts independently (Fig. 9), recounts that after his arrest in 1933 for photographing a political event, local Nazi officials attempted to direct his energies to the new cause.[26] His evasion of their command resulted in his continual observation and an eventual second arrest and imprisonment. Ballhause and several other worker photographers who survived the war and settled in the German Democratic Republic (East Germany) have been honored by their government for their meritorious actions.

Figure 8. *Leben eines Jungproletariers* (The life of a young proletarian), *Der Arbeiter Fotograf* I, 1927.

Having spent its last few years in concentrated opposition to the intensifying fascist threat, in 1933 the worker photography movement succumbed to the Nazis' irrepressible power. In regard to ultimate goals, the movement ended as a failure—no revolution was ever attempted, much less achieved; conditions never improved for any prolonged period, and the fascist enemy refused to be hindered by a movement it could easily quell. Yet the movement did have impact, and an extended influence that can be quantitatively assessed. The *VdAFD* established approximately 100 chapters within Germany, with a membership numbering over 2,400 in 1931. *Der Arbeiter Fotograf* maintained a circulation of 7,000, and at its height, the *AIZ* reached a weekly circulation of 280,000, according to its immodest editors (though other sources cite numbers up to 700,000, particularly during election campaigns).[27] Though reaching only a fraction of the audience

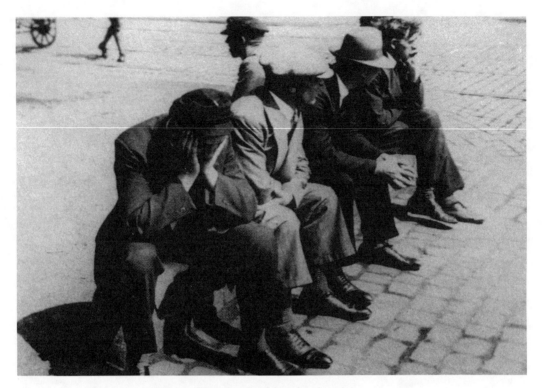

Figure. 9. Walter Ballhause, *Condemned to inactivity*, 1930–33.

met by the major bourgeois periodicals, the workers press inevitably imbued many of its readers with a spirit of solidarity, and some, perhaps, even with revolutionary fervor.

The worker photography movement's social revolutionary goals and its fundamental involvement with the burgeoning field of illustrated magazines thrust it into an international arena where its influence broadened, but diffused. Since the *VdAFD*'s beginning, its leaders had established international contacts, primarily through the *IAH*, which sponsored a tremendous variety of cultural activities worldwide. Music, theatre, film, and photography groups under the auspices or influence of the *IAH* formed in the United States, England, France, Holland, Switzerland, Czechoslovakia, Japan, and elsewhere. In 1931, Berlin hosted the first conference of the International Bureau of Worker Photographers.

The most prominent of the photography groups outside of Germany were based in the United States, England, and Holland. The Workers Film and Photo League, headquartered in New York, was established in 1930

under the guidance of the *IAH*, as an outgrowth of several other camera clubs working since the 1920s to document the class struggle for the working-class press. The league's structure echoed that of its German model, with chapters across the country providing equipment, darkroom facilities, instruction, and exhibitions and serving as a liaison between photographers and publishers. Initially parallel in aims to the *VdAFD*, aspiring to produce photographs of "social and economic implication," the organization eventually dropped "Workers" from its title, and, partially motivated by self-protection, subverted its political foundation. In England the *AIZ* had inspired several publications, and in 1934 a Workers Film and Photo League formed, influenced by both German and American precedents. The league's 1935 manifesto called for rebellion against the capitalist effort to glorify and justify its own existence through photographic and film imagery. In Holland, the Association of Worker Photographers (*VAF—Vereeniging van Arbeiders-Fotografen*) was established in 1931, and it, too, used the *AIZ* as a model for its parent organization's publication. The Dutch *Arfots* slogan ran: "Our own life by our own photographers in our own press!"[28] In addition to the thousands participating internationally in organized collectives, the circulation of *Der Arbeiter Fotograf*, nearly triple that of *VdAFD* membership, suggests that thousands more may have shared the *VdAFD*'s concerns while photographing independently. Walter Ballhause's extensive documentation of the working class in Hanover between 1930 and 1933 exemplifies the extraorganizational aspect of the movement.

The movement's influence continues to reverberate in the Federal Republic of Germany (West Germany), where worker photography groups began to re-form in the early 1970s, embarking on projects to document local working-class issues. A new magazine, *Arbeiterfotografie* (1973 to the present), resembles the earlier *Der Arbeiter Fotograf* in format and content. Following the original movement's inspirational debt to Soviet photography, perhaps the current movement refers to postwar East German photography for examples of positive ideal imagery.

Despite its international and contemporary manifestations, the worker photography movement today is all but forgotten outside of Germany, while the "bourgeois" photography of the Weimar period has long been comfortably installed in the medium's canon. Partially due to its failure to attain any of its tangible political aims, the movement's lack of recognition and nonabsorption into photographic history has more to do with *VdAFD*'s antagonism toward art. The movement's fiery rhetoric, rather than reinforcing the dynamic potential of its products, often provided the photographs' only dynamic content; most worker photography suffers from a static, unvaried quality incongruous with the tension of the workers' struggle. A fear that the use of visually seductive means would corrupt the

movement ensured that worker photography would appeal only to the politically sympathetic. The narrow insularity of this approach replicated microcosmically the problems plaguing the movement's closest political ally, the German Communist Party (*KPD*). Overestimating its own strength while underestimating the obstacles blocking its power, the *KDP*, like the *VdAFD*, anticipated a far greater impact than it ever achieved. Clinging to its rigid ideology, the *KPD* resisted any compromising alliances, and, with the other components of Germany's fractured left, was duly subsumed by the fascist tide.

However curtailed by dogmatic policies and delusive practices—such as weaving forceful verbal propaganda around generally mediocre images—the worker photography movement comprised an integral facet of Weimar era photography. Worker photographers belonged to a generation committed to marrying the communicative force of the mass media with photography's own potential to enact change. Even after half a century, the issues of meaning and context confronted in that union continue to pose implacable challenges.

Notes

1. Bertolt Brecht, quoted in Joachim Buthe, et al., *Der Arbeiter-Fotograf* (Cologne: Prometh Verlag, 1977), 6.

2. R. N. Carew Hunt, "Willi Münzenberg," in David Footman, ed., *International Communism* (London: Chatto & Windus, 1960).

3. Ida Katherine Rigby, *War—Revolution—Weimar* (San Diego: San Diego State University Press, 1983), 64.

4. Cited in Heinz Willmann, *Geschichte der Arbeiter-Illustrierten-Zeitung 1921–1938* (Berlin: Dietz Verlag, 1975), 57.

5. Ibid, 36.

6. Erich Rinka, "The First Conference of Worker Photographers, 1927," *Creative Camera* 197–98 (May–June 1981): 73.

7. Ute Eskildsen, "The A-I-Z and the Arbeiter-Fotograf: Working Class Photographers in Wiemar," *Image* 23, no. 2 (December 1980): 8.

8. Rinka, "The First Conference of Worker Photographers," 72.

9. Ibid.

10. Edwin Hoernle, "The Working Man's Eye," in David Mellor, ed., *Germany: The New Photography 1927–1933* (The Arts Council of Great Britain, 1978), 47.

11. Rinka, "The First Conference of Worker Photographers," 72.

12. Hoernle, "The Working Man's Eye," 49.

13. Mellor, *Germany: The New Photography*, 8.

14. Anke Reuther, "Leafing Through the Journal 'Der Arbeiter Fotograf,'" *Creative Camera* 197–98 (May–June 1981): 89.

15. *Der Arbeiter Fotograf* 5, May 1931.

16. Reuther, "Leafing Through 'Der Arbeiter Fotograf,'" 87.

17. Walter Heilig, "In Memory of a Worker Photographer Eugen Heilig," *Creative Camera* 197–98 (May–June 1981): 76.

18. Buthe, *Der Arbeiter-Fotograf*, 96.

19. Ibid, 98.

20. Rigby, *War—Revolution—Weimar*, 64.

21. Willmann, *Geschichte*, 39.

22. Ernst Thormann, "Ernst Thormann: A Worker Photographer Remembers," *Creative Camera* 197–98 (May–June 1981): 80.

23. Rinka, "The First Conference of Worker Photographers," 73.

24. Willi Münzenberg, "Tasks and Objectives," in Mellor, *Germany: The New Photography.*

25. Rinka, "The First Conference of Worker Photographers," 72.

26. Letter from Ballhause to the author, December 3, 1985.

27. Rinka, "The First Conference of Worker Photographers," 73.

28. Bert Hogenkamp, "Holland: Vereeniging van Arbeiders-Fotografen," in *Photography/Politics: One* (London: Photography Workshop, 1979), 84.

BORGES, STRYKER, EVANS: THE SORROWS OF REPRESENTATION

JUDY FISKIN

[To confront the photograph is] the same
Sisyphean labor: to reascend, straining toward the
essence, to climb back down without having seen
it, and to begin all over again.
Roland Barthes, *Camera Lucida*

 WITH THE ADVENT OF PHOTOGRAPHY, A NEW KIND OF VORA-ciousness was born. Use of a camera, with its mechanical, uncannily detailed representations, can lead to the temptation to commit a particularly photographic pair of sins: the sin of pride, or the striving for a degree of control of the world which is beyond human capacity; and the sin of gluttony, the attempt to consume (or photograph) everything. Jorge Luis Borges, the Argentine writer of speculative fiction, pinpointed these temptations, exploring their roots and consequences in a short story, "The Aleph." And, in one of the more peculiar instances of life-imitates-art, two figures of depression-era documentary photography played out this very set of speculations: Roy Stryker, the head of the photography section of the Farm Security Administration, whose project was to create a photographic document of the entire United States; and his one-time employee, Walker Evans, the foremost documentary photographer of the 1930s.

"The Aleph" opens in Buenos Aires in 1929, with the death of Beatriz Viterbo, a woman whom the narrator, "coincidentally" called Borges, has loved in vain. On that day, Borges notices that there is a new ad for American cigarettes on one of the billboards around Constitution Plaza. This makes him realize that "the wide and ceaseless universe was already slipping away from her and that this slight change was the first of an endless series. The universe may change, but not me, I thought."[1] In these opening sentences, Borges has already identified the root causes of the desires which lead to our photographic sins: separation from the things one loves, and a vain and unreasonable resistance to this inevitable condition of life.

In the story, the narrator Borges begins a series of yearly pilgrimages on Beatriz's birthday to the house where she lived with her father and her fatuous first cousin, Carlos Argentino Daneri, who are not overjoyed to receive his visits. Each year, waiting in the drawing room to be received by his unwilling hosts, Borges studies a collection of photographs of Beatriz, taken at different times in her life. In the course of these visits, Borges becomes better acquainted with the pompous Carlos, who, like the real Borges, holds a minor position at a Buenos Aires library. Carlos confides to Borges that he is working on an epic poem entitled "The Earth," in which he "had in mind to set to verse the entire face of the planet." By the time Carlos reveals his project to Borges, it is 1941, and Carlos has finished sections on

> a number of acres of the state of Queensland, nearly a mile of the course run by the River Ob, a gasworks to the north of Vera Cruz, the leading shops in the Buenos Aires parish of Concepcion, the villa of Mariana Cambaceres de Alvear in the Belgrano section of the Argentine capital, and a Turkish baths establishment not far from the well-known Brighton Aquarium.

This moves the narrative from the realm of life to that of representational art (Carlos insisting that his poem is "unhospitable to the least detail not strictly upholding of truth"), and to the emergence of a new theme: that of an art whose task is to encompass, in a virtually endless catalogue, every fact of the world as it exists at that moment, a concept parallel to Borges's idea of the endless series of material changes which signal the passage of time. The character Borges is scornful of this work, noting that "Daneri's real work lay not in the poetry but in his invention of reasons why the poetry should be admired." Borges, the author, also seems to signal his contempt for the project in inventing a list for Carlos which falls so pitifully short of its goal, in scope as well as internal connections.

Carlos decides to publish the part he has already completed and asks Borges to ask one of his friends, a well-known author, to write a foreword to his poem. Borges promises to contact his friend on Carlos's behalf but never does. He fears reprisals from Carlos over this broken promise, but none are forthcoming. Six months later, Carlos calls, distraught, with the news that his landlords are planning to tear down his house in order to build a cafe. This news upsets Borges as well, for to him, of course, the house represents Beatriz. Carlos, however, is not concerned with memories of Beatriz. He says that without the house he cannot finish the poem because under the dining room there's an Aleph, which he found as a child when he fell down the cellar steps. Carlos explains that an Aleph is

one of the points in space that contains all others, "the only place on Earth where all places are—seen from every angle, each standing clear, without any confusion or blending."

Borges is delighted to find out that Carlos is a madman and immediately rushes over to the house for confirmation. When he arrives, the maid asks him to wait because, "[t]he master was, as usual, in the cellar developing pictures." While he's waiting, Borges picks up a large color photo of Beatriz and speaks to it: "Beatriz, Beatriz Elena, Beatriz Elena Viterbo, darling Beatriz, Beatriz now gone forever, it's me; it's Borges." Carlos comes in. They have a drink and then go down to the cellar, where Carlos instructs Borges to lie on the floor and stare at a certain point on the opposite wall. Carlos goes out, shutting the trap door behind him, after telling Borges, "In a short while you can babble with *all* of Beatriz's images." Borges experiences a moment of panic: "I'd let myself be locked in a cellar by a lunatic, after gulping down a glassful of poison." Immediately thereafter, however, he sees the Aleph.

> I arrive now at the ineffable core of my story. And here begins my
> despair as a writer. . . . Really, what I want to do is impossible, for any
> listing of an endless series is doomed to be infinitesimal. . . .
> Nonetheless, I'll try to recollect what I can. On the back part of the
> step, toward the right, I saw a small iridescent sphere of almost
> unbearable brilliance. At first I thought it was revolving; then I realized
> that this movement was an illusion created by the dizzying world it
> bounded. The Aleph's diameter was probably little more than an inch,
> but all space was there, actual and undiminished. Each thing (a mirror's
> face, let us say) was infinite things, since I distinctly saw it from every
> angle of the universe. I saw the teeming sea; I saw daybreak and
> nightfall; I saw the multitudes of America; I saw a silvery cobweb in the
> center of a black pyramid; I saw a splintered labyrinth (it was London);
> I saw, close up, unending eyes watching themselves in me as in a
> mirror; I saw all the mirrors on Earth and none of them reflected me; I
> saw in a backyard of Soler Street the same tiles that thirty years before
> I'd seen in the entrance of a house in Fray Bentos; I saw bunches of
> grapes, snow, tobacco, lodes of metal, steam; I saw convex equatorial
> deserts and each one of their grains of sand; I saw a woman in
> Inverness whom I shall never forget; I saw her tangled hair, her tall
> figure, I saw the cancer in her breast; I saw a ring of baked mud in a
> sidewalk, where before there had been a tree; I saw a summer house in
> Adrogue and a copy of the first English translation of Pliny—Philomen
> Holland's—and all at the same time saw each letter on each page (as a
> boy, I used to marvel that the letters in a closed book did not get
> scrambled and lost overnight); I saw a sunset in Queretaro that seemed
> to reflect the color of a rose in Bengal; I saw my empty bedroom; I saw

in a closet in Alkmaar a terrestrial globe between two mirrors that
multiplied it endlessly; I saw horses with flowing manes on a shore of
the Caspian Sea at dawn; I saw the delicate bone structure of a hand; I
saw the survivors of a battle sending out picture postcards; I saw in a
showcase in Mirzapur a pack of Spanish playing cards; I saw the
slanting shadows of ferns on a greenhouse floor; I saw tigers, pistons,
bison, tides, and armies; I saw all the ants on the planet; I saw a
Persian astrolabe; I saw in the drawer of a writing table (and the
handwriting made me tremble) unbelievable, obscene, detailed letters,
which Beatriz had written to Carlos Argentino; I saw a monument I
worshiped in the Chacarita cemetery; I saw the rotted dust and bones
that had once been Beatriz Viterbo; I saw the coupling of love and the
modification of death; I saw the Aleph from every point and angle, and
in the Aleph I saw the Earth and in the Earth the Aleph and in the
Aleph the Earth; I saw my own face and my own bowels; I saw your
face; and I felt dizzy and wept, for my eyes had seen that secret and
conjectured object whose name is common to all men but which no
man has looked upon—the unimaginable universe.

So Carlos has his revenge on Borges after all. Coming back down to the
cellar to gloat over his dazed rival, he asks, "Did you see everything—
really clear, in colors?" Borges, seeing his chance for counterrevenge, pre-
tends not to have seen anything and expresses concern for Carlos's health,
advising him to get away to the country for some fresh air and quiet. After
he leaves, Borges descends into the subway, where he is disturbed to
discover that

every one of the faces seemed familiar to me. I was afraid that not a
single thing on Earth would ever again surprise me; I was afraid I
would never again be free of all I had seen. Happily, after a few
sleepless nights, I was visited once more by oblivion.

Borges is here examining the conditions for the act of creation. Any
literary or pictorial image is a monumental simplification of real percep-
tions. The Aleph is the realist's heart's desire: an impossibly complete
representation of the world in its total fullness—a vision and a goal which
must be renounced by every artist, no matter how urgent the longing to
encompass the rich detail of life. The imagination conjures up this spectacle
of totality only to be defeated by it. The Borges character needs sleep—
that is, forgetfulness—without which there *is* no imagination, to function
as an artist.

And, in fact, the story ends in 1943 with a postscript which tells us that
Carlos, with his "pen no longer cluttered by the Aleph," has published the
Argentine section of his poem and won the second prize for national

literature (for which Borges's own book didn't get a single vote). Borges then speculates that the Aleph he saw in Carlos's cellar was a false Aleph. He has found a text of 1867 which gives accounts of several similar Alephs, commenting:

> But the aforesaid objects (besides the disadvantage of not existing) are mere optical instruments. The faithful who gather at the mosque of Amr in Cairo, are acquainted with the fact that the entire universe lies inside one of its stone pillars. . . . No one, of course, can actually see it, but those who lay an ear against the surface tell that after some short time they perceive its busy hum. . . ." Does this Aleph exist in the heart of a stone? Did I see it there in the cellar when I saw all things, and have I now forgotten it? Our minds are porous, and forgetfulness seeps in. I, myself, am distorting and losing, under the wearing away of the years, the face of Beatriz.

The first and last sentences of "The Aleph" speak of the dead Beatriz. It is the wish to hold onto things, either materially in the world, or in the mind, through memory, and the hopelessness of satisfying this desire, that Borges sees as the motive underlying the attempt to replicate the world through the endless series. The world is obdurate, distant, dense. We can neither grasp nor keep it. Yet this is the stubborn project of representational art. Carlos, for example, describes his project, "to set to verse the entire face of the Earth," putting it into remarkably physical terms, as if he were actually going to perform some kind of material transformation.

Carlos, though an extreme case, is exemplary. In taking this desire to its limit, Borges exposes both the impossibility and the undesirability of its attainment. It is Borges, after all, who created Carlos's trivial list of the contents of the world—a river, some shops, a gasworks, a Turkish bath. And it is Borges who describes the Aleph, which *is* a complete representation of the world, only after a qualifying statement of the impossibility of recounting what he saw: "All language is a set of symbols whose use among its speakers assumes a shared past. How, then, can I translate into words the limitless Aleph, which my floundering mind can scarcely encompass?" Borges can't literally reproduce the Aleph, and the Aleph can't literally reproduce the world. That is, even the most veracious representational art is still only a partial reproduction of reality in the end. So, after his dazzling description of the contents of the Aleph, Borges slyly introduces the idea of its incompleteness. By revealing the possible existence of an aural Aleph, he shocks us into the realization of something that he has previously withheld from consciousness—that the original not only couldn't be heard, it couldn't be touched, smelled, or tasted, either. He uses a similar tactic to the same effect in the scene where Borges speaks

so passionately to the photograph of the dead Beatriz, bringing up doubts, and not for the first time in the story, as to which of the main characters is really the fool. Furthermore, total access to the world, no matter how fondly desired, would be paralyzing. Carlos finds success as a writer only after losing the Aleph, and Borges must immediately forget his vision in order to continue his life.

Yet "The Aleph" is not a moral fable like "The Sorcerer's Apprentice," warning us not to lust for powers we cannot control. Its appreciation of the vastness and multiplicity of the world makes it an elegy to our desire to encompass this impossible scale. Borges's identification with Carlos (they are both writers, both librarians, both in love with Beatriz), and the conscious virtuosity of the writing in his list of what he saw in the Aleph, show that he shares the desires that underlie representation. "The Aleph" is a sorrowful recognition of the intractability of these desires in the face of the certain impossibility of their fulfillment.

The story is full of references to photography because, of all the representational arts, it seems to hold out the best hope for the possibility of a total representation. It inspires an extra measure of belief because its inherent superrealism conceals the omissions and abstractions by which we recognize the fictions of art. And, through its combination of fantastic detail and concealed compressions, it can supersede reality in the wealth of experience it seems to offer. Early in the story, Carlos tells Borges his vision of modern man:

> "I view him . . . in his inner sanctum, as though in a castle tower, supplied with telephones, telegraphs, phonographs, wireless sets, motion-picture screens, slide projectors, glossaries, timetables, handbooks, bulletins. . . ." He remarked that for a man so equipped, actual travel was superfluous.

Carlos's ideas are strikingly echoed in the recollection of John Vachon, one of Walker Evans's colleagues in the FSA, of how he became a staff photographer for the bureau. His original job at the department was to caption the photographs which the field photographers sent back to Washington. Sitting at his desk all day, looking at these photographs, he remembers:

> Here was the whole USA spread before me—children playing in a little Arkansas town, a country store in Vermont, a highway in California— all those places I'd never been to, people I'd never seen. There were strange stirrings in me. I wanted to go out and make pictures.[2]

The surprising part of this account is that Vachon, when confronted with this daily array of exotic images, didn't want to visit the places they por-

trayed—he wanted to make photographs of them: a real-life instance of the appeal of realism over reality. Vachon's story, however, pales in comparison with that of his boss, the head of the FSA photo bureau and the true-life counterpart to Borges's Carlos, Roy Stryker.

The photo bureau of the FSA was created during the middle years of the depression to document rural poverty, for the purpose of cementing the political coalition of the rural and urban poor that had helped bring Franklin D. Roosevelt into power. Stryker's ambition, however, was much more far-reaching than this mandate. By the late 1930s, when the New Deal was securely entrenched, Stryker told his photographers to record anything that was significant to American culture. By this he really meant, as we shall see, to photograph everything.

Stryker kept in contact with his people (who were often away for months at a time, all over the country) through regular communiques. These consisted mainly of long lists of what he wanted them to photograph. Here is an excerpt from such a memo to "all photographers" entitled "American Habit": "College football—spectators, girls in fur coats, chrysanthemums, men with blankets; horse races—betting crowds; orange drink; sky writing; spooners, neckers; delicatessen."[3] And so on. Not terribly far removed from the gasworks in Vera Cruz and the Turkish baths near the Brighton Aquarium.

Of course, Stryker's project engendered many images which remain emblematic of the depression years. But measured against his own goals, he failed, and for the same reasons that Carlos was failing before the destruction of the Aleph. A literal attempt to represent everything can only leave one with a sense of what was left out. What has to be left out is infinitely greater than what can be included. Stryker himself has said, "No matter how much came in, we still saw gaps in the file. We wanted more things. We dreamed of an enormous file. I don't think I was ever satisfied we were getting what we wanted. There was always an unhappiness about the fact we missed things."[4] Stryker's file contained 270,000 negatives at the time the project was disbanded.

Stryker went on to express an unconscious intimation of why such an undertaking is doomed: "All this shouldn't have happened to one man. It's been too much, too rich—but yet, it's just too bad we couldn't have done more."[5] If such a total replication of life could be achieved, it would be useless, because, like the world itself, it would be too much to take in. Who could even look at, much less absorb, all the images Stryker did compile? Poor Roy. He could have learned something from one of his staff photographers, Walker Evans. Because when we do contemplate portions of the file, it is never with the sense of completeness we get when looking at Evans's personal projects.

Comparing any group of FSA images of indigenous architecture with

the second half of *American Photographs*, in which Evans attempts to define what is truly American in the built environment, underscores the similarity of the two projects and their crucial difference. The FSA work, seen as a whole, feels partial and contingent, while Evans's work seems to encompass his broad subject with definitive authority. One reason for this, of course, is that Evans was exploring a more limited aspect of the total American scene. But he also succeeded where Stryker failed because Evans settled for art. Stryker succumbed to the false promise of photography, strove to represent literally the world's profusion, and inevitably produced a body of work whose scope seems puny compared to its model. Evans, also working through accumulation, but in a much more condensed, allusive, and circular manner, succeeded in eliciting what Stryker so much wanted to express: a sense of the true multiplicity of the world.

Although there is a consensus as to the largeness of Evans's scope ("a vision of a continent," Lincoln Kirstein said of *American Photographs*[6]), his work has been seen often as social document. But Evans's social criticism was consistently combined with, and often eclipsed by, an expressed appreciation of the world's profusion. Evans himself was conscious of this distinction:

> The term should be documentary *style*. . . . Art is never a document, though it certainly can adopt that style. I'm sometimes called a "documentary photographer." . . . A man operating under that definition could take a certain sly pleasure in the disguise. Very often I'm doing one thing when I'm thought to be doing another.[7]

What Berenice Abbott once said of Atget, whom Evans cited as a major influence, also applies to Evans himself: "The material presentment of life . . . entranced him."[8] We can recognize this aspect of Evans's work in the pure formal beauty of his images as well as in his appetite for the tangible. Like Atget, and for the same reasons, Evans insisted on using a bulky large-format view camera in much of his work of the 1930s, while many of his colleagues were using the more convenient 35-millimeter equipment that was then in common use. However, the larger camera, though in many ways outmoded, produced a negative with an abundance of detail and a long and subtle range of tones unavailable with the smaller apparatus. It was thus far more suited to Evans's taste for palpability.

Evans also insisted on the materiality of his subject matter in his frontal shooting style. When photographed this way, each object becomes an isolated whole, divorced from its surroundings and subjected to the blunt revelations of the direct lighting which Evans consistently favored. We are seeing not places, but things.

Appreciation of plenitude is a natural corollary of this feeling for individual things and is expressed in Evans's work through his cumulative

Figure 1. *Sidewalk and Shopfront, New Orleans, 1935.* Courtesy of the Estate of Walker Evans.

structuring strategies. The sense of accumulation in his work begins internally, within individual photographs, through emphasis on formal repetition (Fig. 1). Individual images are then linked, constructing, through a limited number of examples, a cumulative, encyclopedic portrait of a single class of things. Again in the words of Lincoln Kirstein, "The single face, the single house, the single street strikes with the strength of overwhelming numbers, the terrible . . . force of thousands of faces, houses and streets."[9] In eliciting this double sense of great profusion and exhaustive coverage, Evans's work touches on the idea of the endless series. We

Figure 2. *Main Street Architecture, Selma, Alabama, 1935*. Courtesy Prints and Photographs Division, Library of Congress.

can understand with some precision how he structured the work to produce this effect by looking closely at some of the images and sequences in *American Photographs*.

Published in 1938 to accompany an exhibition of the same name at the Museum of Modern Art, *American Photographs* is a monograph of eighty-seven photographs. In it, Evans attempts to define the commonplaces of American life in the 1930s. *American Photographs* is divided into two parts. The first section is dominated by photographs of cars, advertising signs, architectural exteriors and interiors, views of towns, and casually and formally posed portraits of working people, middle-class types, and the unemployed. Part II is a survey of American vernacular building, rural and urban, domestic and commercial, the recently built and the overtly decayed.

These images have been carefully ordered, using repetition, cross-typing, and hybridization. For instance, if we list first the functions and then

the styles of the buildings he includes in Part II, we begin to see how the single image always contains information about several aspects of the subject matter. So he photographed churches, gas stations, stores, houses and apartments, and factories and plantations, which were built variously in the basic clapboard, Greek Revival, Carpenter Gothic, and utilitarian industrial styles. Commercial storefronts boast Italianate arches (Fig. 2); a clapboard shack houses a church. Furthermore, buildings are photographed with an eye to indicating the locale, status, and occupations of the users.

Evans also had a keen eye for the hybrid, so that the layering of information we have seen within each image is often compounded by his inclusion of examples of mixed styles and uses. *Negroes' Church, South Carolina, 1936* (Fig. 6) displays a mixture of several architectural styles in one building: the basic New England clapboard church, with a Greek Revival porch and a touch of Carpenter Gothic trim in the belfry. *Part of Phillipsburg, New Jersey, 1936*, a view of the town encompassing an iron bridge, a train yard, an Italianate commercial block, several grand Victorian houses, and some modest homes, appealed to Evans for its hodge-podge quality: "This is a very American view—the charm of it is in the ugliness and craziness of the architecture of different periods there together."[10] In *Greek Temple Building, Natchez, Mississippi, 1936* (Fig. 5), there is an incongruous mixture of style and use. A ponderous Greek Revival style structure, which would normally signify a place of official civic business, has become a sign painter's establishment. The allure of *Roadside Stand Near Birmingham, 1936* is in its multiple uses—fish store, fruit stand, house mover.

Finally, the images are obviously sequenced to add up to a conviction of encyclopedic coverage. We can see this at work in four sequenced images of church and temple architecture in *American Photographs*, Part II (Figs. 3–6). The first image is of a rudimentary shack, whose function as a church is announced only by a crude sign attached to the roof, and not at all in the usual way, by the style of the architecture. In the next photograph, the church takes on its characteristic form, although it's still quite dilapidated. There are echoes of the previous example in the peeling paint of the walls, the bare posts of the porch, and the neat bench under the left window, which is a reminder of the pile of wayward benches outside the Church of the Nazarene. This image prefigures the next one as well, in the faint reference to the classical porch made by the four pillars supporting the triangular gable. Figure 5, the classical temple housing a sign painter, is placed in this sequence as a reminder of where the basic vernacular church of Figure 6, slightly more grand than its predecessor, with a two-story porch and a more elaborate belfry, got its characteristic style. This short series, in fact, constitutes a condensed history of the evolution of that

Figure 3. *Country Church, Tennessee, 1936.* Courtesy Prints and Photographs Division, Library of Congress.

style—first, in demonstrating its origins as an overlay of Classic Revival motifs onto the clapboard shack; and second, by beginning with the most elementary example and progressing to the most characteristic. The series has an almost cinematic quality, as if Evans were presenting the development of this type through a series of lap dissolves.

 In the next series, which deals with the plain rectangular clapboard dwelling, Evans does not trace a development, but instead elaborates on a type in almost fugal sequence. The houses follow one after another with their variegated roof lines: flat, peaked, stepped, slanted. They have plain facades, one-story porches, two-story colonnades. They are single homes, duplexes, attached blocks, identical tracts. They are just built; they are falling apart. Five photographs seem to exhaust the possibilities.

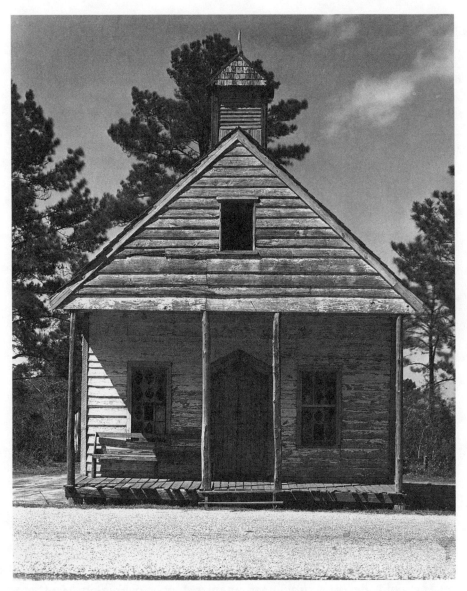

Figure 4. *Negroes' Church, South Carolina, 1936.* Courtesy Prints and Photographs Division, Library of Congress.

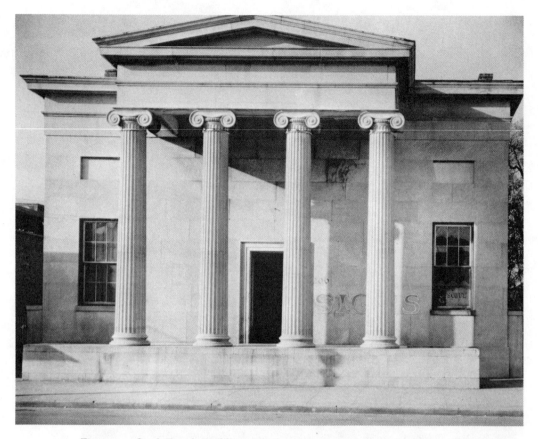

Figure 5. *Greek Temple Building, Natchez, Mississippi, 1936.* Courtesy of the Estate of Walker Evans.

Similarly, a later group on Carpenter Gothic buildings in Massachusetts, New York, and Maine concentrates on the variations in the types of wood tracery: bold, delicate, curvilinear, angular, highly perforated, solid, etc. This play of variations on a theme is a pure visual pleasure and a device for evoking the sense of completeness which characterizes the work.

Evans deployed these images sparingly and with obvious care, but he had some of the greedy impulses of Carlos Argentino and Roy Stryker, and in the first three photographs of *American Photographs*, Part I, he acknowledged the attraction of the idea of the endless series before he wisely abandoned it as a project suitable for his art. These three images are Evans's

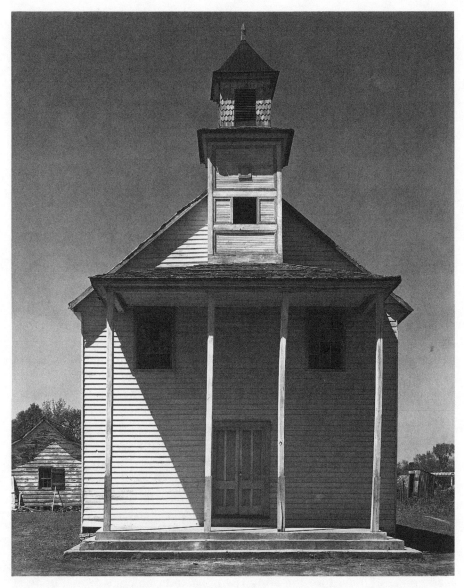

Figure 6. *Negroes' Church, South Carolina, 1936.* Courtesy Prints and Photographs Division, Library of Congress.

statement about appetites and limits in art. *License-Photo Studio* (Fig. 7) is full of his usual strategies for indicating proliferation: the repetition of the word *photo* six times, the graphic repetition of the circular seal shapes, the doubling of the pointing hand. It is also an image of a building with multiple uses: photo studio, license application bureau, driving school, notary public office, and receptacle for passing graffiti artists ("Tootsie Love Fina" and the repeated "Come up and see me some time, come up and see me some time"). This image can be seen as a humorously literal announcement of the contents of the book: photos, photos, photos . . . but even further, it links the concept of the photograph with that of multiplicity. This idea is, in fact, reiterated in the second picture of this sequence (Fig. 8). This is a photograph of the display window of a commercial photographer's studio. As the second image in a carefully sequenced book, it is an obvious extension of the announcement of subject matter: *American Photographs* is about Americans, and here they are. But again we can go further. Evans has cropped out any indication of the window frame surrounding the display, which suggests the possibility of the infinite expansion of the images beyond the borders of the photograph, so that we may read this not only as a declaration of subject matter—Americans—but of scope—*all* Americans.

It is also important to keep in mind that, due to Evans's cropping, this is a photograph of photographs, more than it is a photograph of a window display. As a representation of a representation, it demonstrates what photography can do, how it is particularly suited to deal with the project of "everyone." And finally, as a photograph of dozens of small photographs, it is a statement of representation as itself a thing in the world, not only a recorder of proliferation, but its generator as well. The Aleph, too, contained several examples of representation: the picture postcards sent by the survivors of a battle, the volume of Pliny's *Encyclopedia of Natural History*, and the image of the globe endlessly multiplied between two mirrors. A total representation must itself include examples of representation.

In fact, we can trace this inclination to amass examples throughout Evans's career. Many of the images he included in *American Photographs* were made on assignment for the FSA. The illustated catalogue of that body of work shows him assembling great collections of houses, churches, signs, store fronts, and faces, to be ordered later in *American Photographs*.[11] Even granting that he did not compile this catalogue himself and that most of the books he published himself did not emphasize to this extent the reiterative character of his imagery, any examination of his collected photographs would reveal this quality.

The one book that Evans published whose meaning does depend on a structure of uninflected accumulation is *Many Are Called*.[12] The work in this

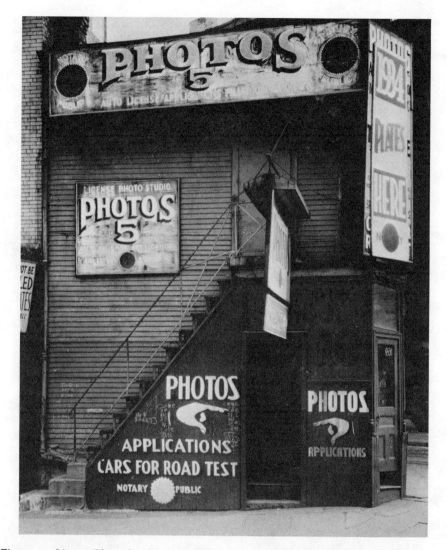

Figure 7. *License-Photo Studio, New York, 1934.* Courtesy of the Estate of Walker Evans.

Figure 8. *Photographer's Window Display, Birmingham, Alabama, 1936.* Courtesy Prints and Photographs Division, Library of Congress.

book was seen as a radical departure from the meticulous imagery of *American Photographs*. And, stylistically, it was. Evans gave up the rigor of the view camera, hiding his 35-millimeter camera under his coat to produce these harsh, grainy, candid portraits. However, if we see this work as another aspect of the project of photographing "everybody," then it is less a departure from his earlier work than an extension of it.

In *Many Are Called*, a literal list of individual people, which by inference could be extended indefinitely, becomes a metaphor for everybody. James Agee meditated on the subway riders in the introduction to the book:

> They are members of every race and nation of the Earth. They are of all temperaments, of all classes, of almost every imaginable occupation. Each is incorporate in such an intense and various concentration of human beings as the world has never known before. Each is also an individual existence as matchless as a thumbprint or snowflake.[13]

Here is the same layering of information that we saw in Evans's record of American architecture, as well as an apprehension, shared by Borges, that the numbers of people, and by extension, things in the world, are so vast as to be virtually infinite. Agee again: "Those who ride the New York subways are several millions. The facts about them are so commonplace that they have become almost as meaningless, as impossible to realize, as death in war."[14]

After viewing the Aleph, it is also in the subway that Borges gets the feeling that he has seen everything on Earth and will never again be surprised by anything. For Evans and Borges, "everybody" is in the subway. *Many Are Called* is Evans's simultaneous attempt to picture that inconceivable abstraction while rescuing it from the sense of the single instances by which it is constituted.

But while Evans was preoccupied with the world's immensity, *Many Are Called* is not a literal attempt to list everyone. He understands the demands of authorship, the need for compressions and idealizations, as he makes clear in the crucial transition between the second and third photographs in *American Photographs*: *Photographer's Window Display, Savannah, 1936* and *Faces, Pennsylvania Town, 1936* (Figs. 8–9). In *Faces*, the device of literal enumeration gives way to the reductions of symbolism. I read this passage as a declaration of authorship, because Evans moves from a photograph of someone else's photographs to one of his own. This image, which verges on Socialist Realism, is unusual for Evans in the self-consciousness of its symbolism. Two young men, marked by their clothing as workers, gaze off into the distance, against a backdrop of an unfocused crowd. It's as if the crisp, compartmentalized portraits of *Photographer's Window Display* have reappeared, racked out of focus, and crammed together, in the back-

Figure 9. *Faces, Pennsylvania Town, 1936.* Courtesy of the Estate of Walker Evans.

ground of *Faces*. We have moved from the list of people in the former to a representation of "the people" in the latter. So, although Evans pays homage to literal fact at the opening of the book, by the third image he embraces the contrivances of fiction.[15]

Evans's trajectory in *American Photographs* has reiterated the themes of "The Aleph": the artist's desire for a total representation of the world, the idea of executing such a project through a listing of facts, and the abandonment of this perilous tactic in favor of the strategies of art. But Evans seems to have relinquished the idea of the endless series with little of Borges's sense of regret. To Borges, the drastic abridgements of method and goal required to set forth an encyclopedic vision of the world result in a perpetual cycle of attempt and dissatisfaction. The artist can't control the world through his or her work, and, worse yet, can't even control the sources or products of her or her own creativity. Carlos's Aleph is destroyed when his apartment is torn down. The aural Aleph is located inaccessibly inside its stone pillar. And the story relates the process of losing Beatriz,

Figure 10. *Tin Relic, 1930.* Courtesy of the Estate of Walker Evans.

Borges's figure for the Muse, who bestows her favors on an unworthy fool and then dies.

Like Borges, Evans was ambivalent about representation. At times, he expressed an uncomplicated appreciation of images, as in his statement about *Shrimp Fisherman's House, Biloxi, Mississippi, 1945,* an interior decorated with photographs: "Look at the expression of the value of pictures. The instinctive joy in pictures, this dressing table shows. The great simple appeal of the picture, here it is among Greek fishermen, decorating their house with love and excitement and plain direct pleasure."[16] Yet, like Borges, who saw in the Aleph "the coupling of love and the modification of death," Evans often linked the act of representation with death. His work is shot through with examples of decaying cultural artifacts (Fig. 10), but it is another of his photographs which most precisely evokes The Aleph's themes of the sorrows of representation—*Photographer's Window Display, Savannah, 1936* (Fig. 8).

While the explicit decay of many of his images is missing, the implication

of decay is what lends this image its terrible poignance, a feeling that was not lost on Evans himself.

> This photograph is uproariously funny and very touching and very sad and very human. . . . All these people had posed in front of the local studio camera, and I bring my camera and they all pose again together for me. I look at it and think, and think, and think about all those people.[17]

Evans's point is that all these smiling people who came to this studio in Savannah in the 1930s to preserve themselves on film are now unalterably changed—or, more likely, dead. All these optimistic people who shared the artist's belief in representation only succeeded in demonstrating that the more accurate the representation, the more sharply felt is the absence of the represented subject. Evans knew what they did not: representation cannot keep its promises.

Notes

1. Jorge Luis Borges, "The Aleph," *The Aleph and Other Stories 1933–1969*, edited and translated by Norman Thomas di Giovanni in collaboration with the author (New York: E.P. Dutton, 1978).

2. John Vachon, prefatory note to *Just Before the War*, catalogue of an exhibition at the Newport Harbor Art Museum and the Library of Congress (New York: October House, 1978), n.p.

3. Ibid., n.p.

4. Ibid., prefatory note by Roy Stryker, n.p.

5. Ibid., n.p.

6. Lincoln Kirstein, "Photographs of America: Walker Evans," in Walker Evans, *American Photographs* (New York: The Museum of Modern Art, 1938), 193.

7. Leslie Katz, "Interview with Walker Evans," *Art in America* 59 (March 1971): 87.

8. Berenice Abbott, "Eugene Atget, Forerunner of Modern Photography," *U.S. Camera* 1 (November 1940): 49.

9. Kirstein, "Photographs of America," 197.

10. Katz, "Interview," 89.

11. Walker Evans, *Photographs for the Farm Security Administration 1935–1938* (New York: Da Capo Press, 1973).

12. Walker Evans, *Many Are Called* (Boston: Houghton Mifflin, 1966).

13. James Agee, introduction to Walker Evans, *Many Are Called*, n.p.

14. Ibid.

15. Alan Trachtenberg persuasively argues a version of this interpretation in "Walker Evans' America: A Documentary Invention" in *Observations, Essays on Doc-*

umentary Photography, ed. David Featherstone (Friends of Photography, 1984), 55–66.

16. Katz, "Interview," 84.

17. Ibid., 83.

AMERICAN GRAPHIC:
THE PHOTOGRAPHY AND FICTION
OF WRIGHT MORRIS

COLIN L. WESTERBECK, JR.

AFTER THE FIRST FEW PAGES OF *CEREMONY IN LONE TREE*, Wright Morris had me for life. I read those pages nearly twenty-five years ago, when the book had just come out. Nothing happens in them. Tom Scanlon, the only inhabitant left in the town of Lone Tree, leads a perfectly eventless life. One day he sees a buffalo grazing the railroad tracks; another day, a drought-crazed wolf is there. We get the feeling that these two days are years apart. The only thing that takes place for sure, day in and day out, is the passing of the trains. Scanlon watches them blow through. Those on the downgrade "leave a vacuum he sometimes raises the window to look at."[1] That's what Wright Morris has done, too—raised a window on the vacuum left by America's past. "Come to the window," says the first sentence of *Ceremony*, and I did. Through those opening pages I got my first glimpse into the world Morris has sustained through thirty books of fiction, memoir, essays, and photographs.

After five pages, something does happen. Scanlon sees on the wires by the track "the body of Emil Bickel, in whose vest pocket the key-wound watch had stopped. At 7:34, proving the train that hit him had been right on time." The opening pages of the novel have been like a single, incredibly beautiful note held for an impossibly long time, and now the rest of the orchestra comes in with a crash. The prelude is over; the plot has begun. If the novel has any flow, it is that the opening is almost *too* good. The remaining 300 pages seem an attempt to balance its power. The plot has a wildness, an antic quality, as if Morris felt a need to wrest the story back from his own initial success with it. This is the pattern of several of his best novels.

All his life Morris has tried to sustain throughout an entire book the kind of elegiac perfection of which he was capable in isolated scenes, lone

vignettes, powerful beginnings. In *Plains Song*, the 1981 novel for which he won the American Book Award, he at last succeeded. With that book he became our definitive poet of the Midwest, as Robert Frost was of New England. The poetry of the plains could only have been written in prose, as Morris has written it. Even in *Plains Song*, however, the best is the opening, where the dying Cora remembers her courtship with her husband Emerson and the terrors that the consummation of the marriage held for her. The novel is a succession of events both caused and illuminated by this star burst with which it begins. And *Plains Song* might remind us that this pattern abides not only in Morris's best work, but in his career as a whole. The experiences with which that career began, during a brief period when he was revisiting the scenes of his Nebraska childhood, are the ones that have lasted him a life-time as a writer.

During a visit I paid Morris at his home in Mill Valley, California, he himself spoke of what he likes in both his writing and his readers. "I am often aware that the better part of what I'm doing is the bloom of it," he said, "that can be seized almost instantly, rather than worked with. . . . The magic lies in the sense of rightness, as it does in your feeling of the person you like, the person you love. . . . The reader who just picks up the book and says, 'Wow!' is the reader I want. He may or may not be able to fathom or savor what it is I'm doing, but he senses what it is that originally animated me: that sense of 'Yes! YES! for Christ's sake!'"[2]

That's the reader Morris got in me, particularly where the book he was speaking about here is concerned. It is *The Inhabitants*, published in 1947. This book and a companion volume entitled *God's Country and My People*, which came out just over twenty years later, are photo-texts. Each was in its way as crucial to Morris's development as *Ceremony* or *Plains Song*. The University of Nebraska Press has been putting Morris's works back into print, and *God's Country*, like the 1948 novel with photographs called *The Home Place*, has now been reissued. But *The Inhabitants* remains out of print; and even if it were to reappear, I fear that for Morris's admirers all these early photographic books have been superceded by the 1982 *Wright Morris, Photographs and Words*. It is to this monograph alone that anyone interested in his pictures now turns. This is a shame because as fine as reproduction there is, we still miss the significance that the photographs first had for him, especially in *The Inhabitants*.

It is partly to compensate for this loss that I am writing here. If either readers or viewers lose sight of these photo-texts, it diminishes our assessment of Morris on two counts. First, we miss the achievement that these books represent, their unique approximation of words to pictures. Second, we are allowed to think of his photography as separate from the writing and less important to him, an activity he did on the side that can now be relegated to different books for another audience. The truth is that

his photographs and writing are inextricable. Neither could have developed as it did without the other.

The photographer Joel Meyerowitz, who accompanied me on my visit to Morris, picked up at once on Morris's exclamation of "Yes! Yes!" This flush of response Morris wants from his readers is, Meyerowitz said, the sort of feeling with which he is filled when taking pictures. Morris agreed. His own experience with a camera was the same. A discussion about writing turned into one about photography. The compatibility of the two is what *The Inhabitants* is about. It was a seminal book for Morris. It and *God's Country* are his most radical experiments as a writer. Each fits his prose to photographs, abandoning narrative, rendering every scene a prose poem of the sort in which Morris reaches the top of his form. And the photographs, many of which are not republished in *Photographs and Words*, are also his very best. Nowhere else is Morris's sensibility seen whole like this.

The Inhabitants is, as the title indicates, about people. Yet none appears in the photographs, which are of places and things. The people are known only by their absence. This might be the motto of Morris's photography, and of his fiction as well. In the novel *The Man Who Was There*, for instance, the man is not there. He has been reported missing before the story begins. From this novel, which was Morris's second, through *Plains Song*, his eighteenth, most of his characters live in that vacuum outside Tom Scanlon's window. (Many live, like Scanlon, in a past they refuse to admit is over.) In *Plains Song*, this sense of life comes to its ultimate ripeness. The main character is Cora, who gets through life by purposely, almost willfully, putting certain things out of her mind. Standing at the edge of her farm, which has been pulled down after her death because nobody wanted it, her niece Sharon wonders, "Was it the emptiness that evoked the presence of Cora?" At Cora's funeral, Sharon ponders the phrase *Abide with Me*. "But what, indeed, had abided?" she asks herself. "The liberation from her burdens, the works and meagre effects of Cora had been erased from the earth."[3]

Unrhetorical questions like Sharon's are typical of Morris's style in *Plains Song*, as if his characters found life a puzzlement that they could never quite work out for themselves. Though they have no answers, the Coras and Tom Scanlons of the world do have a fixity of character. Whatever they cannot understand they can at least endure. What they cannot alter, they let pass. Sometimes events loom large like clouds on the horizon, but then go by almost unnoticed. People's lives follow the weather of the plains, where it never seems to rain here, where you are, but only some place else that you can barely make out in the distance.

On a train trip a stranger says to Sharon, "It's up ahead. We're coming to it. . . Look there!"; then he settles back and declares, "Boy, am I glad to see the last of that!" But peering through the window into the darkened

Figure 1. Wright Morris, from *The Inhabitants*.

Nebraska countryside at which the man points, Sharon "saw nothing but his reflection."[4] So much of life passes this way—anticipated, then regretted, yet strangely absent at the moment it occurs. This it is that gives the lives in *Plains Song* their feeling of changelessness. Impregnations and deaths, entire generations, go by unremarked. "One thing followed another," the narration says, summing up in that single sentence a period of many years.[5] Yet what at first strikes us as mere numbness brought on by living thus turns out to be a sensibility unto itself, a keenness among plain people. In lives where momentous events seem either not to occur or not to bear thinking about, small incidents sometimes take on great moment. When Sharon expresses contempt for the boy her cousin Madge plans to marry, Cora hits her across the hand with a hairbrush.[6] Though neither ever speaks of the incident again, both remember it the rest of their lives.

The spirit that animates this narration is the one seen in the photographs Morris took over thirty years ago in the places in which *Plains Song* is set. The attraction that Nebraska held as a subject was its flatness, its undifferentiated sameness, in the midst of which a detail that might be lost in a busier scene could be noticed. It could be appreciated, like a seemingly insignificant incident in an uneventful life. In the landscape, as in the people, it was the everyday quality that appealed.

This is why a Morris photograph includes a stretch of level foreground,

Figure 2. Wright Morris, from *The Inhabitants*.

often ending in an equally blank wall (Fig. 1)—so that the peculiar mite in the landscape that occasioned the picture, the mere "fice" of a detail (to borrow one of Morris's own words), will take our breath away. Thus do we see the little Vitalis sign in the window of the nameless shop (Fig. 2), the lone clump of snow in the street before the church (Fig. 3), the handle of the pump that casts an illogical shadow on the schoolhouse wall (Fig. 4).[7] That shadow, holding a different position from the handle itself, brings this otherwise still, vacant picture quietly to life. The illusion that the handle

Figure 3. Wright Morris, from *The Inhabitants*.

has moved brings the ghosts of children thronging into the school yard. Each one takes a turn at the pump, quenching our thirst for human presence in the deserted scene.

In an essay entitled "A Museum of Happenings," Morris lamented our "gluttonous appetite" for information. He argued that the artist "need not know it all, merely master what little he knows."[8] Morris's working method as a writer has been to return constantly to certain details and observations, refining their use with each new novel into which he introduces them. The recurrences grow from the need to renew memories again and again. A man's lips pucker "like a hen's bottom" as he's about to spit tobacco juice, and afterwards he wipes his lips with a distinctive twist of thumb and forefinger;[9] a farmhouse whose owner never got around to putting on the

Figure 4. Wright Morris, from *The Inhabitants*.

front porch has a screen door perpetually hooked shut, so children won't fall into the yard.[10] I'm no longer sure which novels I remember these things from. They appear in so many. Morris tells me he has the same trouble.

I find it equally difficult to remember where I first saw certain photographs, for he has returned to some of them again and again in like manner. *God's Country* is made up from essentially the same set of pictures seen in *The Inhabitants* and *The Home Place*. Attending an exhibition of his photographs in March 1983 at the Corcoran Gallery in Washington, D.C., Morris spoke about the sense of renewal he had when preparing *God's Country*. Because of the passage of time, he said, "I could start all over again and write about those pictures."[11] The photographs were gathered, along with the experiences upon which he has drawn in the plains novels, during

that one early period when he returned to the area where he was born. The photographs were made between the late thirties and the early fifties, and Morris has been pondering them, as he has the experiences, ever since.

He has given varying accounts of when he began photographing. In one version, it was in southern California in 1935.[12] Another places him in Vienna in 1933.[13] I prefer Vienna, because the subject that inspired him to get a camera there was some blind people he saw every day in a garden. Characters who can't see in some emotional or spiritual way were to be common in Morris's fiction later, and later photographs are also blind, in a sense, because the human presence is only felt, not seen. The Vienna story has a kind of poetry to it. Whichever account is true (probably both), Morris didn't begin photographing in earnest until 1938. He didn't own a decent camera until then, he told me, although he had already developed what he calls his "confrontational style"—getting close to flat surfaces— before that. The Rolleiflex camera he had earlier didn't permit him to work any other way. Only after he got rid of it could he begin adapting to a wider field of vision what he had learned from its limitations.

Although he has done four books out of the material from that period, Morris still hasn't exhausted his stock of pictures. This is amazing when you consider that, as he informed me, the whole archive consists of only 1,700 images. In California I saw several boxes of photographs that have never been published, many of them as good as any that have. I also saw a full, original print of one picture that has appeared only in cropped form. It was the picture of the shop with the Vitalis sign in its window (Fig. 5). The full negative shows that the shop stands on a corner. The street beyond can be seen on the right side of the frame. The way that Morris cropped the picture in *The Inhabitants* suggests how savvy he was about the medium. The print didn't have to be cut down, for as it is, it doesn't fill the page. But I think Morris realized he could intensify its effect if he closed off the right-hand edge. When I came upon the more open version of the scene the full negative contains, I felt that the visual pressure had suddenly been let out of the image. It was as if an air seal preserving the emotional content of the picture had been broken.

In 1945, Morris went to see Maxwell Perkins with a proposal for *The Inhabitants*. When Perkins seemed hesitant, Morris asked permission to fasten the photographs to some drapes in the office and leave them there a week or so. He said that when he returned, he would take them down and go away if Perkins was still skeptical about the book.[14] The material he left with Perkins that day had been ten years in the making, and during that period it had often taken precedence over the writing of novels. In

Figure 5. Wright Morris, previously unpublished. Courtesy of the artist.

1940–41, in the middle of a 10,000-mile photographic odyssey by car, Morris had had time to begin what would be his first published novel, *My Uncle Dudley,* only because he had to lay over for the winter in Los Angeles.[15] He had conceived *The Inhabitants* as a book about the entire country, and this trip was the culmination of several years spent accumulating photographs. With the pictures from the trip, he would get his first Guggenheim grant the following year in order to continue the project.[16] He was so determined to interest the publishing world in the book that he made an amateurish dummy with an adhesive-tape binding. "Oh Lord, I almost feel pained to think of that terrible thing!" he told me with a smile of reminiscence.

When Morris returned to Perkins's office, the publisher was ready to do

the book. He wanted it to have a big press run and a low price—$3.75—
because he now had high expectations for it.[17] Morris explained to me some
of the production problems they had, which were considerable. Because
of the paper shortage caused by the war, only inferior stock could be
obtained. Perkins had it triple-varnished in order to compensate. The result
was that reproduction was in some instances better than it would be in
God's Country twenty years later. And Morris got his way about having the
photographs bled to the edges of the pages. What he said many years
afterwards about the term "bleed" he no doubt felt then: that the image
created by this technique "accurately conveys the cutting off, the excision,
the amputation of the photograph from its environment."[18]

Despite the high hopes of both author and publisher, the book did poorly.
There was a bookshop where Morris had once bought remaindered copies
of *Let Us Now Praise Famous Men* for thirty-nine cents each. Two years after
The Inhabitants came out, the bookseller got in touch to ask Morris whether
he wanted his own book at seventy-nine cents.[19] *The Inhabitants* was only
the first of three photographic books to which Morris had gotten Perkins
to agree. Perkins kept his commitment to *The Home Place*. But when it didn't
sell either, he advised Morris to drop plans for a third photo-text. *The World
in the Attic* was published as a straight novel.[20] Although I can understand
why *The Inhabitants* wasn't a popular success, I'm surprised that it didn't
become a classic among photographers as Robert Frank's *The Americans*
did. Perhaps the reason was historical bad timing. Frank was slightly older
than the other photographers of his generation, who were coming together,
mostly in New York, around the time his book appeared. Morris was
younger than the photographers to whom he might have appealed. They
had linked up in the thirties. By the war's end, they were drifting apart
again.

In a sense there was no audience there to receive Morris's books. The
culture of photography suffered a kind of diaspora during the late forties
and fifties. (Helen Levitt, for example, took almost no pictures for a decade;
Walker Evans did only commercial work, and brooded.) Yet maybe *The
Inhabitants* didn't quite vanish without a trace after all. When I was with
him, Morris did remember one response he got from a freelance photog-
rapher whom *Time* magazine sent to take his picture a few years later. "Are
you the guy who did that book?" the photographer asked as soon as he
arrived. Only later could Morris get him off the subject of photography
long enough to introduce himself. His name was Robert Frank.

Whether Morris showed Frank more of his photographs than had then
been published I don't know. One or two plains pictures in *The Americans*
closely resemble pictures Morris did (Figs. 6 and 7),[21] and I would like to

Figure 6. Wright Morris, from *The Inhabitants*.

think Frank took those photographs with a sense of *déjà vu*, because a Morris photograph had already lent wonder to a common sight. A case might be made that Morris himself had acquired some of his imagery from predecessors like Walker Evans or Eugene Atget. Questions of influence like these annoy many photographers, who are afraid of being thought derivative. But Morris doesn't take a proprietary attitude toward his vision. In a 1975 interview, he dismissed such controversies with the quip that "being plagiarized before you are born is very tiresome." He feels that photographers share "a common sensibility," as the interview puts it.

"That simultaneous existence at different times of the same sensibility has always fascinated me," he said. "What I later came to was a kind of metaphysical conviction that we really don't possess anything—we are

Figure 7. Wright Morris, Jukebox, Southern Indiana, 1950.

merely the inheritors of a sensibility that moves among us."[22] Being common, this sensibility is not restricted to photographers with reputations like him or Evans. It appears as powerfully in anonymous photographs. In his *American Scholar* essay, Morris discussed a certain picture of this type and acknowledged that either he or Evans might have taken it. "I recognize with a shock," he continued, "that this anonymous photographer was seeing through my eyes, and I through his. The similarities of all photographs are greater than their real or imagined differences."[23]

Among the artifacts that caught Morris's eye on his visits to the Midwest were many anonymous photographs, mementos he found tucked away in forgotten albums, dusty shoe boxes, bureau drawers, the corners of mirrors. He made his own photographs of these images by other, unknown people. One previously unpublished picture of his shows five old prints strewn on a table (Fig. 8). All are in good condition except one, which was not properly washed when it was made. A residue of silver nitrate left on the paper has turned the photograph's subject into a ghost, as if the positive were deteriorating back into a negative again. Lingering wanly amidst familiar scenes and close relatives who go on unaffected in the other prints, the subject of this one has become yet another man who isn't there. He could be taken as an emblematic figure, a representation in human form of Morris's esthetic.

Anonymous photographs like this also turn up in Morris's novels. In *Plains Song*, Cora has her portrait taken at the 1933 World's Fair in Chicago.[24] In *The Works of Love*, a sodbuster advertises for a wife by mailing his portrait to relatives or giving it to drummers to distribute.[25] And in *The Man Who Was There*, an entire section entitled "The Album" is devoted to verbal photographs that, though taken by many hands, all reflect Morris's eye.[26] Virtually all obliterate their subject in some way. The shutter has gone off accidentally revealing only the subject's feet, or the mist at Niagara Falls is making it hard to tell who's posing. In a newspaper photograph, an arrow identifying the subject of the story points to the wrong person. In a class picture, a girl has waved her hand before the face of the boy we want to see. Morris might have slipped into this "Album" a description of the silvery print discussed above. Being flawed, it would have fit right in. Its subject, being an apparition, would also have fit in with the fictitious subjects of the novel's portraits.

Another real photograph that Morris once copied does find its way into the novel's album, and into various other books as well (Fig. 9). A group portrait made outdoors in winter during the late nineteenth century, it, too, is deteriorated. "Lord—it's fadin'!" remarks the old man in *The Home*

Figure 8. Wright Morris, previously unpublished. Courtesy of the artist.

Figure 9. Wright Morris, from *The Home Place*.

Place when handed the picture. "Come to think—. . . they never had much
as faces. Been thirty years since they had faces."[27] The portrait continues
to be passed around for fifteen pages, and the comments on it all pick up
where those in *The Man Who Was There*, published a few years before *The
Home Place*, leave off. "Even the dark eyes have faded into the all-pervading
yellow," the earlier novel says, "—yellow snow, yellow house and the flat
yellow sky." As it ages, the photograph is developing the sort of uniformity
that Morris sees in the plains themselves. The photograph is improving,
as the characters in the novel realize. The narrative informs us that "even
without faces these figures are good portraits—the absence of a face is not
a great loss." One character, who couldn't recognize anybody except him-
self when the faces had features, does better once they fade. "As soon as
their faces were gone he knew them right away."[28]

The introduction of a photograph into a Morris novel is always a signal moment. Cora's portrait at the World's Fair is another of those incidents in *Plains Song* that seem trivial, but have profound effect. "What she saw was so bizarre it left no afterimage," the novel tells us; and yet, "However briefly she had seen this 'likeness' it changed the substance of her nature. She was no longer the person she had been, but something more or less."[29] To Morris, I suspect, that nineteenth-century group portrait means as much. It affects him even more than it does the characters in the novels where it is described. Beginning as a photograph by someone else, someone unknown, it becomes in the novels Morris's own. It is a point at which his ideas about fiction, photography, and memory come together.

In an essay called "Origins," Morris talked about how memory functions for him as a novelist. The discussion there might also serve as a gloss on this portrait and on his attitude toward photography in general. "Image-making begins in earnest where memory fades," Morris wrote. "The skein of memory is often so frail we see right through, and it frays at the edges. Invoking its presence is similar to a seance. Is it really him, we wonder, or an imposter? . . . Over forty years of writing, what I have imagined has replaced and overlapped what I once remembered. The fictions have become the facts of my life."[30]

Memory "fades," like that family portrait in the novels. The language used here is the same that Morris applies elsewhere to photography. When I was with him in California, he laughed at the thought of the Panatomic-X film on which he photographed in the 1940s. "That's what I date from—so slow it doesn't even constitute a film any more," he said. Like his memories, his negatives required a seance—"the seance of the darkroom," he called it—in order to bring forth an image. The image was as "frail" as memory's skein. That skein has taken tangible form in Morris's life recently with the recovery of a roll of film long lost. Made in 1929, these definitely are the first photographs he ever took. The uncle on whose Texas wheat farm Morris was working wanted a picture of himself, his wife and their dog, Jesus (Fig. 10). He handed Morris the camera. "These are like finding a piece of cake pan in an old house," Morris said as I looked at the prints. "And you should have seen the negatives these came out of. Why, they don't look like they've gotten anything on them at all!"

Morris himself has summed up best the attraction that old photographs hold for him. "One of the great and appealing charms of the 'snapshot,'" he wrote in *Critical Inquiry* several years ago:

> is that we can see and easily appreciate what it captures. . . . The
> impression we receive is usually one we have already had. But as these

Figure 10. Wright Morris, previously unpublished. Courtesy of the artist.

> images recede in time and their numbers diminish, their familiar
> 'message' undergoes a sea-change. The timeworn cliché is suddenly less
> time-bound, the commonplace is touched with the uncommon. . . .
> Photographs considered worthless, time's confetti, slipped from the
> niche in a drawer or album, touch us like the tinkle of a bell at a seance
> or a ghostly murmur in the attic. And why not? They are snippets of
> the actual gauze from that most durable of ghosts, nostalgia. They
> restore the scent, if not the substance, of what was believed to be lost.[31]

Particularly instructive is the way Morris used "cliché," deliberately equat-
ing its English-language meaning—commonplace speech—with the French
definition of photographic negative. (Elsewhere, the essay speaks of "ver-
nacular language" as having "its consummation in photographs."[32]) The
common sensibility in which Morris believes is seen not only in anonymous
photography, but in anonymous language of the sort that clichés preserve.

Morris has had a passion for collecting them, too. Old saws, stock expres-
sions, folk sayings, and tuneless ditties abound in the dialogue of his
novels. Like that nineteenth-century portrait, a rhyme that begins "Straw-
berry shortcake / Huckleberry pie" appears in altered form in several of

his novels.[33] When I asked him about it, he rattled off the grade-school cheer on which this doggerel was based. Two lines of the original go, "Are we in it? / Well, I guess!" Morris says that a taste for such compositions was bred in plains folk by the newspaper they all read when he was growing up, *Capper's Weekly*. It's read aloud in several of his novels, and *The Home Place* contains a photograph of verses clipped from it.[34]

"The indescribable appropriate banality of these things!" Morris exclaimed to me.

> "Are we in it? Well, I *guess!*" It just can't be touched. It's *Capper's Weekly* Keats—these little touches of elegance. They have that rhyming expression of an unspeakably durable cliché, and those are the kind that ring the soul, because they have the burden of centuries behind them. Somewhere in about 925, some tough son of a bitch wearing a rusty suit of armor said, "You can't tell shit from Shinola," and the man just slunk away because he knew he couldn't. The old man in *The Home Place* has three or four of these expressions that are dragged out like the tail of a shirt. They just do the work of a lifetime. When nothing else will do, he drags them into a debate and feels he's really settled something. This is why clichés have an almost sacred function.

Morris prizes anonymity in verbal artifacts as much as visual ones because he ultimately wants his characters to seem anonymous. In a novel that attempts to capture ordinary experience, it would be wrong for the characters to have extraordinary personalities. Like the figures in the nineteenth-century portrait, they must not be too distinct. This is the reason that the central character in *The Home Place*, who is based on Morris's own uncle, is referred to only as "the old man." The photographs of the uncle that the text contains are equally general. Tagging along with a camera on his uncle's daily rounds, Morris had no compunctions about manipulating his subject a bit to get the desired effect of an archetype. When his uncle put on a pair of stiff, new overalls, for example, Morris let his disapproval show, and the old, worn pair reappeared the next day.[35] Nor was Morris above manipulating the photograph itself after it was made. I'm pretty sure that he did so in the novel's very first picture, which makes the old man out to be, literally, self-effacing.

The photograph shows the old man just outside his barn door fixing an inner tube (Fig. 11).[36] Though his head is tilted to his work, his face should be visible under the shadow cast by his cap. But the features are blank. They have been retouched out of the picture. Of the four subsequent pictures of the uncle, I suspect only one of having been fudged. It's another where the face should show beneath the hat brim.[37] Instead, the shadow has been printed so black that the features disappear into it (Fig. 12). The

Figure 11. Wright Morris, from *The Home Place*.

Figure 12. Wright Morris, from *The Home Place*.

rest of the photographs remove their subject in other ways. In two, his back is to us. In the remaining one, he sits at the rear of a parlor we see from outside, through a lace curtain (Fig. 13).[38] In the foreground is an empty rocker; the last thing we notice—if we notice it at all—is that in the background the twin to this rocker is occupied by a vague, all but indiscernible figure. These are the only pictures in the Midwest series where the human subject is actually present. Yet even here, that presence remains implicit.

Thus did Morris incorporate into his own pictures the anonymity to which he responded in old snapshots and portraits by photographers unknown. Even when he knew his subject intimately, and had him before the camera, Morris kept him at a remove. He recreated in his photographs what time and deterioration had achieved in that nineteenth-century portrait. The impetus to do so came, I believe, from the subjects themselves. The anonymity of his photographs respects his subjects' own sense of privacy. His aunt wouldn't allow herself to be photographed at all, and Morris sympathized. People like her, *The Home Place* explains, "don't leer at you with the candid camera eye. They lead what you call private lives, which is not so much what you know about them, as what you know is none of your damn business. That's a good deal." Morris's aunt felt that someone's "face [is] a fairly private affair."[39] Out of deference to her, his photographs are circumspect.

Although I intend to return in the end to *The Inhabitants* and *God's Country*, as Morris's most important photographic books, I haven't wanted to praise them at the expense of *The Home Place*. In the latter, fact and fiction—the privacy on which his subjects insisted and the mood of absence to which his own art inclines—complement each other perfectly. Even in the sequencing of the photographs, Morris managed to strengthen the relationship of absence to presence in the book. He did so the way a film director (perhaps Robert Bresson, whose austerity of vision is often similar to Morris's) might have done it.

The structure that Morris built into the book's imagery becomes especially apparent with the closing pictures. The second-to-last shows an empty shed door (Fig. 14).[40] The emptiness is underscored by the fact that we look through the building and out a window at the rear, an effect Morris liked and achieved in a number of settings. The last picture shows the nearly identical door of the barn as Morris's uncle steps into it, filling it up (Fig. 15).[41] The two photographs repeat between them the pattern of the single picture earlier in which there are two rockers, the near one vacant and the far one occupied. This is a pattern played and elaborated throughout the book. It functions the way *montage* does in a movie. It causes the

Figure 13. Wright Morris, from *The Home Place*.

Figure 14. Wright Morris, from *The Home Place*.

Figure 15. Wright Morris, from *The Home Place*.

emotion to accumulate from picture to picture. Thus do the last two photographs complete a sequence that begins with the first photograph, in which the uncle steps out of the barn. Morris is not the only great photographer who has preferred books to other forms of exhibition because the book allowed him to control the viewer's sequence this way. Evans put similar energy into *American Photographs* ten years before *The Home Place;* Frank did so in *The Americans* ten years after.

In *The Home Place*, photographs and text are teamed up. They pull together like the style of anonymity and the theme of privacy in the novel. The result is a kind of oneness, a singularity of purpose, that is perhaps unmatched in *The Inhabitants* or *God's Country.* And yet, I can't help feeling that the latter are the more important books. They are closer to the center of Morris's talents. They are innovative in a way that *The Home Place* is not. Consider the difference between the use made of a photograph of a freshly laid egg in *The Home Place*[42] and in *God's Country* (Fig. 16).[43] In the former, the text relates how Morris's daughter finds just such an egg in just such a spot as the photograph depicts. The picture never becomes more than an illustration of the story, a parallel vision. In the later book, there is a tension between text and picture. The two complicate, rather than just complement, one another.

The text in *God's Country* relates an episode from Morris's youth when his father acquired 3,000 Leghorn chickens to "lay eggs at night so the Pullman diners could have them in the morning." But then a chicken takes sick, and after it, another and another. "One day you find one droopy," the text tells us. "In the next day or two you find half of them dead. . . . People drove out from town to sit in their buggies and watch them die." Morris was locked in an upstairs room with a housekeeper and a dog to wait out the epidemic. "Sick chickens . . . lined the fence like drifted snow. The live ones huddled on the dead ones, and those that weren't dead smothered." In the end Morris's father shipped the three roosters that survived to a brother, who refused to claim them at the depot. Morris's father had to pay return freight to keep them from starving.

This story is also told in Morris's *The Works of Love.*[44] But the briefness of the account in *God's Country* conveys better the terrible, forest-fire speed with which the disease moves. And the picture of the lone egg makes us feel the vastness of these events for the people involved, and their vulnerability. When the first chicken dies, the incident seems, among so many birds, as singular as the egg in the photograph. But within a few lines, an entire empire has fallen. The spirit of capitalism has been laid low by natural disaster the equal of a plague. To oppose such titanic events with so modest a picture now becomes marvelous irony. Photograph and words are not merely in parallel here, but in counterpoint. The cackle of a whole flock

dying on public view resonates through the henhouse where this one egg has been stashed. Amidst soft shadows, the egg looks fragile; but in light of the story it is also sinister, an image of the germ from which the decimation of the flock began. Photograph and text each take on a poignancy neither would have without the other.

Nowhere has Morris been more candid about his life than in certain photo-vignettes in *God's Country* and *The Inhabitants*. Between the words and the photographs is a narrow gap, a border of blank silence on the facing pages, in which Morris has cached his most personal feelings for us to find. One place this happens is in *God's Country* in a scene where a son pesters his bedridden father for a reminiscence of his mother. Morris's mother died less than a week after he was born. She thereby became the first experience of his life—and the ultimate one—in which imagination had to take over for memory. The memoir *Will's Boy* begins by acknowledging her primacy in his emotions. She was his discovery that life is a series of "real losses and imaginary gains"[45]—that real losses *are* the imagination's gains. Having been lost to him thus, his mother became a mythic being. His address on receiving the National Book Award in 1957 makes her into a veritable Annie Oakley.[46] In the scene from *God's Country* she is more tender and more human in scale, though also more of an enigma than ever.

The photograph reflects the prose. In the latter, the father is described lying on his bed; in the former we see, in a mirror, a bed of the same sort (Fig. 17). Yet the photograph also transforms the prose in the way characteristic of Morris, for in the photograph, there is no one on the bed. In the prose passage, the father is full of self-pity to which the son pays no attention. He is concentrated wholly on the memory of his mother. By eliminating the father from the scene and shoving his bed into the background, the photograph reflects not the physical arrangements, but something more elusive—the attitude. In the foreground of the picture, the mother emerges ambiguously. Propped on the dresser is a tiny, framed snapshot of a girl just on the brink of womanhood. She is cuddling two small animals to her breasts. Oblivious to all else, she hasn't noticed how her hem has ridden up on her parted knees. There is a faintly startling sexuality in her posture and her lack of self-consciousness. She is both pure and erotic at the same time, both a figure of innocence and a woman of mystery. She is the forbidden woman that a mother becomes to a son who has never known her.

In pairings of photographs with words such as the two just discussed, *God's Country* is only following the lead of *The Inhabitants*. There, too, photograph and text usually relate through a kind of disparity between them. A typical instance—I could almost select one at random—is the

Figure 16. Wright Morris, from *The Home Place*.

Figure 17. Wright Morris, from *God's Country and My People*.

Figure 18. Wright Morris, from *The Inhabitants*.

vignette that begins, "When her birthday came, it was out on the lawn with colored lights and Japanese lanterns." After the Roman candles and cake and a present, the passage goes on, "We watched my father climb the tree and take down the lanterns and then walk around picking up cups and paper plates." In the accompanying photograph, a yard is covered with snow blown into waves as if it were an ocean turned to stone (Fig. 18). It is uncertain whether the house beyond is even occupied. The windows are dark like vacant eyes. The photograph is everything that the prose passage isn't—lit by harsh sun instead of lanterns, cold rather than warm, still and mirthless rather than full of life. The prose becomes an echo that we hear, dying away, in the photograph. This is how it always is with Morris.

The writing in *The Inhabitants* contains many experiments, particularly with dialect, to which Morris would never return. Although he told me that the kind of "vernacular" is something "you tire of very quickly," he

had flashes of real success with it. In one passage of hardboiled prose set in Chicago, a man who is lying in bed can feel "with his body" the passing of the El train outside. When he gets up, the woman with him continues to lie there. "She raised her knees and made a sound with her skirts and he felt that too with his body." James M. Cain would have given his eye teeth to write that line. If Morris is less concerned now about the reputation of *The Inhabitants* than of other books, it may be because such experiments don't seem important to him in retrospect. Nonetheless, this book and *God's Country* were way stations crucial to his development as a writer. Here midwestern characters from the early novels were kept alive and passed forward in his career to the masterpiece *Plains Song*.

In *The World in the Attic*, the novel that was originally to be the third photo-book, Morris said that remembering the events depicted was like "thumbing the loose pages of an old album, the pictures related but the gist of the story getting out of hand."[47] This is what so often happens in his novels, with their wonderful early scenes and progressively antic plots. The distinction of *The Inhabitants* and *God's Country* is that in them he let the gist of the story go altogether. The last photographic book Morris has done, the 1982 *Photographs and Words*, is intended to be the definitive reproduction of his pictures. My only disappointment with the volume is that he allowed someone else to select the photographs. Many of the best from the earlier books are not included, and none of the prose is. In my mind there still exists the possibility of one book more, a book in which the strongest words and pictures from *The Inhabitants* and *God's Country* are reproduced. Added to them, perhaps, are some of the photographs that have never been published, for which Morris now writes new prose passages.

Such a book would do more than just please the admirers Morris already has. It would establish his influence with a new generation of photographer-writers who are emerging now and are unaware of his example. He finds it ironic that a receptive audience for *The Inhabitants* may finally be developing today, decades after the book has gone out of print. On the one occasion when he met Walker Evans, in the late 1940s, Morris could sense Evans's hostility to *The Inhabitants* and *The Home Place*. Evans felt that writing against photographs as Morris did muddied the water, delaying for other photographers the recognition that their medium deserved in its own right. When he told me this story, Morris admitted that at the time he was not unsympathetic to Evans's point of view. But now, he said, "We've come clear around. The photograph has . . . so over-grazed its available sensibility that language is necessary to restore the substance of it." If that's the case, no language, and no photographs, could do so better than Morris's own.

Notes

1. Wright Morris, *Ceremony in Lone Tree* (1960; reprint, Lincoln: University of Nebraska Press, 1973), 7.

2. Wright Morris, conversation with the author, Mill Valley, California, April 4, 1983. Further quotations and information from this visit with Morris are identified in the text as remarks made directly to me.

3. Wright Morris, *Plains Song* (1980; New York: Penguin Books, 1981), 200, 214.

4. Morris, *Plains Song*, 137.

5. Morris, *Plains Song*, 175.

6. Morris, *Plains Song*, 75.

7. Wright Morris, *The Inhabitants* (New York: Charles Scribner's Sons, 1946). Since pages in this book are unnumbered, readers who want to find my references to it will have to identify them by the photographs either described or reproduced here. For this reason, no further references to the book are noted.

8. Wright Morris, *A Bill of Rites, A Bill of Wrongs, A Bill of Goods* (1968; reprint, Lincoln: University of Nebraska Press, 1980), 13.

9. I have been unable to track down this particular simile, though Morris assures me it appears more than once. More or less fastidious spitters are to be found in *Plains Song, The Home Place, The Inhabitants, Will's Boy,* and elsewhere.

10. This image can be found in Morris, *Plains Song*, 25, and *The Home Place* (1948; reprint, Lincoln: University of Nebraska Press, 1968), 15.

11. Wright Morris, press conference, Corcoran Gallery, Washington, D.C., March 15, 1983.

12. Wright Morris, "Three Francs Bought Me a Bowl of Borscht," *New York Times Book Review*, April 10, 1983, 3.

13. *Wright Morris: Photographs & Words* (Carmel, Calif.: Friends of Photography, 1982), 15.

14. Morris, *Photographs*, 43.

15. Morris, "Three Francs," 3.

16. Morris, *Photographs*, 37.

17. Morris, *Photographs*, 43.

18. Wright Morris, "Photographs, Images, and Words," *American Scholar* 48 (Autumn 1979): 461.

19. Morris, *Photographs*, 44. In conversation with me, Morris elaborated on this incident. This is why my account differs slightly from the published version.

20. Morris, *Photographs*, 49. See also "Photography and Reality: A Conversation Between Peter C. Bunnell and Wright Morris," *Conversations with Wright Morris: Critical Views and Responses*, Robert E. Knoll, ed. (Lincoln: University of Nebraska Press, 1977), 148–49.

21. Compare Morris, *Photographs*, Pl. 24 with Robert Frank, *The Americans* (1958; Millerton, N.Y.: Aperture, 1978), 71. Both photographs not only have the same subject—a rural mailbox in Nebraska—but are composed the same way. Where the telephone pole stands in Frank's picture there is a tree trunk, perhaps also serving as a pole, in Morris's. Both these strong verticals run straight to the top of the

frame and out of the picture, and in both photographs a dirt road curves in from the left foreground, just kissing the pole or tree near its base. I wonder as well whether a photograph Morris made in 1950 might not have started Frank taking notice of juke boxes. Compare Morris, Pl. 61 with Frank, 97.

22. Morris, "A Conversation," 142–43.

23. Morris, "Photographs, Images, and Words," 466–67.

24. Morris, *Plains Song*, 142–43.

25. Wright Morris, *The Works of Love* (1951; reprint, Lincoln: University of Nebraska Press, 1972), 5–6.

26. Wright Morris, *The Man Who Was There* (1945; reprint, Lincoln: University of Nebraska Press, 1977), 63–84.

27. Morris, *Home Place*, 154.

28. Morris, *Man*, 64.

29. Morris, *Plains Song*, 142–43.

30. Morris, *Conversations*, 156.

31. Wright Morris, "The Camera Eye," *Critical Inquiry* 8 (Autumn 1981): 9–10.

32. Morris, "Camera Eye," 2.

33. Wright Morris, *The World in the Attic* (1949; reprint, Lincoln: University of Nebraska Press, 1971), 100. See also Morris, *Works of Love*, 47, and *Ceremony*, 11.

34. Morris, *Home Place*, 139.

35. Morris, *Photographs*, 46.

36. Morris, *Home Place*, opp. 1. I have also looked at a first edition of the novel, where the reproduction of the photographs is perhaps even worse than in the reprint. Though I remain confident about the interpretations given here, I must admit that they are speculative due to the reproductions' poor quality.

37. Morris, *Home Place*, 126.

38. Ibid., 161.

39. Ibid., 35–37.

40. Ibid., 175.

41. Ibid., 177.

42. Ibid., 10.

43. Wright Morris, *God's Country and My People* (New York: Harper & Row, 1968). This book is, like *The Inhabitants*, unpaged. I have therefore again not noted further references, which the reader will have to find by searching for the photographs.

44. Morris, *Works of Love*, 122–24.

45. Wright Morris, *Will's Boy: A Memoir* (1981; New York: Penguin Books, 1982), 4.

46. Wright Morris, "National Book Award Address, March 12, 1957," *Critique* 4 (Winter 1961–62): 74.

47. Morris, *World*, 168.

CRITICAL THEORY AND
ANALYSIS

MEDITATIONS ON AN
UKRAINIAN EASTER EGG

JAMES HUGUNIN

This Essay Is Dedicated to Kenneth Josephson

*What a lot of texts we could quote which tell that
the eye is a center of light, a little human sun
which projects its light on the looked at object, well
looked at in a will to see clearly.*
The Poetics of Reverie
Gaston Bachelard

I.

 I CAN'T DESCRIBE MISS WINNOA JOSEPHINE IRVIN. I CAN HOLD her full-length portrait before me, looking at her in her *analogical plenitude,* as Roland Barthes would say. Yet this very fullness of mirrored presence frustrates a simple description. It's not just a matter of me being imprecise or incomplete in my method. To describe, Barthes has quipped, "is to change structures, to signify something different to what is shown."[1] I can only approach a description of Miss Irvin asymptotically. More precisely, to the denotational level of the photograph is grafted ". . . a relay or second-order message derived from a code which is that of language and constituting in relation to the photographic analogue . . . a connotation. . . ."[2] I begin to marvel at the myriad of "universes" contained within this curious turn-of-the-century portrait. My meditations take the form of three perspectives, three interrelated *close readings* of Winnoa Irvin's photographic likeness. These readings are, respectively, structural, sociological, and psychological, constituting three second-order commentaries "parasitic" on the photographic text sitting before me on my desk.

II.

A young girl leans against a table with an air of relaxed masculine self-assuredness. On this table rests a framed portrait, a picture-within-a-picture, that reflects the child's immediate environs. Behind the table, on a tall pedestal, rests a large Easter egg, while to her left stands a femininely frilly chair. The girl stares confidently forward with one normal eye; the other is abnormally skewed to her left. These manifestations, among others,

constitute the rhetoric of the image. Behind this rhetoric lie fragments of ideology, of culture, knowledge, and history.

I turn over the 4¹/₄-by-6¹/₂-inch cabinet card, the material support of this portrait, and read the "verbal translation" of this image. Written in an elegant hand, in the upper left corner of the backing, is the name *Winnoa Josephine Irvin*. The sharp pen quill has gouged into the print's backing— a support finely decorated with a delicate faded green floral pattern. I assume the name refers to the child portrayed. Centered on the backing, printed in eye-turning red ink, is the portraitist's logo. The contents of this insignia bespeak the wedding of art and technology: a view camera is flanked by a painter's palette on the left and an oval-framed portrait on the right. Behind is pictured a chemist's paraphernalia. A sunburst pattern highlights the composition which rests upon an elaborate scroll pattern, the portraitist thus symbolizing the fusion of natural means (light) with esthetic intentions (the ornamental scroll). Here we do not have the chance encounter of a sewing machine with an umbrella on an operating table, but rather a self-conscious creation professionalizing the photographer's product. Below this logo, the portraitist identified himself:

A. B. PAXTON
Photographer and Artist
ALBANY. OREGON

A pretension to creativity is evidenced. In "reading" this portrait of Miss Irvin, I must interweave these verbal declarations with the ambiguities of the visual information in the portrait. Turning the card over again, I study the furniture, dress style, skylighting, and print mounting and estimate the portrait to date from about the 1890s.

Here, then, is a photograph meant for intimate viewing, another addition to a family album, but whose possession by relatives has been usurped by time. Did the family die out, or did later generations of relatives lose interest in their forebear's visage? Somehow, though, this portrait found its way into a stack of old photographs in an antique shop in Pearblossom, California. There, three years ago, I purchased it for a dollar and a half. Now, sitting on my desk, this portrait provides me long hours of speculation and reverie. I've found Winnoa's presence to have shifted from *that-has-been* to the present tense, *there-she-is*. But only recently did it become apparent how futile was my attempt to resurrect her personality. I realized I could never experience this child's "reflection" as her own relatives could, nor conjure up actual memories of her. This image, for me, must remain a site upon which to pour my feelings, sharpening my critical faculties in speculating on photography and its social context. My relationship to this

Winnoa Josephine Irvin (c. 1890), A. B. Paxton; cabinet card.

image is analogous to the photographer who shot it, both of us using the young girl as an *object* upon which to exercise our professional skills. But what a curious object!

Like myself, the photographer must have been intrigued by the irony of childhood beauty marred by the abnormality of that crossed eye. The photographer, rather than play down the child's defect, emphasized it. He, in fact, built his composition around it. The child is posed frontally. One eye returns the camera's gaze; the other, a crossed eye, stares wildly askew. The girl seems to be staring in two different directions simultaneously. Strange, as the photographer could have easily had Miss Irvin look to her left, bringing her normal eye into symmetry with her eye-errant, or he could have simply hid that offending eye by posing the child at an oblique angle. But no, the photographer further emphasizes the *internal strabismus* by "doubling" that defect in having the child cross her right leg. Maintaining the asymmetry of the mismatched eyes, Paxton does everything he can to extend the mirroring of that defect within the composition. He has, for example, posed Winnoa's right arm so her hand and dress cuff stare as directly at the camera as her "good" eye, while her left arm hangs limp as if as useless as her "bad" eye. Paxton has built a composition around the paradigm: *straight/skewed*.

I've mentioned that the child's bifurcated gaze is doubled by her crossed leg, but those legs also repeat other pictorial elements of the composition: 1) the child's left foot rests firmly on the floor near one of the table's "feet"; both that table's left "foot" and the girl's point in the same direction; 2) the crossed right leg of the child permits her right foot to be positioned toe-down near a chair leg that similarly stands "toe-down"; 3) the child sports decorative stockings whose patterning invites comparison with decoration on the large Easter egg to the right of and behind Miss Irvin. It is that leg, crossed to match the crossed eye, that constitutes the poignancy of this portrait, its "wound," "prick," or *punctum*, as Roland Barthes has termed this visual disturbance.[3] Why not the crossed eye? It can be too easily coded as *aberrant*, and "what I can name cannot really prick me. The incapacity to name is a good symptom of disturbance."[4] But that crossed leg resists such naming, being a "subtle beyond" within the context of that crossed eye.[5]

Other doublings can be found. Within the portrait and on the back of the card, oval shapes echo each other. I can draw an imaginary oval within the composition with the ovoid Easter egg, the oval-matted tabletop portrait, and Winnoa's markedly ovoid head on the circumference. On the back of the print, the obliquely rendered painter's palette and camera lens form ovoids that echo the adjacent rendering of an oval-matted portrait (which, interestingly, depicts a rendition of a full-length female portrait).

The oval, a popular shape for painted miniatures and women's vanity mirrors, is an "aberrant" circle, an optically distorted rendition of a perfect Platonic form. If the circle signifies a higher plane of spiritual unity, the oval, a distortion of perspective, suggests the "accidents" of imperfect vision. Within the context of the light-exposed, lens-formed image, the oval shape conforms to the lens's edge fall-off; turned on its side, the oval repeats the form of the human eye, the model for the photographic lens. Flipping the print back to the emulsion side, to Winnoa's divided attention, I see that her eyes are large ovoids. They are further repeated in the pupil-within-oval patterning that runs around the draping tablecloth that covers the obliquely rendered, hence oval-shaped, table that the child rests her arm on. These eye-patterns, circling the table, seem to stare out in diverse directions further mirroring Winnoa's defect.

Further morphological homologies can be found. Around Miss Irvin's neck hangs a braided clasp culminating in a small tassel; "doubling" this accoutrement is the braided fringe on the chair and the braided chain strung necklace-like around the edge of the Easter egg's pedestal. A large tassel hangs limply from the chair's shoulder alongside the girl's own finger-tasseled arm.

The objects surrounding the child are curiously anthropomorphic, with girl and furniture each dressed in their Easter best. The table models a long "skirt" that hangs in folds about it; the upholstered chair sports a nice braid fringe, while Winnoa bridges the gap between, decked out in her fine taffeta. A table's foot peeks from under its garment, while the head-and-shoulders portrait, encased in an oval frame resting on the top of the table, provides the "table-person" with a torso.

This glass-covered portrait-within-a-portrait both depicts someone's countenance (a relative of Winnoa's?) and simultaneously reflects the por-traitist's own illuminating skylight. The tabletop portrait's oval shape not only echoes the shape of Winnoa's head, but, like a cyclopean eye, it "sees" in double vision, mirroring the child's own split gaze. Winnoa stares *both* directly into the camera (which stares back at her!) *and* off to stage-left. The cyclopean portrait reflects (as a frozen memory, as history) what *had been* in front of the camera, while also literally reflecting the immediate surroundings of Paxton's studio at the moment of exposure. In this photograph-within-a-photograph I can see in front of *and* in back of Miss Irvin in both a spatial and temporal sense.

Behind and to the right of that oval desk portrait rests the decorated egg, its vein-like patterning culminating in a pupil-like dot that mirrors Winnoa's own normal eye. It looks as if this eyeball has been plucked from the cyclopean desk portrait's "socket." If that egg-eye were to stand in for Winnoa's defective eye, she'd gaze at us in normal binocularity.

This portrait depicts Winnoa Josephine Irvin, but also acts as a self-reflexive commentary on photography as a distorting mirror, as an aberrant gaze toward the world, a Medusan gaze in which what *was* shifts into what *has been*, fixing a fluid *then* into an immobile, perpetual *now*. As Winnoa stares both *at* and *away from* what was before her, so does every photograph display a gaze at what is literally in front of the camera (denotation) *and* what is only symbolically there (connotation). The desk portrait, that image-within-an-image, simultaneously registers both the means of photographic rendition (light) and the end product (a frozen likeness). This textual fragment, like those fragments within this portrait, mirrors in microcosm the larger whole of the portrait itself. In literary jargon such an intratextual web of mirrorings is a rhetorical device known as *mise en abyme*. However, this suggestion of indefinite substitution, repetition, and splitting of the Self in a visual *anadiplosis* is not one of perfect symmetry.[6] Eyes and legs are crossed, the child's arms are arranged perpendicular to each other. The compositional paradigm is: *straight/skewed*.

Here's a portrait whose visual rhetoric suggests a parallel with Jorge Luis Borges's image of the world as a concatenation of secret syllables, with the notion of an absolute idiom or cosmic letter which underlies the rent fabric of languages—the supposition that the entirety of knowledge and experience is prefigured in a final tome containing all conceivable permutations of the alphabet.[7] For me, Paxton's photograph is such a final tome harboring in cipher the mysteries and paradoxes of the photographic image.

III.

So far, my meditation has bracketed Miss Irvin's portrait from its contextual situation, blurring the distinction between *then/now* and *private/public*. I shall re-focus my discussion.

In late 1866, the cabinet card photograph was introduced in America. Edward L. Wilson—publisher of the *Philadelphia Photographer,* an important trade journal of the day—discussed this new format which quickly replaced the popular carte-de-visite:

> Something must be done to create new and greater demand for photographs. The carte-de-visite, once so popular and in so great demand, seems to have grown out of fashion. . . . The adoption of a new size is what is wanted. . . . From Mr. G. Wharton Simpson we have received a specimen picture [from London] . . . they call it the cabinet size. It is something like a carte-de-visite enlarged.[8]

The large format presented new problems to the portraitist:

Flaws that were not particularly obvious in the smaller carte now became unacceptably visible. A misplaced strand of hair in the carte was hardly noticeable, in the cabinet photo it became a virtual rope across the brow or face. Therefore much great care had to be taken in posing the subject and preparing the prints.[9]

After 1906, very few cabinet cards were produced, hence Paxton—if my guess as to the date of Winnoa's portrait is accurate—was active during the zenith of such cards' popularity on the last frontier, in a small off-the-beaten-track town east of Salem and south of Portland, Oregon. Judging from the skylight reflection in the tabletop portrait, Paxton hadn't upgraded his lighting to the newfangled arc lighting his East Coast contemporaries were using. His materials were probably collodion dry plates contact-printed via sunlight onto an albumen paper positive. The going price in that day was usually four prints for two dollars.[10] As suggested by Wilson's aforementioned commentary on the cabinet card, Paxton had to be more aware of what he was including in his photograph than if he had been shooting the smaller *cartes*. I am assuming, then, Paxton's conscious deliberations over Winnoa's unflattering pose. Surprising? But we must remember that this strange portrait was destined for private display among family members and within the context of a small community that knew of, was used to, the child's birth defect. Displaying that flaw meant testifying to the camera's veracity; to mask it would have probably evoked remonstrations over the falseness of the portrait, maybe even have elicited charges of vanity by severely moralist townfolk.

The situation is wholly reversed today. A portrait destined for family consumption is tackled by our commercial portraitists as if your visage was to grace the cover of *People* magazine or *TV Guide*. Moreover, as a sitter, you'd demand such a flattering likeness. Even if only a participant in the ritual of the family snapshot, you'd probably pose yourself in a manner most coincident with your self-image (a self-image in part conditioned by the Media). If your image failed to measure up to your expectations, you'd probably accuse the camera of lying.

The erosion of the private sphere into the domain of the public—not wholly accomplished in Paxton's time—is now complete: a murdered child's school portrait finds its way to the front page of newspapers; friends peruse the intimacies of the family photo-album, judging your "professionalism" as an image-maker; you display—if you're white collar—a flattering portrait of your wife and kids on your desk; or stuff them—if you're blue-collar—in your wallet to show the guys in the shop. If the photographic renditions don't do our loved ones justice, we apologize for our lack of picture-taking skills: "She's really not *that* chubby." Although only private citizens, our

images must sell us as being cute or sexy, macho or sensitive. Our portraits commodify us, help us maintain our *persona*.

Winnoa's defective eye ruptures any such cosmetic, speaking to me of a time when people really *saw* each other and didn't mind really being *seen*, when the terms *perfect/flawed* were constitutive of the whole person. Today, the last term in the opposition is actively suppressed giving us a lopsided vision of ourselves. Thomas Merton has always shown a keen insight into our duplicities, our constructed selves:

> . . . if we think our mask is our true face, we will protect it with fabrications even at the cost of violating our own truth.[11]

Winnoa's portraitist, hidden away as he was in the backwoods of Oregon, was insulated from the burgeoning rhetoric of glamour, from the theatricality of such conveyors of public image as New York portraitist Napoleon Sarony (1821–1896) whose professional dealings with actors, politicians, and poets encouraged visual flattery. No, Paxton depicted Winnoa in the fullness of a description that encompasses, and strikingly asserts, the mutual dependency of the terms *perfect/flawed* in a photographic mirroring that uses that opposition as a formal device.

IV.

Finally, Winnoa Josephine Irvin's sexuality has been imaged ambiguously. What I've described as a structural tension between *straight/skewed*, and as a normative tension between *perfect/flawed*, becomes from a psychosexual perspective a sexual tension between *male/female*. Paxton gives us a mature male's gaze at a prepubescent female (Reverend Charles Lutwidge Dodgson's—a.k.a. Lewis Carroll—portraits of young girls come to mind here). Might Paxton's portrait be a visual "utterance" of obscure desires? There is no evidence, except this photograph, which speaks to me as I proceed to read into it. Interpretation becomes a form of ventriloquism.

Let me complete my list of paradigms:

> male/female
> perfect/flawed
> straight/skewed

This schematic abbreviates the ideology of patriarchal dominance given credence by the Scriptures and Freudian psychoanalysis. It also, however, suggests a less sexist ideal, hints at the human psyche's primitive androgynous state where, according to Jungian terminology, the *animus* (male

principle) is balanced by the *anima* (female principle). Modern social life, with its gender-mixing competitions, teaches us to curb manifestations of that original androgyny, to enforce the patriarchal stereotype. But in our reveries, our poeticizing, our image-making, a yearning for this Ur-wholeness may surface.

In Balzac's philosophical poem *Séraphîta*, we have, for instance, a celebration of androgyny. The first chapter is entitled *Séraphîtüs;* the second, *Séraphîta,* and the third, *Séraphîta-Séraphîtüs*. Thus, the integral being, the sum of the human, is presented successively as masculine, then as feminine, before the synthesis is produced between them.[12]

Similarly, Diane Arbus's photograph *Hermaphrodite and a Dog in a Carnival Trailer, Md., 1970* depicts a contemporary androgyny—half man, half woman. Perusing Nietzsche's *Philosophy in the Tragic Age of the Greeks,* I found an interesting textual reference: "Empedocles remembered being . . . boy and girl." But back to Winnoa's portrait.

In my "dreaming observation" (Gaston Bachelard) of this child's picture, does the irony I find there have its roots beyond the crossed eye, deeper than the *punctum* of the crossed leg? Are those physical crossings merely surface indicators of a deeper crossing? Gaston Bachelard observes: "Isn't it striking that more often than not the contradictions between *animus* and *anima* give rise to ironic judgements?"[13] But whose ironic judgements? Mine or Paxton's? Am I speaking through this portrait or is Paxton, the photographer? I have as much evidence to suspect myself as much as I do him.

Winnoa has been posed in a way that mixes, in a veritable "animosity," masculine and feminine traits: 1) the girl's dress, frills, and hairdo clash with her more masculine, arm-on-the-table self-assuredness; 2) her left eye engages the viewer in a direct way more characteristic of the male portrait, while her abnormal eye gazes distractedly, more femininely, out of frame; 3) her right hand rests near a book, the male symbol of learning and wisdom, yet she also stands in proximity to a sign of Nature's spring renewal, of feminine fecundity: an egg. Only *in potentia* a woman, this prepubescent's sexuality is less differentiated from the masculine than a mature woman's, more androgynous. Even her middle name, Josephine, is a feminized version of a male appellation.

Paxton's portrait juxtaposes inconsistency with platitude, hence the irony. This "animosity" of genders in Paxton's portrait and Diane Arbus's hermaphrodite brings to mind an insight of Jung's from his *Psychology and Religion:* "The *anima* gives rise to illogical outbursts of temper; the *animus* produces irritating commonplaces," clouding hopes for a dreamed-of communion between these principles. Can we say that in both Paxton's and Arbus's photographs there is coded the history of the soul with its opposing sexual principles? Yes or no, this image still remains textually "open," conducive to readings that are never quite exhausted.

Notes

1. Roland Barthes, "The Photographic Message," *Photography in Print*, ed. Vicki Goldberg (Albuquerque: University of New Mexico Press, 1988), 524.

2. Ibid., 524.

3. Barthes, *Camera Lucida* (New York: Hill and Wang, 1981), 26–27.

4. Ibid., 51.

5. Ibid., 59.

6. Craig Owens, "Photography *en abyme*," *October* 5 (Summer 1978): 81. Owens says: "*Reduplication* has at times been identified with the etymologically parallel figure *anadiplosis* (*ana*, again + *diploun*, to double) in which the final word of a phrase is repeated at the beginning of the next. *Anadiplosis* thus establishes a mirror relationship between two segments of text. . . ."

7. George Steiner, *After Babel* (New York: Oxford University Press, 1981), 67.

8. George Gilbert, *Photography: The Early Years* (New York: Harper & Row, 1980), 96.

9. Ibid., 96.

10. Ibid., 101.

11. Thomas Merton, *The Rain and the Rhinoceros*.

12. Gaston Bachelard, *The Poetics of Reverie* (Boston: Beacon Press, 1971), 86.

13. Ibid., 69.

THE PRIVILEGED EYE

MAX KOZLOFF

CONSIDER AN ACTION PHOTOGRAPH IN WHICH ONE OR A BUNCH of figures is on the move. No matter how visually explicit, its story content is moot. Because it's unnaturally congealed, the pictorial activity becomes literally equivocal in its drive or purposes. In the next instant the ball which looks about to be triumphantly caught might have been fumbled. The head that turned might have signified denial rather than distraction. Everyone is willing to take that into account, if need be. Show us where we may be hasty in interpreting an event and we shall delay our judgment, admit a different outcome . . . provided there are no stakes in the matter.

Most of the time, we don't have such stakes, so that we make confident determinations about the incident without being aware that they're conjectural. By the shortest common-sense route, we work on a number of cues that invite us to make a provisional settlement of the narrative issue framed by the picture. I may not know what I'm looking at—the actual circumstances—but I scan quickly for the approximate import of the scene. If it doesn't unduly disturb my sense of probability, the situation is *typed* for response. I have to get on with my intercourse with images, which requires that I don't think of them as problematical, even if I can't convince myself of the benign stability of their meaning. My impatience doesn't presume to exhaust the real possibilities of the image, it just fades them in comparison with the preferred scenario. Were I not conventional in this matter, wouldn't I be perpetually staggered and stymied by the overload of inexplicable images around me?

Still, without my having helped it, the photo can return to me more than

the little enough I may have put into it. I can very well conceive of people profoundly affected by a photographic subject for natural reasons of ego, and yet being inattentive to the picture which contains and phrases it. What difference does it make to those who have an intense experience that it was easily elicited? The image seeks them out and grips them in their unwarned, passive state. This seemingly direct visual transmission from the outer world finds them credulous in the extreme, so that it isn't an affair of willful attention or inattention, but only of stimulus and hyper-subjective reflex.

The claims of the subjective ego are, in every interpretive sense, privileged, nominally unsharable, a despair to those interested in a consensual approach to photography. My psychic idiosyncracies or yours are our own singular and primary virtues or defects. In either case they cannot be argued with.

Yet it's exactly with such privilege, the leaning of our sensitive and personal organism, that we have to start figuring out the difference which these photo pictures make to us.

John Berger was right in stating (of imagery in capitalist culture):

> there is no space for the social function of subjectivity. All subjectivity is
> treated as private, and the only (false) form of it which is socially
> allowed is that of the individual consumer's dream. . . . It seems likely
> that the denial of the innate ambiguity of the photograph is closely
> connected with the denial of the social function of subjectivity.

When I *think* of photographs, not just react to them, that phrase of Berger's, "the social function of subjectivity," becomes a suggestive one.

It implies that there is a value in our psychological reception of imagery that is neither economic nor ideological. It hints that we are creatures of our fantasy, but are not locked up in it. If responses were only self-regarding and self-confirming, we could not recognize them in others. We would be alienated from our fellows, therefore, and without society. And if, on the other hand, we could be counted on to react in a predictable and standard fashion to photographic stimuli, how, then, could we be called individuals in the least? We would have become all too socialized, put instantly in range of everyone else but hardly in touch with ourselves.

Photographs make the possibilities of social misapprehension very pointed and critical. If their "truth" quotient weren't so high, they could not deceive as indiscriminately as they often do. But if they were outright fictions, they wouldn't grant me the privilege of feeling that I can hold the world, sporadically, in a set of miniature durations. Because I am informed, though only partially, by this set of images, I am all the more prone to inject my

Henri Cartier-Bresson, Alicante, Spain, 1932. Courtesy Magnum Photos, Inc.

internal states into it. Is there any way into productive talk about this seduction, where facts and feelings are so entangled with each other? That is, can I make my subjectivity social?

Cartier-Bresson has a strange picture, *Alicante, Spain, 1932*, in which the probabilities are so askew that it seems that we're all, when looking at it, very much on our own. It pictures three people, an epicene creature in an undershirt, center, flanked on the left by a fat lady in a Phrygian cap, brandishing a table knife, and a frizzy-haired black woman on the right. The whole frame is aflutter with their arms and kindled by their glaring eyes. Nothing prevents me from imagining that Cartier-Bresson seized unexpectedly upon a lived moment that was, perhaps, nondescript and ordinary. I can entertain the possibility that nothing of any consequence was occurring here. I can discount any significance to the frame whatsoever—in the name of prudence. All this would be a reasonable reaction, to be sure, and an irrelevant one.

For the last thing one would want to say, subjectively, about these people is that their behavior looks humdrum. The action gives priority to another sense altogether—of a human exchange that is vaguely indecent, perverse,

a ritual these individuals practice which we were not intended to know. The photograph seems to be making an argument about the kind of life observed, but evasively, and to no clear end. There is no probable rationale here, only a mysterious opportunity, an unpleasant invitation.

How does the idea of "privilege" work in this interim estimate of Cartier-Bresson's photo? To have known, more or less precisely, what was going on—as the photographer could have known—this strikes me first off as *not* an advantage. Lacking an "approximate import," this image throws me into what I must recognize as a fruitful perplexity.

The viewers of photographs fall, structurally, into two groups, one immeasurably larger, and even so, with every moment, gaining over the other. They are the outsiders to the photographic event, with every conceivable disparity in background and understanding, and the insiders . . . who were there. The number of actual witnesses to anything naturally shrinks through attrition, while those whose prepared or imperfect knowledge of it can come only by hearsay is bound to increase. Space and time, in these matters, divide us very unevenly. Most of our knowledge is hearsay, i.e., indirect, vicarious, prefiltered, secondary, etc. Photography is one of those modern devices intended to give greater magnitude to hearsay experience. By now, the magnitude has conferred its own level of privilege upon us, so that very few feel any embarrassment or qualification when they claim that a photograph has given them to know something.

But here I am saying of Cartier-Bresson's picture that not knowing, a decided lack of knowledge (except of visual specifics that don't add up), can become a value in itself. In this photo, I believe that I have learned something beyond hearsay, but I don't know what it is. If there is any such thing as a revelation that does not explain its content, this is an example. (Religious faith, which this sounds like, I'll admit, is not the parallel. I would liken the sensation, rather, to a dream.)

A formula comes to mind: With many photos, one is introduced to other people's lives, of which the interruptive frame presents an aspect. These lives may be relatively exotic, but they are still earthly, still obviously social, as ours is. With the dream, one is seduced into thinking that one has been given the semblance of another, perhaps a shadow life. In the rational light of scrutiny, the viewer wants almost to reject the photographic appearances, as in Cartier-Bresson's picture. So much do they seem unconvincing, implausible, strange, incongruous. The fingers that touch—heads, shoulders, palms—in a kind of crazy pavanne; and then, the grasping of scalps, as if they were to be sheared! That soft, flabby flesh and those hard stares. Lacking any evidence that the scene was staged, I have to accept that it was like this, if only momentarily.

The expressive power of the photographic experience does not vanish,

nor does its imaginative grip weaken because it has a verifiably material and historical base. I can fancy that someone might have been having an outdoor shave in 1932, or that three prostitutes were hassling each other or horsing around. But that judgment could do nothing but shrivel in the heat of an explosive emotional effect that is as ferocious as it is uncalled for. I would rather have the effect and forget entirely about the question of knowledge, that is, of cause. Yet the dream would not be dreamlike if it were not built out of the peculiar facts at my disposal.

They set my mind to wander and yet, paradoxically, the last thing I want to do is to free associate. The concrete peculiarities in a photo can release fantasies but keep me also on line, with a more or less interesting slack. All that the eye sees are surfaces, but "surface," says Cesare Pavese in his journal "This Business of Living," "is never anything more than a play of reflections of *other* things." Cartier-Bresson could not have done other than to have given me an array of surfaces. But the way they are here wrinkled, that is, animated, expressed, configured, is so out of countenance with historical and social expectations that I am buoyed by an enigma. I am at sea in these matters and cast about; but I know my place.

I seem to be describing a false insecurity or an anxious certainty. On one thing I'm clear: this is a privileged state sometimes given to us by photographs in particular. The privileged ones are those outside the experience, the majority of us. Photography redefines what privilege might be because the medium simultaneously gives a kind of entrée to events or situations and denies it. Photographs provide at best a form of pseudo-intimacy. The picture places us close to something in a once extant guise, but only at a remove. Without many sensuous properties of its own, the photograph either tempts or figuratively insulates the flesh, according to the desire elicited by the subject. Attraction and repulsion are felt but are unconsummated or short-circuited. One has no genuine privilege and no concrete alienation, though the whole gamut of these real possibilities is implied by photographic culture.

No one ever said that photos make anything definitive. But I'm interested here in how they qualify their content, and with that, address our psychic needs. In the sense of benefit, prerogative, and advantage, photographic privilege contributes a great deal. It's customary to speak of how scanty or mendacious the photographic material is, but one of its perennial features, nevertheless, is its gift of allowing us to see more, at any one instant, than its subjects could have seen. "Seen," I say, not necessarily known; and "more," that is, in terms of consultable information, not the knowledge that comes from participating.

In view of the fetching but abortive character of photographic meaning, we have a lot to learn about how these images really satisfy us. I think

that they induce a peculiar state of pleasurable ambivalence, unknown before the invention of the medium. In photography, someone is always acting for us and probing ahead, a proxy figure on reconnaissance, so that whatever is sent back has been gained without our effort or risk. The ambivalence consists in being thankful for that but yet also in feeling jealous and deprived (or possibly delighted!) in not having been there, not having literally seen it . . . the event. To be made pleasurably ambivalent is to be teased—the surrogate eye roams appetizingly far, but is still only a surrogate. Couldn't it be that before we are interested, excited, repelled, or moved by a photograph, it's the tease that gets it all going, just as the spark plug ignites the gas that starts the piston?

But this is all, by definition, still preliminary. I go back to the moot, inconclusive Cartier-Bresson. The people it shows are by now probably all extinct, or soon enough will be. There's nothing special about that . . . and so what? But what if I say this *moment* of their lives, which the photograph gives me, this, too, is extinct? Again, this certainly doesn't distinguish it from the moment of every other photo. What it shows in the present has long since evaporated in the past. If it were a question of an epoch that was somehow epitomized in this shot, or a singular instant in the personal lives of three people, or an iconic reinforcement of character, then the expressive value of the image might also have a historical significance. (As in Eisenstaedt's picture of the malign Goebbels.) But this issue isn't raised in the Cartier-Bresson.

Just the same, the moment is amazing, an instantly memorable occasion that has been extracted and recorded out of those countless micro-intervals that, in themselves, one supposes, would hardly raise an eyebrow. The suspicion of these subjects, their apparent fractiousness, of which, all the more excitingly they may not have been conscious, inflames my awareness of them. It may even be that this long past moment has power over me because it appears as a sudden, strange whole much greater than the partial excitement of its subjects. The circuit of energy writhes from left to right and then just as forcefully back again. All is movement, action, yet I don't know who acts and who is acted upon, who is doing what to whom (although there can be no doubt about the purposeful doing). The interplay of arms and hands, particularly the nexus of fingers that touch the shoulder, has all the elaborate nervousness of Botticelli's *Primavera*, but is much more sinister and ridiculous.

Evidently, the scene is one in which an intruder happens upon a self-contained activity and ruffles it, so that a new emotion, perhaps a surprised wariness, is superimposed upon a residue of past behavior. Between the occurrence that is about to vanish and the stance that is beginning to form

there is a minuscule balance, a temporal lever, which Cartier-Bresson has divined and visualized. The bodies go toward each other; the eyes look away and outward . . . at our proxy . . . and now at us. At this point, though I'm not curious about Cartier-Bresson himself, I perceive that he has become part of the action, is even responsible for an element of it— the splayed and deflected bearing of the subjects themselves. Insofar as his presence is the cause of their turned heads and embryonic displeasure, he has created an effect that vibrates and becomes its own content.

I have before me an image of three people whose personal territory has been transgressed at what has been called "the killing range." If it were only a matter of someone's having been startled at the trespass of a photographer, or caught off guard (as in Weegee), there would have been no lasting disturbance or enigma. An unforeseen stimulus merely triggers a predictable reflex. Being able to fish out the unseen cause from the obvious effect, though hardly a precise science, is one of the more mechanistic aspects of photographic experience. Generally, when a photographer intervenes, he or she brandishes the product of the intervention, profiled against the trace of the recessive events that preceded it. The relation between the two kinds of temporal episodes might be likened to that between figure and ground, if I wanted to intuit a spatial coefficient for a social reflex.

But here, body language as opposed to facial expression, neither yielding to the instinct of the other, part ways in a manner so odd and intimidating that a psychological space is opened up in the narrative moment. The "ground" wrestles with but hardly overcomes the figures, which are fierce enough in their own right. "An instant photographed can only acquire meaning," says Berger, "insofar as the viewer can read into it a duration extending beyond itself. When we find a photograph meaningful, we are lending it a past and a future. . . ." Contra Berger, this photograph is meaningful to me *because* of its discontinuity. I cannot disarm it by placing it in any larger flux or social order. With its brutal tension, it entirely possesses the moment at hand and wards off all others. If I want to extend the given duration beyond itself, I flounder in an interpretive void. I am not moved by this scene, not touched by pity or tenderness. It is all surface, yet I have the impression that an interior life has erupted and charged into view. It is what I see and it is shocking.

Sightings of this sort do occur in life, but so fleetingly that they can be pondered only after the fact. The cinema provokes and manipulates us with these spectacles, by constructing and then magnifying them. In film, viewers are lavished with total privilege of this kind, closeted as they are with an artful and heightened mimicry of life called acting. Those who

consent or allow their persons to be the object of still photography are, of course, already acting, but mostly as directed or improvised by and for themselves. Since it's matrixed in self-imagery, such amateur performance still has a historical value relative to the actor, unlike the professional kind which plays a different role.

Besides, as Barthes remarks, film is "deteriorated photography," in the sense that it is animated. ". . . In the Photograph, something *has posed* [he means happened] in front of the tiny hole and has remained there forever . . . but in cinema, something has *passed* in front of this same tiny hole: the pose is swept away and denied by the continuous series of images." Film transmits nuances of expression, even instructs us as to how and why they might occur, but then dissolves them right away by its fluidity. Only the stilted photograph can precipitate and restore one from the infinity of poses that existed.

When Hinckley shot Reagan, TV kept on replaying the video, asking viewers to look for the hand holding the gun, an image totally obscured until it was finally freeze-framed. As relayed in time, the sequence gave a general invaluable idea of the scattering of its main lines through space, that is, their short-term duration. I got the most kinetic sense of what happened with the popping of the pistol, an event from which a score of bodies recoiled at as many angles. Contrarily, the stopped-action image, taken out of time, provided the once invisible cause of the scatter, but at the cost of arbitrarily arresting any physical effect.

This is simply to review the obvious. A photo sometimes yields crucial and precise evidence about how things were once disposed. And it does so as no other medium can. But it reveals nothing distinct about their course of action. A film, on the other hand, can be very articulate on that score, but doesn't *pinpoint* anything.

. . . Like life, one's tempted to say, except that life segments are rarely experienced as broken down and spliced together, as they are in film cutting. When something unexpected happens to us in life we may very well perceive it as abrupt, but we don't understand it as a controlled event or as a fragment inserted among others according to some principle of order. Movies and stills are both photographic media built out of discontinuity exemplified by frames that mark off incident. With film, though, the seemingly endless "frames" are invisible, for though they're the boundaries of each "still" shot, extracting material surely enough, they come at us without pause, or without any more pause than the merest blink. With photographs, on the other hand, the single frame not only makes the pause indefinitely "long," but overtly materializes the edges. Range is sacrificed in favor of concentration.

Establishing a total, one-shot discontinuity, the photograph is contacted

without warning. It may have the most elaborate contextual prelude but in terms of its *moment* there's no way of easing into it. All appearances there are eternally pointed, in the sense that there can be no narrative transitions that slope toward or away from them, no intervals that can cushion or reinforce the attention we give to them. Everything happens irrevocably at once. We either first deal with the Cartier-Bresson in this discommoded way or we may demure and turn aside. No matter when the shot occurs in time, relative to the significance of an episode, the image is literally dissociated from the business at hand. The relation of the image to the subject depends on how the subject is defined, but the photograph has unquestionably cut away from it, not only as a part is taken from the whole, but as an inert presence differs from an active process. There can be no photographic restitution of that process, and therefore no matching of its thrust. In reading a photograph, we realize that everything we see is "between the lines," temporally, and yet capable of being explicit, spatially.

A photograph can be endowed or gifted with visual form, but that of itself does not rescue it from its only inferential status as a document of time. The way appearances can be said to be visually organized in a photograph does not imply a principle of order, but only an opportune fit of changing variables and static frame. It's tempting to talk about arrangements in photographs because they can be analyzed. One speaks of connecting passages or preparatory planes, of subordinate and dominant masses. But that is to miss the point of the problem that really nags and finally excites us in photography . . . the problem of time . . . which levels out all the contents of the image on one historical plane.

I can't distinguish between the instants in a photograph (since there is only one), as I can discriminate between the masses seemingly disposed within that instant. The same applies to expressions and gestures. It's not as if human subjects contribute to the moment in their differing states of awareness, but rather that their being "trapped" in those states defines the moment—such of it as we have. Paradoxically, the explicit space is malleable and divisible—it can be blocked or opened in printing, right out to the resources of the negative. It can also be cropped, which might radically change its character. But I cannot, *a posteriori,* "crop" the time of the shot. From the temporal point of view, everything in the pictures has the same fixed historical stratum, urgent or trivial as that may be. Performing physical surgery on the image does nothing whatsoever to alter the temporal identity of its moment. And that moment, whatever else it is, is abrupt.

If I want to look for meaning in the picture, I have to search for it in that abruptness. The image can only come into existence by a severance (actually an almost simultaneous engagement and exit) from those life

appearances which it otherwise registers more faithfully than any other visual mode. The quality of that severance, affected by a range of obvious discrepancies with the original, is sudden, as I want to stress, but also has a certain icy hardness. Sontag speaks of the effect of the photograph on its subject as a "soft murder." Couldn't it be turned around and expressed as a "hardened vivacity"? Though there is a current of transformation implied in this metaphor, it doesn't suggest any necessary principle of order. The figure of speech alludes only to that cardinal thing that has happened to phenomena. For all of its incipient preciseness, its array of physical detail, the photograph is vague in meaning. "Hardness" may invoke strength, or a concrete state of being, but also bruteness and resistance to accommodation. The picture does so very much on its own but then stops suddenly short of delivering, not its particulars, but their significance. It supplies an enormous amount of what we may need—visual data—but finally denies us what we want—the import of its message.

Now, the fact that the "hard" photograph in itself can't be digested is intolerable. By and large, it needs to be melted and softened by the warmth of spectator usefulness. It has to be given a job, no unemployment allowed, and here even the Cartier-Bresson is seen to labor, if in nothing else than to strengthen the canon of works by a great photographer. What makes it so interesting, though, is that it's a particularly hard case, one of those sullen, bristling, malingering images that refuses to sign up in decorous work. Given these attributes, isn't discussion of it problematical, other than as art; and, anyway, doesn't the category of art beg the whole question of what's psychologically at stake in the photo?

In his *Theory of Film*, Bela Balazs writes: "The fact that the features of the face can be seen in space . . . loses all reference to space when we see, not a figure of flesh and bone, but an expression—when we see emotions, moods, intentions and thoughts, things which . . . are not in space." Balazs insists on the same kind of observation as Pavese who spoke of surfaces being the reflection of other things. Balazs coins the term "micro-physiognomy," meaning the minute, fugitive changes in features that signal emotional states. He was thinking of film, where these flickering configurations can be spooled out almost melodically.

> In one of Eisenstein's films there is a priest, a handsome, fine figure of a man. . . . He is like the sublime image of a saint. But then the camera gives an isolated big close-up of one eye; and a cunningly watchful furtive glance slinks out from under his beautiful silky eyelashes like an ugly caterpillar out of a delicate flower.

Where the cinematographer has all the time necessary to stage such

expressive transitions, the still camera has none, and therefore might give us either the saint or the peasant, but not the critical moment when the one uncoils, becomes, the other.

To get from the first impersonation to the second, the actor does not traverse space, he twitches minimally a few muscles. But even this is too coarse and physical an account of character we're made to sense as a deep current, of which there passes over the face, momentarily, an abbreviated ripple. In any event, a photographer like Cartier-Bresson is not out to type or determine character, but to breach social conduct, and to flush from it microphysiognomies that are a product of his intervention. With his Leica, equipped for only single shot exposures, the chance of missing the mark far outweighs the possibility of hitting it—assuming that the "mark" actually appears.

In the nature of things, performing an act is generally a slower deed than pulling a face. Once limbs have gotten underway, they engage in motions that are coherently sequenced. Our instantaneous expressions have no such visible progression. Without any determined order, they flare up and dissipate in a twinkling—at such speed that nothing but a still camera can be the wiser. I am not talking about the crests in any psychological dynamic, but the multitude of unproductive occasions between them. Having a filmic trajectory in mind, Eisenstein could plot a telltale passage, a showy visual artifice that was supposed to reveal the inner person. The revelations of the psychologically low-budget photograph, on the contrary, are much more ill-determined, vaguely unwanted but instructive, for all that. For they show, over and over again, that there is no visual analogue in time between what we call character or even mood, and outward demeanor. Examined randomly by the camera, it's found that nominal moments of serenity are fairly loaded with grimaces, and that obviously agitated scenes are filled with numbed faces.

We've glimpsed this kind of dissonant spectacle for about a hundred years, but in the main have not known what to do with it. It makes a shambles of the idea that consciousness is *composed* of perceptions assembled in a certain order that is appropriate to their stimulus. Still photographs illuminate the microhistory of sociability, if you will, and disclose that it does not necessarily conform, at any one point, to our memory or our anticipations. For if living expectancy usefully skims the highlights of an exchange and deduces that they were some sort of composite, this synthesis is as much an artifice as Eisenstein's analysis. The still photograph, as often as not, *decomposes* the norms of this artifice, and shows them as behavioralistic guidelines for, not accurate observations of, what has happened. Who is wrong, who is right in this equation? I couldn't possibly guess, nor do I even know if the moral terms are relevant. But I

do imagine that the photographer artist can seize these useless microphy-siognomies and appraise them differently than we're wont to do. Photography offers us insights into a social and psychological reality so much counter to the one we know that it might not even be reasonable to call it social.

Sociability, we might say, rises up temporarily on tap, and lasts only as long as it's called for. I should go further and state that even here the intelligible social signal is surrounded and adulterated by physiognomic chaff. There is a core of volatile consciousness, out of which we reckon with each other or our environment only fitfully. When purposeful in this manner we're no more authentic as individuals than when we're distracted, but the contrast is nevertheless between masked and unmasked states of being. If the photograph tells me that (as my own introspection implies it), I'm also shown that the same thing happens with the individual's perception of time. Even when the moment is socially identified, it is still not clear from people's faces whom or what they think is asserting it. Their desires for the moment, assuming they have any idea about which moment it is, only sporadically correspond with the interval that we, the privileged viewers, see. In photography, the responses of subjects to their scene are always given simultaneously, but are rarely shown in unison. It is an advantage that has to be formulated.

Cartier-Bresson hands me a moment that, for all practical purposes, didn't exist, though he didn't make it up, either. Like thousands of its kind, this scene is an intermission, a sort of time-out from the game of life. As I judge it further, though, it turns for me into something more complex, for the principals seem both on and off-stage simultaneously. They exhibit a priceless fusion of distraction and attention, of vulnerable and armored comportment. I can compare, without being able to measure, the different velocities of their expressions and their action. If they have not yet thoroughly confronted their intruder it's because they're still fud-dled in their self-involvement which has, just the same, begun to decay, like an afterimage. It looks as if what has been privately social will become publicly aggressive, even antisocial (for good reason, considering the cam-era's unwarranted presence.) The condition is literally unsettled and un-settling. At either end of a probable spectrum, I can dimly imagine these people being more focused in their performance. But the photograph for-ever maroons them in a bitchy indeterminacy, more alive than I could ever have anticipated.

Could it be that part of my excitement is generated by my advantage over these subjects, my privilege in catching them out, without suffering any of the risk that Cartier-Bresson might have suffered? Still, the excite-ment is compounded also of provocation because if I know more than they

could have known—their disarray in one revealing microsecond of sight—I know far less—what they were actually doing. My hard ignorance crashes into my soft knowledge to produce that singular combustion which is the effect of this picture. Had I been able to identify their activity, I would not have searched so anxiously into faces whose owners were unconscious of how they looked. The delicacy of the timing only sets the whole thing to snarl.

Cartier-Bresson's most famous theoretical statement was written as the introduction to his book *The Decisive Moment*, twenty years after he took this picture. In it he says "To me, photography is the simultaneous recognition, in a fraction of a second, of the significance of an event as well as of a precise organization of forms which give that event its proper expression."

He was here well past the surrealizing moment of Alicante, Spain, which can never be understood, acute though it is, as a "precise organization of forms." His own, subsequent development now, however, prompts him to speak of the decisive moment as the one in which the release of the shutter "fixed a geometric pattern without which the photograph would have been formless and lifeless." It would appear that a temporal sensitivity acts only to support a spatial finesse. If this were so, however, then the most satisfying "compositions" would have the most intense animism, which is clearly not the case. A sentence later, nonetheless, Cartier-Bresson writes:

> I believe that, through the act of living, the discovery of oneself is made concurrently with the discovery of the world around us, which can mold us, but which can also be affected by us. A balance must be established between these two worlds—the one inside us and the one outside us.

The discovery of which he speaks comes to seem like that in the photograph, an interruption in the act of living, as experienced by the subjects, the photographer, and the viewer.

Cartier-Bresson realized all along that he had been an intruder in that outer world, and he had furnished himself with a "velvet hand," "a hawk's eye." In the fifties, though, his intrusions had to be tactful, for a "false relationship, a wrong word, or attitude, can ruin everything." The relationship he instigated with these Spanish subjects was certainly "wrong," but I for one, would not care to call it "false." In violating decorum, the photographer began to discover what his inner world, and ours, was like. Good composition, like right thinking, like decorum itself, is, perhaps, his mode of retrospective justification. He knew only afterwards what it looked

like and sought for it again on the next prowl. He set store by formal opportunities, which must have quickened him. But the dilemma of the itinerant street photographer is that he cannot make an appointment with "geometry." The self-imagery of the artist as a clandestine observer is more to the point. In Alicante, he had come out of "himself," forsaken his disguise, and aroused hostility. In the heat of the ensuing moment there was reflected some of our own contradictory and teased apprehension of life. It is no more real than it is fictive, no more social than it is savage. One has to think of it, finally, as an enigmatic privilege transmitted by the medium of photography, an experience communicated with the speed of light.

"The Privileged Eye" is the title essay in Max Kozloff's *The Privileged Eye* (Albuquerque: University of New Mexico Press, 1987).

VICTORY GARDENS:
THE PUBLIC LANDSCAPE
OF POSTWAR AMERICA

DEBORAH BRIGHT

WHEN LOOKING BACK AT THE YEARS IMMEDIATELY FOLLOWING the Second World War, there has been a widespread, if mistaken, tendency to think of them as happier and simpler times. For a sizeable segment of the American public, the postwar 1940s and 1950s came to symbolize an imaginary world, free of civil disobedience, racial confrontation, secularism, diverse sexual practices, unwinnable wars, abortion, pornography, homelessness, drugs, radioactive waste, and terrorism. Indeed, a wave of pop-culture nostalgia for the "fabulous fifties," exploited in movies like *American Graffiti* and its television spin-off *Happy Days*, heralded the ascendency of right wing politics in the later 1970s and the ensuing conservative backlash against the social disruptions of the preceding decade.

Another more recent manifestation of the desire to retrieve a vanished Golden Age (of the mind) has been visible in the return to the traditional genre of landscape painting.[1] A new generation of American artists, including April Gornik, Stephen Hannock, David Deutsch, and Gregory Crane, has resuscitated the romantic syntax of the picturesque and the sublime, cultivating exquisite artisanal techniques to evoke the luminosity of the mid-nineteenth-century landscape views of Fitzhugh Lane and Frederic Church. Calculated to appeal to a market hungry for bankable signs of "mastery" and "tradition," these pastoral utopias are familiar, reassuring, and defiantly nostalgic.

But this conservative impulse in contemporary landscape painting reveals much about the current crisis of representations of our environment. Within the popular consciousness today, the "natural landscape" of the U.S. is not so much viewed as the providential symbol of the nation's

Manifest Destiny, as the embattled site of conflicting political interests. Decades of corporate indifference and governmental mismanagement have left irreparable scars on the countryside. Chemical and radioactive materials leak into soils surrounding dumpsites contaminating water supplies. Raw sewage spews into Boston Harbor. Yosemite is choked with car-campers, and Yellowstone amply demonstrated its limitations as a "managed" environment during the 1988 summer burns. Television news shows Yellowstone's "protected" bison abandoning the scorched park in search of forage and being shot at point-blank range by Montana hunters under the supervision of park rangers in a grotesque reenactment of the ritual of frontier manhood. Instead of the sublime presence of the natural environment, today's middle-class tourist-consumers are met with the greenhouse effect, trees killed by acid rain, cancer from the sun, poisoned salmon, polluted beaches, and sludge-drowned sea otters.

Such contemporary factors throw into sharp relief the historical contingencies of a dominant culture's attitudes toward its "native landscape" and how profoundly these can change in a short period of time—as little as two decades. If by *landscape*, we mean the historical representation of human organizations of space, then it follows that we can read landscape "documents" in cross-section from a particular cultural period. These documents, including the texts that surround them, reveal the larger structures of feeling dominant at the time. While the obvious contrasts between mid-nineteenth-century views of the exploitable/civilizable landscape (the railroad builders) and the twentieth century's legacy of progressive conservationism (the backpackers) have been much discussed, little has been said about the commerce of landscape tourism itself. Nor has this activity, whether as elite, middle-, or lower-class, been discussed within the context of a specific historical politics. What this article proposes to investigate is why the desire to mass-consume the spectacle of our national landscape was stimulated on such a large public scale in the years following World War II, and what economic and socializing ends such consumption accomplished.

From our current vantage point, it is particularly disorienting to reread the image of the American landscape as it was packaged for tourist consumption thirty or forty years ago.[2] This was the world of my white middle-class childhood, the world I saw from the rear seat of my father's Chevy sedans (ritually purchased every three years) during the 1950s (Fig. 1). My brother and I were hauled off at annual intervals for automobile trips to the Appalachians, the Delaware seacoast, the Shenandoah, the Grand Tetons, Yellowstone, the Grand Canyon, pre-dam Glen Canyon, Bryce and Zion national parks, and the Great Smoky Mountains. These were enchanted lands with convenience-equipped log cabins and dude ranches, trail rides and raft trips, all catering to family "togetherness."[3]

Figure 1. The author and her brother getting ready for the family vacation, c. 1955. Photo A. S. Bright.

What we didn't know at the time was that the vernacular landscape we were seeing was disappearing, along with the grassroots sensibility of its architecture, roadside stands, town retail strips, and locally operated tourist amenities—the American landscape, in short, celebrated in black and white by Walker Evans in his photographs from the 1930s as well as by Roy Stryker's Standard Oil photographers during the following decade (Fig. 2). This regional (kitschy) character of the landscape was to become an object of nostalgia by the 1960s, memorialized monumentally in the canvases of pop artists Richard Estes, Don Eddy, and Ralph Goings, and more modestly by art photographers Lee Friedlander, Hank Wessel, Steve Fitch, William Christenberry, and Stephen Shore. In his film *The Last Picture Show* (1974), Peter Bogdanovich used Evansian monochrome to reconstruct his imaginary rural Texas town of the immediate postwar era.

But in fact, that period is not best remembered in stark black and white. The "natural landscape" and the family fun for which it provided the setting

Figure 2. The disappearing roadside attraction. John Vachon, "Hub Cap Display on U.S. Highway 1, near Jersey City, NJ; July, 1947."

is more often recalled in "living color"—both the peculiar hues of chromo-lithographic reproduction just gaining its first widespread use, the brilliant chromes of postcards which replaced hand-colored scenes after the war, and the more convincing hues of Kodachrome slides, widely favored by family snapshooters over the still-standard black-and-white prints. The immensely popular Viewmaster, with its wheels of miniature color transparencies, reduplicated the pleasures of the stereograph enjoyed by an earlier generation.[4] But it was more than the spectacle of regionalism that accounted for the fascination and aura of these landscapes in the 1950s. It was the palpable sense of patriotism and pride they evoked, as though appreciating the scene was itself an homage, a ritualized expression of what it meant to be American in a dark, godless, and threatening world.

This struck me forcefully when I picked up a popular 1952 tour guide to the western states in a used book store several years ago. The title of

the booklet itself seemed dissonant and strange: *The Glory of Our West. Our West.* That possessive pronoun hinted at assumptions that no longer seemed tenable. This West (a geographic region of the continental United States) apparently belonged to "us." That it was indeed glorious was amply demonstrated by the Ansel Adams color photograph of Yosemite on the cover. But in 1952, consumers of this book and its images also understood that the United States was the undisputed leader of "the West," a geopolitical label synonymous with the "Free World" and abstract ideals like "free enterprise," "democracy," "individualism," and "godliness." (Its antithetical values, "collectivism," "totalitarianism," and "atheism," were necessarily ascribed to our arch-rival, the Soviet Union.)

It seems clear in retrospect that this Cold War appropriation of "the West" was completely conflated with an older, more localized, understanding of the term. The West of the nineteenth-century American frontier had always provided the wellspring for myths about the historical uniqueness of the American character: *our* rugged individualism, self-reliance, god-fearing values, and spirit of free enterprise. Ronald Reagan was only the most recent play-actor on the national stage to resuscitate the frontier myth with his white hat, shoot-em-up bravado, and Santa Barbara ranch.[5]

The American landscape in the immediate postwar period was to become a salient metaphor for the American mission of global Manifest Destiny.[6] It would bear witness to our fitness as a nation to lead the world and show the tired, humbled, war-torn states of Europe irrefutable evidence of our superior "native gifts." Landscape books, travel guides, and periodicals produced during the late 1940s and early 1950s became didactic primers for teaching American citizens (as well as foreigners) about their country, their culture and its history. Although marketed by independent publishers and business interests across a range of middle-class markets, there is an unmistakable ideological unity among them.

For one thing, the audience for these publications in 1946–56 is assumed to share an entirely unified and conflict-free perception of the American character and American history. This perception was distilled from a boilerplate array of conservative social Darwinist folk myths (frequently reproduced in school history books) about the cultural evolution of "our nation." In the words of one critic of mid-century historiography: "It was as if all American history had been chewed, swallowed, digested, and then spewed forth as giant tasteless Wonder bread. . . ."[7] In this consensus history-writing of the 1950s, the "heroes" of American history are transmuted into organization men, good guys preserving an already self-evident (conservative) *American way of life:* a life based on upward mobility and consumption. The national allegory usually begins with the humble pilgrim origins in New England and Virginia (respecting North/South competition

for honors as the New World's "cradle of civilization"). After the Pilgrim Period comes the Pioneer Era when a civilization of "free men" moves bravely westward, unshackled from ties to a decadent, reactionary Europe of popes, princes and peasants. A quote from *Holiday* magazine's picture book, *The USA in Color*, (1956) gives the flavor of this Wonder bread world:

> Travel is an old American custom and a good one. Those rugged and admirable souls, our forefathers, traveled to get here, and had barely arrived when they started to push down, up and across until the entire continent was opened and looked upon.[8]

Or, to quote from the introduction to another contemporary picture-book, *Look at America: The Country You Know and Don't Know* (1947):

> Into the untouched continent went the settlers, wrestling it from the Indians, felling trees, breaking the land to plough. . . . They telescoped the work of a millennium into three centuries; the speed of the achievement was breathtaking. . . . As the frontier advanced, the frontier attitude—bold, openhanded, friendly, on the whole optimistic, democratic, hospitable, courteous—became ingrained in our national temperament.[9]

Having purified itself through a bloody Civil War and the taming of its "Wild West," the nation now shows itself ready for world leadership, testing its mettle in two world wars in which we "saved" the Allied cause and preserved (our quaint, ancestral) Europe. All that appeared to stand in the way of a blissful global paradise of unending peace and prosperity (led, of course, by the U.S.) was the conspiracy of world communism which we had to oppose to the death, even as we had vanquished the fascism of Nazi Germany and Japan.

In a special postwar edition of *Fair Is Our Land* (first published in 1942), a picture book portraying "the beauty of the American countryside," Donald Moffat muses in the introduction on the relationship among the rural landscape, the nation's (mythical) history, and the recent war:

> Standing thus at the very edge of America, sweat on my back and the sun pouring down, behind me the white clapboard farmhouse, the woodpile, the apple trees and lilacs . . . my eyes went on and on; I saw the country whole, and suddenly I knew that the war had not been fought in vain. There it lay under my mind's eye, our ancient heritage; and I prayed that we might have the wisdom, faith, and courage to be worthy of it in peace as we had been in war.
>
> We are Americans. Yet, standing in the sun that day, it came to me that we had won the war not because we are Americans, but because

Figure 3. Page-spread from *Fair Is Our Land* (People's Book Club, 1942).

we are free men. . . . Our land was conceived in freedom. Our
settlements were struck from the wilderness by men and women who
by sheer instinct set themselves to searching out new places in the land
where they could live in freedom. . . .[10]

Suitably, a large percentage of over 300 photographs and prints in *Fair Is
Our Land* are those of the middle landscape. With the exception of the
section on "Mountain Ranges and the Nation's Parks," pastoral scenes of
family farms and small towns predominate over "wild nature."[11] Reflecting
wartime contingencies, the photographs are printed in black and white on
flimsy paper stock. Generically titled "The Old Farm," "Early Planting,"
"Silver Frost in the Adirondacks," a number of the views reflect the lin-
gering influence of turn-of-the-century pictorialism in their hazy chiaros-
curo and traditional genre subjects (Fig. 3).

Almost one-third of the photographic reproductions came from the files
of the Farm Security Administration's Historical Section, which had been

subsumed by the Office of War Information in 1942, the year the book was first published. After war broke out in Europe, the FSA had abruptly changed from documenting the New Deal domestic resettlement programs to making government propaganda pictures that proclaimed the abundance and privilege of American life. Pictures of town meetings, bounteous harvests, happy families, and productive workers populated the files from these years and found their way into many books and publications both during and after the war.

This is "*not* a state-by-state encyclopedia of scenic wonder," announces the dust jacket of *Fair Is Our Land*, "but the picture of a peaceful America—staunch, serene and comforting." The aim here is to reinforce a pre-existing agrarian ideal of an innocent, republican life, unsullied by contact with other cultures and nurturing a unique and homogeneous race.

> Americans have looked into the four corners of the world. For the first time most of us have left the fireside, learned from the evidence of our very eyes how other people live, seen the beauty and variety of the lands they dwell in; and know now by firsthand experience that to no other people in the world has nature been more generous in her gifts. . . . At no time have so many of us been given the opportunity to see and compare. Nine young Americans out of ten have been sent, if not abroad, at least to hitherto unfamiliar parts of his [sic] own country, and learned, incidentally, that the people who live in them . . . look a whole lot like the folks back home.[12]

The uprooting effect of the world war on a whole generation of young men and women is well documented. However, the mobility of American youth that Moffat refers to *within* the borders of the United States was the result of the Great Depression and its dislocations (precisely from rural farms to urban/industrial centers). New Deal employment programs played a major role in the new mobility as well. The popular Civilian Conservation Corps (1933–42), dispersed 2.5 *million* unemployed, single young men throughout the country to work on government-sponsored construction and reforesting projects.[13]

Far from producing reassuring illusions of a familiar, coherent landscape, historians of the depression have remarked that the 1930s were more often marked by the sharp, sometimes violent, clashes of domestic cultures brought about by these migrations. Racial and class tensions were inflamed by economic competition for a dwindling supply of jobs. Even the CCC boys, many of whom were poor eastern city kids, did not always find the welcome warm in their new rural locales. Often they were regarded by locals as invaders and "noxious harbingers of civilization."[14] The myth of the homogeneity of American culture was belied by the persistent conflicts of resettlement and racial violence, particularly lynchings of black men in the

South. Ironically, it was this same decade that worked the hardest to construct an ideology of a singular, "native" Anglo-American character, "the common man." A correspondingly simplistic iconography was disseminated in the products of the New Deal itself—particularly in the public artworks produced for the Works Progress Administration.

After the domestic turmoil of the depression, World War II and the ensuing Cold War provided external monsters on which Americans of all classes could project their fears and contradictions. Landscape, as always, was useful for creating public consensus around abstract values, for promoting patriotic pride and instilling a necessary vigilance. If the House Committee on Un-American Activities enforced (through innuendo, imprisonment, and blacklisting) an outward conformity and the containment of "dangerous ideologies," landscape photography (and tourism), along with advertising, Hollywood, and broadcast television brought the American public the commodified gospel of a permissible (consumable) spiritual heritage:

> We are seeing again the matchless beauty of our own beloved country
> in the clear new radiance that courage and sacrifice have lighted in our
> hearts. Let us in all humility learn to be worthy of this shining land of
> ours.[15]

At the close of the nineteenth century, Frederick Jackson Turner proposed that the western states had always held a privileged place in American consciousness.[16] Turner's influential thesis concerning the frontier's influence on the national character assumed, among other things, that "character" was white, male, and acquisitive, in other words, proto-capitalist. In contrast, what marks postwar versions of our "national character" is their distinctly *corporate* flavor. In *Fair Is Our Land*, the introduction to the chapter, "The Great West," characterizes "the westerner" as a builder of roads, dammer of rivers, and irrigator of deserts:

> The Westerner has a right to his self-confidence. He has spanned the
> wilderness with rail and highway, tunneled the mountain barriers,
> curbed the torrent, made the desert fertile. Daily he meets the challenge
> of hostile nature, and daily he gets the best of her.[17]

In other words, "the Westerner" is none other than Jay Gould, Leland Stanford, Mulholland, Sutro, and others who profited greatly from the land speculation that their capital investment in its development made possible. The corporatization of the American character is reflected in similar terms in *Look at America: The Country You Know and Don't Know*, the immensely popular master volume to a comprehensive series of regional travel guides published by the editors of *Look* magazine in the late 1940s.

Figure 4. A typical page-spread from America's travel books in the 1950s: oil, cowboys, and Indians. From *The USA in Color*, published by *Holiday* magazine (1956).

> It took initiative and self-reliance to push the frontier west, north and south, to thrust long ribbons across the plains, over mountains and through deserts, to reach the Pacific coast. . . .
>
> Enterprise and temerity were needed to uncover and exploit the resources of the land—the plains that nourished great herds, the prairies that made possible huge farms, the seemingly limitless forests, the coal, the iron ore, the copper, the oil. Imagination and resourcefulness were needed for inventions to make possible the development of industries, to make America the nation where the machine age finds its fullest expression. Faith and enthusiasm were needed to work out a concept of democracy in which every man should have the opportunity to better himself.[18]

Across the page from the foregoing quotation is a full-page color photograph of the Grand Canyon, shown as "pure wilderness," without a sign of human presence. However, such pictures were outnumbered in *Look at America* by images of American industry and agriculture by a ratio of approximately five to one (Fig. 4).

Like its competitors *Life* and *Fortune*, *Look* served as an uncritical prop-

aganda organ for American business and global free enterprise. The war had dramatically changed the face of corporate America. When mobilization began in 1940, the 100 largest corporations were responsible for about 30 percent of the country's manufactured products. By 1943, the figure had jumped to a whopping 70 percent, including 80 percent of all government contracts.[19] By 1955, the U.S., with 6 percent of the world's population, was producing almost half the world's goods. At the same time, small businesses were being gobbled up by large companies in unprecedented numbers or forced out altogether. Industrial oligopolies colluded in the regulation of prices and markets so that by the late 1950s, 5 percent of U.S. corporations garnered 87.7 percent of all corporate net income. In a reversal of the New Deal, Roosevelt filled his wartime cabinet with corporate officers rather than intellectuals and politicians—a trend that continued under his successors after the war ended.[20]

The much ballyhooed homogeneity of the American character was, in fact, the shared parochial ethos of elite white male industrialists who had scaled new heights of national political influence and who set about consolidating their power through the use of skillful public relations.[21] They viewed the nation as *their* trust and the means to its (their) continued prosperity as new markets opened for American goods and capital investment (and political influence). Only socialism and communism threatened this corporate dream of global marketing. But the communist menace also gave business the broad public consent its managers sought for a profitable peacetime military buildup and the silencing of those who questioned their objectives.

The oil industry and its affiliates, in particular, used representations of the American landscape to enhance their patriotic public image and to create an illusion of beneficent stewardship in the late 1940s and early 1950s. The industry faced public relations problems in the immediate postwar period. Standard Oil of New Jersey (now Exxon) had been accused of collaborating with the German chemical company, I.G. Farben, in withholding domestic synthetic rubber production during the early years of the war.[22] This had brought calls for a congressional investigation, with Standard Oil's actions being labeled as "treasonous" by many, including Harry Truman. As Nicholas Lemann and others have noted, Standard Oil's hiring of former FSA director Roy Stryker in 1943 to build a corporate picture file on the importance of oil in American life was part of a large-scale public relations effort to rebuild confidence in the company.[23] The photographs by FSA alumni such as Edwin Rosskam, Russell Lee, John Vachon, and John Collier were reproduced in stockholders' annual reports and Standard Oil's glossy house publication, *The Lamp*. "With the documentary photographs emphasizing what the company's Washington lobbyist termed 'the humanizing angle,' it was hoped that the public's perception

of Standard Oil would change from that of a secretive, predatory 'octopus of oil' to that of an open, likable 'good citizen.'"[24]

Stryker's file concentrated on the kinds of social subjects that had preoccupied him at the FSA, and which had been effective in garnering public consent for the New Deal's social policies. These included images of communal and private life, work and leisure, housing and transportation, billboards and roadside attractions, as well as the requisite publicity shots of corporate personnel and roughnecks working on the rigs. But the oil companies also saw the value of the iconography of American landscape, particularly that of the West, for reassuring the American public of their national loyalty and identifying themselves as defenders of freedom.

During the immediate postwar years, the Standard Oil Company of California (now Chevron) issued a series of color picture-folders of the West for motorists. These were distributed free of charge at the company's gas stations. Each folder contained a color photograph of a "scenic wonder" and was accompanied by a short commissioned essay by writers of note, including popular writers like Ernie Pyle, J. B. Priestly, and Erle Stanley Gardner. The photographers, too, represented a range from self-conscious fine artists like Ansel Adams to popular free-lance professionals like Joseph Muench and Ray Atkeson whose western landscape work was widely published during the decade, if not as celebrated as Adams's. These folders proved immensely popular, far surpassing the promoters' expectations. As Joseph Henry Jackson reported in his introduction to *The Glory of Our West*:

> . . . in 1947, just to quote a single year, 33 *million* picture-folders were distributed. Teachers based school projects on the pictures and the text that went with them, and throughout the country a brisk trading-market sprang up because of the eagerness with which the public tried to acquire complete sets. . . . Several people established small businesses which they operated solely for the purpose of trading the color prints.[25]

In 1952, Doubleday published a spiral-bound selection of fifty "of the very best and most representative scenes" from the Standard Oil of California series under the title *The Glory of Our West* and sold it for a modest $2.95. While one would be hard-pressed to see *The Glory of Our West* as shrill conservative propaganda for big business and the Cold War, a little history-conscious reading between the lines shows how the postwar interests of ruling business and political elites were more subtly served.

The Glory of Our West opens with a George E. Stone photograph of Point Lobos, California—a good specimen of the baroque scenic sublime, with brooding thunderheads and surf crashing on craggy, cypress-crowned headlands (Fig. 5). The four-paragraph text by Robinson Jeffers extolls the

Figure 5. "Point Lobos, California," from *The Glory of Our West* (Doubleday, 1952).

scene's ancient grandeur, then proceeds to an anecdote from "Mexican times" about a certain Marcellino Escobar who once owned a great ranch that included Point Lobos. Escobar, we are told, gambled his land away to ten soldiers at the Monterey Presidio one night in 1841. One of the soldiers, "a Captain Jose Castro, bought up or wangled the shares of the others . . . and became the second owner of the place. Land was not so valuable in those days," Jeffers continues:

> . . . [S]ince that time Point Lobos has passed through many vicissitudes. It has been used as a whaling station . . . it has been used as a rock-quarry . . . it has been used as a port . . . it is now a state park. And none of these vicissitudes ever seriously marked it, nor damaged the fantastic beauty of the place.[26]

So, what do we learn from Jeffers's brief text? That Mexicans are foolish gamblers who don't appreciate the value of property (and therefore don't deserve it) and that they are sneaky "wanglers." We are also assured that "the land" will always survive economic and historical "vicissitudes," as Jeffers euphemistically puts it, including such invasive enterprises as quarrying and commercial development. What the term *vicissitudes* also encompasses, but which Jeffers has no intention of discussing, was the brutal displacement of Mexican land-holders (including Captain Castro) from California in the late 1840s by Anglo cattlemen who appropriated their ranches. Now the land is productive, "preserved by some miracle" as a symbolic commodity to be consumed (appreciatively) by the American tourist.

Racial minorities, particularly Chicanos and Native Americans ("Mexicans" and "Indians"), play an important role in these travel narratives of the West. They are used for "local color" to lend narrative exoticism and tension; or they are used as avatars of a primitive Nature, to show readers how far "civilization" has come. In the text titled "Remember the Alamo," a predictable bit of Wonder bread history, soldiers of Santa Ana are referred to as "the Mexican hordes." In his disquisition on Mesa Verde National Park, accompanying a classically composed Ansel Adams photograph of the cliff ruins, Thomas Hornsby Ferril Anglicizes the cliff-dweller culture, describing them as "thrifty," leading a "town-meeting sort of life as practical in its way as any that was to arise in New England," and who "worshipped God in their own way."

> These people were serious, devoutly religious. . . . They switched chores around; the men would weave, the women would plaster. They even seem to have simplified mother-in-law problems at the source by letting the old ladies own most of the property.[27]

The sexism and utter contempt for diverse cultural histories is not only palpable, but is so commonplace in *The Glory of Our West* and other texts of the period as to be numbing. More typically, Native Americans were characterized as ignorant dreamers, superstitious, and full of tall tales. They avoided Yellowstone as "a place of mystery and superstitious terror."[28] "Every few years Indians would hear sounds in the church at night, ghostly footsteps in the pueblo. . . . "[29] "The Indians shunned [Bryce Canyon] as the abode of strange spirits. . . . One may share their superstitious fear by walking in the midst of the 'man-shapes' in moonlight."[30]

Following Point Lobos, the second "scenic wonder" presented in *The Glory of Our West* is the San Francisco–Oakland Bay Bridge, photographed at sunset by Mike Roberts. While the presentation of human engineering and architectural feats alongside images of "wild nature" seems curious, it is typical of most of these picture books from the period. *The Glory of Our West* features the Mormon Temple at Salt Lake, gold-rush Columbia, California, Mount Rushmore, the Grand Coulee Dam, and the Alamo among its more typical scenic views of mountains and canyons. Nard Jones's text on Grand Coulee trumpets the merits of this structure in prose befitting the most awesome of natural wonders:

> The Grand Coulee Dam is the biggest thing ever built by man. Its bulk
> is four times that of the Great Pyramid. Into it was poured enough
> concrete to build a standard highway from Seattle to New York and
> back to Puget Sound again by way of Los Angeles! . . . What was done
> by the engineers staggers the imagination. . . .

And the beneficent and patriotic hand of corporate enterprise is made manifest in history.

> [The Grand Coulee Dam] is one of the basic elements that won the war:
> it powered the building of ships and planes, and the making of the
> plutonium that went out from Hanford, Washington, to blinding
> destiny at Nagasaki and Hiroshima. And it is one of the things that will
> make the nation great in peace, for Grand Coulee power is being used
> in the new towns, the new farms, and for new industries in the Pacific
> Northwest.[31]

The romanticization of atomic power was a commonplace in the late 1940s and early 1950s, particularly when the U.S. was the only nation using nuclear technology—another tangible sign of our Manifest Destiny. Although scientists and technicians in the service of the military had produced the ultimate tool of death and destruction, the public was shown

Figure 6. Moonrise over Phelps-Dodge. "The Smelter at Douglas," Joseph Muench, "Take Your Camera to Cochise County," *Arizona Highways*, April 1958.

repeatedly that Science (epitomized by those objective, omniscient, and beneficent white Mr. Wizards in shining white lab coats) could do anything—remake nature and, if necessary, replace it.[32] Nature became completely functional—to be exploited for raw materials or profitably packaged for tourist consumption (Fig. 6).

Wonder bread history, technological achievements, and "nature" are interwoven seamlessly in *The Glory of Our West*, suffused with patriotic value in equal measure. There is little hint here of the environmental controversies to come. Mount Rushmore is a "miracle of patriotism" as well as "a mechanical miracle." It is:

a shrine of Americanism. The heads are not the heads of gods or kings or mighty conquerors, but of four plain men, four Americans who rose by their own efforts to high places and fought good fights that won

them immortality as benefactors of humanity. . . . Thousands of visitors throng to the memorial and depart better and prouder Americans than before they came.[33]

The "Redwood Empire," illustrated by an Ansel Adams photograph, is presented as a perfect (and effortless) resolution of corporate needs and nature conservation:

> Timber owners and operators have cooperated with public agencies to good purpose, and some 50,000 acres of fine old trees now stand in state parks . . . immune to almost everything but Time, which the Sequoia measures by the century and the millennium.[34]

The real (and subsequently well-documented) story has been one of unending pressures by timber companies to harvest the protected trees, requiring the constant vigilance of conservationists.

Indeed, the federal government, theoretically the arbiter of "the public good," routinely sided with business and development in decisions concerning land management in the late 1940s and early 1950s. With a rapidly growing population whose housing needs and status-consumption demand seemed limitless, local and national conservation groups were hard-pressed in their claims for wilderness preservation and realized they had to consolidate and clearly define their political goals. By the mid-1950s, the battle lines were drawn over the Echo Park Dam, part of the ten-dam, billion-dollar Colorado River Storage Project that threatened Dinosaur National Monument in Utah. Echo Park became the political proving ground for the Sierra Club, the Wilderness Society, and allied conservation groups, battling against powerful business interests for the hearts and minds of the American public. Senator Arthur V. Watkins of Utah best summarized the dominant mood of the time:

> I am as much interested in beauty, in rugged scenery and preservation of nature's greatest wonders [as anyone] . . . but I want to point out . . . that to my mind, beautiful farms, homes, industries and a high standard of living are equally desirable and inspiring.[35]

The preservationists set the limited goal of having Echo Park Dam scratched from the project, and published "hard-hitting, illustrated pamphlets, prepared for mass distribution, [asking] the public: 'Will you DAM the Scenic Wild Canyons of Our National Park System?'"[36] A professionally made color motion picture was circulated throughout the country and the controversy was extensively covered in *Life*, *Collier's*, *Newsweek*, and the *Reader's Digest*.

While the preservationists appealed to the old progressive nostrums about the necessity of wilderness as a refuge from the strains of modern life and as a locus of spiritual values, it was the newer, more functional "ecology theory" of naturalist Aldo Leopold that appealed to an educated, middle-class, technocratic public.[37] Leopold stressed the necessity of wild country for the study of "the balances of Nature, the web of life, the interrelationships of species, massive problems of ecology" which would be observed nowhere else. Wilderness advocates fought the developers and engineers on their own turf with mathematical formulas and statistics of their own showing the limited profitability of the Echo Park venture. Even the Cold War played a role as preservationists argued for wilderness as a necessary symbol of freedom in contradistinction to the kind of to-talitarian society described in George Orwell's *1984* (1949) where the state leaders abolished wilderness because it supported independent action.[38]

The Echo Park dispute raged in Congress with both houses split on the issue despite strong support for the dam from the Interior Department. Finally public opinion tipped the balance against Echo Park, with one western senator lamenting that pro-dam forces had been out-funded and out-organized by the preservationists. On April 11, 1956, a bill was passed forbidding the construction of any dam or reservoir within any national park or monument, the first of many victories for the Sierra Club and conservationist groups in the following two decades.

In the travel picture books of the late 1940s and early 1950s, however, one can clearly see that "common sense" favored development and one would have found inconceivable those later policies that sought to limit public and corporate access. Indeed, access was precisely the goal of the tourist industry and the purveyors of goods and services that supported it, particularly the all-powerful automobile industry and its allied interests: oil, steel, rubber, and highway construction. The depression and four years of wartime gasoline and rubber rationing had created a massive pent-up demand for new automobiles and touring services—a demand that these travel guides and landscape books exploited.

The 41,000-mile interstate highway system, initially proposed in 1944 as a wartime defense network, was funded by the federal government in 1956 after heavy pressure from the auto-dominated oligopoly. The system was 90 percent funded by U.S. taxpayers (a corporate windfall in juicy guaranteed contracts which may help explain the current "infrastructure crisis") and over 70 percent of it was constructed on new rights-of-way, a gigantic appropriation of rural land.[39]

At the same time that the auto and oil industry lobbyists were pressuring Congress on the Highway Act, these interests were systematically acquiring control of efficient inter-and intraurban light rail and trolley systems and

systematically dismantling them. "By 1955, General Motors had been involved in the replacement of more than 100 electric transit systems with its own buses in 45 cities, including New York, Philadelphia, Baltimore, St. Louis, Oakland, Salt Lake City, and Los Angeles."[40] It should be noted that Standard Oil of California collaborated with GM in the liquidation of Los Angeles's Pacific Electric Railway, the largest interurban railway in the country.

Standard Oil's *The Glory of Our West* is a picture book designed to stimulate automobile travel, gas consumption, and lodging in modern, corporate-run motel chains. New categories of leisure activities were brought into being, and their status-value was stimulated through advertising and glamorous media coverage. Chief among these was skiing. "In 1910," Ernest Haycox recounts, "it was a three-day adventure from valley to snow field, and then only in summer months. . . ."

> Today by auto it is not more than an hour's ride from the major centers
> of the Northwest into these snow fields; thus the whole pattern of
> American wintertime life has been changed in a single generation by
> the extension of roads.[41]

Ray Atkeson's photograph shows a lone skier pausing to wax his skis in the drifted powder landscape of Mount Baker. Photographs of skiers also appear in *Look at America, The U.S.A. in Color,* and the *Saturday Evening Post*'s picture book, *The Face of America* (1955) (Fig. 7). The explosive growth of the ski industry in ensuing years was to amaze even the most optimistic resort promoters.

One of the most influential landscape-consumption publications during the postwar decade (and beyond) was a monthly magazine published by the Arizona Highway Department, *Arizona Highways,* edited at the time by Raymond Carlson. The magazine's target audience was the burgeoning cohort of mobile middle-class families whose tourism accounted for a significant portion of the state's economy. For a reasonable $3.00 per year, subscribers received each month a lushly illustrated picture magazine of Arizona landscapes, people, and travel features, punctuated by short anecdotal and historical essays. The magazine took no advertising. Instead, it used its pages for full-color bleeds, spreads, and even occasional fold-outs of brilliantly hued Southwestern landscapes, reproduced with the latest color lithographic technology, suitable for framing (Fig. 8).

Arizona Highways was an immense success; one million copies of its popular annual Christmas issue were printed in 1956. In addition, the magazine marketed 35mm color slides of its photographs so that consumers could collect their own set of landscape spectacles to show in their homes.

Californians claim that nowhere else on the globe is outdoor living and playing more fun than in the Golden State. They base this claim on the fact that no spot in California is more than 225 airline miles from the ocean, that the sun *does* shine 355 days of the year and that temperatures — even during the winter — seldom fall below 46 degrees.
356

Californians also boast that, in their land of sunshine, winter sports are as close as the nearest mountain. Above, skiers gather on a slope of Snow Valley, near Big Bear City.
357

Figure 7. From *Look At America*, published by the editors of *Look* (1947).

For each color photograph, technical data were provided for the benefit of reader-tourists seeking to emulate with their Brownies and Exactas the results of the professional photographer (who customarily used a view camera or 4×5 Speed Graphic).

The July 1955 issue is typical of the range of subjects and imagery a reader would find in *Arizona Highways*. On the cover is a genre photograph by Chuck Abbott of a little Navajo girl, dressed in colorful costume and cradling a small goat (Fig. 9). The picture is titled "Friendship—Navajo Style": "This young lady agreed to pose prettily for the photographer, but she insisted that her friend be with her. They make a pretty picture, indeed."

One is reminded of the century-long history of imperialist photography where Anglo gentlemen-tourists set up their cameras in "exotic lands," posed and paid their quarry, then sold their confections to a home audience

Figure 8. Most people bought *Arizona Highways* for its landscape spectaculars in color. This spread from the December 1956 issue is a good example. Photo by Ray Manley.

whose racial and ethnic biases were reinforced by such "objective" and external evidence of the subject's otherness. Indeed, Raymond Carlson's introduction for this issue featuring Arizona Indians is titled, "The Strange Land." Both physically and metaphorically, everything makes reference to the highway as the signifier of modernity and civilization:

> To the north and east, beyond the smooth, fast highway, is the strange land of the Navajo and Hopi. In the south, not far from the smooth, fast highway, in the desert country along the Gila, is the equally strange land of the Pima. The miles are not many which separate these strange lands; yet the people living therein might be worlds apart, so much do they differ from each other.[42]

And from us, he might have added. In almost every issue, *Arizona Highways*

Figure 9. Native American genre, *Arizona Highways* style. Covers, July 1955, August 1957.

consistently juxtaposed the wild, untamed exoticism of the state's land-scape and Indian inhabitants with the modernity of its Anglo culture. This continually reminded the potential tourist that Arizona was not the cultural backwater many imagined it to be, lacking in community service institutions or the latest technological developments.

As if to underscore the point, the opening article of this particular issue features the Phoenix Junior Chamber of Commerce, "Model for a Community Club." In 1953, the Phoenix Jaycees were "officially proclaimed to be the top chapter of all the 2,250 chapters in the nation. . . . Its Jaycees are an example for every community in the country of how a group of young men can be truly useful to their town, given a sufficient quantity of energy, imagination and altruism." In a decade obsessed with "perverts," "juvenile delinquency," and the new scourge of rock and roll, these must have been comforting words indeed. The Jaycees are followed by C. W. McCullough's "Modiste to Miss Navajo," a condescending, Anglocentric

story on the historical origins of Navajo reservation women's "gaudy out-fits": "No one could produce the volume of *Vogue* a la Navajo that first turned desert seamstresses to flowing skirts and velveteen jackets."[43] Re-marking that the Navajo "has never been an originator" but an adapter, McCullough concludes it was "our own feminine forebears" who were "stylists to the Navajos":

> Stalking the Navajo Indian Reservation in 1954 are the colorful ghosts of
> New York's Fifth Avenue Easter parades of the post-Civil War
> years. . . . [Before contact with white women's dress] the almost
> universal costume was a number called the squaw dress, consisting of a
> large blanket with a hole in the center. . . . who is to say that the
> feminine Navajos were not ripe for a change?[44]

As with the perennially popular *National Geographic*, the portrayal of women *across cultures* was sexist and demeaning. What women primarily concerned themselves with was their femininity, physical attractiveness, and displaying their coquettish charms to the best advantage (Fig. 10).[45] To close the circle, McCullough ends with a page-spread of fashion designs for Anglo women, adapted from Navajo dress by Arizona designers: "On these two pages are shown some of the delightful ways Miss Navajo's dress has been used to please the exacting tastes of the modern American miss, best-dressed girl in the world."[46]

McCullough's article is followed by Joseph Stocker's "Indian Country." Stocker continues the appeal of *Arizona Highways* to white middle-class consumer values as the standard by which all cultures are measured:

> Until recent times it was only the hardier, explorer type of tourist who
> ventured into the Indian country. Roads ranged from just barely
> tolerable to downright horrible. Tiled filling-station rest rooms, with
> foot-button valves and electric air-purifiers, were non-existent.

But now, of course, the roads and roadside amenities are improved, thanks to the state of Arizona: "Today you can bundle your family into the car and, in reasonable comfort and complete safety, see America's last strong-hold of primitivism."[47]

Bert Robinson's article on the Pima Indians, the third in the "Strange Land" series, is less condescending than the others, perhaps because Robinson worked for the U.S. Indian Service on the Pima reservation in the 1920s. He paid a sentimental journey to the reservation thirty years later and found it:

> greatly changed. I approached the village of Komatke over a modern

Figure 10. Illustration from C. W. McCullough, "Modiste to Miss Navajo," *Arizona Highways*, July 1955. Photo by Ray Manley.

> paved road. We found . . . a thriving farming community. The fields
> were lush and green with growing crops. The canals were filled with
> water brought down from the Coolidge Dam. This part of the
> reservation is under the San Carlos Irrigation Project.[48]

What Robinson fails to mention is that the very year he visited the reservation (1954), the Pimas had their irrigation rights revoked because they refused to go along with the federal government's termination program. This program, devised by the Bureau of Indian Affairs, dissolved the governing tribal corporations that had been set up in the 1930s and pressured Indians to relocate from the reservations to cities where they could be better assimilated. The termination policy was an ill-disguised effort by mining, oil, and lumber interests, with the collusion of state authorities, to acquire mineral-rich reservation lands cheaply from individual Indians who could not afford to hold them without the tribal corporation's backing.[49] As a reporter at the time noted: "'when Pima farmers get restive, threats are made to freeze their tribal funds or cut off the meager water they get from Coolidge Dam—which was built for them' but instead supplied big white-owned farms."[50]

This is quite a different story from the *Arizona Highways* Wonder bread version, which ends with two photographs showing an irrigated "Pima cotton farm" and a bounteous "Pima harvest" of corn. In the August 1957 issue, editor Carlson tips his hand in his editorial:

> Oil companies paid over $40,000,000 to the [Navajo] tribe this year for
> oil leases. . . . But here is the tragedy. Officials believe that even with
> full economic development the reservation can only support 45,000
> Navajos. . . . Much will depend on a far-seeing understanding
> government policy before the Navajo problem will be solved.[51]

The problem, we are to understand, is a "Navajo problem" which can only be solved by the good will of a paternalistic, white government.

Indians in *Arizona Highways* fulfill their predestined functions for Anglo tourist-readers as living spectacles of a "primitive, wild Nature" or diminutive "pets" for interactive family fun (Fig. 11). Stocker admonishes his readers not to "walk uninvited into a Navajo hogan or the stone house of a Hopi and prowl around, staring at the Indian children and fingering the Indians' possessions." These Indians make no demands on whites:

> Little or nothing is required of the outside world and they have
> developed a gentle serenity which stems from a solid religious belief.
> Their prayers are for all mankind and their hope is for a peaceful
> world.[52]

Like the Indians, nature is also spiritualized—not in the individualized, meditative vein of Thoreau's transcendentalism—but with the schmaltzy piety of middle-American religiosity. The 1956 Christmas issue of *Arizona Highways* is thoroughly Christianized, opening with the editor's effusive "O Joyous Day . . . O Joyous Day," wherein we read:

> The centuries have added luster to His Holy Word, radiance to the
> Goodness and Holiness for which He lived and for which He died. . . .
> The Light of Our Savior glows more brightly today than ever
> before. . . .[53]

Recalling that the magazine was state-funded, we see that the boundaries between church and state were fluid indeed. While Carlson's text might seem startling, even offensive, to many of today's civil-liberties-conscious readers, it was right at home in the pious politics of the Cold War era. In 1954, Congress enacted legislation adding the words "under God" to the Pledge of Allegiance. Two years later, "In God We Trust" was adopted as the national motto "with neither debate nor a single dissenting vote in the House or Senate."[54] Aptly, it appeared on the nation's currency.

Religious affiliation was the *sine qua non* of social acceptance during the conformist 1950s, and 96 percent of the public identified themselves in national surveys as Protestants, Catholics, or Jews. The Cold War made the forces of evil seem all too imminent and the officially sanctioned atheism of the Soviet Union was a most effective anticommunist propaganda weapon. Even if most Americans didn't understand Marxist economic theory, they heard the "A-word" loud and clear. The freedom to worship was held so demonstrably sacred that a citizen was not free "not to worship." Public religious belief was a sign of patriotism, and agnostics and atheists were accused of being Soviet agents. As red-baiting Senator ("Tailgunner Joe") McCarthy put it: "the fate of the world rests with the clash between the atheism of Moscow and the Christian spirit throughout . . . the world."[55]

In such a climate, it should not be surprising to observe that the natural landscape became a sort of hallowed setting for pious communal ritual (Fig. 12). Passion plays were a form of entertainment that gained in popularity as a tourist attraction, and nonsectarian churches and chapels proliferated in dramatic landscape settings. *The Face of America* devoted a two-page spread to "the first Roman Catholic ordination ever held out-of-doors in the United States" . . . "under God's sky" in St. Augustine, Florida.

The architectural experiments of Frank Lloyd Wright, in particular, inspired a whole genre of ecclesiastical architecture in the 1950s that sought to harmonize buildings with their natural surroundings by using local materials and natural, "organic" shapes, particularly paraboloids. In his architecture, Wright ingeniously joined modern industrial streamlining and

Figure 11. "An Arizona Scrapbook in Navajoland." *Arizona Highways*, August 1957.

mass production to the symbolism of primordial nature. Wright's winter studio, Taliesin West, was located in the red-rock country near Phoenix. In 1955, *Arizona Highways* devoted a lavish article to a proposed Wright-esque "Shrine of the Ages" on the south rim of Grand Canyon—to be built on national park land.

> Those of Catholic, Jewish and Protestant faiths . . . are working together to make the Chapel possible. Others professing no faith but believing in the forces of God and eternity likewise are sharing . . . in furthering a project that will stand as one of America's great monuments to the brotherhood of man. . . . With the most impressive site of all for a temple of worship, Arizona is to share notably in a tribute to the Divine.[56]

Besides its "sweeping view of the canyon" through floor-to-ceiling windows facing the main pews, plans for the Chapel included a massive "stereophonic" pipe organ and three separate altars (for the three faiths) mounted on hydraulic lifts operated from the basement. The main auditorium's

shape was inspired by the kiva, the Pueblo culture's ceremonial chamber. Like the contemporary fashion designs adapted from Navajo women's dress, Anglos were forever "playing Indian," indulging the fantasy of a "primitive," "natural spirituality" that could be universally shared by an equally fantastic "brotherhood of man."[57] The Shrine of the Ages Chapel, however, was nothing so much as a shrine to materialism, consumption, and "positive thinking." "Nature" (the Grand Canyon) became an extension of the ritual experience of "feeling good about ourselves"—basking in the "timelessness" of God's harmonious world in the face of godless tyrannies and nuclear threats. Norman Vincent Peale, the nation's most popular cleric, urged his national radio and television listeners to repeat to themselves, "If God be for *me*, who can be against *me*?"[58]

If the popular representations of the American landscape during the Cold War period reflected the pious and patriotic values of the white middle class and its ruling elite, it is not surprising that the culture's professional nonconformists—the Beats and other "rebels without a cause"—sought to liberate the great American landscape as a locus for individualized expression (and reaction). This is the history of landscape photography we are more familiar with from the period: the metaphysical meditations of Minor White, Henry Holmes Smith, and their students; the abstract art of Aaron Siskind and Harry Callahan; the gritty urban docu-dramas of Weegee and Bruce Davidson, and the alienated "road songs" of Robert Frank and his imitators. The impulse was neoromantic—retrieving the authenticity and integrity of private (alienated) sensibilities in the face of massive social pressure to "blend in" and adapt.

But, at the time, such strategies failed to challenge effectively the entrenched values of the status quo, for in general, the Beats and free-lance rebels were as bereft of a historical, class-conscious perspective as the bourgeois public they despised. Autonomous "islands of alienation," their gestures were easily co-opted, tamed, and sold to a titillated (consuming) public through the mass media and Hollywood. *Life, Look* and *Time* published exposés on the decadence of beat life, Maynard G. Krebs became a comfortable fixture on television's prime-time *Dobie Gillis* show, and suburban teenagers read *Catcher in the Rye* (1956) and knew "hip" from "square." By the time the U.S. Edition of Frank's *The Americans* was published with Jack Kerouac's introduction (1959), the tide had already begun to turn: Jasper Johns was painting his American flags, black activists were staging sit-ins at segregated lunch counters, the New Left was in its embryonic stages on the campuses of Berkeley and Madison, and the following year, John Kennedy would be elected president, promising a "New Frontier" led by "a new generation."

The decade of 1946–56 witnessed the production of a unique vision of the American landscape that was marketed widely to a mass public looking

Figure 12. "The sun shining through mist transforms Grand Canyon into a cathedral." From "Shrine of the Ages," *Arizona Highways*, August 1955, p. 15.

for simple reassurances in a complicated world. Neither the publicly engineered landscapes of the New Deal nor the privatized, consumable "wilderness experience" of the present, this landscape bore witness to a seamless and coherent national culture and history, blessed by God, and full of unlimited material and spiritual benefits. But public consensus around this fantasy was bought at a high price: the suppression of cultural diversity and civil liberties, a naive belief in infinitely expanding markets, and acquiescence to corporate values in all matters of public life. Today, these picture books and magazines haunt us with their frightful arrogance, even as they occasionally amuse with their quaint naiveté. If migrating pioneers once viewed the American landscape as a hostile wilderness, it seems clear that their mid-twentieth-century descendants found it an accommodating refuge from their collective psychic fears.

Notes

I would like to thank Jan Zita Grover and Elizabeth Grossman for their thoughtful comments and suggestions concerning both the style and substance of this paper.

1. For an excellent discussion of the conservative historical function that "Golden Ages" perform in Western culture, see Raymond Williams, "Golden Ages," in *The Country and the City* (London: Oxford University Press, 1973), 35–45.

2. I use the adjective *American* in this paper in the imperialistic sense that it was understood during this time: "America" being synonymous with the United States.

3. "In 1954, the editors of *McCall's* magazine were batting around editorial ideas for improved promotion and increased circulation. Eureka! They came up with the word 'togetherness.' . . . 'For a time,' wrote Betty Friedan, togetherness 'was elevated into virtually a national purpose.'" Marty Jeter, *The Dark Ages: Life in the United States 1945–1960* (Boston: South End Press, 1982), 223.

4. Kodachrome roll film was first marketed in the mid 1930s. Initially after the war, Kodak color products for the mass market were limited to 35mm transparencies rather than color prints, though prints could be made from slides. Thus Kodak created a new consumer market for slide-projection equipment during the late 1940s and early 1950s and the family slide show was a popular (if much derided) pastime. See Naomi Rosenblum, *A World History of Photography* (New York: Abbeville, 1984), 602.

5. In contrast, Jimmy Carter's populist persona as a Georgia peanut farmer added to the public's perception of him as weak and ineffectual. Unlike his cowherding counterpart, the American small farmer has not been held in high esteem as a public symbol since the depression and the massive rural exodus that accompanied it. More often, the farmer's "hayseed" qualities were emphasized. This bias is obvious in 1950s and 1960s television drama; compare *The Lone Ranger, Rawhide, Gunsmoke,* and *Bonanza* to the *Real McCoys* and *Hee-Haw.*

6. "In addition to celebrating American culture and living standards, many people saw the United States in the middle of the twentieth century as having a peculiar and providential mission. 'We are living in one of the great watershed periods of history,' asserted Adlai Stevenson in the 1952 campaign. This era 'may well fix the pattern of civilization for many generations to come. God has set for us an awesome mission: nothing less than the leadership of the free world.'" Douglas Miller and Marion Nowak. *The Fifties: The Way We Really Were* (New York: Doubleday, 1977), 9.

7. Ibid., 227.

8. *The USA in Color* (Philadelphia: Curtis, 1956), 5.

9. *Look at America: The Country You Know—And Don't Know* (Boston: Houghton Mifflin, 1947), 18, 22.

10. Samuel Chamberlain, ed., *Fair Is Our Land* (Chicago: Peoples Book Club, 1942), 15–16.

11. "Middle landscape" is Leo Marx's designation for the uniquely American pastoral ideal first espoused by Thomas Jefferson in his *Notes on Virginia.* It refers

to a rational landscape of the "just mean," the self-sufficient family-sized farm, husbanded by noble, "democratic men" without ambition for surplus wealth. "Later this 'mythical cult-figure' [the Jeffersonian husbandman] of the old pastoral will reappear as the Jacksonian 'common man.' If this democratic Everyman strikes us as a credible figure, it is partly because the pastoral ideal has been so well assimilated into American ideology." Leo Marx, *The Machine in the Garden* (London: Oxford University Press, 1964), 130.

12. Chamberlain, *Fair Is Our Land*, 17.

13. See Maren Stange, "Publicity, Husbandry, and Technology," in Pete Daniel et al., *Official Images: New Deal Photography* (Washington: Smithsonian Institution, 1987). Also, Phoebe Cutler, *The Public Landscape of the New Deal* (New Haven: Yale University Press, 1985).

14. Cutler, ibid., 95.

15. Chamberlain, *Fair Is Our Land*, 21.

16. Frederick Jackson Turner, *The Frontier in American History* (new York, 1920). "Turner recast [the role of the frontier] from that of an enemy which civilization had to conquer to a beneficent influence on men and institutions. His greatest service to wilderness consisted of linking it in the minds of his countrymen with sacred American virtues." Roderick Nash, *Wilderness and the American Mind* (New Haven: Yale University Press, 1967), 146.

17. Chamberlain, *Fair Is Our Land*, 116.

18. *Look at America*, 7–8.

19. Jeter, *The Dark Ages*, 25.

20. *The New Republic* quipped that Eisenhower's first cabinet consisted of "eight millionaires and a plumber." "[They] quickly let business know where the administration stood. Even before taking office as Secretary of Defense, Charles Wilson, then president of General Motors, told the Senate Armed Services Committee that 'what was good for our country was good for General Motors and vice versa.'" Miller and Nowak, *The Fifties*, 109.

21. The growth of the corporate public relations industry was phenomenal during the 1950s. In 1944, there were 100 public relations firms. Twenty years later, the number had climbed to 1,500. Corporate giving to charities and the arts, and company sponsorship of public entertainment, particularly television programs, were among the new high-profile activities corporations engaged in during the decade.

22. Nicholas Lemann, *Out of the Forties* (New York: Simon and Schuster, 1983), 21.

23. Also see Christopher Phillips, "Standard Bearer," *Camera Arts* (June 1983): 47 ff, and Steven Plattner, *Roy Stryker: U.S.A., 1943–1950* (Austin: University of Texas, 1983).

24. Phillips, "Standard Bearer," 59.

25. Joseph Henry Jackson, Foreword, *The Glory of Our West* (New York: Doubleday, 1952), 7.

26. *The Glory of Our West*, 10.

27. Ibid., 58.

28. Ibid., 44.

29. Ibid., 71.

30. Ibid., 88.

31. Ibid., 30.

32. Polyester replaced King Cotton, and "completely washable" plastic plants were the rage.

33. Ibid., 48.

34. Ibid., 14.

35. Nash, *Wilderness and the American Mind*, 211.

36. Ibid., 212.

37. Aldo Leopold, naturalist and philosopher, shaped the modern ecology movement with his analysis of the essential relationship between environment and its organisms. The land and its creatures functioned as a single, complex "biotic community," dependent upon the interdependent operations of its parts. Wild places were necessary, Leopold argued, as "a base-datum of normality, a picture of how healthy land maintains itself as an organism." See "Aldo Leopold: Prophet," in Nash, *Wilderness and the American Mind*, 182–99.

38. Ibid., 263.

39. "'The interstate system,' . . .—leaving out all the freeways and thruways and expressways and byways built before it—will, when complete, consist of enough concrete so that, as a parking lot, it would accommodate two-thirds of the automobiles in the U.S. (it would be 20 miles square). It will take up 1.5 million acres of *new* right of way (the right of way, as opposed to just the concrete, would cover an area 1 1/2 times the size of Rhode Island). It will use up 30 tons of iron ore to make its steel, plus 18 million tons of coal and 6.5 million tons of limestone. The coal, of course, will be combined with oxygen while the concrete covers photosynthetic plants. Its lumber requirements would take all the trees from a 400-square-mile forest. Who needs it?" Gene Marine, quoted in Stephen A. Kurtz, *Wasteland: Building the American Dream* (New York: Praeger, 1973), 14.

40. Jeter, *The Dark Ages*, 140.

41. *The Glory of Our West*, 36.

42. *Arizona Highways* 31, no. 7 (July 1955): 1.

43. C. W. McCullough, "Modiste to Miss Navajo," ibid., 8.

44. Ibid., 11, 12.

45. Of course this was the normative gender role prescribed for middle-class women in the 1950s—to consume fashions and cosmetics and lavish vast amounts of time on improving their personal appearance.

46. Ibid., 17.

47. Ibid., 18.

48. Ibid., 37.

49. "Such interest groups maintained powerful Washington lobbies, and the Indian Affairs men acting for the Truman and Eisenhower administrations favored these lobbies. Some officials also had an unflattering race relations record. Dillon S. Myer, appointed Indian commissioner in 1950, previously had been the director of the internment camps where over 100,000 Japanese-Americans were imprisoned

during World War II. . . . Other men high in the BIA went there straight from lobbying against native tribal interests in the West." Miller and Nowak, *The Fifties*, 202–3.

50. Ibid., 202.

51. Raymond Carlson, "Distant Indian Trails . . . ," *Arizona Highways* 33, no. 8 (August 1957): 1.

52. Joseph Stocker, "Trailer Teachers in Navajoland," *Arizona Highways* 33, no. 8 (August 1957): 33.

53. *Arizona Highways* 32, no. 12 (December 1956).

54. Miller and Nowak, *The Fifties*, 88.

55. Ibid., 90.

56. Ken Park, "Shrine of Ages," *Arizona Highways* 31, no. 8 (August 1955): 11.

57. For a trenchant historical analysis of the uses of "playing Indian" for Euro-American culture, see Rayna Green, "The Tribe Called Wannabee: Playing Indian in America and Europe," *Folklore* 99, no. 1 (1988): 30. ". . . Playing Indian is one of the most subtly entrenched, most profound and significant of American performances. Perhaps relief of guilt is an inherent part of the role, but, when taken in connection with other cultural performance epiphenomena of American life, I have come to think that cultural validation is the role's most important function" (p. 49).

58. Miller and Nowak, *The Fifties*, 95.

THE CRISIS OF THE REAL:
PHOTOGRAPHY AND
POSTMODERNISM

ANDY GRUNDBERG

*Disneyland is presented as imaginary in order to
make us believe that the rest is real, when in fact all
of Los Angeles and the America surrounding it are
no longer real, but of the order of the hyperreal
and of simulation. It is no longer a question of a
false representation of reality (ideology), but of
concealing the fact that the real is no longer real. . . .*
Jean Baudrillard[1]

 TODAY WE FACE A CONDITION IN THE ARTS THAT FOR MANY IS both confusing and irritating—a condition that goes by the name of postmodernism. But what do we mean when we call a work of art postmodernist? And what does postmodernism mean for photography? How does it relate to, and challenge, the tradition of photographic practice as Beaumont Newhall has so conscientiously described it?[2] Why are the ideas and practices of postmodernist art so unsettling to our traditional ways of thinking? These are questions that need to be examined if we are to understand the nature of today's photography, and its relation to the larger art world.

What *is* postmodernism? Is it a method, like the practice of using images that already exist? Is it an attitude, like irony? Is it an ideology, like Marxism? Or is it a plot hatched by a cabal of New York artists, dealers, and critics, designed to overturn the art-world establishment and to shower money and fame on those involved? These are all definitions that have been proposed, and, like the blind men's descriptions of the elephant, they all may contain a small share of truth. But as I hope to make clear, postmodernist art did not arise in a vacuum, and it is more than merely a demonstration of certain theoretical concerns dear to twentieth-century intellectuals. I would argue, in short, that postmodernism, in its art and its theory, is a reflection of the conditions of our time.

One complication in arriving at any neat definition of postmodernism is that it means different things in different artistic media. The term first gained wide currency in the field of architecture,[3] as a way of describing a turn away from the hermetically sealed glass boxes and walled concrete

bunkers of modern architecture. In coming up with the term postmodern, architects had a very specific and clearly defined target in mind: the "less is more" reductivism of Mies van der Rohe and his disciples. At first, postmodernism in architecture meant eclecticism: the use of stylistic flourishes and decorative ornament with a kind of carefree, slapdash, and ultimately value-free abandon.

Postmodernist architecture, however, combines old and new styles with an almost hedonistic intensity. Freed of the rigors of Miesian design, architects felt at liberty to reintroduce precisely those elements of architectural syntax that Mies had purged from the vocabulary: historical allusion, metaphor, jokey illusionism, spatial ambiguity. What the English architectural critic Charles Jencks says of Michael Graves's Portland building is true of postmodern architecture as a whole:

> It is evidently an architecture of inclusion which takes the multiplicity
> of differing demands seriously: ornament, colour, representational
> sculpture, urban morphology—and more purely architectural demands
> such as structure, space and light.[4]

If architecture's postmodernism is involved with redecorating the stripped-down elements of architectural modernism, thereby restoring some of the emotional complexity and spiritual capacity that the best buildings seem to have, the postmodernism of dance is something else. Modern dance as we have come to know it consists of a tradition extending from Loie Fuller, in Paris in the 1890s, through Martha Graham, in New York in the 1930s. As anyone who has seen Graham's dances can attest, emotional, subjective expressionism is a hallmark of modern dance, albeit within a technically polished framework. Postmodernist dance, which dates from the experimental work performed at the Judson Church in New York City in the early 1960s, was and is an attempt to throw off the heroicism and expressionism of modernist dance by making dance more vernacular.[5] Inspired by the pioneering accomplishments of Merce Cunningham, the dancers of the Judson Dance Theater—who included Trisha Brown, Lucinda Childs, Steve Paxton, and Yvonne Rainer—based their movements on everyday gestures such as walking and turning, and often enlisted the audience or used untrained walk-ons as dancers. Postmodern dance eliminated narrative, reduced decoration, and purged allusion—in other words, it was, and is, not far removed from what we call modern in architecture.

More recently this esthetic of postmodernist dance has been replaced in vanguard circles in New York by an as-yet-unnamed style that seeks to reinject elements of biography, narrative, and political issues into the structure of the dance, using allusion and decoration and difficult dance steps

in the process. It is, in its own way, exactly what postmodern architecture is, inasmuch as it attempts to revitalize the art form through inclusion rather than exclusion. Clearly, then, the term postmodernism is used to mean something very different in dance than it does in architecture. The same condition exists in music, and in literature—each defines its post-modernism in relation to its own peculiar modernism.

To edge closer to the situation in photography, consider postmodernism as it is constituted in today's art world—which is to say, within the tradition and practice of painting and sculpture. For a while, in the 1970s, it was possible to think of postmodernism as equivalent to pluralism, a catchword that was the art-world equivalent of Tom Wolfe's phrase "The Me Decade." According to the pluralists, the tradition of modernism, from Paul Cézanne to Kenneth Noland, had plumb tuckered out—had, through its own as-sumptions, run itself into the ground. Painting was finished, and all that was left to do was either minimalism (which no one much liked to look at) or conceptualism (which no one could look at, its goal being to avoid producing still more art "objects"). Decoration and representation were out, eye appeal was suspect, emotional appeal thought sloppy if not gauche.

Facing this exhaustion, the artists of the 1970s went off in a hundred directions at once, at least according to the pluralist model. Some started making frankly decorative pattern paintings. Some made sculpture from the earth, or from abandoned buildings. Some started using photography and video, mixing media and adding to the pluralist stew. One consequence of the opening of the modernist gates was that photography, that seemingly perennial second-class citizen, became a naturalized member of the gallery and museum circuit. But the main thrust was that modernism's reductiv-ism—or, to be fair about it, *what was seen as modernism's reductivism*—was countered with a flood of new practices, some of them clearly antithetical to modernism.

But was this pluralism, which is no longer much in evidence, truly an attack on the underlying assumptions of modernism, as modernism was perceived in the mid to late 1970s? Or was it, as the critic Douglas Crimp has written, one of the "morbid symptoms of modernism's demise"?[6] According to those of Mr. Crimp's critical persuasion (which is to say, of the persuasion of *October* magazine), postmodernism in the art world means something more than simply what comes after modernism. It means, for them, an attack on modernism, an undercutting of its basic assumptions about the role of art in the culture and about the role of the artist in relation to his or her art. This undercutting function has come to be known as "deconstruction," a term for which the French philosopher Jacques Derrida is responsible.[7] Behind it lies a theory about the way we perceive the world that is both rooted in, and a reaction to, structuralism.

Structuralism is a theory of language and knowledge, and it is largely based on the Swiss linguist Ferdinand de Saussure's *Course in General Linguistics* (1916). It is allied with, if not inseparable from, the theory of semiotics, or signs, pioneered by the American philosopher Charles S. Pierce about the same time. What structuralist linguistic theory and semiotic sign theory have in common is the belief that things in the world—literary texts, images, what have you—do not wear their meanings on their sleeves. They must be deciphered, or decoded, in order to be understood. In other words, things have a "deeper structure" than common sense permits us to comprehend, and structuralism purports to provide a method that allows us to penetrate that deeper structure.

Basically, its method is to divide everything in two. It takes the sign—a word, say, in language, or an image, or even a pair of women's shoes—and separates it into the "signifier" and the "signified." The signifier is like a pointer, and the signified is what gets pointed to. (In Morse code, the dots and dashes are the signifiers, and the letters of the alphabet the signifieds.) Now this seems pretty reasonable, if not exactly simple. But structuralism also holds that the signifier is wholly arbitrary, a convention of social practice rather than a universal law. Therefore structuralism in practice ignores the "meaning," or the signified part of the sign, and concentrates on the relations of the signifiers within any given work. In a sense, it holds that the obvious meaning is irrelevant; instead, it finds its territory within the structure of things—hence the name structuralism.

Some of the consequences of this approach are detailed in Terry Eagleton's book *Literary Theory: An Introduction:*

> First, it does not matter to structuralism that [a] story is hardly an example of great literature. The method is quite indifferent to the cultural value of its object. . . . Second, structuralism is a calculated affront to common sense. . . . It does not take the text at face value, but "displaces" it into a quite different kind of object. Third, if the particular contents of the text are replaceable, there is a sense in which one can say that the "content" of the narrative is its structure.[8]

We might think about structuralism in the same way that we think about sociology, in the sense that they are pseudo-sciences. Both attempt to find a rationalist, scientific basis for understanding human activities—social behavior in sociology's case, writing and speech in structuralism's. They are symptoms of a certain historical desire to make the realm of human activity a bit more neat, a bit more calculable.

Structuralism fits into another historical process as well, which is the gradual replacement of our faith in the obvious with an equally compelling

faith in what is not obvious—in what can be uncovered or discovered through analysis. We might date this shift to Copernicus, who had the audacity to claim that the earth revolves around the sun even though it is obvious to all of us that the sun revolves around the earth, and does so once a day. To quote Eagleton:

> Copernicus was followed by Marx, who claimed that the true
> significance of social processes went on "behind the backs" of individual
> agents, and after Marx Freud argued that the real meanings of our
> words and actions were quite imperceptible to the conscious mind.
> Structuralism is the modern inheritor of this belief that reality, and our
> experience of it, are discontinuous with each other.[9]

Poststructuralism, with Derrida, goes a step further. According to the poststructuralists, our perceptions only tell us about what our perceptions are, not about the true conditions of the world. Authors and other sign makers do not control their meanings through their intentions; instead, their meanings are undercut, or "deconstructed," by the texts themselves. Nor is there any way to arrive at the "ultimate" meaning of anything. Meaning is always withheld, and to believe the opposite is tantamount to mythology. As Eagleton says, summarizing Derrida:

> Nothing is ever fully present in signs: it is an illusion for me to
> believe that I can ever be fully present to you in what I say or write,
> because to use signs at all entails that my meaning is always somehow
> dispersed, divided and never quite at one with itself. Not only my
> meaning, indeed, but *me:* since language is something I am made out
> of, rather than merely a convenient tool I use, the whole idea that I am
> a stable unified entity must also be a fiction. . . . It is not that I can
> have a pure, unblemished meaning, intention or experience which then
> gets distorted and refracted by the flawed medium of language: because
> language is the very air I breathe, I can never have a pure,
> unblemished meaning or experience at all.[10]

This inability to have "a pure, unblemished meaning or experience at all," is, I would submit, exactly the premise of the art we call postmodernist. And, I would add, it is the theme which characterizes most contemporary photography, explicitly or implicitly. Calling it a "theme" is perhaps too bland: it is the crisis which photography and all other forms of art face in the late twentieth century.

But once we know postmodernism's theoretical underpinnings, how are we to recognize it in art? Under what guise does it appear in pictures? If we return to how postmodernism was first conceived in the art world of

the 1970s—namely, under the banner of pluralism—we can say quite blithely that postmodernist art is art that looks like anything *except* modernist art. In fact, we could even concede that postmodernist art could incorporate the modernist "look" as part of its diversity. But this pinpoints exactly why no one was ever satisfied with pluralism as a concept: it may well describe the absence of a single prevailing style, but it does not describe the *presence* of anything. A critical concept that embraces everything imaginable is not of much use.

The critical theory descended from structuralism has a much better chance of defining what postmodernist visual art should look like, but even with that there is some latitude. Most postmodernist critics of this ideological bent insist that postmodernist art be oppositional. This opposition can be conceived in two ways: as counter to the modernist tradition, and/or as counter to the ruling "mythologies" of Western culture, which, the theory goes, led to the creation of the modernist tradition in the first place. These same critics believe that postmodernist art therefore must debunk or "deconstruct" the "myths" of the autonomous individual ("the myth of the author") and of the individual subject ("the myth of originality"). But when we get to the level of *how* these aims are best accomplished—that is, what style of art might achieve these ends—we encounter critical disagreement and ambiguity.

One concept of postmodernist style is that it should consist of a mixture of media, thereby dispelling modernism's fetishistic concentration on the medium as message—painting about painting, photography about photography, and so on. For example, one could make theatrical paintings, or filmic photographs, or combine pictures with the written word. A corollary to this suggests that the use of so-called alternative media—anything other than painting on canvas and sculpture in metal—is a hallmark of the postmodern. This is a view that actually lifts photography up from its traditional second-class status, and privileges it as the medium of the moment.

And there is yet another view that holds that the medium doesn't matter at all, that what matters is the way in which art operates within and against the culture. As Rosalind Krauss has written, "Within the situation of postmodernism, practice is not defined in relation to a given medium—[e.g.,] sculpture—but rather in relation to the logical operations on a set of cultural terms, for which any medium—photography, books, lines on walls, mirrors, or sculpture itself—might be used."[11] Still, there is no denying that, beginning in the 1970s, photography came to assume a position of importance within the realm of postmodernist art, as Krauss herself has observed.[12]

Stylistically, if we might entertain the notion of style of postmodernist

art, certain practices have been advanced as essentially postmodernist. Foremost among these is the concept of pastiche, of assembling one's art from a variety of sources. This is not done in the spirit of honoring one's artistic heritage, but neither is it done as parody. As Fredric Jameson explains in an essay called "Postmodernism and Consumer Society":

> Pastiche is, like parody, the imitation of a peculiar or unique style, the wearing of a stylistic mask, speech in a dead language; but it is a neutral practice of such mimicry, without parody's ulterior motive, without the satirical motive, without laughter, without that still latent feeling that there exists something *normal* compared to which what is being imitated is rather comic. Pastiche is blank parody, parody that has lost its sense of humor. . . .[13]

Pastiche can take many forms; it doesn't necessarily mean, for example, that one must collage one's sources together, although Robert Rauschenberg has been cited as a kind of Ur-postmodernist for his combine paintings of the 1950s and photocollages of the early 1960s.[14] Pastiche can also be understood as a peculiar form of mimicry in which a simultaneous process of masking and unmasking occurs.

We can see this process at work in any number of artworks of the 1980s. One example is a 1982 painting by Walter Robinson titled *Revenge*. The first thing to be said about *Revenge* is that it looks like something out of a romance magazine, not something in the tradition of Picasso or Rothko. It takes as its subject a rather debased, stereotypical view of the negligee-clad *femme fatale*, and paints her in a rather debased, illustrative manner. We might say that it adopts the tawdry, male-dominated discourse of female sexuality as found at the lower depths of the mass media. It wears that discourse as a mask, but it wears this mask not to poke fun at it, nor to flatter it by imitation, nor to point us in the direction of something more genuine that lies behind it. It wears this mask in order to unmask it, to point to its internal inconsistencies, its inadequacies, its failures, its stereotypical unreality.

Other examples can be found in the paintings of Thomas Lawson, such as his 1981 canvas *Battered to Death* (Fig. 1). Now nothing in this work—which depicts a blandly quizzical child's face in almost photo-realist style—prepares us in the least for the title *Battered to Death*. Which is very much to the point: the artist has used as his source for the portrait a newspaper photograph, which bore the unhappy headline that is the painting's title. The painting wears the mask of banality, but that mask is broken by the title, shifted onto a whole other level of meaning, just as it was when it appeared in the newspaper. So this painting perhaps tells us something about the ways in which newspapers alter or manipulate "objectivity," but

it also speaks to the separation between style and meaning, image and text, object and intention in today's visual universe. In the act of donning a mask it unmasks—or, in Derrida's terminology, it deconstructs.

There is, it goes without saying, a certain self-consciousness in paintings like these, but it is not a self-consciousness that promotes an identification with the artist in any traditional sense, as in Velasquez's *Las Meninas*. Rather, as Mark Tansey's painting *Homage to Susan Sontag* (1982) makes explicit, it is a self-consciousness that promotes an awareness of photographic representation, of the camera's role in creating and disseminating the "commodities" of visual culture.

This self-conscious awareness of being in a camera-based and camera-bound culture is an essential feature of the contemporary photography that has come to be called postmodernist. In Cindy Sherman's well-known series *Untitled Film Stills*, for example, the 8-by-10-inch glossy is used as the model from which the artist manufactures a series of masks for herself (Figs. 2 and 3). In the process, Sherman unmasks the conventions not only of *film noir* but also of woman-as-depicted-object. The stilted submissiveness of her subject refers to stereotypes in the depiction of women and, in a larger way, questions the whole idea of personal identity, male or female. Since she uses herself as her subject in all her photographs, we might want to call these self-portraits, but in essence they deny the self.

A number of observers have pointed out that Sherman's imagery borrows heavily from the almost subliminal image universe of film, television, fashion photography, and advertising. One can see, for instance, certain correspondences between her photographs and actual film publicity stills of the 1950s. But her pictures are not so much specific borrowings from the past as they are distillations of cultural types. The masks Sherman creates are neither mere parodies of cultural roles nor are they layers like the skins of an onion, which, peeled back, might reveal some inner essence. Hers are perfectly poststructuralist portraits, for they admit to the ultimate unknowable-ness of the "I." They challenge the essential assumption of a discrete, identifiable, recognizable author.

Another kind of masking goes on in Eileen Cowin's tableaux images taken since 1980, which she once called *Family Docudramas* (Fig. 4). Modeled loosely on soap-opera vignettes, film stills, or the sort of scenes one finds in a European *photo-roman*, these rather elegant color photographs depict arranged family situations in which a sense of discord and anxiety prevails. Like Sherman, Cowin uses herself as the foil of the piece, and she goes further, including her own family and, at times, her identical twin sister. In the pictures that show us both twins at once, we read the two women as one: as participant and as observer, as reality and fantasy, as anxious ego and critical superego. Cowin's work unmasks many of the conventions

Figure 1. Thomas Lawson, *Battered to Death*, 1981. Oil on canvas, 48 × 48″. Courtesy Metro Pictures, New York.

of familial self-depiction, but even more important, they unmask conventional notions of interpersonal behavior, opening onto a chilling awareness of the disparity between how we think we behave and how we are seen by others to behave.

Laurie Simmons's photographs are as carefully staged—as fabricated, as directorial—as those of Cindy Sherman and Eileen Cowin, but she usually makes use of miniaturized representations of human beings in equally miniaturized environments. In her early doll-house images, female figures grapple somewhat uncertainly with the accoutrements of everyday middle-class life—cleaning bathrooms, confronting dirty kitchen tables, bending over large lipstick containers. Simmons clearly uses the doll figures as stand-ins—for her parents, for herself, for cultural models as she remembers them from the sixties, when she was a child growing up in the suburbs. She is simultaneously interested in examining the conventions of behavior she acquired in her childhood and in exposing the conventions of representations that were the means by which these behavior patterns were transmitted. As is true also of the work of Ellen Brooks, the doll house functions as a reminder of lost innocence.

Figure 2. Cindy Sherman, *Untitled Film Still #13*, 1978. Courtesy Metro Pictures, New York.

Figure 3. Cindy Sherman, *Untitled Film Still #56*, 1980. Courtesy Metro Pictures, New York.

The works of Sherman, Cowin, and Simmons create surrogates, emphasizing the masked or masking quality of postmodernist photographic practice. Other photographers, however, make work that concentrates our attention on the process of unmasking. One of these is Richard Prince, the leading practitioner of the art of "rephotography." Prince photographs pictures that he finds in magazines, cropping them as he sees fit, with the aim of unmasking the syntax of the advertising photography language (Fig. 5). His art also implies the exhaustion of the image universe: it suggests that a photographer can find more than enough images already existing in the world without the bother of making new ones. Pressed on this point, Prince will admit that he has no desire to create images from the raw material of the physical world; he is perfectly content—happy, actually—to glean his material from photographic reproductions.

Prince is also a writer of considerable talent. In his book, *Why I Go to the Movies Alone*, we learn something of his attitudes toward the world—attitudes that are shared by many artists of the postmodernist persuasion.

Figure 4. Eileen Cowin, *Untitled*, 1984. Courtesy Jayne H. Baum Gallery, New York.

The characters he creates are called "he" or "they," but we might just as well see them as stand-ins for the artist, as his own verbal masks:

> Magazines, movies, T.V., and records. It wasn't everybody's condition but to him it sometimes seemed like it was, and if it really wasn't, that was alright, but it was going to be hard for him to connect with someone who passed themselves off as an example or a version of a life put together from reasonable matter. . . . His own desires had very little to do with what came from himself because what he put out (at least in part) had already been out. His way to make it new was *make it again,* and making it again was enough for him and certainly, personally speaking, *almost* him.

And a second passage:

Figure 5. Richard Prince, *Untitled (from four men looking in the same direction)*, 1978. Courtesy Barbara Gladstone Gallery, New York.

They were always impressed by the photographs of Jackson Pollack, but didn't particularly think much about his paintings, since painting was something they associated with a way to put things together that seemed to them pretty much taken care of.

They hung the photographs of Pollack right next to these new "personality" posters they just bought. These posters had just come out. They were black and white blow-ups . . . at least thirty by forty inches. And picking one out felt like doing something any new artist should do.

The photographs of Pollack were what they thought Pollack was about. And this kind of take wasn't as much a position as an attitude, a feeling that an abstract expressionist, a TV star, a Hollywood celebrity, a president of a country, a baseball great, could easily mix and associate together . . . and what measurements or speculations that used to separate their value could now be done away with. . . .

> I mean it seemed to them that Pollack's photographs looked pretty
> good next to Steve McQueen's, next to JFK's, next to Vince Edwards',
> next to Jimmy Piersal's and so on. . . ."[15]

Prince's activity is one version of a postmodernist practice that has come
to be called appropriation. In intelligent hands like those of Prince, ap-
propriation is certainly postmodernist, but is not the *sine qua non* of post-
modernism. In certain quarters appropriation has gained considerable
notoriety, thanks largely to works like Sherrie Levine's 1979 *Untitled (After
Edward Weston)*, for which the artist simply made a copy print from a
reproduction of a famous 1926 Edward Weston image (*Torso of Neil*) and
claimed it as her own. It seems important to stress that appropriation as
a tactic is not designed *per se* to tweak the noses of the Weston heirs, to
épater la bourgeoisie, or to test the limits of the First Amendment. It is, rather,
a direct, if somewhat crude, assertion of the finiteness of the visual uni-
verse. And it should be said that Levine's *tabula rasa* appropriations fre-
quently depend on (one) their captions, and (two) a theoretical explanation
that one must find elsewhere.

Those artists using others' images believe, like Prince, that it is dishonest to
pretend that untapped visual resources are still out there in the woods, waiting
to be found by artists who can then claim to be original. For them, imagery is
now overdetermined—that is, the world already has been glutted with pic-
tures taken in the woods. Even if this weren't the case, however, no one ever
comes upon the woods culture free. In fact, these artists believe, we enter the
woods as prisoners of our preconceived image of the woods, and what we
bring back on film merely confirms our preconceptions.

Another artist to emphasize the unmasking aspects of postmodernist
practice is Louise Lawler. While perhaps less well-known and publicized
than Sherrie Levine, Lawler examines with great resourcefulness the struc-
tures and contexts in which images are seen. In Lawler's work, unlike
Levine's, it is possible to read at least some of its message from the medium
itself. Her art-making activities fall into several groups: photographs of
arrangements of pictures made by others, photographs of arrangements
of pictures arranged by the artist herself, and installations of arrangements
of pictures.

Why the emphasis on arrangement? Because for Lawler—and for all
postmodernist artists, for that matter—the meaning of images is always a
matter of their context, especially their relations with other images. In
looking at her work one often gets the feeling of trying to decode a rebus:
the choice, sequence, and position of the pictures she shows us imply a
rudimentary grammar or syntax. Using pictures by others—Jenny Holzer,
Peter Nadin, Sherrie Levine's notorious torso of Neil—she urges us to
consider the reverberations between them.

Figure 6. James Welling, *Untitled*, 1981. Courtesy James Welling and the Jay Gorney Modern Art Gallery, New York.

In James Welling's pictures yet another strategy is at work, a strategy that might be called appropriation by inference (Fig. 6). Instead of re-presenting someone else's image they present the archetype of a certain kind of image. Unlike Prince and Lawler, he molds raw material to create his pictures, but the raw material he uses is likely to be as mundane as crumpled aluminum foil, Jello, or flakes of dough spilled on a velvet drape. These pictures look like pictures we have seen—abstractionist photographs from the Equivalent school of modernism, for instance, with their aspirations to embody some essence of human emotion. In Welling's work, however, the promise of emotional expressionism is always unfulfilled.

Welling's pictures present a state of contradiction. In expressive terms they seem to be "about" something specific, yet they are "about" everything and nothing. In the artist's eyes they embody tensions between seeing and blindness; they offer the viewer the promise of insight but at the same time reveal nothing except the inconsequence of the materials with which they

were made. They are in one sense landscapes, in another abstractions; in still another sense, they are dramatizations of the postmodern condition of representation.

The kind of postmodernist art I have been discussing is on the whole not responsive to the canon of art photography. It takes up photography because photography is an explicitly reproducible medium, because it is the common coin of cultural image interchange, and because it avoids the aura of authorship that poststructuralist thought calls into question—or at least avoids that aura to a greater extent than do painting and sculpture. Photography is, for these artists, the medium of choice; it is not necessarily their aim to be photographers, or, for most of them, to be allied with the traditions of art photography. Indeed, some of them remain quite happily ignorant of the photographic tradition. They come, by and large, from another tradition, one rooted theoretically in American art criticism since World War II and one rooted practically in conceptual art, which influenced many of them when they were in art school. But at least as large an influence on these artists is the experience of present-day life itself, as perceived through popular culture—TV, films, advertising, corporate logoism, PR, *People* magazine—in short, the entire industry of mass-media image making.

I hope I have made clear so far that postmodernism means something different to architects and dancers and painters, and that it also has different meanings and applications depending on which architect or dancer or painter one is listening to. And I hope that I have explained some of the critical issues of postmodernism as they have made themselves manifest in the art world, and shown how these issues are embodied in photographs that are called postmodernist. But there remains, for photographers, still another question: "What about Heinecken?" That is to say, didn't photography long ago become involved with pastiche, appropriation, questions of mass-media representation, and so on? Wasn't Robert Heinecken rephotographing magazine imagery, in works like *Are You Rea?* (Fig. 7), as early as 1966, when Richard Prince was still in knickers?

To clarify the relationship between today's art world–derived postmodernist photography and what some feel are its undersung photographic antecedents, we need to consider what I would call photography's inherent strain of postmodernism. To do this we have to define photography's modernism.

Modernism in photography is a twentieth-century esthetic which subscribes to the concept of the "photographic" and bases its critical judgments about what constitutes a good photograph accordingly. Under modernism, as it developed over the course of this century, photography was held to be unique, with capabilities of description and a capacity for verisimilitude beyond those of painting, sculpture, printmaking, or any other medium.

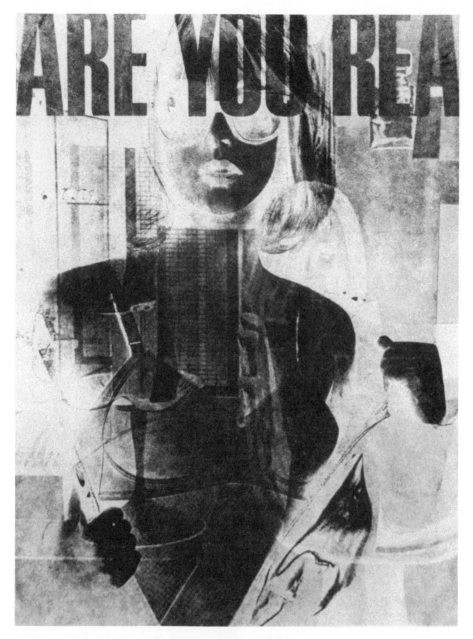

Figure 7. Robert Heineken, *Are You Rea #1*, 1966. Copyright Robert Heineken, courtesy Pace/MacGill Gallery, New York.

Modernism in the visual arts valued (I use the past tense here partly as a matter of convenience, to separate modernism from postmodernism, and partly to suggest modernism's current vestigial status) the notion that painting should be about painting, sculpture about sculpture, photography about photography. If photography were merely a description of what the pyramids along the Nile looked like, or of the dissipated visage of Charles Baudelaire, then it could hardly be said to be a form of art. Modernism required that photography cultivate the photographic—indeed, that it invent the photographic—so that its legitimacy would not be questioned.

In a nutshell, two strands—Alfred Stieglitz's American Purism and László Moholy-Nagy's European experimental formalism—conspired to cultivate the photographic, and together they wove the shape of modernism in American photography. Moholy, it should be remembered, practically invented photographic education in America, having founded the Institute of Design in Chicago in the 1930s. As the heritage of Stieglitzian Purism and Moholy's revolutionary formalism developed and coalesced over the course of this century, it came to represent photography's claim to be a modern art. Ironically, however, just at the moment when this claim was coming to be more fully recognized by the art world—and I refer to the building of a photographic marketplace in the 1970s—the ground shifted underneath the medium's feet.

Suddenly, it seemed, artists without any allegiance to this tradition were using photographs and, even worse, gaining a great deal more attention than traditional photographers. People who hardly seemed to be serious about photography as a medium—Rauschenberg, Ed Ruscha, Lucas Samaras, William Wegman, David Haxton, Robert Cumming, Bernd and Hilla Becher, David Hockney, etc., etc.—were incorporating it into their work or using it plain. "Photographic-ness" was no longer an issue, once formalism's domain in the art world collapsed. The stage was set for what would come next; what came next we now call postmodernism.[16] Yet one can see the seeds of a postmodernist attitude within what we think of as American modernist photography, beginning, I would argue, with Walker Evans. However much we admire Evans as a documentarian, as the photographer of *Let Us Now Praise Famous Men*, as a "straight" photographer of considerable formal intelligence and resourcefulness, one cannot help but notice in studying his work of the 1930s how frequently billboards, posters, road signs, and even other photographs are found in his pictures.

It is possible to believe, as some have contended, that these images within Evans's images are merely self-referential—that they are there to double us back and bring us into awareness of the act of photographing and the two-dimensional, cropped-from-a-larger-context condition of the photograph as a picture. But they are also there as signs. They are, of course,

signs in the literal sense, but they are also signs of the growing dominion of acculturated imagery. In other words, Evans shows us that even in the dirt-poor South, images of Hollywood glamour and consumer pleasures—images designed to create desire—were omnipresent. The Nehi sign Evans pictured was, in its time, as much a universal sign as the Golden Arches of hamburgerland are today.

Evans's attention to signs, and to photography as a sign-making or semiotic medium, goes beyond the literal. As we can see in the images he included in *American Photographs,* and in their sequencing, Evans was attempting to create a *text* with his photographs. He in fact created an evocative nexus of signs, a symbology of things American. Read the way one reads a novel, with each page building on those that came before, this symbology describes American experience as no other photographs had done before. And the experience Evans's opus describes is one in which imagery plays a role that can only be described as political. The America of *American Photographs* is governed by the dominion of signs.

A similar attempt to create a symbolic statement of American life can be seen in Robert Frank's book *The Americans.* Frank used the automobile and the road as metonymic metaphors of the American cultural condition, which he envisioned every bit as pessimistically as today's postmodernists. While not quite as obsessive about commonplace or popular-culture images as Evans, he did conceive of imagery as a text—as a sign system capable of signification. In a sense, he gave Evans's take on life in these United States a critical mass of pessimism and persuasiveness.

The inheritors of Frank's and Evans's legacy adopted both their faith in the photograph as a social sign and what has been interpreted to be their skeptical view of American culture. Lee Friedlander's work, for example, despite having earned a reputation as formalist in some quarters, largely consists of a critique of our conditioned ways of seeing. In his picture *Mount Rushmore, South Dakota,* we find an amazingly compact commentary on the role of images in the late twentieth century (Fig. 8). Natural site has become acculturated sight. Man has carved the mountain in his own image. The tourists look at it through the intervention of lenses, like the photographer himself. The scene appears only as a reflection, mirroring or doubling the condition of photographic appearances, and it is framed, cropped by the windows, just like a photograph.

Although Friedlander took this picture in 1969, well before anyone thought to connect photography and postmodernism, it is more than a modernist explication of photographic self-referentiality: I believe it also functions critically in a postmodernist sense. It could almost be used as an illustration for Jean Baudrillard's apocalyptic statement, "For the heavenly fire no longer strikes depraved cities, it is rather the lens which cuts through

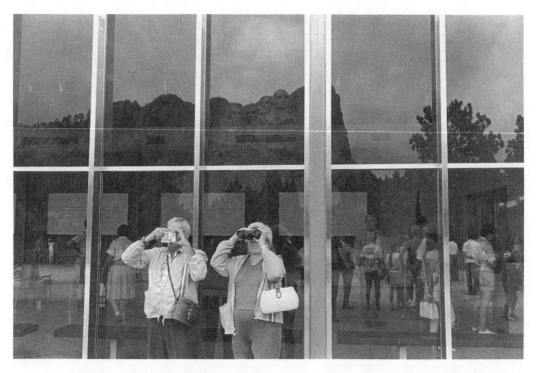

Figure 8. Lee Friedlander, *Mount Rushmore, South Dakota,* 1969. Courtesy Laurence Miller Gallery, New York.

ordinary reality like a laser, putting it to death."[17] The photograph suggests that our image of reality is made up of images. It makes explicit the dominion of mediation.

We might also look again at the work of younger photographers we are accustomed to thinking of as strictly modernist. Consider John Pfahl's 1977 image *Moonrise over Pie Pan*, from the series *Altered Landscapes*. Pfahl uses his irrepressible humor to mask a more serious intention, which is to call attention to our absence of innocence with regard to the landscape. By intervening in the land with his partly conceptual, partly madcap bag of tricks, and by referencing us not to the scene itself but to another photograph, Ansel Adams's *Moonrise over Hernandez*, Pfahl supplies evidence of the postmodern condition. It seems impossible to claim in this day and age that one can have a direct, unmediated experience of the world. All we see is seen through the kaleiodoscope of all that we have seen before.

So, in response to the Heinecken question, there is abundant evidence that the photographic tradition incorporates the sensibility of postmodernism within its late or high modernist practice. This overlap seems to appear

not only in photography but in the painting and sculpture tradition as well, where, for example, one can see Rauschenberg's work of the 1950s and 1960s as proto-postmodern, or even aspects of Pop Art, such as Andy Warhol's silkscreen paintings based on photographs.[18] Not only did Rauschenberg, Johns, Warhol, Lichtenstein, and others break with Abstract Expressionism, they also brought into play the photographic image as raw material, and the idea of pastiche as artistic practice.

It seems unreasonable to claim, then, that postmodernism in the visual arts necessarily represents a clean break with modernism—that, as Douglas Crimp has written, "Post-Modernism can only be understood as a specific breach with Modernism, with those institutions which are the preconditions for and which shape the discourse of Modernism."[19] Indeed, there is even an argument that postmodernism is inextricably linked with modernism—an argument advanced most radically by the French philosopher Jean François Lyotard in the book *The Postmodern Condition: A Report on Knowledge*:

> What, then, is the Postmodern? . . . It is undoubtedly a part of the modern. All that has been received, if only yesterday . . . must be suspected. What space does Cézanne challenge? The Impressionists. What object do Picasso and Braque attack? Cézanne's. What presupposition does Duchamp break with in 1912? That which says one must make a painting. . . . *A work can become modern only if it is first postmodern.* Postmodernism thus understood is not modernism at its end but in the nascent state, and this state is constant.[20]

It is clear, in short, that postmodernism as I have explained it—not the postmodernism of pluralism, but the postmodernism that seeks to problematize the relations of art and culture—is itself problematic. It swims in the same seas as the art marketplace, yet claims to have an oppositional stance toward that marketplace. It attempts to critique our culture from inside that culture, believing that no "outside" position is possible. It rejects the notion of the avant garde as one of the myths of modernism, yet in practice it functions as an avant garde. And its linkage to linguistic and literary theory means that its critical rationale tends to value intellect more than visual analysis. But for all that, it has captured the imagination of a young generation of artists. And the intensity of the reactions to postmodernist art suggests that it is more than simply the latest fashion in this year's art world.

Many people, photographers among them, view postmodernism with some hostility, tinged in most cases with considerable defensiveness. I suspect that the problem for most of us with the idea of postmodernism is the premise that it represents a rupture with the past, with the traditions

of art that most of us grew up with and love. But it is only through considerable intellectual contortions that one can postulate so clean a break. One has to fence in modernism so tightly, be so restrictive about its practice, that the effort hardly seems worthwhile. So perhaps, *contra* Crimp, we can find a way to conceive of postmodernism in a way that acknowledges its evolution from modernism but retains its criticality.

One of the ways we might do this is by shifting the ground on which we define postmodernism from questions of style and intention to the question of how one conceives the world. Postmodernist art accepts the world as an endless hall of mirrors, as a place where all we *are* is images, as in Cindy Sherman's world, and where all we *know* are images, as in Richard Prince's universe. There is no place in the postmodern world for a belief in the authenticity of experience, in the sanctity of the individual artist's vision, in genius or originality. What postmodernist art finally tells us is that things have been used up, that we are at the end of the line, that we are all prisoners of what we see. Clearly these are disconcerting and radical ideas, and it takes no great imagination to see that photography, as a nearly indiscriminate producer of images, is in large part responsible for them.

This essay is the title piece of the author's anthology, *Crisis of the Real* (New York: Aperture, 1990). It also appears in a substantially revised version in *Photography and Art: Interactions Since 1946* (New York: Abbeville Press, 1987).

Notes

1. Jean Baudrillard, *Simulations*, trans. Paul Foss, Paul Patton, and Philip Beitchman (New York: Foreign Agents Series/ Semiotext(e), 1983), 25.

2. In his classic text, *The History of Photography from 1839 to the Present*, Newhall uses the technological development of the medium as a model for describing its esthetic tradition. In other words, by his account the artistic practice of photography progresses in an ascending curve from its primitive beginnings to an apotheosis in the High Modernism of the 1930s. As a result, in his 1983 revision of the history (Museum of Modern Art, New York) Newhall is unable to account coherently for photography's path since. Anything after Weston and Cartier-Bresson is, in his eyes, *prima facie* "post."

3. I have been unable to ascertain a "first use" of the term *Post modern*, which is also encountered as *Postmodern* or *Post-modern*, but it almost certainly dates from the late 1960s. In architecture, it is most often associated with Robert Venturi, the advocate of vernacular forms. In "On the Museum's Ruins" (*October* 13), Douglas Crimp cites the usage of "postmodernism" by the art critic Leo Steinberg in 1968, in Steinberg's analysis of the paintings of Robert Rauschenberg. But the term's popularity in the art world came much later; as late as 1982 John Russell of *The*

New York Times could call postmodernism "the big new flower on diction's dung-heap" (August 22, 1982, Section 2, p. 1).

4. Charles Jencks, *The Language of Post-Modern Architecture* (New York: Rizzoli International Publishers, 1981), 5.

5. See Sally Banes, *Terpsichore in Sneakers: Post-Modern Dance* (New York: Houghton-Mifflin, 1980), 1–19.

6. Douglas Crimp, "The Museum's Old, The Library's New Subject," *Parachute* 22 (Spring 1981): 37.

7. See Derrida's seminal work, *Writing and Difference* (Chicago: University of Chicago Press, 1978), a collection of eleven essays written between 1959 and 1966.

8. Terry Eagleton, *Literary Theory: An Introduction* (Minneapolis: University of Minnesota Press, 1983), 96.

9. Ibid., 108.

10. Ibid., 129–30.

11. Rosalind Krauss, "Sculpture in the Expanded Field," *October* 8 (Spring 1979): 42.

12. "If we are to ask what the art of the '70s has to do with all of this, we could summarize it very briefly by pointing to the pervasiveness of the photograph as a means of representation. It is not only there in the obvious case of photo-realism, but in all those forms which depend on documentation—earth-works . . . , body art, story art—and of course in video. But it is not just the heightened presence of the photography itself that is significant. Rather it is the photograph combined with the explicit terms of the index." Rosalind Krauss, "Notes on the Index: Part 1," *October* 3 (Spring 1977): 78.

13. Fredric Jameson, "Postmodernism and Consumer Society," in *The Anti-Aesthetic: Essays on Postmodern Culture,* ed. Hal Foster (Port Townsend, Wash.: Bay Press, 1983), 114.

14. See, for example, Douglas Crimp's essay "Appropriating Appropriation," in the catalogue *Image Scavengers* (Philadelphia: Institute of Contemporary Art, 1982), 33.

15. Richard Prince, *Why I Go to the Movies Alone* (New York: Tantam Press, 1983), 63 and 69–70.

16. A more elaborated and political view of art photography's waning dominion can be found in Abigail Solomon-Godeau's "Winning the Game When the Rules Have Been Changed: Art Photography and Postmodernism," *New Mexico Studies in the Fine Arts,* reprinted in *Exposure* 23:1 (Spring 1985): 5–15.

17. Baudrillard, *Simulations,* 51.

18. For further evidence of photographic imagery's impact on Pop and concurrent movements see the catalogue to the show "Blam," organized by the Whitney Museum, which surveyed the art of the sixties.

19. Douglas Crimp, "The Photographic Activity of Postmodernism," *October* 15 (Winter 1980): 91.

20. Jean François Lyotard, *The Postmodern Condition: A Report on Knowledge,* trans. Geoff Bennington and Brian Massumi (Minneapolis: University of Minnesota Press, 1984), 79. The emphasis is mine.

THE VIEWLESS WOMB:
A HIDDEN AGENDA

SUZANNE SEED

*One response to the crisis of boundaries is a desperate
attempt to hold fast to all existing categories, to keep all definitions
pure. . . . The opposite response is to destroy, or seek to destroy, all
boundaries in the name of an all-encompassing oneness. . . . These two
absolute responses share a schematic disdain for man's
symbol-forming connection with history. . . .
This longing for a "Golden Age" of absolute
oneness . . . not only sets the tone for the restoration
of the politically rightist antagonists of history . . .
it also, in more disguised form, energizes that transformationist
totalism of the Left which courts violence in a
similarly elusive quest.*
Robert Jay Lifton
Boundaries[1]

WHEN HUMANS FIRST WALKED UPON THE MOON, I WATCHED
the live television transmission of that walk with my young
daughter, who seemed not to share my excitement at the
event. Assuming that she thought the telecast version a
fiction, I led her through the length of our house and out
onto our porch roof into the night, with its real moon.
"There, *that* moon," I told her, believing I was giving her an experience
she would always remember. "I know it's that moon, Mom," she said,
looking at me with surprised interest, and still not at the moon. It was not
the moonwalk she would remember, but the experience of being whisked
through the house and out into the night on the apron strings of her
mother's enthusiasm. She knew as well as I what the telecast was of, that
even if the transmission were faked, the event could happen. She simply
was not surprised or interested at that moment in its happening, for not
only did she take such technology for granted, she was at a kinetic stage
of her childhood when only what happened in the immediate-close-at-
hand was of interest to her.

Seeing myself through her eyes, I began to examine my own reaction to
the moon event. What had I wanted to give my daughter, in making the
larger world as immediate for her as the close-at-hand? What did I seek
for myself? Initially, what kept me out there on the roof was a desire to
be closer, see more intimately. I was excited to be somehow in the same

space as the moon. Alone in the dark countryside, I was, miraculously, technically present at the moon event each time I stepped from the telecast inside into the presence of the moon outdoors.

Yet what was the true nature of this immediacy? The image I was seeing outdoors was as much a transmission as a television image. The light I saw had not left the moon the instant I saw it, but had traveled, just as the light of stars long dead travels, reaching us only after the stars themselves are gone. And no matter how close I might get to the moon itself, my vision of it would be transmitted by my body's own mechanics of seeing; I saw *whatever* I saw by means of those incremental pulses that are human sight, and only after light had traveled from front to back of my focusing mechanisms and through my brain's translations. And just as both the moonlight and the telelight had been transmitted, by wave, ray, and pulse, the information which swelled the event into such importance for me had been transmitted, through the complex cultural technology of language and images.

Thus I knew through *agency*—agency of eye and mind, culture and technology. I knew through *media,* organic and inorganic, and through media alone. And I knew that even if I were to visit the moon itself, I would require a transmission, through media of travel, and would experience the moon from the mediated indoors of a spacesuit, with the same mental and bodily media that I must use on earth. To be any closer than these media could bring me, I would have to be a part of the air itself, for some form of mediation is always as close as we get. The real itself is always mediated. *Yet this does not make it less real.*

Thus, imagining its televised visitors while looking at the moon did not replace what I really saw with what I had seen on television. Each visual experience replaced the other. The telecast moon event had not spoiled the mystery of the moon, but brought me back to renewed wonder toward it. Seeing by-means-of was not seeing "through a glass darkly" but was seeing in the only way possible. To be separate and autonomous was a condition of existence, and mediation a condition of that autonomy. Total immediacy, as a steady state, could come, if ever, only before birth and after death. To be just this close and no closer was close enough. To exist through mediacy, in contingency and finitude, was simply what was, and beautiful.

But this attitude ran counter to the prevailing ideology of those sixties times: a be-here-now quest for total immediacy. Worshippers of immediacy craved an Eden of immersion and fusion, an ultimate place that knew no other: a viewless womb. This viewless-womb ideology was uncomfortable with transmission and travel, views and images, for being media and not the "thing itself." Since immediacy was worshipped, mediacy was condemned, and images were singled out as the worst form of mediation.

Apollo 17 view of Earth, courtesy of NASA.

Though this trend began with a favoring of photography for its seeming immediacy, it soon began to disparage photography as most obviously mediated. Even now, the trend is to criticize visual media, especially photographic ones, as media *per se*, ignoring use and content. Thus, criticism of image-media, and especially photographic ones, has become a self-serving academic shell game, based on unexamined assumptions and hidden agendas. At the heart of this game is not the political message that it pretends to, but an irrational human longing which politics does not address but only manipulates. Though we associate this ideology with the sixties, it was never merely a sixties phenomenon; it is perennial. It inhabits both Right and Left,

Modernism and Postmodernism, bubbling up from a contradiction in the human psyche that is so familiar it is almost never fully recognized or deeply examined. Yet what edifices are built upon it! At present this ideology figures not only in productions of popular and alternative culture, but also in the work of many widely discussed intellectuals, among them Roland Barthes, Jacques Lacan, Susan Sontag, and Jean Baudrillard. It is hidden within many current Isms, especially the poststructuralist critique of representation, and it fuels numerous French theories of deconstruction, discourses of Desire, and neo-Nietzschian histrionics.

This viewless-womb ideology is dangerous, for being a covert form of the very totalisms it condemns, it slithers back and forth between Left and Right in a miasma of charged code words steeped in affect and aimed at the unconscious. And in each of its incarnations, this viewless-womb ideology gives birth to an iconoclastic scapegoating as old as humanity. Within this iconoclasm, the sin of Adam was not so much eating the apple as evolving from an immersed, preconscious existence to climb the apple tree and gain a perspective view. Thus perspective view becomes the original sin, the West becomes Adam, media become fallen modes of expression, and alienation a punishment for their use. Photography, which cannot help but give us a perspective view, is currently chosen by this myth to play the role of the snake.

I am curious about the roots of this attitude. Recalling the Apollo moon landing, I remember most clearly how media then restored lost immediacies to me, rather than alienating me from immediacy. Traveling mentally in the darkness, I had returned to a time when my ancestors lived more out-of-doors than in, and back again, reclaiming a relation to the sky that indoor living had made me forget.

Rather than forsaking earth for a transcendant sky, I had, by this imaginary, mediated flight, reclaimed my full experience of earth, for earth is set in sky. A long-lost sense of geographical direction returned. A truer sense of distance developed. Far from feeling we had conquered space, I felt more grounded within it. And I suspect the astronauts did, too, for the circuit of those early trips to space had a classic sort of enlightening feedback: its voyagers reached for a new plateau as if to become new beings, and were returned, not new beings but slightly more evolved and conscious selves.

In such travel we realize that media and travel are inseparable, and that images make travelers of us all. As functions of our curiosity, images are natural to us as well, an essential part of human consciousness, and of the Nature that evolved human consciousness. And images are neutral, in that our frame of mind creates their frame of use. Thus in the proper frame of mind, space travelers might gain the perspective of a very long view of

things from their physically very long view. The first moon visitors were powerfully challenged to do so by their unique experience.

And one of the most important agents of that experience was seeing the earth from space. This was something we, as well as the astronauts, had already done before their trip took place. We had seen the earth from space through the mediacy of Applications Technology Satellite Three, when in November 1967, it sent back a color photo image of—for the first breathless time—the whole Earth. Thus in watching the moon, we knew someone there watched back, and knowing what he saw, from having seen it ourselves, we were able to vividly imagine how it must look live. Feeling ourselves seen as part of Earth, we knew yet again that we are a part of it as if part of an organism, evolving in concert with it. Though we had known this before, having the image gave a kind of physicality to the knowledge, the kind we have in seeing an X-ray of our own bones. For a people to have such an image is to have evidence of what they are and are not, evidence which they need.

Whether or not everyone felt space travel itself was right at that time, there was no protest against the image itself. Not until recently that is, when none other than the *Whole Earth Review* published "Use and Misuse of the Whole Earth Image," by Yaakov Jerome Garb. In the world according to Garb, any use of the whole-Earth image is ultimately a misuse, and photographic images, for him, are especially culpable. Because the whole-Earth image, like any word or image, can be used toward "alienation and escape" as well as "perspective and insight," it is therefore, for Garb, a "questionable image" with "inherent flaws."[2] Moreover, this argument is extended, by implication, to all images, all stepping back, all perspective:

> When we step back to get a "better view" we create . . . psychic aloofness. The landscape perspective gives rise to . . . detachment and spectatorship. . . . When we look at a "landscape" we are disengaged observers of rather than participants in the reality depicted. . . . If the landscape perspective leads to alienation, then the supreme landscape—the whole Earth image—leads to extreme alienation from the Earth. . . .
>
> Our technology enables us . . . to see any place on earth and even beyond . . . [this has] diluted our human presence. . . . Living in place . . . was the norm for ancient and primitive cultures. . . . The "at homeness" and belonging that pre-modern cultures felt toward the earth was accompanied by their sense of living in a closed universe . . . the world of the bushman . . . was contained in a few hundred square miles. . . .[3]

Garb suggests neither balance nor middle ground. For him, immersion

is good, distance bad; primitive good, modern bad; "direct" experience good, mediated experience bad. This makes his ideal the preconscious state, where there are no thoughts, but only participation; no options, but only instinctive action; no media, but only immersion. He valorizes a parochial world of short perspective in which one is the center of the world, one's own group are the real human beings and the rest is perimeter. It is the totally subjective self image of newborns, and of newborn humankind. It is the fantasy of a viewless womb where nothing has yet been out of reach, a fantasy of hunt-and-gather abundance with no need for planning and agriculture. It ignores the fact that resources are finite. Its closed, circular, uroboric economy cannot allow the spiral of evolution or invention, though Nature itself tends to spiral, evolve, and invent. It is an idea based in a nostalgic conservatism posing as liberation.

When Garb says of the whole-Earth image that "this banner of perspective and insight is also—just below the surface—a banner of alienation and escape from the earth," he is asserting that perspective and insight are only a surface gloss, beneath which lies a true core of alienation and escape.[4] It is the challenge of perspective and insight themselves that he sees as alienation, for one cannot have these and still be fully immersed in the immediate. Since images make travelers of us all, his is nostalgia for a preimage existence.

This covert fear of *any* image becomes clear when Garb states specific criticisms of the whole-Earth image, naming what he calls its "inherent flaws," which, according to Garb, are only compounded, not created, by misuse. Among these are the fact that the image is "small, comprehensible, two-dimensional . . . machine made . . . external, distant, static."[5] Each of these "flaws" is something that no image can help being. And with his inclusion of "machine-made" as a "flaw," he criticizes the image for being something that no photograph can help being as well. He criticizes the whole-Earth image for being "small, comprehensible, two-dimensional" while it tries to depict a reality that is unfathomably immense and complex. Yet to be as immense and complex as what it represents, any image would have to be the thing itself. He criticizes the whole-Earth image for being limited as if any representation could be as comprehensive as the Earth itself. He criticizes it for showing the Earth as "static," which no still image can help being. He criticizes it for showing the Earth as "distant," and for being "external" to the Earth, which it must do and be if one is to show the whole Earth at all. Every image becomes for him a graven image, simply for not being the thing itself. The covert wish here is just that: for nothing to be more than the thing itself, nothing to be more or less or added to the thing itself, for awareness to stop at the thing itself, and not evolve,

not travel, not transmit, and for us never to realize our own mediacy, contingency, and finitude.

A very similar viewless-womb theme appears also in a major pop fantasy, Arthur C. Clark's *2001*. From a womb-among-the-galaxies, the star-child hero, an embryo god, is free from all media and vision. He is "beyond the necessities of matter," has "senses more subtle than vision," and wields godlike powers as a result.[6] Yet at the same time he remains a cozy captive of the gods who cradle him.

> . . . He would never leave this place where he had been reborn, for he would always be part of the entity. . . . Here, time had not yet begun. . . . He would never be alone. . . . He was back, precisely where he wished to be. . . . He was master of the world.[7]

The image of the star-child and his Earth-toy is Garb's worst nightmare, yet the fantasy mirrors Garb's own. Garb simply substitutes the womb of a mother god for that of a father of hermaphroditic god. And how alike are these wombs! All magically give us our hubristic heart's desire, yet keep us in comforting thrall.

Zoe Sophia, from whom Garb evolved his argument, also fails to see the futility of simply turning the tables. In "Exterminating Fetuses: Abortion, Disarmament, and the Sexo-Semiotics of Extraterrestrialism," Sophia sees such fantasies as *2001* purely as a glorification of male values. She views "ambivalent relations to life and death" as strictly a male failing and sees "technologies of transport, communication and information" as masculinist.[8] She thus excludes women from most of the core of our human condition. Technologies of "transport, communication and information," according to Sophia, "allow the object to be constructed and separated from its appearance."[9] In other words, they allow us to *represent*, to use words and images. And this itself she sees as a danger, for she implies that if we dare to represent, the world will be "hollowed out," that if we dare to employ "technologies of transport, communication and information," we will inevitably "cannibalize" reality by representing it at a "distance," and if we dare to travel we will inevitably exploit.[10] Her solution of "nonbiological parenting" sounds very much like the nonbiological parenting of Clarke's star-child, which she condemns as disdaining women.[11]

What Sophia's feminist version of this ideology preserves is only the phallic game it seems to condemn. For its choices are adversarial, either/or, like those of the game it protests: choices of immurement or alienation, servility or exploitation, primitivism or Star Wars, mother or father gods.

If to represent is to hollow out, if to travel is to exploit, if the Earth is a

goddess-womb whom we dare not represent without blasphemy, then by this logic of Garb's and Sophia's, we dare not create any image of Earth. But there is a hidden agenda in their taboo against representing it. Notice that though the whole Earth has long been represented, it is the *photographic* representation that stirs their iconoclastic impulses. Easy jabs at the machine-made nature of photographs bolster these writers' hidden agenda. If one can make such a benign, important, and popular photographic image as the whole-Earth image seem alienating, then it is an easy job to make photography *as such* seem an alienating, greedy pornography of reality. And from there, one can imply the same of all images, and finally of our image-generating consciousness itself. And if one can make an exciting and historic form of travel seem a sacrilege, it is a small step toward making travel *as such* suspect. Like Plato's brutal reductions of art, such rule-or-ruin strategies are reactionary, whether Left- or Right-Wing inspired. Behind them is the wish for a viewless womb.

This ideology is present also in more sophisticated critiques. And a particularly poignant example occurs in Roland Barthes, one of whose primary themes is the desire for an unmediated world, a covert demand for a viewless womb. Linked to this, predictably, is a profound ambivalence toward photographic images, expressed in slippery arguments posed as a drama of seduction and abandonment. His *Camera Lucida* reads like a stylishly tragic romance of betrayal by, and masochistic devotion to, photographic images. It ends in a dramatic plea for their abolition.

Barthes begins the book with hope of a refuge in photography, which he sees as a primitive, mindless form, "simple, banal" and "without culture," a medium which he hopes will allow him to escape himself: "I wanted to be a primitive without culture. . . . I am a primitive, a child, or a maniac: I dismiss all knowledge, all culture, I refuse to inherit anything from another eye than my own."[12]

Barthes styles Photography as a refuge from his life of discourse, a refuge which does not make observations, a refuge like his mother, who, he tells us, "never made a single observation." Because his mother did not observe, or "*suppose* herself" or "struggle with her image" as he did, he believes that therefore she possessed a "sovereign innocence."[13] And because he "never 'spoke' to her, never 'discoursed' in her presence" he imagines that he and his mother both believed "without saying anything of the kind to each other" that this wordless, imageless vacuum was "the very space of love."[14]

In this observationless, womblike "space of love," Barthes hopes to live in an unmediated present, where one can suspend metaphor, imagery, language itself; where one need not maintain perspective, but may follow only one's private whims. Here, he wants to believe, he can be a "primitive, a child, a maniac," avoiding awareness of death, contingency, finitude,

and mediacy. But reality intervenes, for one cannot escape death, contingency, finitude, and mediacy.

Barthes blames his desired photographic refuge for not exempting him. He tells us that after his mother's death he was seeking her image in old family photographs. He finds an image of her at age five and wants to "enlarge this face in order to see it better, know its truth . . . finally reach my mother's very being . . . to *know* at last."[15] Because the photograph cannot satisfy such magical, primitive-child-maniac thinking, cannot erase the knowledge that his mother is dead, he declares that "the Photograph is violent . . . because in it nothing can be refused or transformed. . . . Photographers . . . are agents of death."[16] There follows his now-famously premonitory despair: "what life remained would be absolutely and entirely without quality. . . . At the end of this first death, my own death is inscribed. . . . I am Goland exclaiming 'Misery of Life' because he will never know Melisande's truth."[17] His remedy is to kill the messenger: "Let us abolish the images, let us save . . . immediate Desire."[18]

Barthes wants a medium without time, without future, yet finds it is acceptance of time which allows us to bridge distance. He demands that photography be "without culture," yet then complains that because it is "without culture," it cannot "transform grief into mourning."[19] He sees his mother as a being without culture, one who never supposed or observed, one to whom one need not even speak. At the same time, he agonizes that he never knew her. Yet one *cannot* know a person who never observes, supposes, or speaks. He wants not to inherit or bequeath, but to exist only in the present, a perpetual child of his mother. Yet he bemoans the result: because he had "not procreated," his death would be "total, undialectical": he would be the "final term" of his lineage.[20] To be a parent is to accept time, mediacy, finitude, and death, and because he could not accept these, and clung to a fantasy of himself as eternal child in eternal communion with his mother, he feels he has died when she does.

But Barthes will not admit that what he reaps is merely the result of his own faulty definitions. Instead, he adopts the fashionable theory that images are at fault—that we have fallen from Nature into Culture from which there is No Exit, and that most fallen of all are advanced societies with their photographic images and supposed culture of capitalism.[21] Yet it is not any of these which reduces Barthes to enlarging the photo of his mother again and again, hoping to reach behind the emulsion to draw out her soul. His obsession reminds us that idolatry is not the making of images, but the demand that they be magic, and this demand can be made of words as well. Barthes's magical thinking preserves his hope for a viewless womb by making the photographer an "agent of death," ignoring the fact that all of life is such an agent.

Ironically Barthes, who abhorred absolutisms, is caught in one. He longs to find a womb of absolute immediacy, as he describes it in *A Lover's Discourse:*

> Absolute appropriation . . . is fruitful union. . . . I want there to be a point without an *elsewhere*, I sigh . . . for the consistency of the Same . . . that each of us be without sites . . . without limits . . . what I dream of is all the others in a single person. . . . The lover's constant thought . . . *the other owes me what I need*.[22]

This point without an elsewhere, without sites, limits, or any unappropriated other: this is clearly a viewless womb, where there are no perspectives to challenge one's star-child status.

The seductive absolutism of this viewless-womb ideology had one of its most elaborate recent incarnations in the writings of Jacques Lacan, an enormous influence in France during Barthes's key working years. Though Lacan seemed to be giving a new slant on things, he was only offering new couture for an old fantasy. And he did this primarily through his dramatized interpretation of Freud's concept of the mirror stage:

> This event . . . can take place . . . from the age of six months. . . . The I is precipitated in a primordial form . . . this form situates the agency of the ego . . . in a fictional direction. . . . The total form of the body by which the subject anticipates in a mirage the maturation of his power is given to him . . . in an exteriority. . . . The mirror stage is a drama . . . whose internal thrust is precipitated from insufficiency to anticipation . . . and lastly to the assumption of the armor of an alienating identity, which will mark with its rigid structure the subject's entire mental development. . . . This moment . . . tips the whole human knowledge into mediatization . . . and turns the I into that apparatus for which every instinctual thrust constitutes a danger.[23]

As Lacan sees the mirror stage, it marks our first awareness of created images, of something standing for something else, of the realm of imagination, of metaphoric thinking. To think metaphorically, at one remove, is to become aware of separation and autonomy, of our human condition. Lacan sees this self-awareness as a tragic fall which ejects us from a supposed Eden of autoerotic autism, a steamy bath of disconnected, polymorphous parts. For Lacan, every mirror stage, sick or well, is an unavoidable Fall, from which words only partly rescue us. Every use of imagination loses us in a play of reflections, every recognition of our image becomes a capture.

Other psychiatrists disagree, seeing maturation as a sometimes blocked

unfolding of each stage into the next, rather than a lapsarian melodrama. They see a successful mirror stage as creating the best forms of awareness available to us as humans. The infant's behavior in front of the mirror, stretching itself up and reaching, is not a deluded mimicry of adulthood, as Lacan believed, but a social sharing of the out-of-reach: mirrors, spectacles, imaginings. And it is an investigation, a reaching to touch, to greet, to investigate boundaries, to understand where one leaves off and the other or the image begins. *For the mirror stage is a boundary-identifying stage.* Delusion and narcissism are not effects of the mirror stage, they are a failure to successfully complete it. They are a regression to a *pre*-mirror stage, to a viewless womb of fusion and immersion, of the dissolved boundaries of schizophrenia, of the iron boundaries of autism. The narcissist has a weak ego, not a strong one. He or she is frightened of autonomy and seeks a viewless womb where closeness is free, gratification immediate, oneness absolute.

Lacanians evolved this attitude into a specious political critique, in which the political West was individualistic and therefore evil, while the political East promised a communal, viewless womb, portrayed as our rightful place. They romanticized schizophrenia as a viable political method and fantasized regression to the preoedipal state as a challenge to patriarchy. If the preoedipal state was Eden, then the mirror stage was a Fall, images the Snake, and the visual mode a step down from a superior natural state.

To bolster this prejudice, Lacanians frequently quote the Lacan of *Four Fundamental Concepts of Psychoanalysis,* in which he relies upon Judeo-Christian iconoclasm and primitive superstition:

> This appetite of the eye that must be fed produces the hypnotic value of painting . . . this value is to be sought in that which is the *true* function of the organ of the eye, the eye filled with voracity, the evil eye. . . . There is no trace anywhere of a good eye, of an eye that blesses. What can this mean, except that the eye carries with it the *fatal function* of . . . a power to separate. . . . The evil eye is . . . that which has the effect of arresting movement and *literally,* of *killing life.* . . . In the scopic field . . . the subject is determined by separation. It is in so far as *all* human desire is based on castration that the eye assumes its virulent, aggressive function. . . . In the Bible and even in the New Testament, there is no good eye, but there are evil eyes all over the place [italics mine].[24]

What a mine of material for iconoclasts! According to Lacan, all desire is based in castration; all seeing must therefore be virulent, aggressive; the eye's true function is evil, voracious, fatal. And why is the eye so "evil," so "alienating?" Because, for Lacan, it reveals that we are not only linked,

but also separate, for his most vehement existential complaint is that: "You never look at me from the place from which I see you."[25] In other words, the eye lets us see our autonomy, our natural boundaries. It grounds us, showing us we cannot be in two places at once, seeing and being seen in an autoerotic womb. Its power to focus and separate is a healthy one, but Lacan implies that it is somehow an injustice, a "castration" which makes looking and being looked at entirely a matter of master-slave domination, power, and privilege:

> As soon as I perceive, my representations belong to me . . . this *belong to me* aspect of representation, so reminiscent of property . . . goes so far as to reduce the subject apprehended . . . to a power of annihilation. . . . The picture, certainly is in my eye. But I am not in the picture . . . the depth of field . . . grasps me. . . . The gaze of the painter . . . claims to impose itself as being the only gaze.[26]

The current poststructuralist critique of representation elaborates on just these Lacanian complaints. It borrows from his supposed Marxism the idea that property is theft, and from his Freudianism the idea that culture is a Fall. And it concludes that *anything* which *belongs to one*, even identity, must be a form of property, therefore inauthentic. Thus the very existence of individual points of view becomes an alienation, every representation becomes a domination, every gaze a rape, every identity a theft. One-point perspective is seen as inherently an apparatus of power, and thus photography, which cannot avoid one-point perspective, is a prime target for the critique.

According to the critique, we are dominating simply by gaining perspective, exploiting merely by using, aggressing merely by asserting, appropriating merely by surviving. The critique sees only in terms of master and slave, like Lacan; worship or exploitation, like Garb; possessed or possessing, like Barthes. The critic Herbert Blau has pointed out that within such current continental theories, a self-dramatizing sixties consciousness has "surfaced again in *theory* as a new erotics of discourse." He reminds us of that consciousness's "mean-spirited binary thinking . . . a self-cancelling politics . . . with an inability to sort out, as nostalgic academics still can't—the undeniable instances of oppression from the stereotyping of authority."[27]

Though the critique of representation seems at first to be Marxist, or feminist, this is only very superficially so. Its ostensible objective—to show us how meaning is made—is obscured by its more seductive subtext: the ideology of the viewless womb. For the primary complaint of the critique, as of Lacan's, is that *anyone* should be an observer, *anyone* observed.

In the United States, the most popular proponent of these views has been Susan Sontag. For Sontag, "to photograph people is to violate them, by seeing them as they never see themselves, by having knowledge of them they can never have; it turns people into objects that can be symbolically possessed . . . to photograph someone is sublimated murder."[28] How closely this echoes Lacan's "You never look at me from the place from which I see you," and his view of the visual function as aggressive. Sontag simply transfers his views to photography, ignoring the fact that to look at others at all, with or without a camera, is to see them as they cannot see themselves! If all picturing and representation are domination, then it is easy to portray the camera as especially evil. And it is easy to equate users of photographic images with capitalist oppressors, as Sontag does in *On Photography:*

> . . . even an entirely accurate caption . . . cannot prevent *any* argument or moral plea which a photograph is intended to support . . . from being qualified by the acquisitive mentality implicit in *all* picture-taking. . . . [Photography's] *main* effect is to convert the world into a department store . . . in which *every* subject is depreciated into an article of consumption. . . . A capitalist society requires a culture based on images. . . . To consume means to burn, to use up . . . images consume reality [italics mine].[29]

Where Barthes calls upon us to abolish the images, Sontag demands that we apply an "ecology" to them. How does one "apply the conservationist remedy" to what she admits is an "unlimited resource"?[30] Obviously her "ecology" is a euphemism for censorship and limitation, a Platonist distrust of images *per se*. It is revealing that her either/or attitudes toward politics are tempered by travel and experience, but her attitudes toward the visual remain simplistic and doctrinaire. There is something distorted in her idea that to consume is to "burn, to use up." This idea ignores the cycles of nature, and the necessity of consumption to life. It is oddly similar to her equally skewed idea, stated in an interview, that "to *live* is an aggression."[31] Though this statement was made by her in defending the excess of negative words, such as *aggression*, used against photography by her, it is in keeping with all her writing. She seems to feel overwhelmingly that merely to be separate and autonomous is to be devouring and aggressive. And thus she admires the primitive and the fanatic, expressing frequent wishes to overcome alienation through ecstatic community, romanticizing the concept of the Great Forgetting. For her, to be mediated is to be violated. Yet what do media per se violate? They merely lead us from the womb of unknowing, offer us an alternative to a permanent Great Forgetting. They eject us from limbo, not heaven.

Sontag's characters in *Death Kit* seem to speak for her in seeking an imageless Eden:

> It occurs to Diddy that perhaps all his terrors derive from the mixed
> blessing of being able to see. Because he can see, he can perceive the
> world abstractly. At a distance. That's what Diddy has to unlearn.
> Disband his imagination . . . to be in the present; to be without
> imagination, unable to anticipate anything, to be.[32]

Yet to avoid imagination in order simply "to be" is to avoid *human* being. Sontag ambivalently realizes this, thus her "ecology" would mainly limit others' spheres. Her own version of simplicity is never without books and cities, which she cannot renounce, even though, oversaturated, she wishes to jettison her critical consciousness, her perspective.

For it is perspective that she covertly fears, as do Garb and Sophia, Barthes and Lacan, and numerous critics of representation. What is the root of this fear, this longing for a viewless womb? How do we put this fear of perspective into deeper perspective? How do we defuse it?

Certainly much of its strength comes from our fear of life and death, of contingency and finitude, and from our rebellion against them. But the attitude is most dangerous when it romanticizes that rebellion, glamorizing Dionysiac, anarchistic revolt against the very mediacy and balance that sustain life itself.

This longing for a prelapsarian viewless womb has been institutionalized in politics and religion, nationalism and war. It creates a blind spot in every theory, a worm at the heart of every radical politics, a black hole within every religious orthodoxy, a flaw at the center of every utopia, a fault in the foundation of every chauvinism. These gaps are found within a theory in those areas that call upon faith, magic, or romance. They are gateways through which the theorist expects a god to step—seductive, magical vacuums that represent a viewless womb. Whatever element is made magical—laissez faire, the proletariat, the literal bible, holy war—is the element that represents a god-womb. And into such vacuums steps totalitarian terror. It is exactly such a blind spot in Freud which Lacan fetishizes—the idea of a Fall. And those who adopt Lacan seek out and embrace his melodramas upon the same theme. Above all, viewless-womb ideologists of the Left lean on Marx—here too, at his weakest point, a similar myth of Fall and Reenwombment. Especially since World War II, neo-Marxists have clung to this area of Marx's thinking—his liberation theory—with its fantasy of a totally conflictless, divisionless society, and its justifications in the untestable prehistoric past and posthistoric future. Alvin Gouldner in

Against Fragmentation, has located the viewless-womb premise in Marx's theory:

> Marx's epistemology, its sociology, and its politics all share a common
> deep structure, reunification of a fragmented world; yet . . . this
> reunifying rationality is not without its own new contradiction. . . .
> [Marx] assumes that there can be unity only when things have the same
> or a common substance permeating the whole. . . . Marx's abiding aim
> to transcend "alienation" is a characteristically romantic effort. . . . The
> call to wholeness is tainted by a romanticism which . . . implies that all
> share the same ideology and morality. . . . The quest for totality
> expressed a longing for a vision that transcends the multiplicity of
> diverse and shifting perspectives—seeking, indeed to vanquish
> perspectivity as such.[33]

Marx's romantic wish to vanquish perspectivity as such is a search for a womb with no view. Like Barthes's "place without an elsewhere" it would be a space of no perspective, no specialization. And of *no exit*—for it pre-plans the ultimate state of humankind. A society that lacks difference is not a society at all, but a mass of cells. Just as Marx spoke of our inability to exist except as social beings, so in turn is society dependent for its being upon individuals being individual. As Marx and Engels imagined the future, it was to be a polymorphous, primitive, posthistoric world. And Marx, early and late in his career, was captured by visions of a womblike world of radically unspecialized labor, radically unpaired, communal sex, and radically unfamilial, communal childraising. In this world, he believed, society would, by magically regulating whatever productions he chose to produce, allow him to:

> . . . do one thing today and another tomorrow, to hunt in the
> morning, fish in the afternoon, rear cattle in the evening, criticize after
> dinner, just as I have a mind, without ever becoming hunter,
> fisherman, shepherd or critic.[34]

In his imagined world, Marx can pursue all the favorite masculine pursuits without the realities of skill and dedication that make each a specialization. In reality, his world would not be a society at all, but a world of separate, amateur subsistence farmers who base their timetables upon their own desires, ignoring the fact that cattle, for example, have their own timetables which dictate a rancher's time. In such a world, one need not mention child care, as Marx does not in his daydream of communist society, for

there he is the child, enjoying the benefits of society, "just as I have a mind," without the specializations that even minimal society requires, trusting his society to check and balance itself, since it has sprung from his imagination. Such extravagant faith creates a vacuum. Marx's vision trusts the group at large, the state or party, to the exclusion of individuals, and trusts a diffuse group-as-a-whole even with child care to the exclusion of particular parents; no checks and balances exist, even though the group, like the individual, is fallible and human. It can never be the maternal god-womb this star-child aspect of Marx sought, any more than the great leader can be the paternal god-womb sought by right-wing theorists. This hidden agenda, the quest for a god-womb, is the blind spot, the vacuum through which totalitarianism enters a theory and then begins to repress what can challenge it—travel, media, and imagination. For its womb must be without perspective, a womb with no view. The vision of a totally conflictless society ignores those inherent conflicts which cannot be legislated away and therefore leaves us at their mercy. And because adherents to such views believe conflict will not exist in their planned future, they feel license to destroy those who are not true believers. Such theories allow no checks and balances, no safeguards against abuse of power, because to admit we need checks and balances is to admit we will always need them; it is to admit we will never achieve our final answers, our viewless womb.

Such hopes for what Robert Jay Lifton has called the "Golden Age of absolute oneness" fuel reaction left and right, as Lifton has warned. The Left denies all boundaries, seeking a womb of boundariless schizophrenia; the Right craves iron boundaries and a womb of autistic stasis. They demand to be everywhere and nowhere, to the same effect. They want, like Barthes, that "each of us be without sites"—and without sights as well, for it is characteristic of fundamentalisms and orthodoxies that they are puritanical and iconoclastic, fearful of imagination, of perspective. There is no room within them for that most consciousness-raising aspect of media, especially of photo-media—the perspective view.

Yet we need this perspective view. It is part of what makes us human and may have evolutionary significance far beyond our current intuitions. There *are* ways to use media well. There are clues within travel, photography, and the whole-Earth image.

For whatever implications of conquest and escape clouded the Apollo journey, the central motive remained: the irrepressible and necessary human need to step out of immersion and immurement, to take a look around and gain perspective. It is a crucial need, essential to evolution, insight and understanding. It is a natural human function. *Every voyage is not a conquest, as every gaze is not a rape, as every image is not a loss.* In fact, an

image, even a photographic image, may sometimes be vitally necessary.

For photographs have an ontological function as well as the obviously anthropological, descriptive one they are often narrowed to by iconoclasts. Photographs are an extension not just of our sight, but of our thought. Like human thought itself, they use displacement, metaphor, and analogy; they step back to give us perspective and orientation. They allow us to evolve. When photography was first invented, all of humanity began to travel, vicariously. Those who had never dared leave their place began to see travel as a possibility. It is this quality of photography that makes it such a compelling subject for critics, and a threat to fundamentalists and totalitarians. Behind their attacks is a fear of how the photograph makes travelers of us all, how it allows us a perspective view, Westerners or not, of the whole Earth. When critics misrepresent representation itself, especially at its visual onset in the mirror phase, they misrepresent something vital; and this can be demonstrated most clearly by a look at *real* mirror phases rather than theoretical ones.

Think of your own (it is often one's first memory). Mine recurred to me at the beginning of this essay, when I described moon-gazing from a darkened porch roof. It is a memory of the night sky. At the age of two or so, I was taken out onto our doorstep one night by my father to see fireflies, which outnumbered and mingled with the stars. Just as exciting to me were larger lights, also new to me: porchlights and streetlights and lights behind windows, all glowing in the night, wonders without names. The whole seemed a delightful maze, of near and far perspectives mingled, human and nonhuman illuminations intertwined. Degrees of otherness, displayed in light, stretched out into the night as far as my eye could see.

I remember trying to assess and understand the distance between myself and these engagingly varied lights, and knowing I must do this from my father's arms, for in the darkness I was not able to crawl about and learn by touch and taste. And these new entities were obviously not to be known in that immediate, immersed manner, for the streetlights alone were beyond even my father's reach, while the fireflies came and went erratically. Confronted with this, I remember the first stirrings of something new: trying to assess, from a distance, what I could not touch, realizing that there were other ways to know the world, and most of all, finding that these ways might be a social experience. For in pointing at and sharing this spectacle of lights, I was learning a human power, and learning also that I shared it with others and might use it to share. It was thus clear that there was a world very much *out* there, unlike the close-at-hand, immediate space of home and parents' arms. Out there was a world of multiplicity, variety and difference, and of communication between these differences.

To know that we are not the center of the universe may come as a delight, much as expulsion from a womb that one has grown too large for must come as a relief, however mixed with stress. When we separate from outgrown certainties, we are rewarded with new fulfillments and evolutions. Separation and alienation are not synonymous. Limbo is not heaven.

Thus outside among the fireflies, I knew that a larger world existed, a world in which the outdoors changed miraculously to darkness once a day, in which lamps glowed outdoors as well as in, magically higher than even one's father's reach, and in which tiny living lamps darted about in the darkness, an outside which was their indoors.

And just as my father had given me this first memory, this first awareness of the larger world, by showing me the night sky, so had his mother given him his first memory in a similar way. She had carried him hurriedly out into the night landscape to point out a burning World War I German Zeppelin over their seaside home in northern England. As an infant, he did not know what it was beyond being a spectacularly interesting sight. But it was a sight he remembered *sharing*, and perhaps remembered for having shared. The spectacle of the distant, untouchable night sky has long been a favorite vehicle for awakening human awareness in many cultures. For it is quintessentially Other and literally not everyday. It cannot readily be touched. It is known indirectly. And this is just what encourages communications that go beyond the narcissistic immersion of infancy, awakening us to both autonomy and socialization, helping us to mediate between them. Moreover, this is a continuing need. In taking my daughter out into the night to see the moon, I had instinctively tried using the powerful tool of the night sky to encourage in her what my father had encouraged in me: an excursion from immersion to an awakening of wonder, a strengthening of both autonomy and social awareness. For these are not things we learn only at the mirror stage, but at each maturational challenge. And we learn them not only through the night sky and mirrors, but at every out-of-reach phenomenon, everything we can know only at one remove; every *image*, every *spectacle*, every *representation*, every *mediated experience*.

At each of these accepted challenges we reach and stretch, trying to relate ourselves to a new concept, as a child tries to first grasp the concept of the moon in the night sky. If such a concept seems overwhelming, we are tempted either to idolize or attack. But if we resist these responses, new paths can form for imagination while reason holds at bay the twin walls of a parted Red Sea—one wall of servility and thrall, one of arrogance and aggression. Media, used well, help us to form this centered path.

And such a balance is not a compromise or common denominator, it is our true element. It is not a mere middle but the *medium* in which we thrive and grow. Within a wondering reason and a balanced center we are

sustained and challenged. Within it, we neither submerge nor escape, but reach a *whole* understanding beyond Right and Left. Whole and less afraid, we can then accept the mediacy, contingency, and finitude that allow us to be at all. And thus mediated and mediating, we can function and thrive in a state natural to us, buoyed between gravity and weightlessness like the earth itself, standing free between earth and sky, neither enwombed nor bestarred, and seeing that mediated and mediating state as miracle enough.

Notes

1. Robert J. Lifton, *Boundaries: Psychological Man in Revolution* (New York: Simon and Schuster, 1967), xi–xii, 60–61.

2. Yaakov Jerome Garb, "The Use and Misuse of the Whole Earth Image," *Whole Earth Review* 45 (March 1985): 18, 25.

3. Ibid., 19–21.

4. Ibid., 18.

5. Ibid., 24–25.

6. Arthur C. Clarke, *2001: A Space Odyssey* (New York: New American Library/Signet, 1968), 218–19.

7. Ibid., 218–21.

8. Zoe Sophia, "Exterminating Fetuses: Abortion, Disarmament, and the Sexo-Semiotics of Extraterrestrialism," *Diacritics* 14 (Summer 1984): 59, 48.

9. Ibid., 48

10. Ibid., 48, 58.

11. Ibid., 58.

12. Roland Barthes, *Camera Lucida* (New York: Farrar, Straus and Giroux, 1981), 7, 51, 90, 115.

13. Ibid., 67, 69.

14. Ibid., 72.

15. Ibid., 99.

16. Ibid., 91–92.

17. Ibid., 73, 93, 100.

18. Ibid., 119.

19. Ibid., 90.

20. Ibid., 72, 98.

21. Ibid., 118.

22. Roland Barthes, *A Lover's Discourse* (New York: Farrar, Straus and Giroux, 1978), 226–28, 232.

23. Jacques Lacan, *Ecrits* (New York: W. W. Norton, 1977), 1–5.

24. Jacques Lacan, *Four Fundamental Concepts of Psycho-Analysis* (London: Hogarth Press, 1977), 115, 118–19.

25. Ibid., 103.

26. Ibid., 81, 96, 113.

27. Herbert Blau, "(Re)sublimating the Sixties," *Formations* 2 (Spring 1985): 66–67.

28. Susan Sontag, *On Photography* (New York: Farrar, Straus and Giroux, 1973), 14.

29. Ibid., 109–10, 178–79.

30. Ibid., 180.

31. Jonathan Cott, "The Rolling Stone Interview: Susan Sontag," *Rolling Stone* (October 4, 1979): 53.

32. Susan Sontag, *Death Kit* (New York: Dell, 1967), 229.

33. Alvin W. Gouldner, *Against Fragmentation: The Origins of Marxism and the Sociology of Intellectuals* (Oxford: Oxford University Press, 1985), 266, 271, 275, 282, 290.

34. Karl Marx, "The German Ideology," in Robert C. Tucker, ed., *The Marx-Engels Reader* (New York: W. W. Norton, 1978), 160.

APPENDIX A:
LOGAN GRANT RECIPIENTS AND
JURORS, 1983–89

A Note on the Logan Grant Program:

Guidelines for the Logan Grant program have undergone changes from year to year, reflecting recommendations from jurors and responses from the critical community. As a result, the essays in the following list represent two categories of submission: Completed Manuscripts and Proposals. Awards for each year are listed in descending order.

1983 (Jurors: Andy Grundberg and Alan Trachtenberg)

COMPLETED MANUSCRIPTS:

Awards

James Hugunin	"Meditation on An Ukranian Easter Egg"
Max Kozloff	"The Privileged Eye"
Maren Stange	"Documentary Photography in American Social Reform Movements: The FSA Project and Its Predecessors"

Honorable Mentions

Marjorie Munsterberg	"Louis de Clerq's 'Stations of the Cross'"
Steven Youra	"Rapid Transit: Walker Evans, From Tenant Farm to Subway"

Finalists

Virginia C. Dell	"John Szarkowski's Guide: Locating Photography Among the Arts"
David L. Jacobs	"Toward Photographic Literacy"
Mark Johnstone	"Photography, Computers, and the Man in the Stands"
Ted Landsmark	"Post-Modernism in Photography and Photojournalistic Insights"

Michael Starenko — "Photography, Mirrors and Psychoanalysis: On the Subject of Lacan"

1984 (Jurors: Ben Lifson and Beaumont Newhall)

COMPLETED MANUSCRIPTS:

Awards

Colin L. Westerbeck, Jr. — "American Graphic: The Photography and Fiction of Wright Morris"

Mary Warner Marien — "Toward A New Prehistory of Photography"

Nancy Ann Roth — "Electrical Expressions: The Photographs of Duchenne de Boulogne"

Honorable Mentions

Timothy Druckrey — "Atget in the Current of History"

Alice Wingwall — "Camera/Room. Notes on: Photographs as Architectural Shelter; Photographs of Architectural Shelter"

Finalists

Bill Jay — "The Curious Case of the Combination Portrait"

James Jenson — "A New Era: The History of the National Photographic Association"

Robert Leverant — "Recontacting Dorothea Lange"

Carol Loeb Shloss — "Targets of Destruction: Photography and the Discourses of World War II"

Jody Zellen — "The Aesthetics of Conceptual Documentation"

Betty Hurwich Zoss — "What Dr. Erich Salomon Saw"

1985 (Jurors: A. D. Coleman and Naomi Rosenblum)

COMPLETED MANUSCRIPTS:

Awards

Andy Grundberg — "The Crisis of the Real: Photography and Post-Modernism"

Thomas Goodman — "Collaborating in Character: James Agee and Walker Evans"

Diana Schoenfeld — "Symbol and Surrogate: An Interpretive Description of the Picture-Within-the-Picture in Photography"

Honorable Mentions

Edward W. Earle — "Toward a Historiography of Photography"

Joseph Masheck — "Reflections Across Time on Paul Strand's Christos With Thorns"

PROPOSALS FOR NEW MANUSCRIPTS:

Awards

Shelley Rice "Parisian Views"
Miles Orvell "Almost Nature: The Typology of Late Nineteenth Century American Photography"

Honorable Mentions

David Herwaldt "A Concise Account of the Brief Life of the Association of Heliographers—Part One"
David L. Jacobs "Lange, Adams, and *Three Mormon Towns*"

Finalists

Jaroslav Andel "Photography and Images of the Modern Self"
Daile Kaplan "The Urban Landscape: Photography in New York City from 1965 to 1975"
Theodore C. Landsmark "Hustler Magazine and Photographic Taste-Setting Today"

1986 (Jurors: Nathan Lyons and Anne Tucker)

COMPLETED MANUSCRIPTS:

Awards

Judy Fiskin "Borges, Stryker, Evans: The Sorrows of Representation"
Suzanne Seed "The Viewless Womb: A Hidden Agenda"
Jake Seniuk "Walking on Silver Splinters: Joel-Peter Witkin and the Photography of Obsession"

Honorable Mentions

David Robinson "Street Photography"
Elizabeth Winter "Occupied Territory"

PROPOSALS FOR NEW MANUSCRIPTS:

Awards

David Levi Strauss "Photography and Propaganda: Richard Cross and John Hoagland in Central America"
Edward W. Earle "Halftone Effects: A Cultural Study of Photographs in Popular Periodicals 1890–1905"
Leah Ollman "The Worker Photography Movement: Camera As Weapon"

Finalists

Christopher Burnett "THINK: Photography, Computers, and Simulation at the World's Fair"

Constance Pierce "The Photographic Convention in Contemporary Fiction"

April Rapier "Regional Surveys of Unexhibited Art"

Michael Starenko "Re-Reading *On Photography*"

1987 (Jurors: Vicki Goldberg and Colin Westerbeck)

COMPLETED MANUSCRIPTS:

Awards

Dan Meinwald "Icons of War"

Megan Seielstad "Clarence John Laughlin and the Third World of Photography"

John A. Wood "Photography and the Romantic Imagination"

PROPOSALS FOR NEW MANUSCRIPTS:

Awards

Roger Hull "Emplacement, Displacement, and the Fate of Photographs"

Robert Silberman "W. Eugene Smith's Pittsburgh"

Ann-Sargent Wooster "How the Nexus of Painting, Sculpture, Video, Dance and Film Changed the Language of Photography in the Late Sixties and Early Seventies"

Honorable Mentions

Richard Bolton "Broken Messages: Photography and the End of Representation"

Grant Kester "New Social Documentary Photography in the American City"

Finalists

Anna Novokov "Man Ray in California"

Melissa Banta "Images of Others and Ourselves: Representations of Cultures at World's Fairs and Expositions"

1988 (Juror: Thomas Barrow)

PROPOSALS FOR NEW MANUSCRIPTS:

Awards

Deborah Bright "Victory Gardens: The Public Landscape of Postwar America"

Anne McCauley "François Arago and the Politics of the French Invention of Photography"

Anne Hoy "Postmodernism and Late Modernism in Some Current American Photography: How the Terms Are Worn"

APPENDIX B:
ABOUT THE CONTRIBUTORS

DEBORAH BRIGHT teaches the history and criticism of photography at Rhode Island School of Design. Her writings on photography and cultural issues have appeared in numerous publications including, *Afterimage, exposure, The New Art Examiner,* and *VIEWS: The Journal of Photography in New England.* She pursues her own photographic work on several fronts and is currently working on two projects: *Chicago Stories* and *Dream Girls.*

JUDY FISKIN is a photographer who teaches at California Institute of the Arts. Her photographs have been published in *Paris Review* and have been exhibited at Newspace (Los Angeles), Los Angeles Institute of Contemporary Art, Real Art Ways (Hartford), and DIA Art Foundation (New York).

ANDY GRUNDBERG is the author of numerous books, including *Alexey Brodovitch* (Harry N. Abrams, 1989) and *The Crisis of the Real* (Aperture, 1990), a collection of his writings, and is the co-author of *Photography and Art: Interactions Since 1946* (Abbeville Press, 1987). He is the director of programs at the Friends of Photography in San Francisco and the chief curator of the Ansel Adams Center there.

JAMES HUGUNIN is an adjunct professor in the Department of Art History, Theory, and Criticism at the School of the Art Institute of Chicago. He is the Midwest editor of *The New Art Examiner* and was the founder/editor of two West Coast art journals, *U-Turn* and *The Dumb Ox.*

ROGER HULL teaches art history (including American photography) at Willamette University (Salem, Oregon). His writing has appeared in the *Sadakichi Hartmann Newsletter, Art Journal, New Mexico Studies in the Fine Arts, History of Photography, VIEWS: The Journal of Photography in New England,* and the *Willamette Journal of the Liberal Arts.*

MAX KOZLOFF was a freelance art critic from 1961 to 1976. His books on photography include *Photography and Fascination* (Addison House, 1979), *The Privileged Eye* (University of New Mexico Press, 1987), and *The Duane Michals Story* (Twelvetrees Press, 1990). He is also a practicing photographer whose subjects are the streets and more recently, portraits.

ANNE MCCAULEY is an associate professor of art history at the University of Massachusetts, Boston. She is the author of *A.A.E. Disdéri and the Carte de Visite Photograph* (Yale University Press, 1985), and numerous articles on the social history of art, particularly nineteenth-century French photography. She is completing a book on commercial photography in Paris from 1848 to 1870.

MARY WARNER MARIEN teaches photographic history and art criticism in the Department of Fine Arts at Syracuse University and writes frequently for *Afterimage*, *The Christian Science Monitor*, and *VIEWS: The Journal of Photography in New England*. She recently completed the book *Photography and Cultural History*.

LEAH OLLMAN is an art critic for the *Los Angeles Times/San Diego County Edition*. Her writing has also appeared in *ARTnews*, *Afterimage*, *High Performance*, and *Women Artists News*. She is the curator of *Camera as Weapon: Worker Photography Between the Wars*, a traveling exhibition originating at the Museum of Photographic Arts in San Diego.

MILES ORVELL is a professor of English and American studies at Temple University (Philadelphia), where he teaches courses on the history of photography and on photography and literature. He is the author of *The Real Thing: Imitation and Authenticity in American Culture, 1880–1940* (University of North Carolina Press, 1989).

SHELLEY RICE is a critic and historian on the faculty of New York University and the School of the Visual Arts. She has contributed columns to *The Village Voice*, *The Soho Weekly News*, and *Artforum* and has written for *Art in America*, *Art Journal*, *Afterimage*, *The New Republic*, and *Ms. Magazine*. She has curated several exhibitions, including *Deconstruction/Reconstruction* (New Museum, New York).

NANCY ANN ROTH is an assistant professor in the Department of Art and Design at the University of Wisconsin-Stout. Her writing has appeared in *Afterimage*, *Aperture*, *ARTnews* and *Artpaper*. She is writing her dissertation on the photomontages of John Heartfield.

SUZANNE SEED worked for twelve years as a photojournalist and editorial photographer for magazines, newspapers, and television stations. She has authored two photo-interview books and has exhibited her photographic work in New York, Chicago, and Los Angeles. Her criticism continues to be based upon psychosocial origins of political and critical attitudes.

MAREN STANGE is an assistant professor of Communications and American Studies at Clark University (Worcester, Mass.) and is the author of *Symbols of Ideal Life: Social Documentary Photography in America, 1890–1950* (Cambridge University Press, 1989). She is also a co-author of *Official Images: New Deal Photography* (Smithsonian Institution Press, 1987).

ALAN TRACHTENBERG is professor of American studies and English at Yale University and is the author of *Brooklyn Bridge: Fact and Symbol* and *The Incorporation of America: Culture and Society, 1865–1893*. His most recent book is *Reading American Photographs: Images as History—Mathew Brady to Walker Evans* (Hill and Wang, 1989).

COLIN L. WESTERBECK, JR., is assistant curator of photographs at the Art Institute of Chicago. Before assuming his present position, he was a regular contributor to *Artforum, Commonweal,* and *Aperture.* He is a contributing essayist and a curator of the traveling exhibition and book *On the Art of Fixing A Shadow: One Hundred and Fifty Years of Photography* (Little, Brown and Company, 1989).